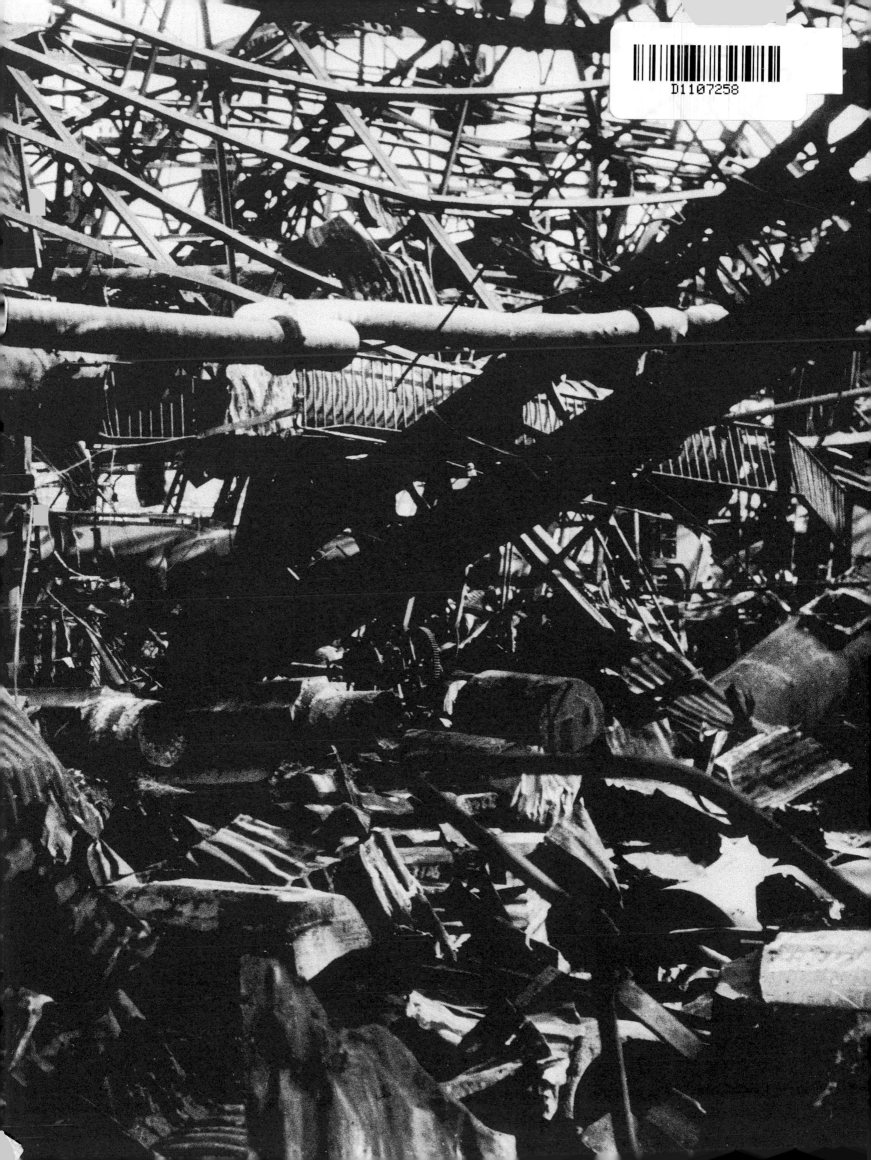

FLASH
OF LIGHT

WALL
OF FIRE

FLASH
OF LIGHT
WALL
OF FIRE

JAPANESE PHOTOGRAPHS DOCUMENTING THE

ATOMIC BOMBINGS OF HIROSHIMA AND NAGASAKI

BRISCOE CENTER FOR AMERICAN HISTORY

UNIVERSITY OF TEXAS PRESS, AUSTIN

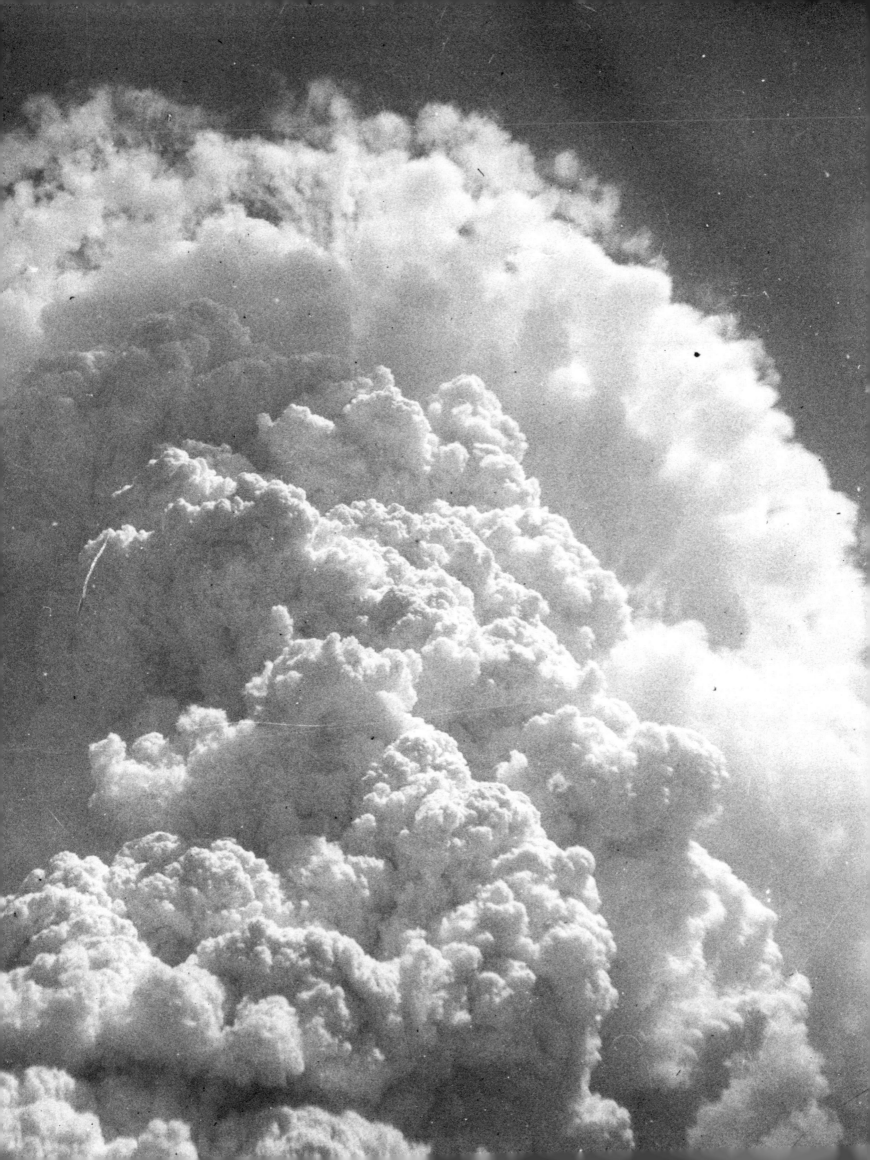

The publication of *Flash of Light, Wall of Fire* has been made possible by funding from the Dolph Briscoe Endowment.

Requests for permission to reproduce material from this work should be sent to:

 Permissions
 University of Texas Press
 P.O. Box 7819
 Austin, TX 78713-7819
 utpress.utexas.edu/rp-form

♾ The paper used in this book meets the minimum requirements of ANSI/NISO Z39.48-1992 (R1997) (Permanence of Paper).
ISBN 978-1-4773-2151-5

Library of Congress Cataloging-in-Publication Data

Names: Dolph Briscoe Center for American History.
Title: Flash of light, wall of fire : Japanese photographs documenting the atomic bombings of Hiroshima and Nagasaki / The Dolph Briscoe Center for American History.
Other titles: Japanese photographs documenting the atomic bombings of Hiroshima and Nagasaki
Description: First edition | Austin, TX : University of Texas Press, 2020.
Identifiers: LCCN 2020001811 | ISBN 978-1-4773-2151-5 (cloth)
Subjects: LCSH: Hiroshima-shi (Japan)—History—Bombardment, 1945—Pictorial works. | Nagasaki-shi (Japan)—History—Bombardment, 1945—Pictorial works. |
 Atomic bomb victims—Japan—Hiroshima-shi—Pictorial works. | Atomic bomb victims—Japan—Nagasaki-shi—Pictorial works. | Hiroshima and Nagasaki Atomic Bomb
 Photographs Archive (Dolph Briscoe Center for American History)—Photograph collections—Exhibitions. | Dolph Briscoe Center for American History—Exhibitions.
Classification: LCC D767.25.H6 F55 2020 | DDC 940.54/25219540222—dc23
LC record available at https://lccn.loc.gov/2020001811

Book Design: EmDash, Austin, TX

In November 1945,

three months after Japan surrendered unconditionally to the Allied nations, ending the most destructive war in human history, an armed troop of United States military forces entered the Toho-sha office where Shigeo Hayashi worked as a photographer. He was twenty-seven, a junior employee, so his boss, Ihei Kimura, dealt with the American officer, who was accompanied by a translator. Years later Hayashi recalled that he hid in a back room and listened while the officer demanded that Kimura, who went on to become one of Japan's most renowned photographers, hand over all the photographic film his company had recently taken. The officer had been informed that Kimura's photographers had documented the aftermath of the atomic bombings of Hiroshima and Nagasaki, dropped by American forces on August 6 and 9, 1945, respectively.

Japan had surrendered on August 15. By November, the United States had occupied Japan, and American military authorities had imposed censorship on Japanese media outlets. Discussion of the atomic bombings was strictly regulated, and, in most cases, publishing images of atomic devastation was prohibited. Ironically, the militarists who ruled Japan when the bombs were dropped had also banned the public release of such photographs.

Responding to the American officer, Kimura said, "The films, which represent the work of our photographers, should carry the same weight as the gun you carry on the right-hand side of your waist. Put your gun on the desk here, then I will bring out all the photo works our guys have produced. We can then trade those films for your gun." Obviously startled, the officer refused Kimura's request. "If so, I cannot surrender our films," Kimura retorted. The American army officer and the Japanese photographer eventually reached a surprising compromise. Kimura could keep his film on the condition that he made copies for the officer. Kimura explained that he had no paper or chemicals to develop and print copies, and the Americans soon delivered a supply of both. If Kimura was brave in the face of the American officer, it must also be noted that the officer exhibited patience and diplomacy in dealing with former enemies who were now under his authority.

Seventy-five years later, historians can sympathize with the positions of both men. For Kimura, those images served as important visual documentation of nuclear blast damage and devastation, including the burnt human flesh, the horrific aftereffects of radiation, and the mass human suffering that resulted. For American occupation authorities, evidence of the destruction wrought by the atomic bombs remained a military secret. It was feared that dissemination of these images to the Japanese public could lead to civil unrest and even violence. That was one reason the Japanese wartime government also had censored the images, although its basic motive was to mislead its citizens into thinking its military was winning the war.

As a result of the compromise between the American officer and Kimura, a batch of historically significant images documenting the unimaginable destruction caused by the first use of nuclear weapons was preserved, making it possible for those images eventually to be shared on public platforms on both sides of the Pacific Ocean. But by no means was Kimura the only one to hide prints and negatives that otherwise would have been confiscated or perhaps even destroyed. The "Hiroshima and Nagasaki Atomic Bomb Photographs Archive" of the Anti-Nuclear Photographers' Movement of Japan (ANPM) is an important way this legacy has been preserved. Consisting of 826 images (415 taken in Hiroshima and 411 in Nagasaki) by approximately fifty Japanese photographers, the archive provides stunning and revelatory visual evidence of what happens when even relatively small nuclear weapons are used against human beings and their built and natural environments. Now housed at the University of Texas at Austin's Briscoe Center for American History, the Hiroshima and Nagasaki Atomic Bomb Photographs Archive is the source for the disturbing images that you will see in this book.

The ANPM, the organization that established the archive, was founded in 1982. According to ANPM steering committee member Kenichi Komatsu, this was a time when "waves of calls for 'peace on earth by abolishing nuclear weapons' were at its height around the world as well as in Japan." According to Komatsu, the movement's founding was thus "a reflection of the social situation . . . [and the] very strong atmosphere [against] nuclear weapons." The founding of ANPM also coincided in the late 1970s and early 1980s with what the sociologist and historian Akiko Hashimoto has called Japan's atomic bombings "memory boom."

More than 550 individuals came together to support the founding of the ANPM. Its founders, just like current steering committee members Kenichi Komatsu and Kenichi Shindo, were prominent Japanese photographers. Founding supporters included Shunkichi Kikuchi, Shigeo Hayashi, Eiichi Matsumoto, and Yoshito Matsushige, who were among the photographers who had documented

the immediate aftermath of the atomic bombings. Although the ANPM specifically sought members who were photographers or were engaged in photography-related industries, a number of artists, musicians, and novelists have also been involved in the organization's program.

The ANPM was founded to help bring about the "ultimate abolition of nuclear weapons and arms reduction" in the world. These efforts included lobbying the Japanese government to ensure that "Japan shall neither possess nor manufacture nuclear weapons, nor shall it permit their introduction into Japanese territory." The ANPM's main activity, however, has always been gathering evidence for preservation in its archive, which not only included collecting and copying images but also documenting when, where, and how those images were produced—by interviewing their creators, whenever possible—and then making the resulting resources available through books and exhibits. In the years after its founding, members visited surviving but aging photographers in Hiroshima and Nagasaki, interviewed them, and collected their photographs and writings. When photographers were deceased, ANPM activists worked with their heirs. Many of the prints and negatives they collected were in poor shape, so copies were photographed in high resolution and printed on high-quality paper. The ANPM eventually digitized the images.

A reverence for the original photographers has always been important to the ANPM. Komatsu and Shindo have stressed that those photographers "took pictures under extremely harsh conditions, pushing them to their mental limits," and that "they . . . exerted extraordinary efforts to preserve their films against grave pressure to confiscate them under the reign of the occupation army after the war." The photographers "risked their lives to capture the sheer reality of devastation right after the bombing" as well as "the extreme agonies and sufferings that people had to go through subsequently." Compelling medical evidence exists to suggest that several of the original photographers died from radiation-related afflictions.

For the ANPM's members, the collected images are visual testimony to the immediate impact of the atomic bombs and the persistence of these effects. In their archival efforts the members of the ANPM have always had an activist goal in mind as well. They intended their collection to serve as "the tool for conveying a clear message about the magnitude of the devastation," and they wanted it to be a "weapon for those photographers to carry" to further their antinuclear goals.

The ANPM also established its archive as a resource for educating future generations. Komatsu has lamented that the "memory of such catastrophic experience [of the atomic bombings] seems to be fading out." Indeed, the original photographers have now all died. There are *hibakusha* (the Japanese name for the survivors of the bombings) still living, but their numbers grow smaller with every passing year. Japan experienced an "economic miracle" in the postwar years and developed into one of the most prosperous economies in the world. Hiroshima and Nagasaki have been rebuilt. And while each city has outstanding museums dedicated to educating the public about the bombings, the historical evidence continues to erode architecturally, bodily, and within public memory.

Aware of the threat that historical forgetfulness poses, the members of the ANPM have actively used their photographic archive to remind their fellow Japanese citizens and the rest of the world about what happened in Hiroshima and Nagasaki in August 1945 and to plead that such horrors should never recur. In 1995 the ANPM produced and displayed a major exhibition of its photographs in Tokyo to memorialize the fiftieth anniversary of the atomic bombing. Although the exhibit was open for only one week, it attracted more than thirty thousand visitors. In 2015, the ANPM mounted an exhibit of its photographs that drew another large audience. One press report noted that the lines of people outside the gallery waiting to view the display stretched down the street and around the block.

Ever since its founding, the ANPM has continued to discover, copy, and document new photographs. In 2015, its steering committee decided to publish the entire archive. Bensei Publishing Company issued the collection in two volumes: *The Collection of Hiroshima Atomic Bomb Photographs* and *The Collection of Nagasaki Atomic Bomb Photographs*. The publications featured images captured by twenty-seven photographers in Hiroshima and Nagasaki. "Most of them had passed away," Komatsu noted, "and the support extended to us by their heirs was a major contribution to compiling those books." The Japan Congress of Journalists recognized the publication by presenting its JCJ Award to the co-authors, Kenichi Komatsu and Kenichi Shindo.

In 2017, ANPM's leaders grew deeply concerned about the proliferation of nuclear weapons and the increasingly unstable and dangerous geopolitical situation, especially in Asia. Because of those worries and the fear that younger generations were unaware of the reality of the horrors of nuclear war, the organization decided to seek a publisher in the United States for its two-volume book. ANPM members

hoped the publication would bring the images to the attention of a wider audience and help raise public awareness of the danger of nuclear war.

Accordingly, they worked with Hank Nagashima to seek out an American project partner. Nagashima, a good-humored, intelligent, and friendly man, lived and worked in the United States for seventeen years as a representative of a Japanese photographic lens company. During that time, he became a good friend of famed American photojournalist Eddie Adams and his wife, Alyssa. Eddie Adams, who died in 2004, had gained worldwide attention during the Vietnam War with his Pulitzer Prize–winning photograph of the street execution of a Vietcong prisoner in Saigon during the Tet Offensive in February 1968. For advice about how to find an American publisher for the ANPM photo archive, Nagashima called on Eddie's widow, Alyssa Adams, a professional photo editor who runs the Eddie Adams Workshop photojournalism seminar. She recommended to Hank that he contact me, the executive director of the Briscoe Center, which is the home of the Eddie Adams Photographic Archive. Alyssa donated her late husband's vast archive to the center in 2009, and in 2017 we copublished a book of images from the Adams archive with the University of Texas Press titled *Eddie Adams: Bigger Than the Frame*.

Nagashima, now based in Tokyo, contacted me in December 2017. In his initial email, he stressed that the ANPM's photo books "featured the devastation and aftermath of the atomic bombing of Hiroshima and Nagasaki respectively, pages of which are filled with nothing but tragedies." He asked if the center might have an interest in publishing them in the United States, and he offered to send me copies. Knowing nothing about the ANPM, or whether they had a polemical agenda, I was at first wary of the project. As a historian and director of a history research center at a public university, I was keenly aware of how controversial the subject of the atomic bombing of Japan had become in the United States.

My father was in the Army Air Force in World War II. On August 6, 1945, he was training at an army camp in California for the invasion of Japan when the news broke that the United States had dropped an atomic bomb on Hiroshima, followed three days later by one on Nagasaki. By August 15 the war was finally over. My father always believed the atomic bombs saved his life, along with those of many of his comrades. Understandably, he supported President Harry S. Truman's decision to drop the bombs. In the early 1970s as a doctoral student specializing in the political

history of the United States in the twentieth century, I learned that President Truman's decision was a much more controversial and heavily contested issue among historians of the era than my father or I had ever realized. In 1995 I had closely observed the Smithsonian Museum's plans to display the restored *Enola Gay*, the B-29 that dropped the bomb on Hiroshima, and I followed the angry and emotional battle that followed over the exhibit's interpretive texts referring to the ongoing debate about whether the bombing had been necessary to end the war.

Despite the sensitivity of the subject, and my concern that the ANPM might be using the photographs to argue that the United States had committed war crimes by dropping the bombs, I wanted to know more about the archive. The Briscoe Center has amassed an extensive collection of news and documentary photographs, now approaching eight million images in size, including the entire archives of several of the most important American photographers in both fields, several Pulitzer Prize winners among them. I wanted to see the books to determine whether a copy of the ANPM's digital photo archive might make a valuable addition to our photographic holdings. Hank sent me the ANPM's publications, and after a close review and some research, I was struck by how few of the images of Hiroshima and Nagasaki taken by Japanese photographers had ever been published in the United States. It was obvious that the archive would be an important resource for research at the Briscoe Center.

It also occurred to me that if ANPM agreed to make the center the US location for its digital photograph collection, we could publish a large sample of the images in a book, we could produce and display them temporarily in the center's exhibition gallery, and both the book and the exhibit could be timed to coincide with the seventy-fifth anniversary of the bombings and the end of World War II. The center's policy is to only publish or arrange to publish books based on the center's collections.

Nevertheless, before I began negotiations with ANPM, I still needed to know the organization's agenda. I had no interest in the Briscoe Center engaging in any effort to refight World War II in the Pacific, involve itself in the important but endless debate over the decision to drop the atomic bombs, or assign war guilt. I contacted Alyssa Adams, who assured me that Nagashima was a friend who was highly regarded within the community of professional photographers in Japan as well as in the United States. On January 3, 2018, I emailed him regarding my interest in the project. "I've now had an opportunity to look at the books you sent me," I wrote. "They are remarkable and, of course,

document the horrible reality of atomic warfare, which some people need to be reminded of during these strange and scary times."

Nagashima offered to come to Austin in February 2018 to discuss my proposal and to address my concerns. At our meeting, I presented my idea about the ANPM placing a copy of the archive at the Briscoe Center, as well as the possibility of publishing an entirely new English-language version of the book and producing a major exhibit of the photographs. I stressed that although the center's interest in the archive was as a valuable resource for studying one of the most historically significant events in American history, I also was keen on the idea that the collection and the book had educational potential as a resource for understanding the effects of nuclear war. As such, it could be a beneficial tool for using the past as a warning for the future.

When I explained that the center had no interest in using the collection for any political purposes, Nagashima assured me that the ANPM had no such goal. The organization's mission, as reflected in the "Anti-Nuclear" part of its name, was to disseminate the images as a means to remind the world of the dire consequences of nuclear war. I agreed that this goal was one that all rational and thoughtful human beings should share. World War II is over. Nuclear war is now our common enemy. We agreed that the project would be about photographs as historical evidence—our specialty—as well as about the immediate and long-term effects of using nuclear weapons, an issue that has gained new urgency in this moment of renewed nuclear anxiety.

When Nagashima took my proposal back to the ANPM steering committee in Tokyo, its members eagerly accepted it. They sent word back to me through Nagashima that they liked the idea of reproducing their archive at a major research university in the United States where it could be made available for teaching, research, and public education. Most of the committee members ranged in age from their sixties to their eighties, and they wanted to guarantee that the collection survived them and would remain available to future generations. As Kenichi Komatsu, one of the ANPM's leaders, stated, "We inherited those images and the history behind them as well. Essentially, those two are equal to the national heritage and need to be preserved." The ANPM steering committee was especially attracted to the idea of the archive being housed in a university history research center that not only specialized in preserving news and documentary photography but also had a well-known reputation for making its collections available

through exhibits, public programs, publications, and documentary films.

With the ANPM's preliminary agreement in hand, I took their books to a meeting with Dave Hamrick, director of the University of Texas Press, to discuss the possibility of copublishing a book of the photographs. Dave has made the University of Texas Press one of the country's leading publishers of photography books. Over the years, the center has partnered with the press to publish and/or distribute several books based on the center's collections, including *Selma*, photojournalist Spider Martin's photographs of a landmark event in the history of the civil rights movement in the United States; *Struggle for Justice*, which showcases the Briscoe Center's extensive photographic holdings documenting a variety of episodes and personalities associated with the civil rights movement; *The Making of Hillary Clinton*, featuring the work of White House photographer Bob McNeely; and *Front Row Seat: A Photographic Portrait of the Presidency of George W. Bush*, featuring the work of White House photographer Eric Draper. After a close examination of the ANPM photos, Dave quickly decided that not only would the press partner with the Briscoe Center on this book project, but he would personally oversee its production, including serving as the photo editor.

In August 2018, seventy-three years to the month after the United States dropped nuclear weapons on the cities of Hiroshima and Nagasaki, the ANPM signed a formal agreement with the Briscoe Center to house its photographic archive at the center and to cooperate on the publication of a book and the production of an exhibit to accompany it. After the signing, Komatsu declared, "The images are now in your hands. The mission of this movement to preserve the images and to transfer them to future generations will be well served with this cooperation."

In November 2018, two of my Briscoe Center colleagues, Director of Special Projects Alison Beck and Associate Director of Communications Ben Wright, and I spent nearly two weeks in Japan with Nagashima as our translator and guide. We toured the atomic bomb museums in Hiroshima and Nagasaki, met with members of their friendly and helpful professional staffs, and got a feel for the topography of both sites. In addition, we visited various shrines and monuments that have been erected as memorials to the victims of the nuclear attacks. During our stay in Japan, we also were fortunate to meet and interview *hibakusha*. In Nagasaki we met Dr. Masao Tomonaga, chairman of the Nagasaki Global Citizens' Assembly for the Elimination of Nuclear Weapons, who is both a *hibakusha* and a leading expert on the long-term effects on human

beings of the radiation emitted by the bombs. In Tokyo, we had an informative discussion with another *hibakusha*, Terumi Tanaka, the former secretary-general of the Japan Confederation of A- and H-Bomb Sufferers (Nihon Hidankyo). We capped our visit with a dinner hosted by the ANPM steering committee, including Hank Nagashima, Kenichi Komatsu, Kenichi Shindo, Tsuneo Enari, Keisuke Kumakiri, Toru Shozaki, and Miu Madzuki. There, we had a productive exchange of views and an in-depth discussion of mutual goals for our project.

Although my colleagues and I do not claim that our visit gave us any special expertise about Japan, the atomic bombings of Hiroshima and Nagasaki, or the current state of the Japanese antinuclear movement, we departed from Japan far better prepared to plan and produce this book and the exhibit than we had been before we made the trip. We are grateful to all of our new friends in Japan for their help and support.

What the ANPM collection ultimately represents is a comprehensive visual history of an epochal world event. Today, we take it for granted that historical events will be recorded by those experiencing them in real time. But it is important to remember that these photographs were not supposed to exist at all. In addition to surviving the censors of the American occupation forces, they were taken in spite of a scarcity of film across Imperial Japan and a military regime that harshly punished the unauthorized possession and use of cameras. Many, if not most, of the images in this book have never been published in the United States, and no similar collection (in extent, size, or subject) exists in this country. They are vital to our understanding of what happened when the bombs were dropped from those two American B-29s. They constitute an essential part of the history of the Manhattan Project, a part that has failed to receive as much attention in the United States as that given to the development and delivery of those weapons.

As you page through this book and contemplate these images, I urge you to take time to read the text. Dr. Michael Stoff, a member of the faculty of the University of Texas at Austin's Department of History, has contributed a thoughtful and deeply informed essay about the photography and the photographers as well as his thoughts about the meaning of this work. Dr. Stoff has researched and is currently writing a separate book with the working title, "'The Most Terrible Weapon': Fat Man, Nagasaki and the Meaning of the World's First Nuclear War." Japanese journalist Michiko Tanaka, a reporter for the *Chugoku Shimbun*, a Hiroshima-based

daily newspaper, was born several years after the war but grew up in Hiroshima and attended school in the city. In her essay, she gives us the perspective of a woman who experienced the educational and cultural legacy of the bombing as an impressionable youth.

The Hiroshima and Nagasaki Atomic Bomb Photographs Archive is now open and available for research at the Briscoe Center, which is located next to the Lyndon B. Johnson Presidential Library on the campus of the University of Texas at Austin. To supplement the atomic bombing photo archive, the center has initiated a project to collect additional archival material related to the aftermath of the nuclear bombings and the history of the US occupation of Japan, including newspapers, scrapbooks, letters, diaries, and other photographs. They join the center's other collections documenting American military history.

The Briscoe Center's mission is to preserve original documents, photographs, publications, and artifacts that constitute the evidence essential to an understanding of the American past and make them available to anyone in need of them. The purpose of the center's exhibits, research projects, and publications is to inform the university's students and faculty, as well as our many researchers who are not affiliated with the university, about the resources available at the center. We leave it to our users to form their own interpretations using their critical thinking skills based on the evidence they find at the center.

I think it fitting to close with a quote from the late Eiichi Matsumoto, one of the original supporting members of the ANPM, who as a young photographer covered the aftermath of both atomic bombings for the Asahi Shimbun publishing company: "It is my hope that people who look at our pictures depicting the Atomic Bomb devastation would be inspired to talk among themselves to weigh the absolute value of the peace. Our true wish is the day would come when a Movement like this would become unnecessary because of the permanent peace the world has achieved. Your contribution to that would be highly appreciated."[1]

It is the Briscoe Center's fervent hope that *Flash of Light, Wall of Fire* will not only benefit research and teaching but also help in some way to make Matsumoto's wishes come true.

Don Carleton
Executive Director
BRISCOE CENTER FOR AMERICAN HISTORY
THE UNIVERSITY OF TEXAS AT AUSTIN

Note
1. "Words by Photographers Who Captured Apocalyptic Scenes of Atomic Bomb Explosions," interview of Eiichi Matsumoto and Shigeo Hayashi conducted by Kenichi Komatsu, 1991, for the *Japan Photographers Association Newsletter* (no. 88), translation drafted by Hank Nagashima, reviewed and corrected by Tsukasa Yokoyama.

HIROSHIMA

POPULATION AT THE TIME OF THE BOMBING:

approximately
350,000

ESTIMATED DEATH TOLL:

140,000 (+-10,000)

NUMBER OF INJURED:

79,130

RATIO OF VICTIMS TO POPULATION:

Approximately
63 percent

NUMBER OF HOUSES AFFLICTED:

76,327

TOTAL AREA CONSUMED BY FIRE:

5.1 square miles

ヒロシマ

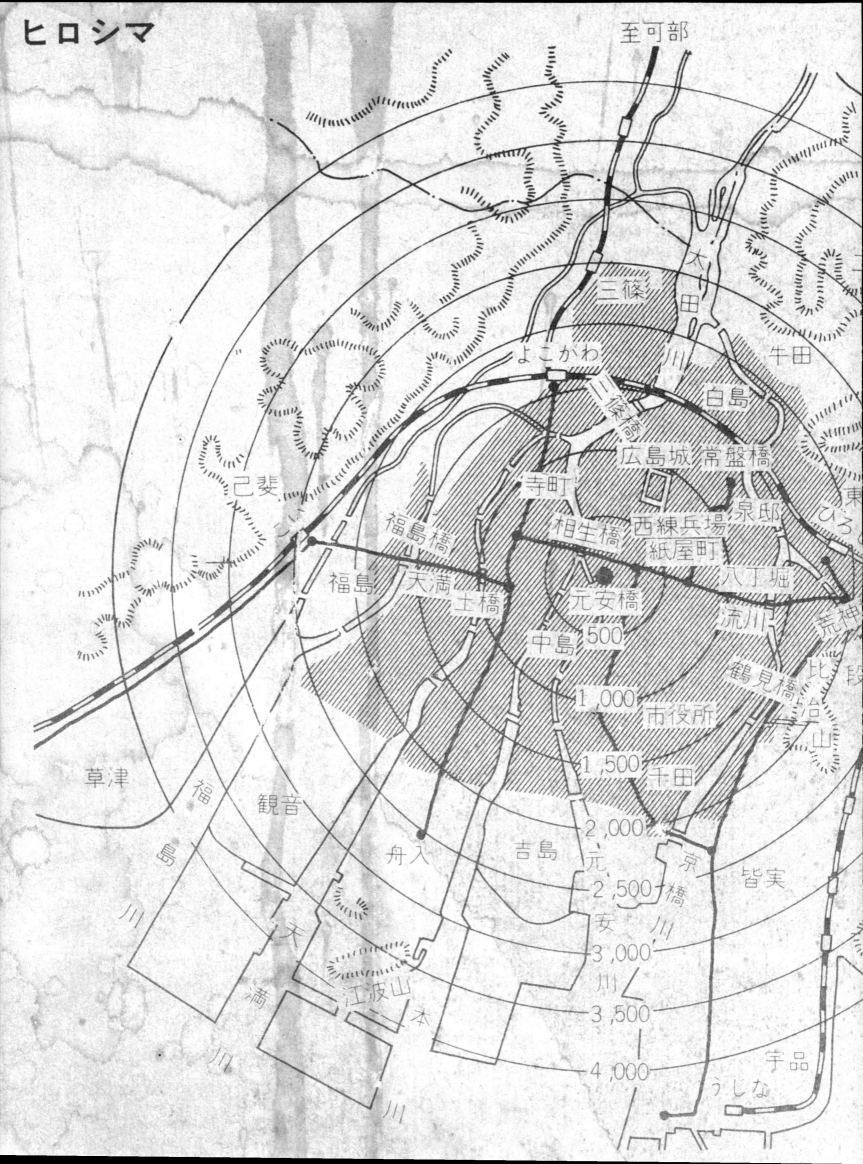

至可部

三篠

太田川

牛田

よこがわ

白島

京橋川

広島城　常盤橋

寺町

泉邸

東ひろ

相生橋　西練兵場

福島橋

紙屋町

八丁堀

福島

天満

元安橋

流川

荒神

土橋

中島　500

市役所

鶴見橋

比治山

1,000

草津

福

観音

1,500

千田

島

舟入

吉島　元

2,000

京橋

皆実

川

天

2,500

安

川

満

3,000

川

江波山

本

3,500

宇品

川

4,000

うしな

Map of Hiroshima
showing the epicenter
of the atomic blast.
AUGUST 1945.

は焼失区域

葉山

至十日市

練兵場

矢賀

蟹屋

大洲

むかいなだ

大河

向洋

至大阪
東京

本浦

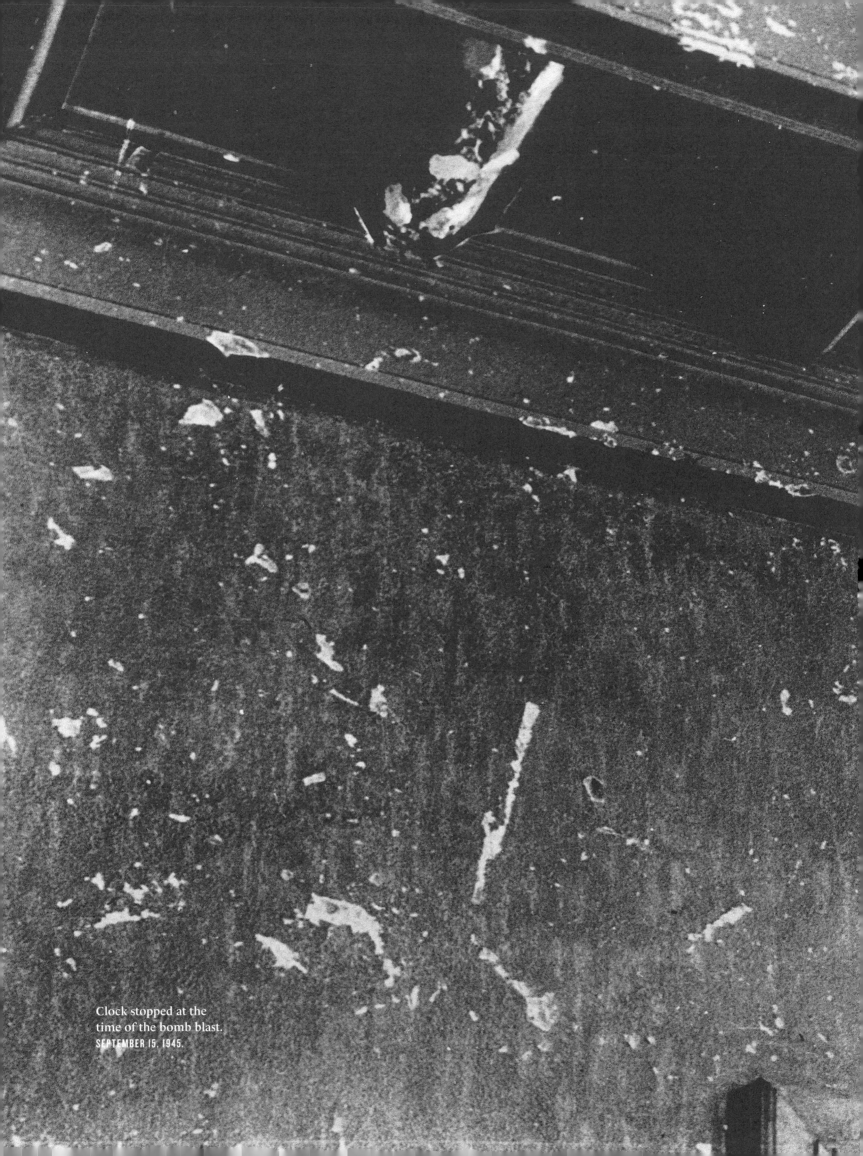

Clock stopped at the
time of the bomb blast.
SEPTEMBER 15, 1945.

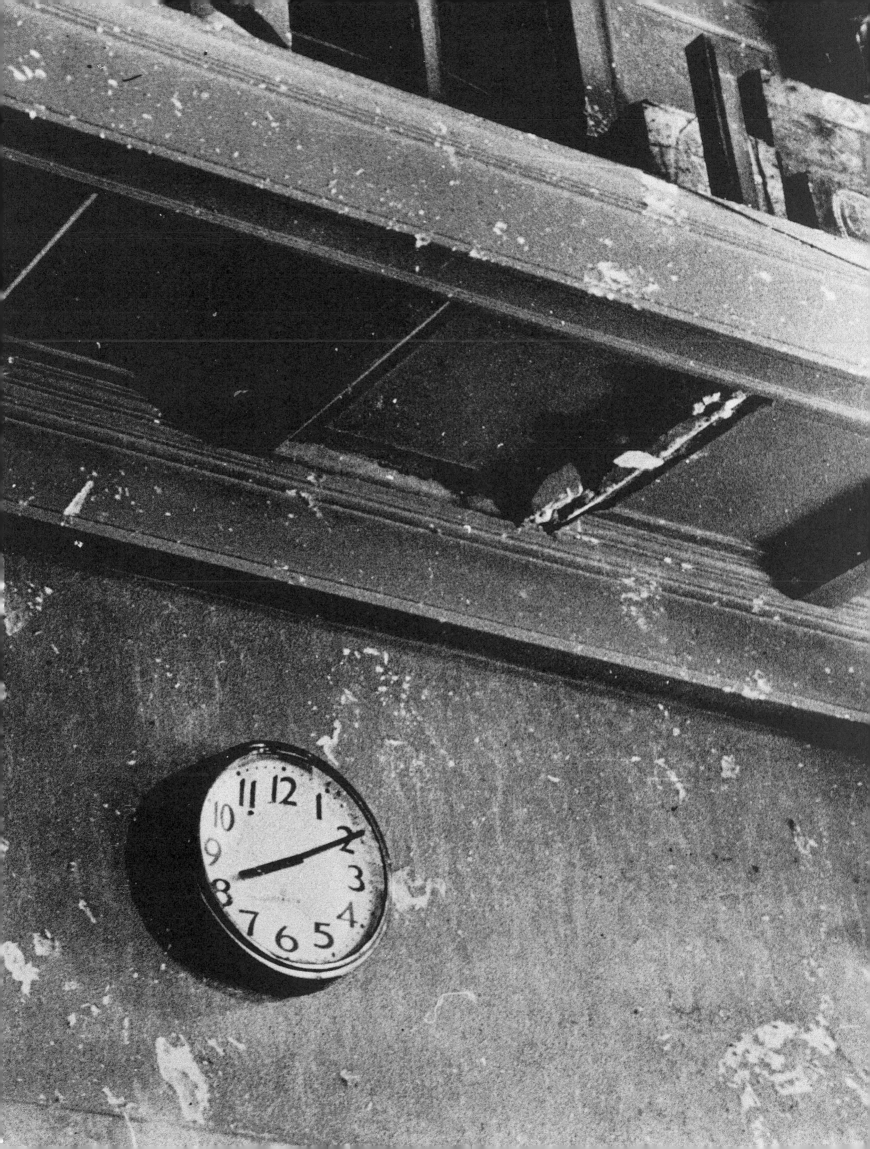

2.8 miles from ground zero.
AUGUST 6, 1945.

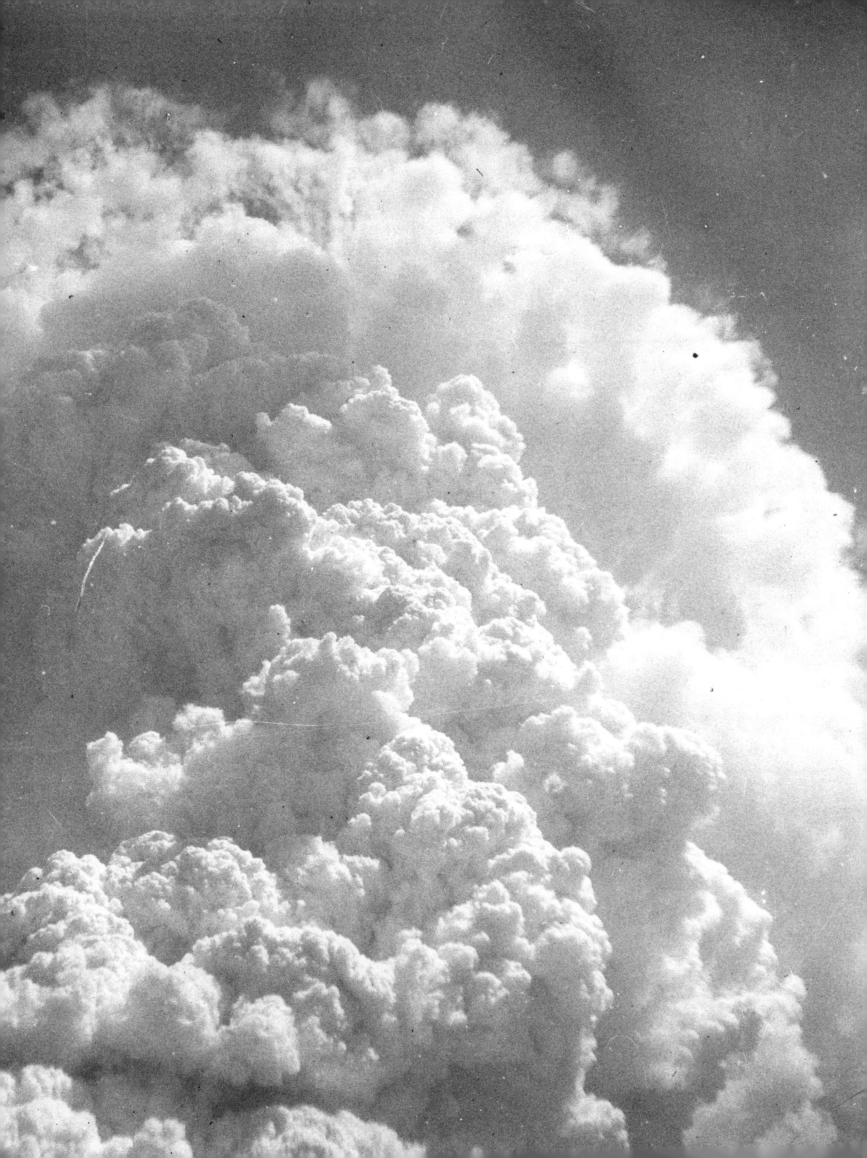

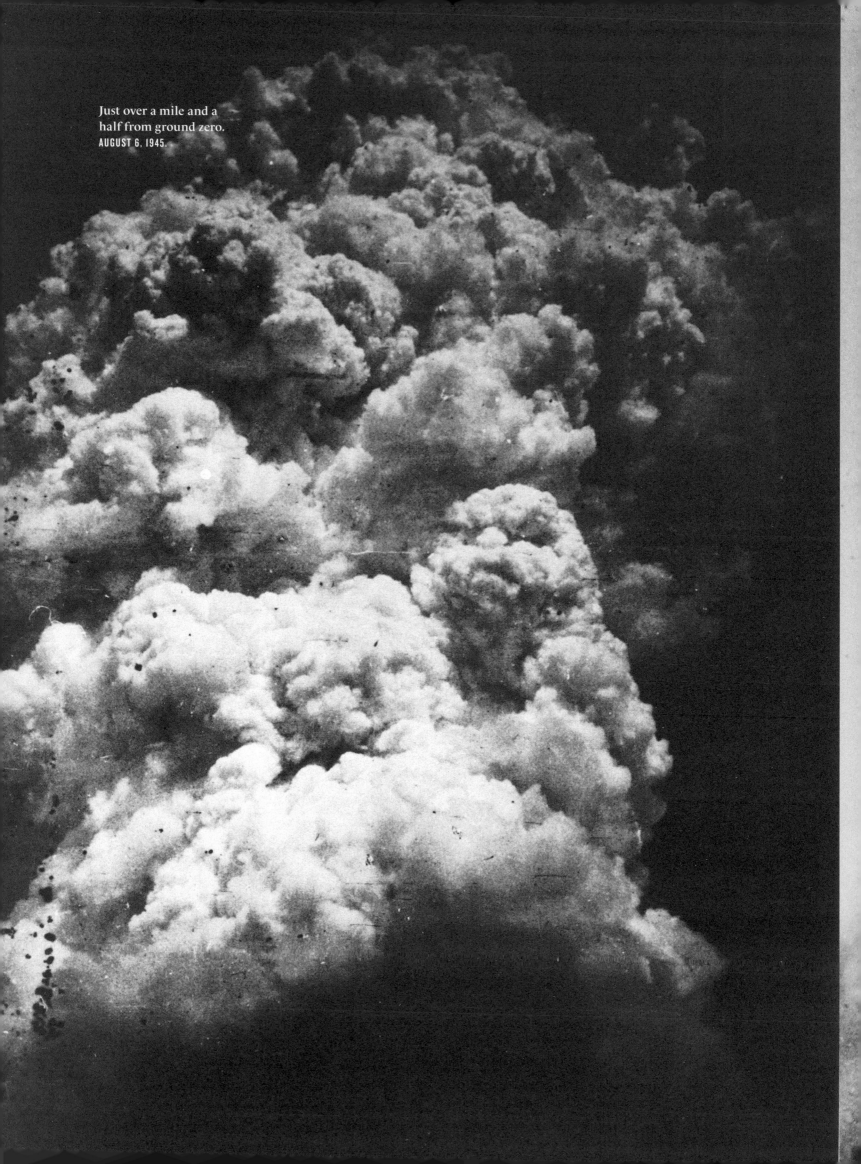

Just over a mile and a
half from ground zero.
AUGUST 6, 1945.

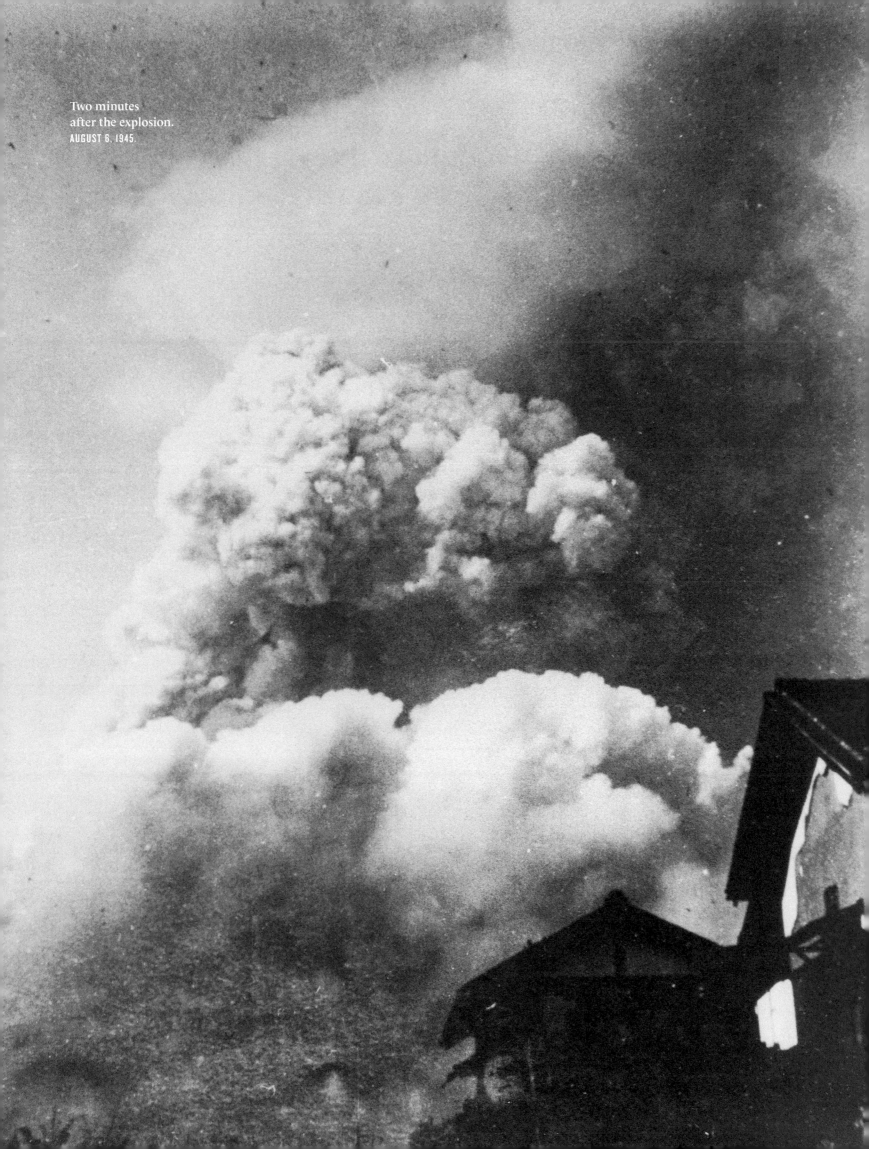

Two minutes
after the explosion.
AUGUST 6, 1945.

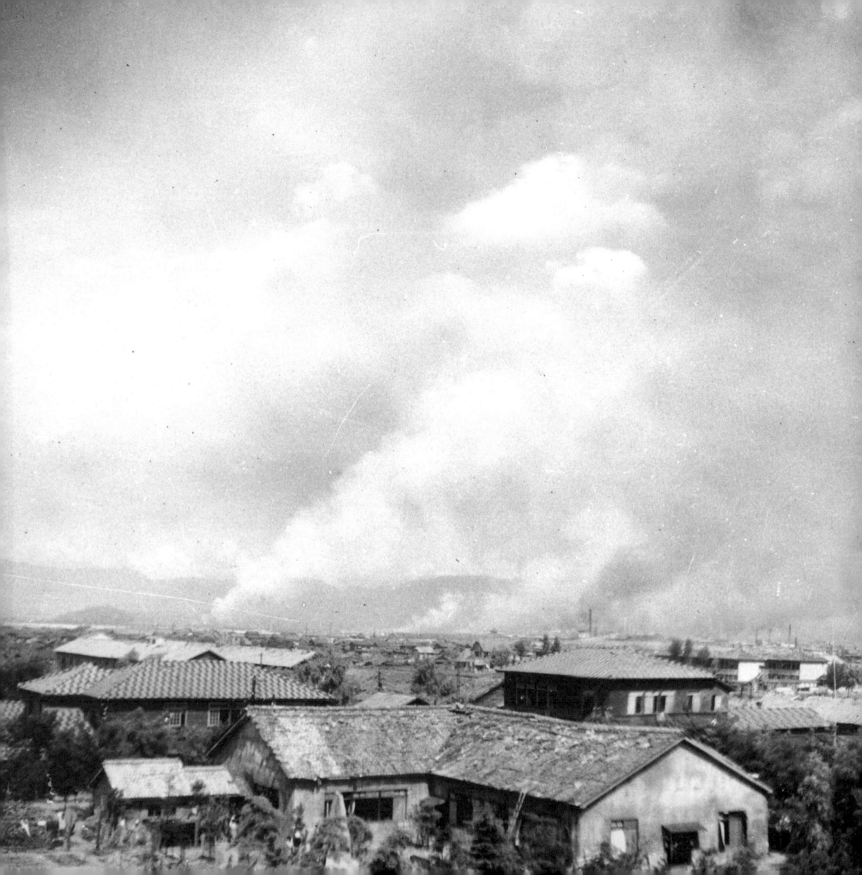

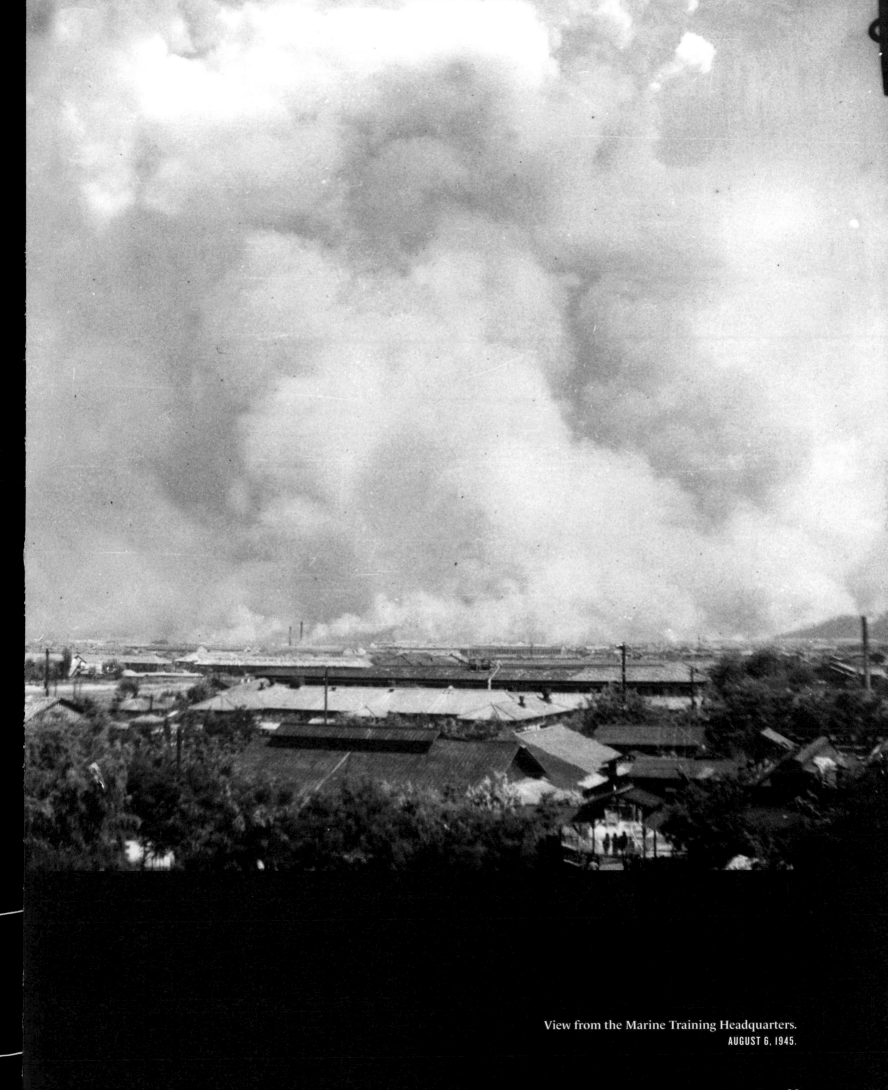

View from the Marine Training Headquarters.
AUGUST 6, 1945.

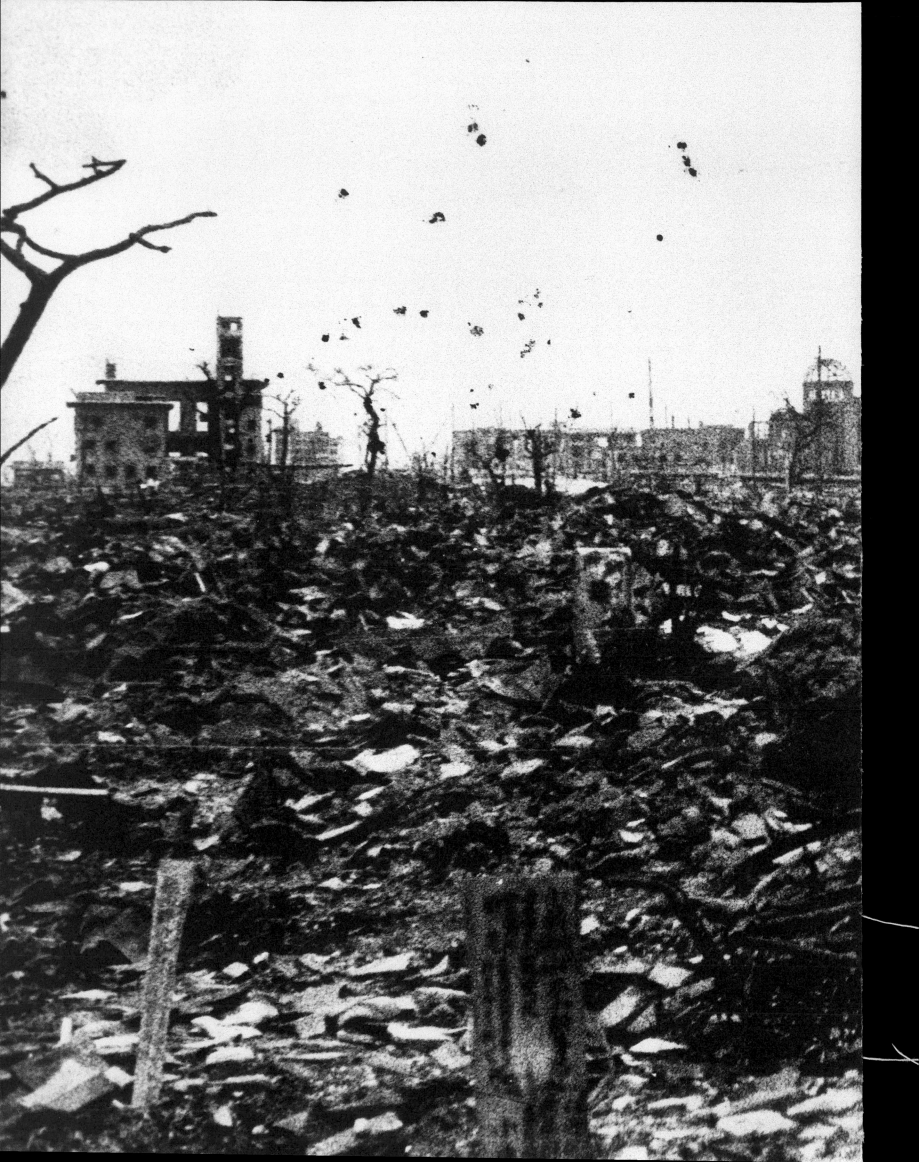

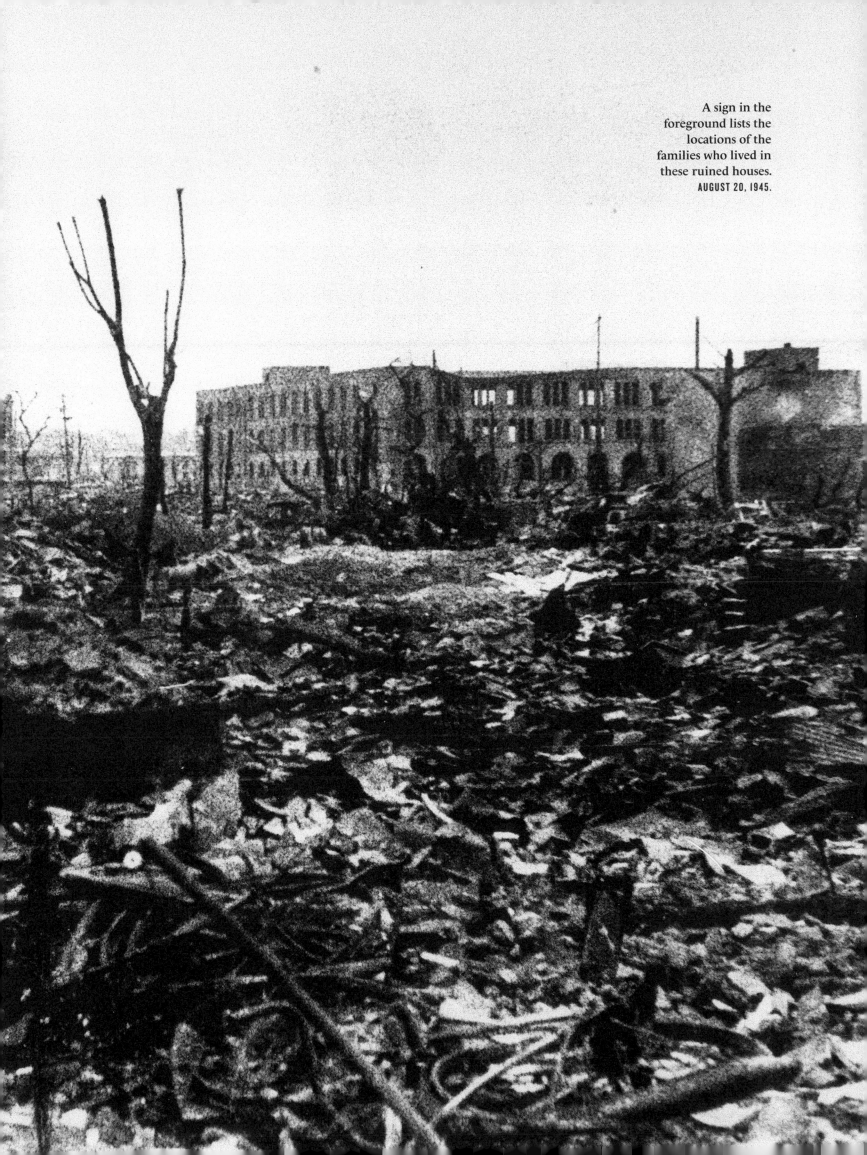

A sign in the
foreground lists the
locations of the
families who lived in
these ruined houses.
AUGUST 20, 1945.

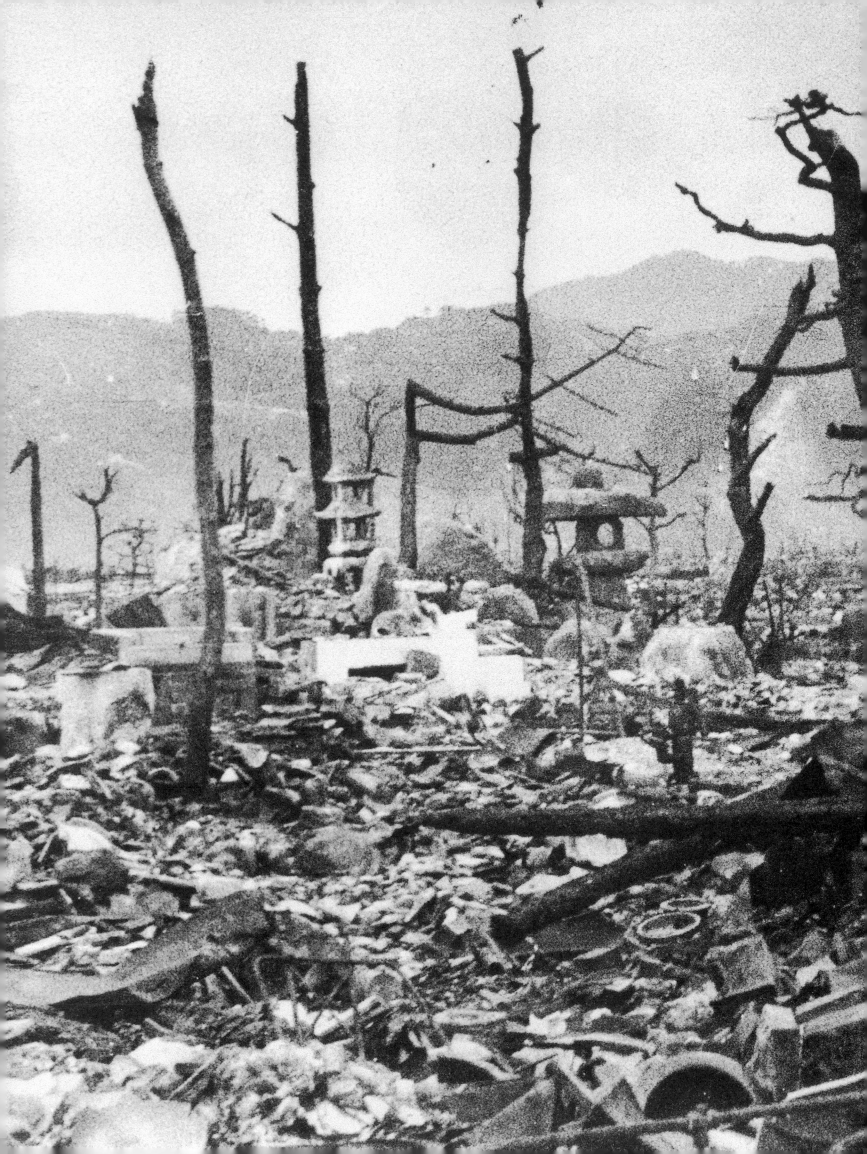

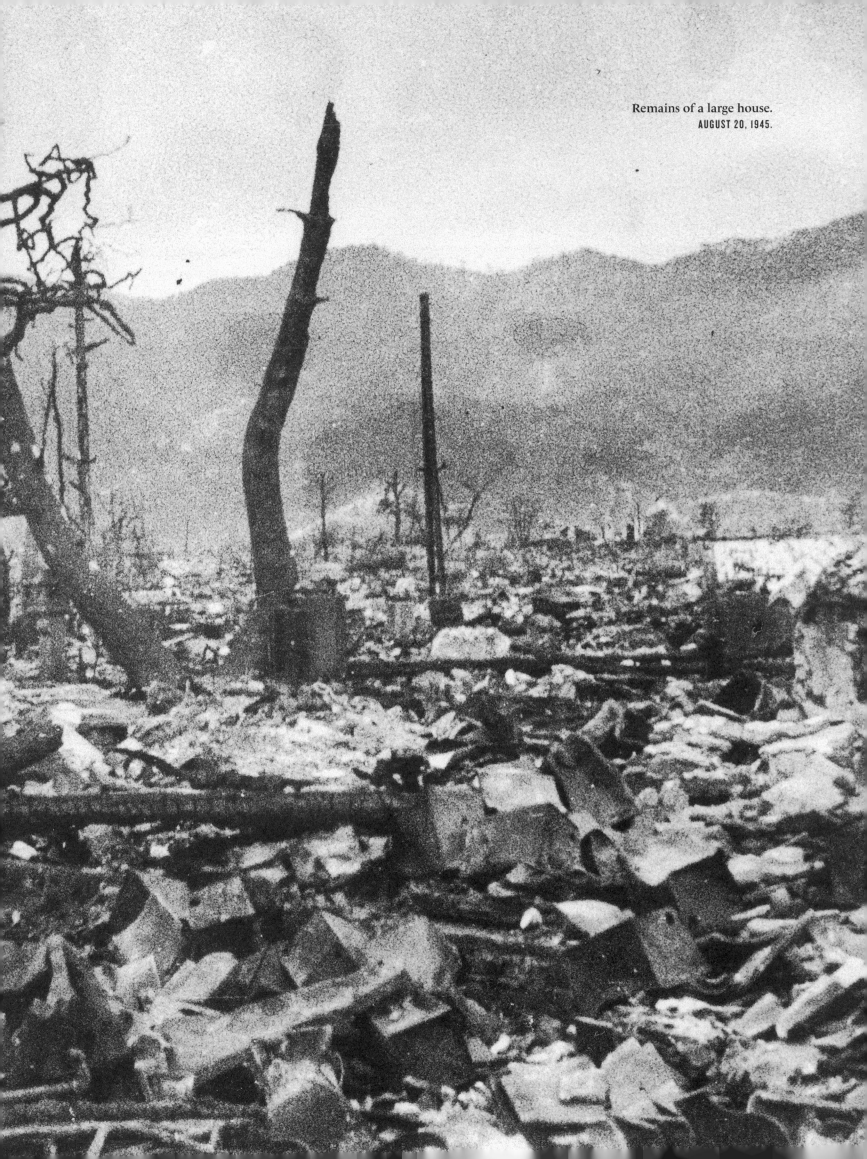

Remains of a large house.
AUGUST 20, 1945.

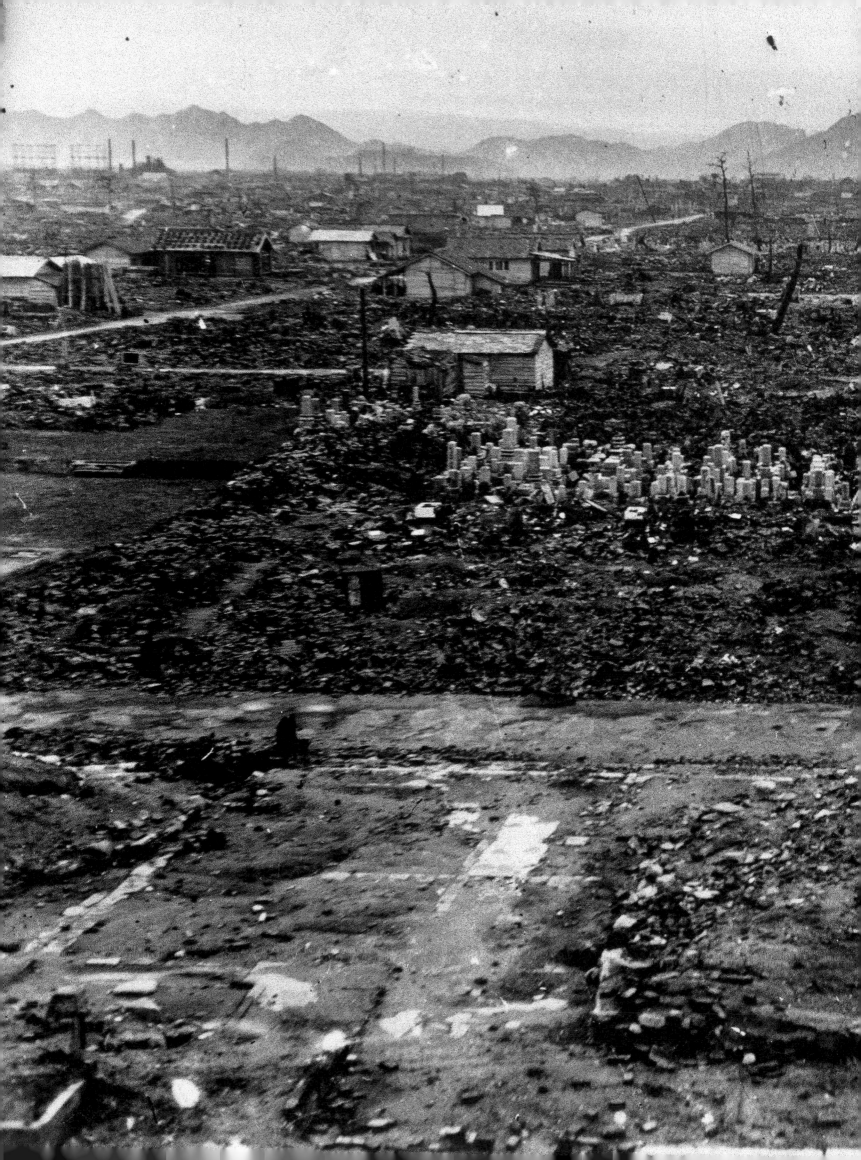

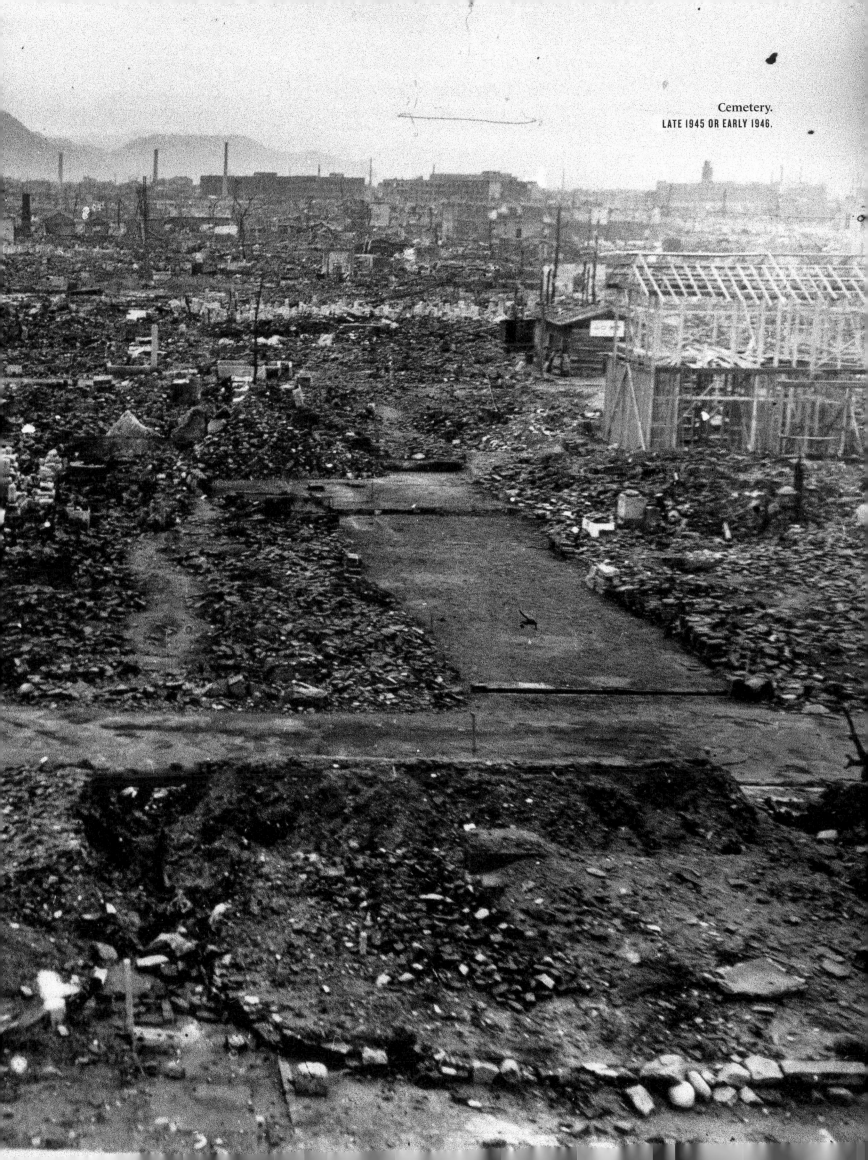

Cemetery.
LATE 1945 OR EARLY 1946.

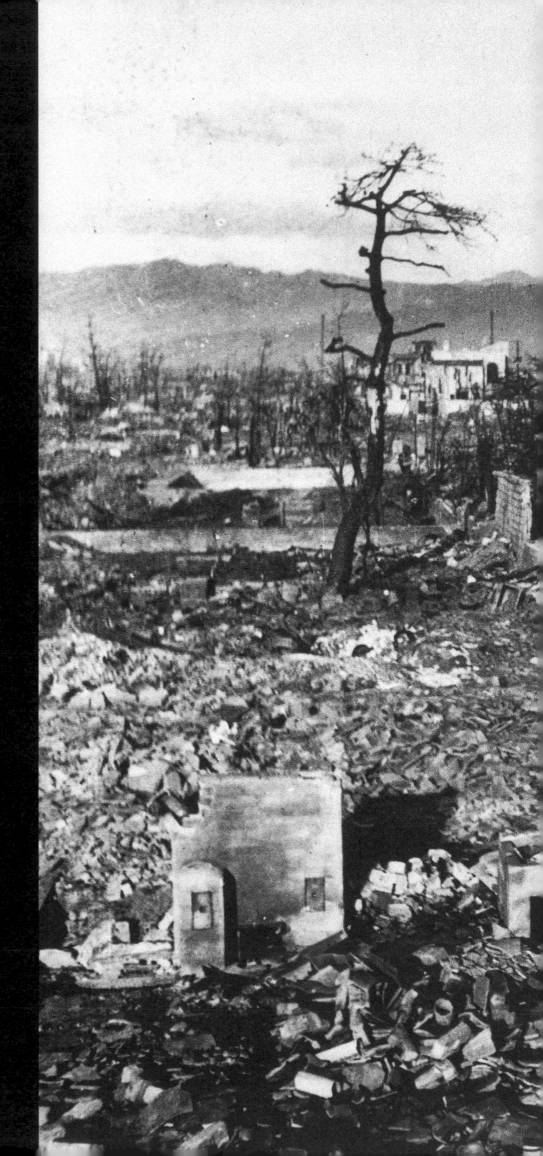

View from the top of
Kyobashi Bridge, just
under a mile northeast
of ground zero.
NOVEMBER 1945.

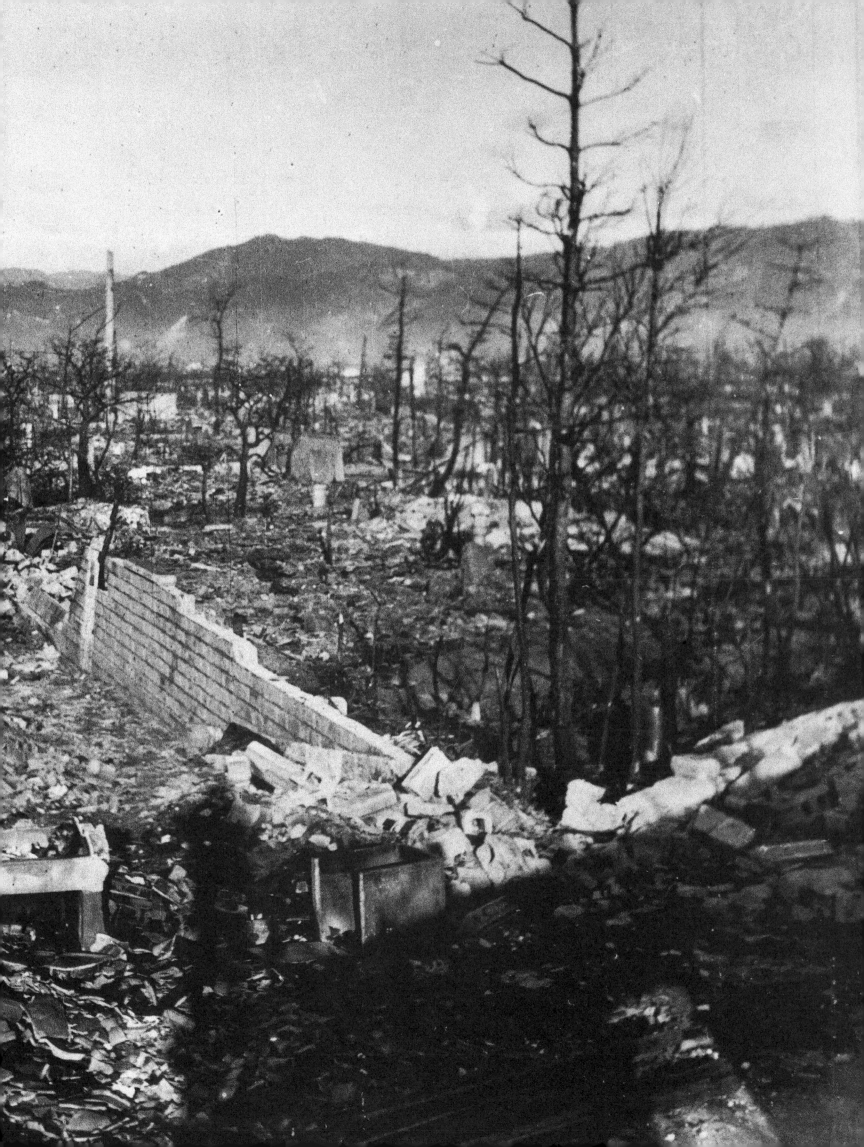

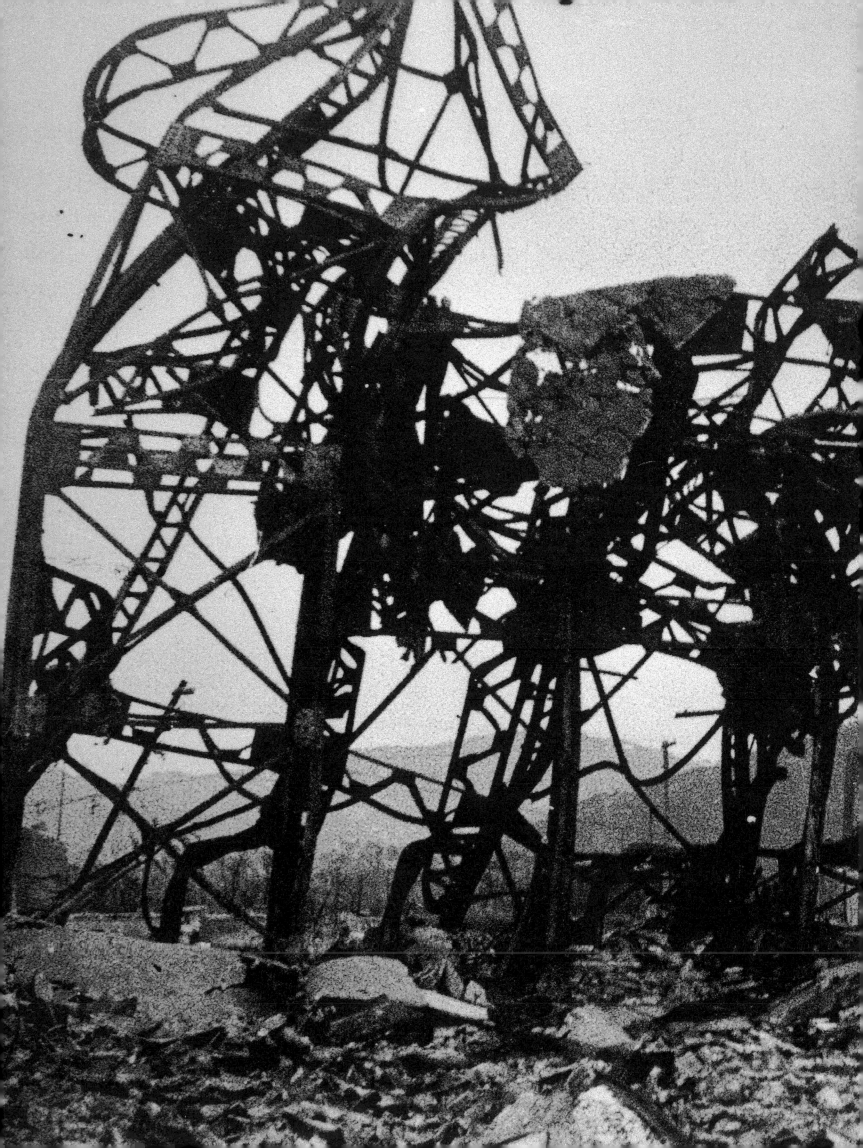

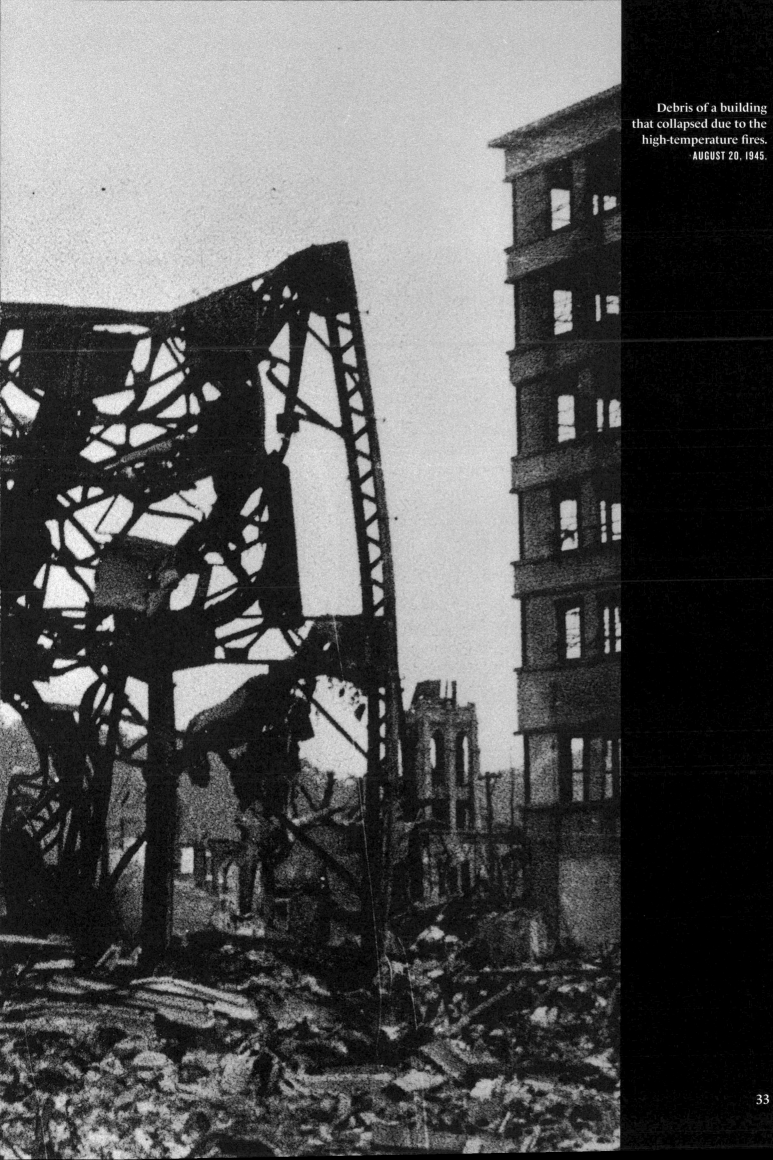

Debris of a building
that collapsed due to the
high-temperature fires.
AUGUST 20, 1945.

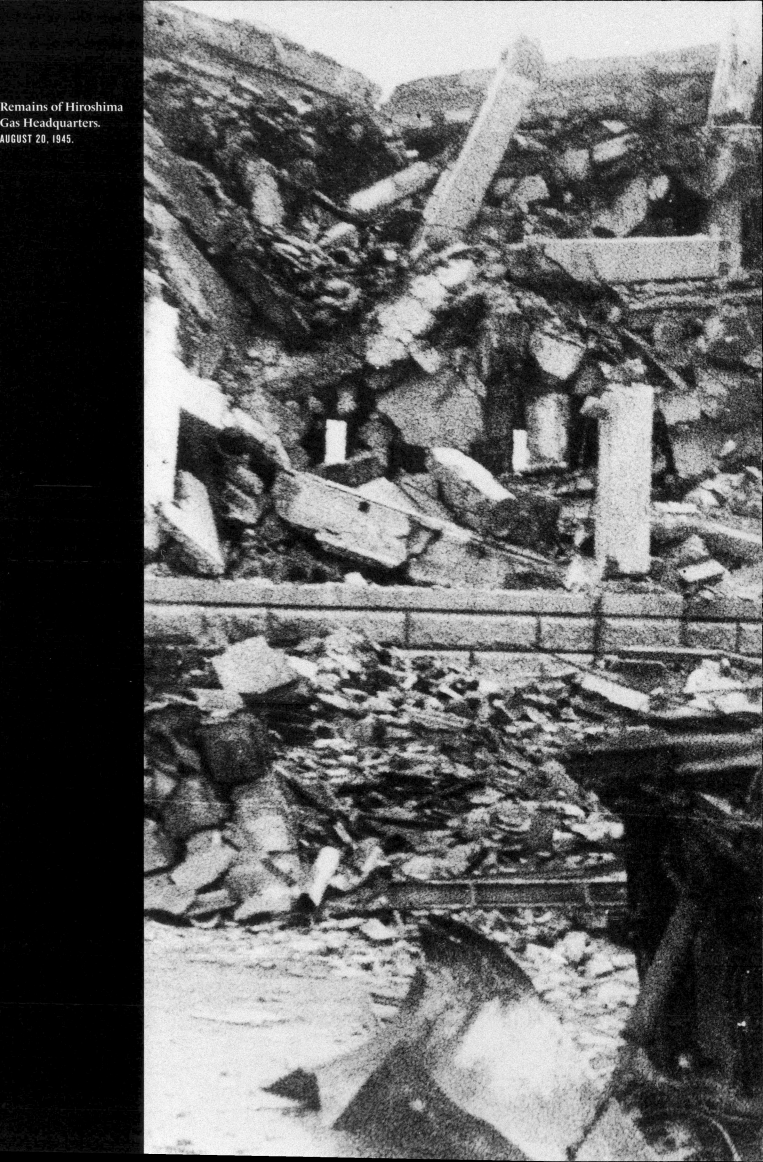

Remains of Hiroshima
Gas Headquarters.
AUGUST 20, 1945.

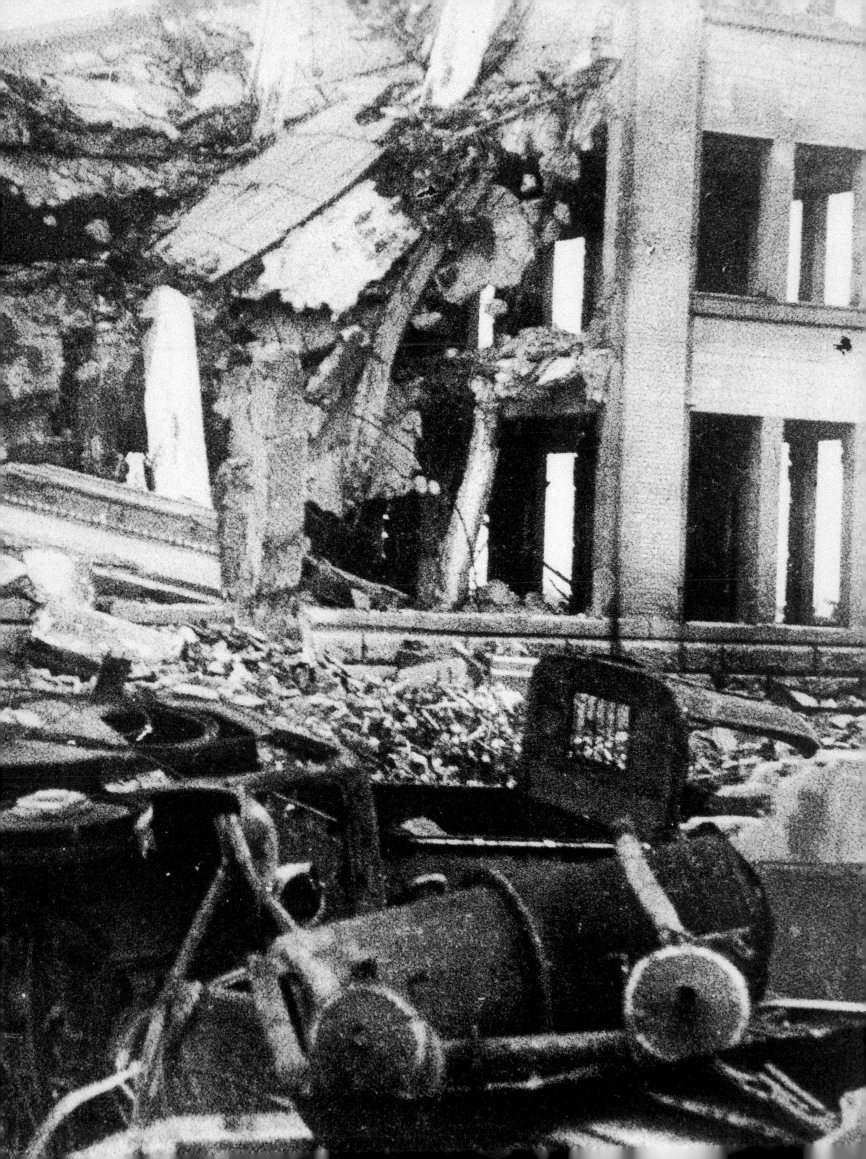

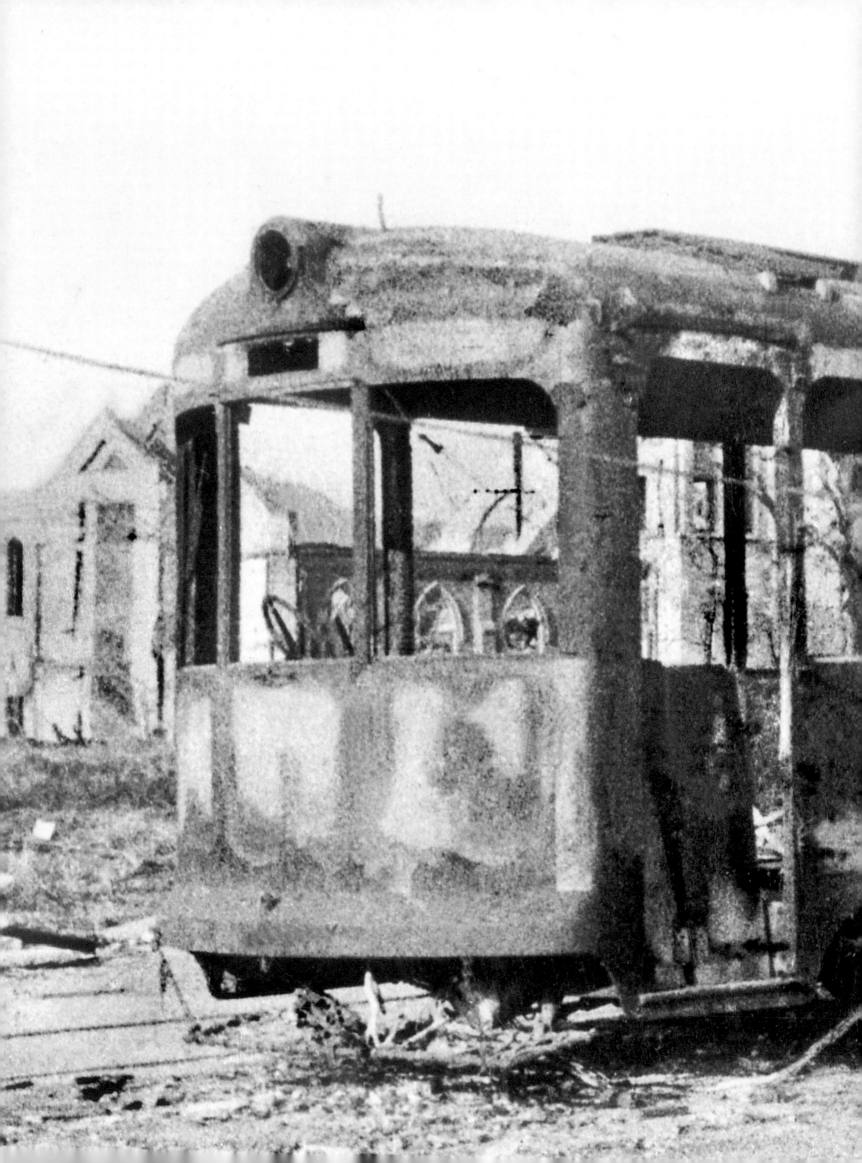

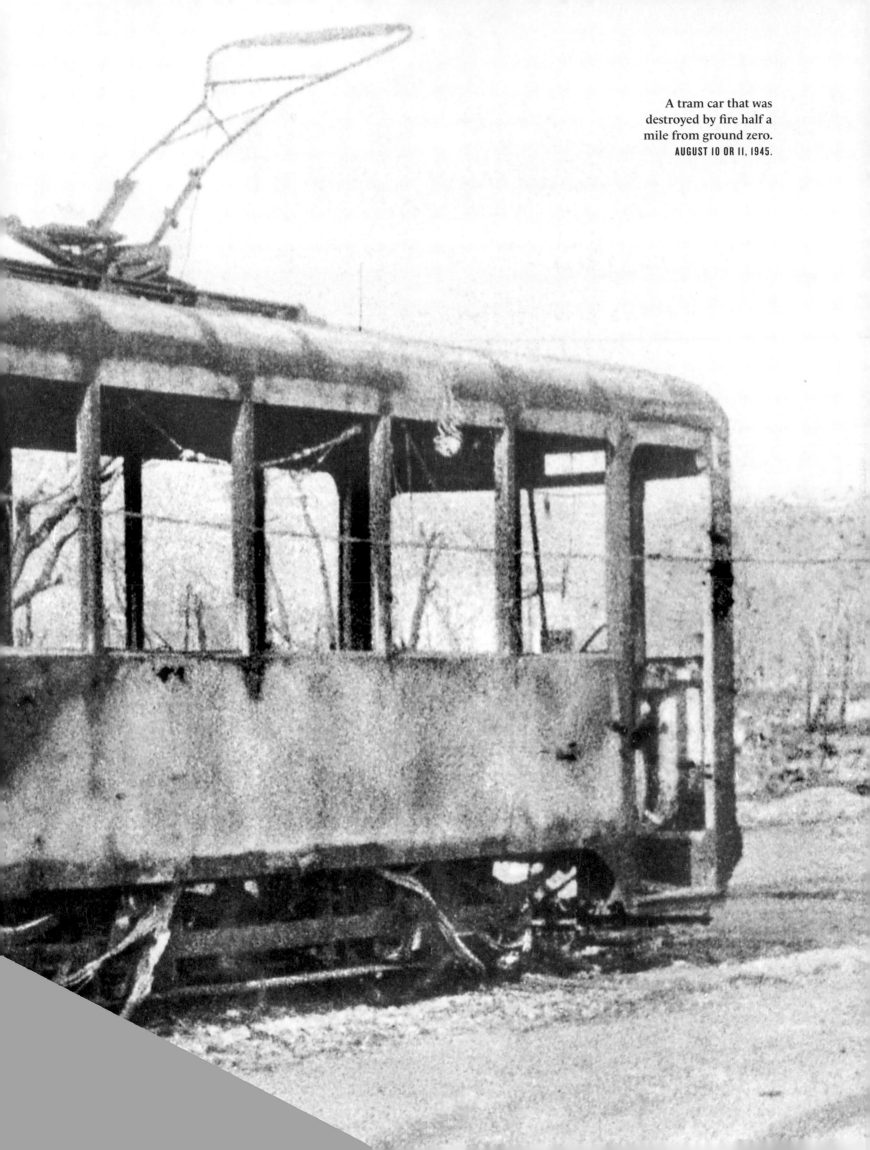

A tram car that was destroyed by fire half a mile from ground zero.
AUGUST 10 OR 11, 1945.

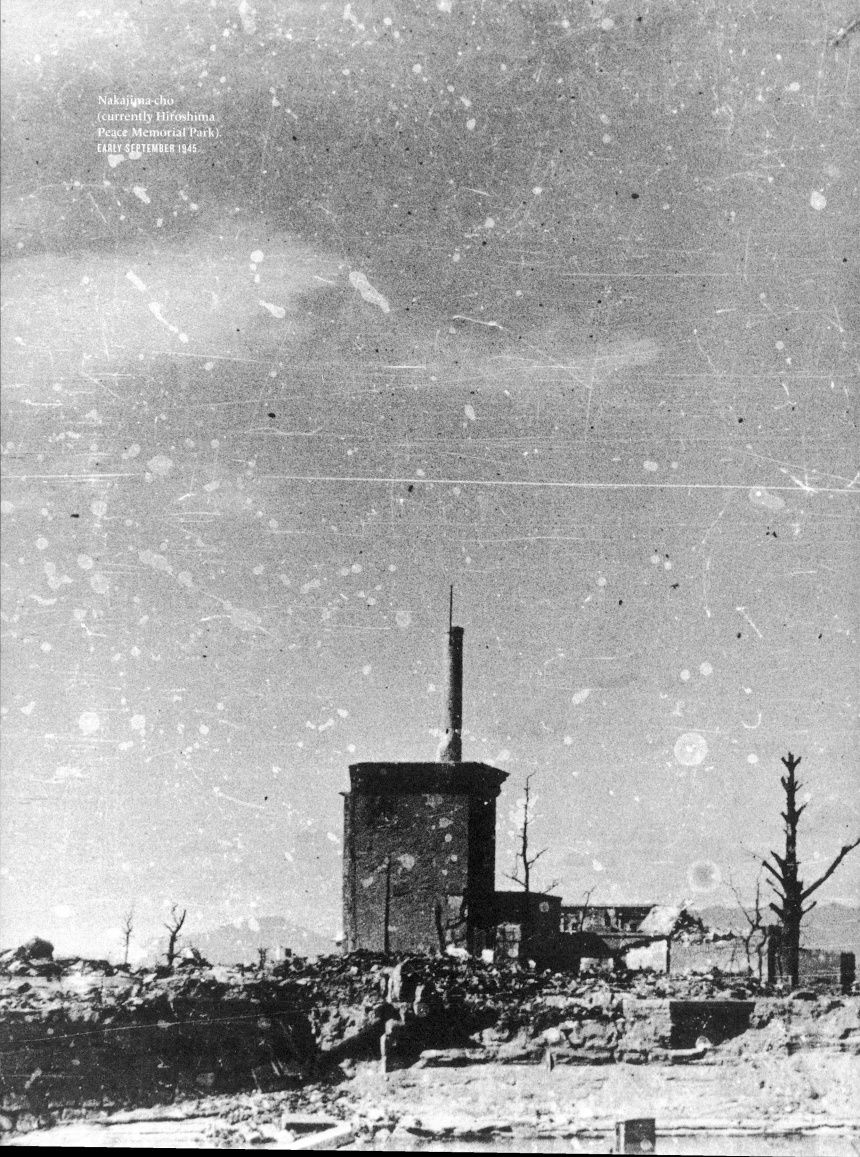

Nakajima-cho
(currently Hiroshima
Peace Memorial Park).
EARLY SEPTEMBER 1945.

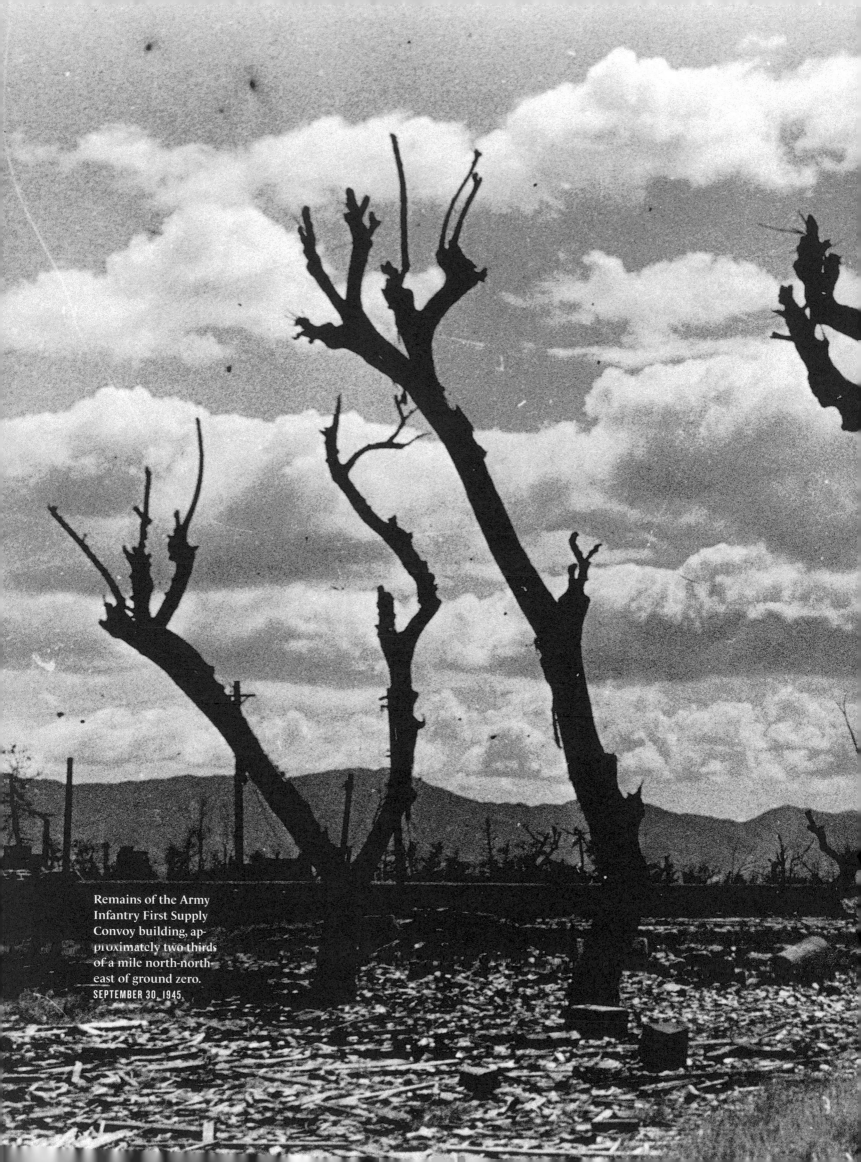

Remains of the Army Infantry First Supply Convoy building, approximately two thirds of a mile north-northeast of ground zero.
SEPTEMBER 30, 1945.

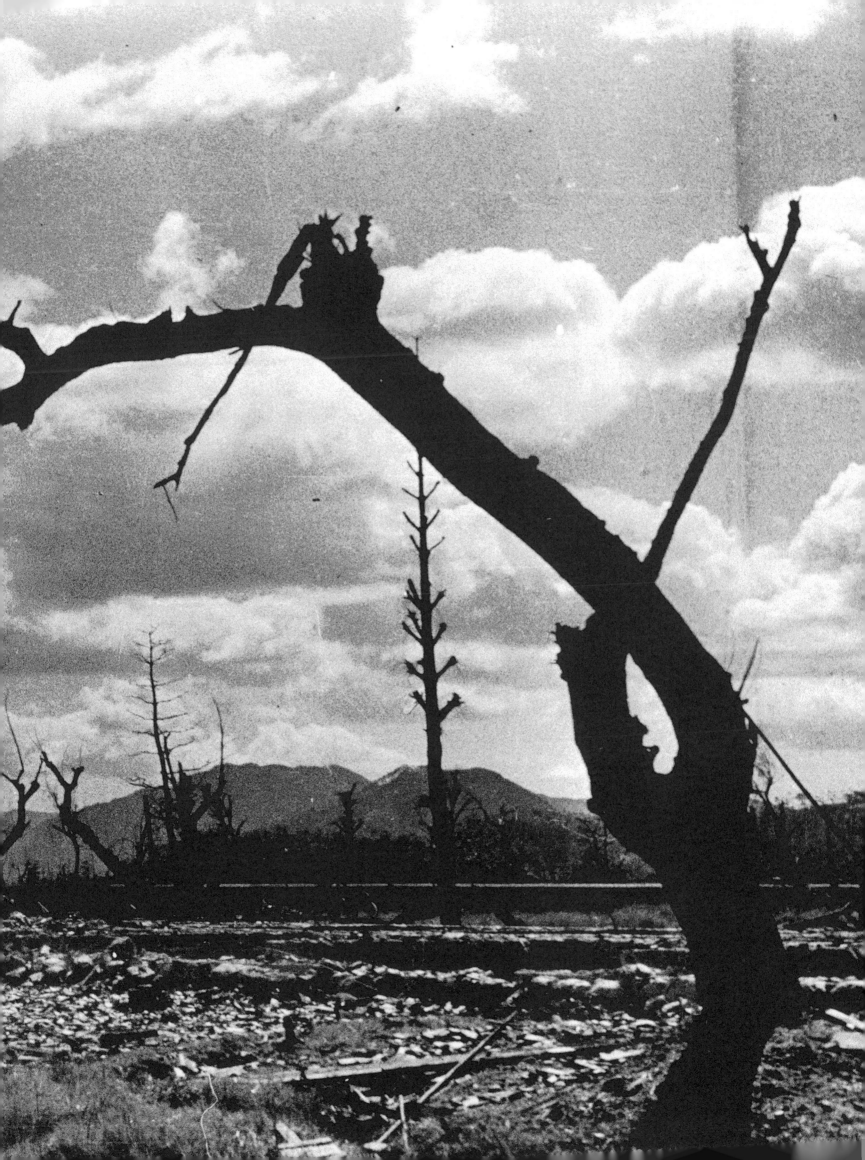

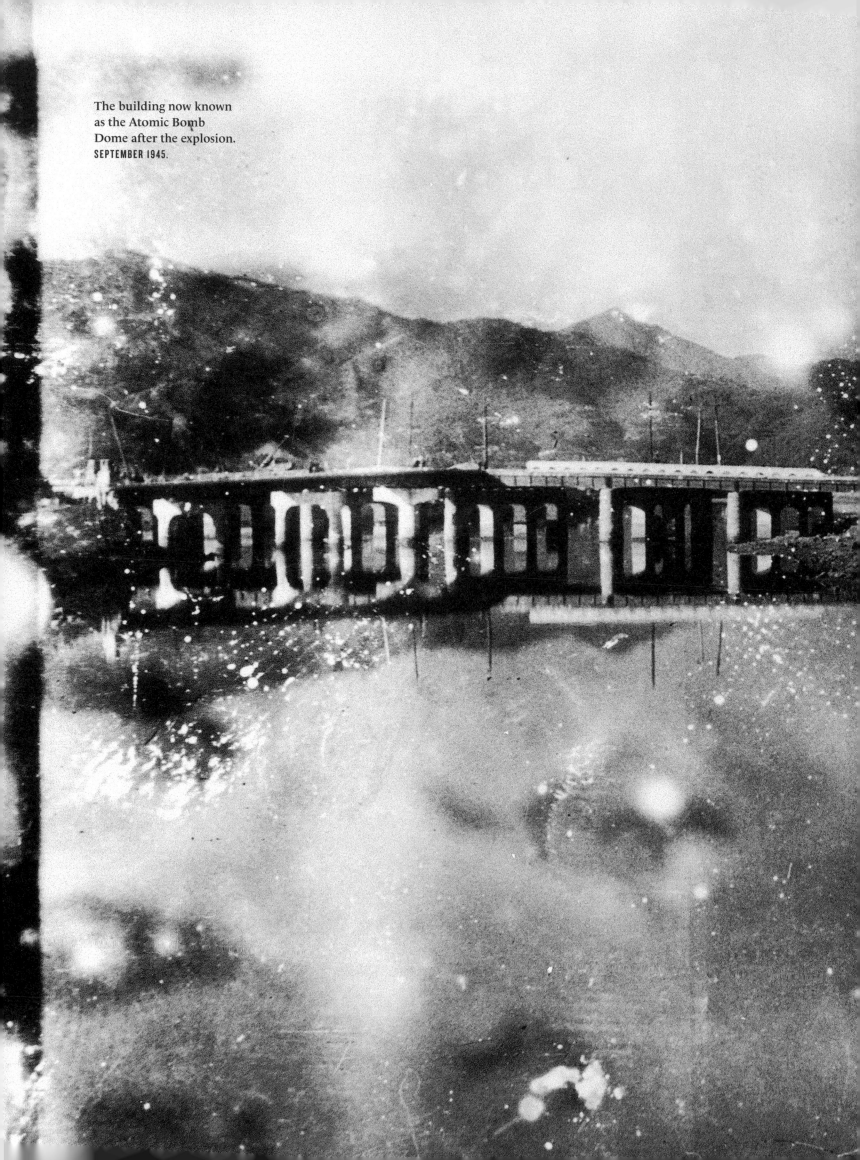

The building now known as the Atomic Bomb Dome after the explosion.
SEPTEMBER 1945.

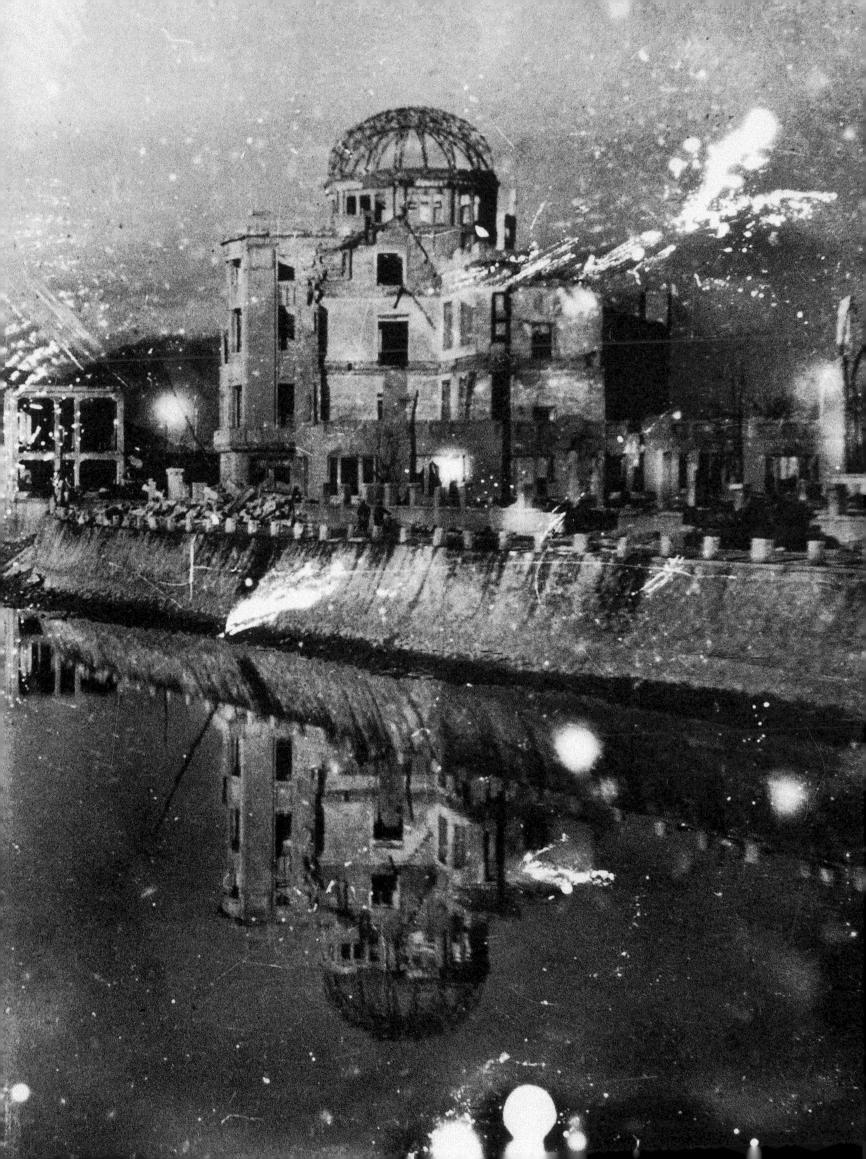

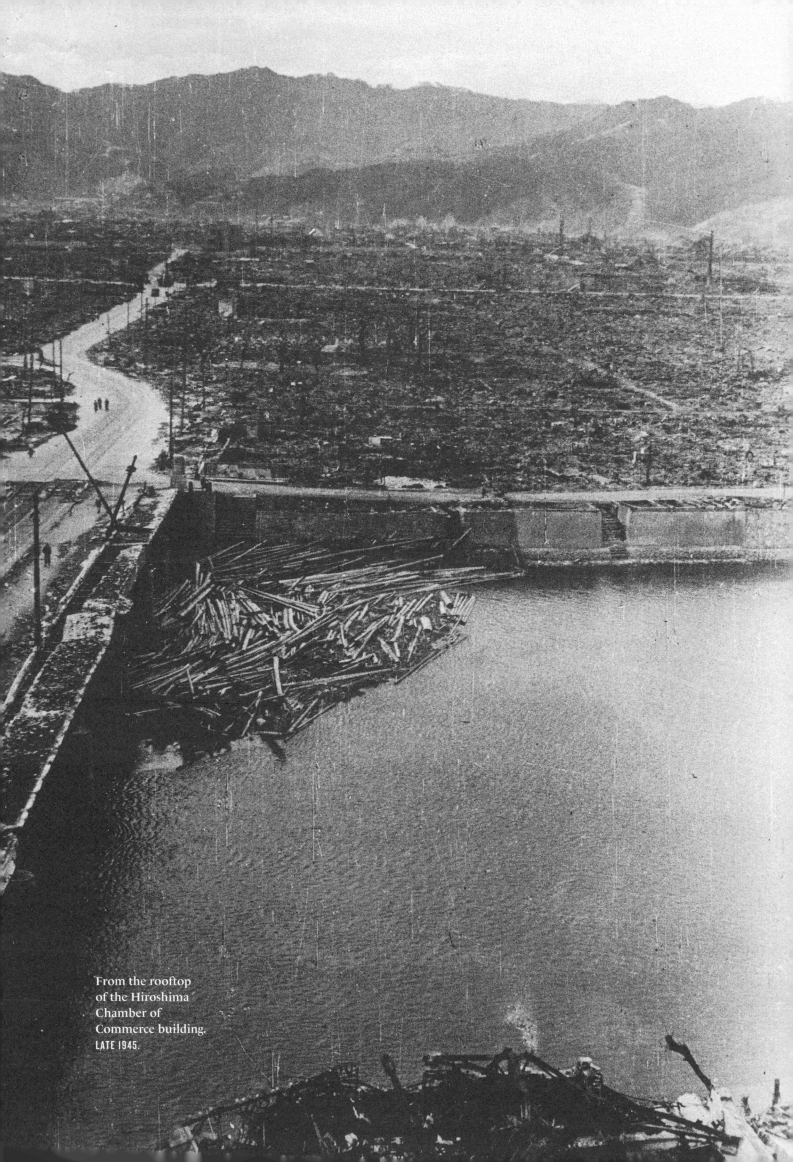

From the rooftop
of the Hiroshima
Chamber of
Commerce building.
LATE 1945.

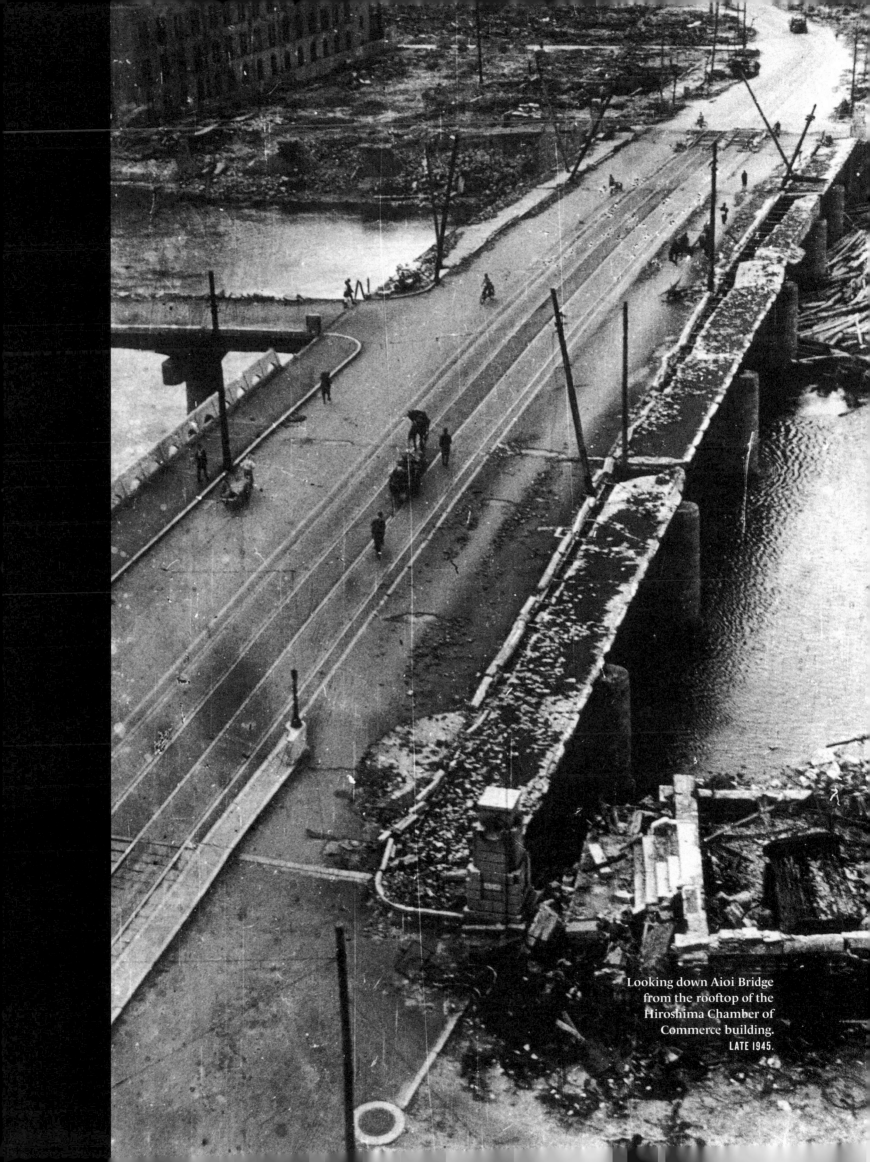

Looking down Aioi Bridge from the rooftop of the Hiroshima Chamber of Commerce building.
LATE 1945.

Bomb victims
being rushed by truck
to relief stations in
the city suburbs.
AUGUST 6, 1945.

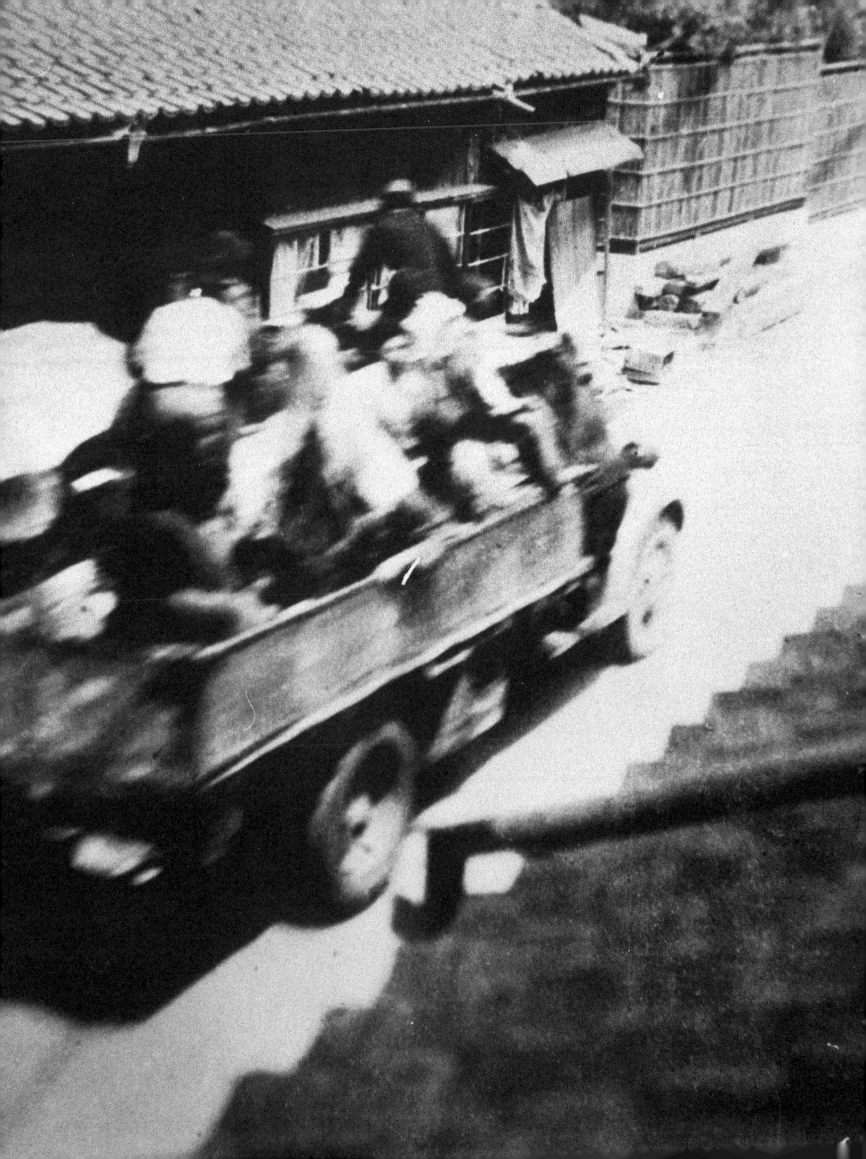

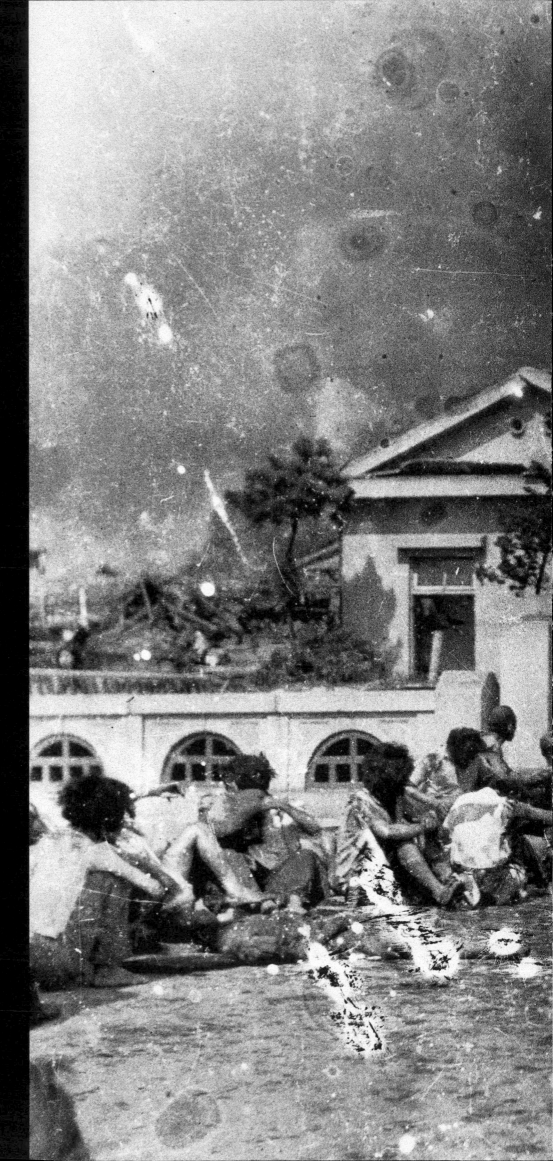

A temporary aid station
that was quickly set up
outside the Senda-machi
police box.
AUGUST 6, 1945.

48

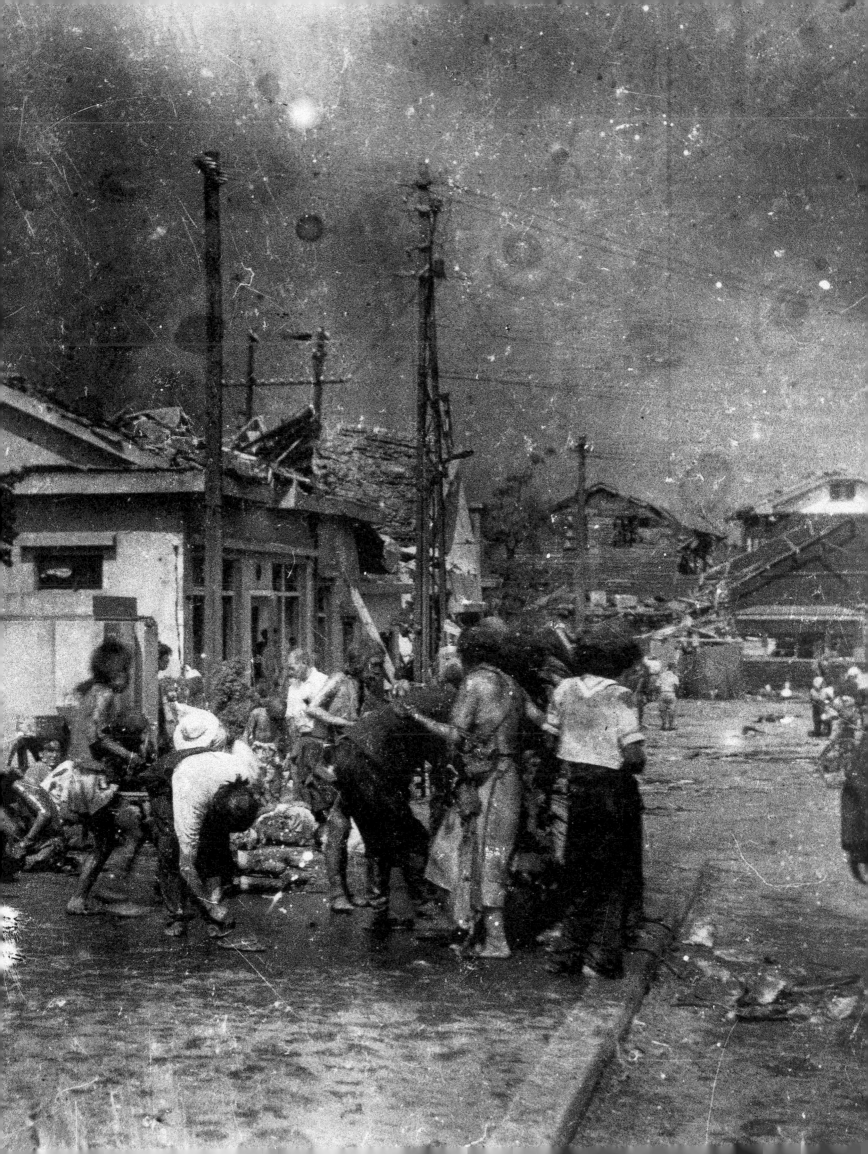

At the west end
of Miyuki Bridge.
AROUND 11:00 A.M.,
AUGUST 6, 1945.

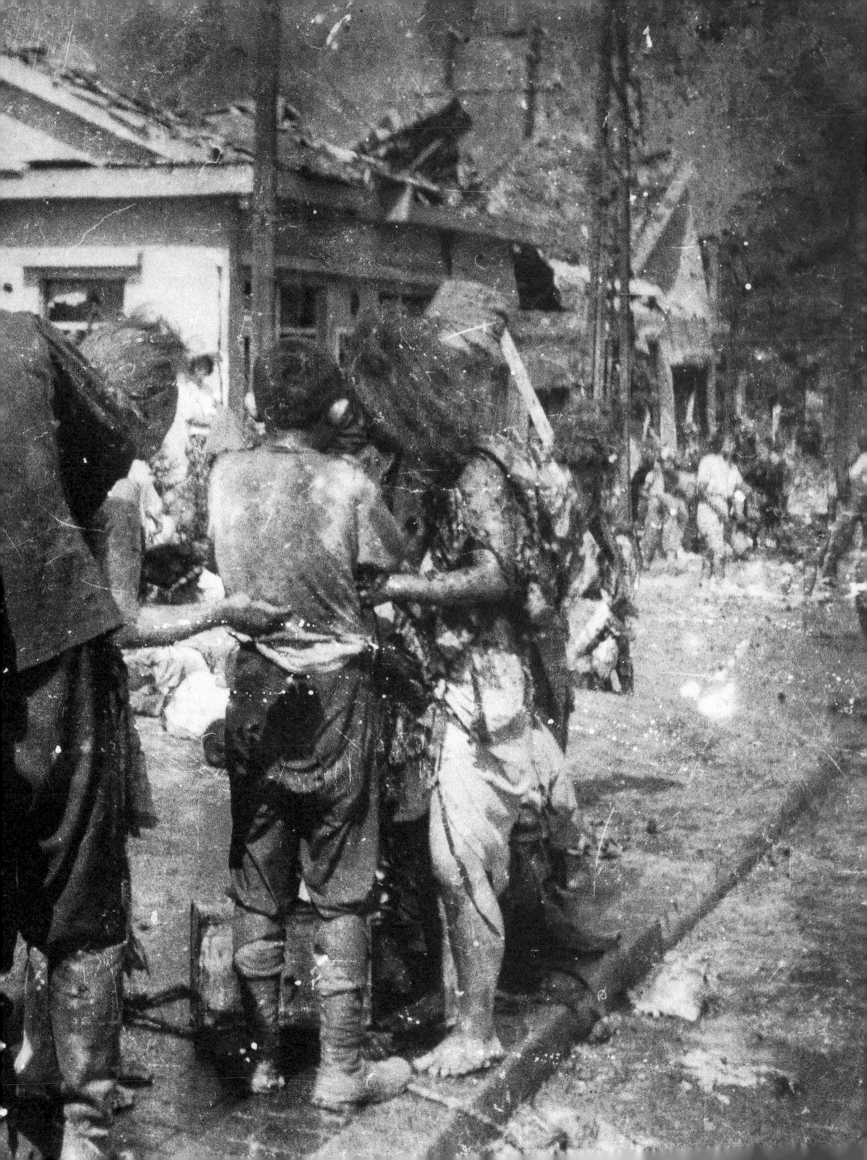

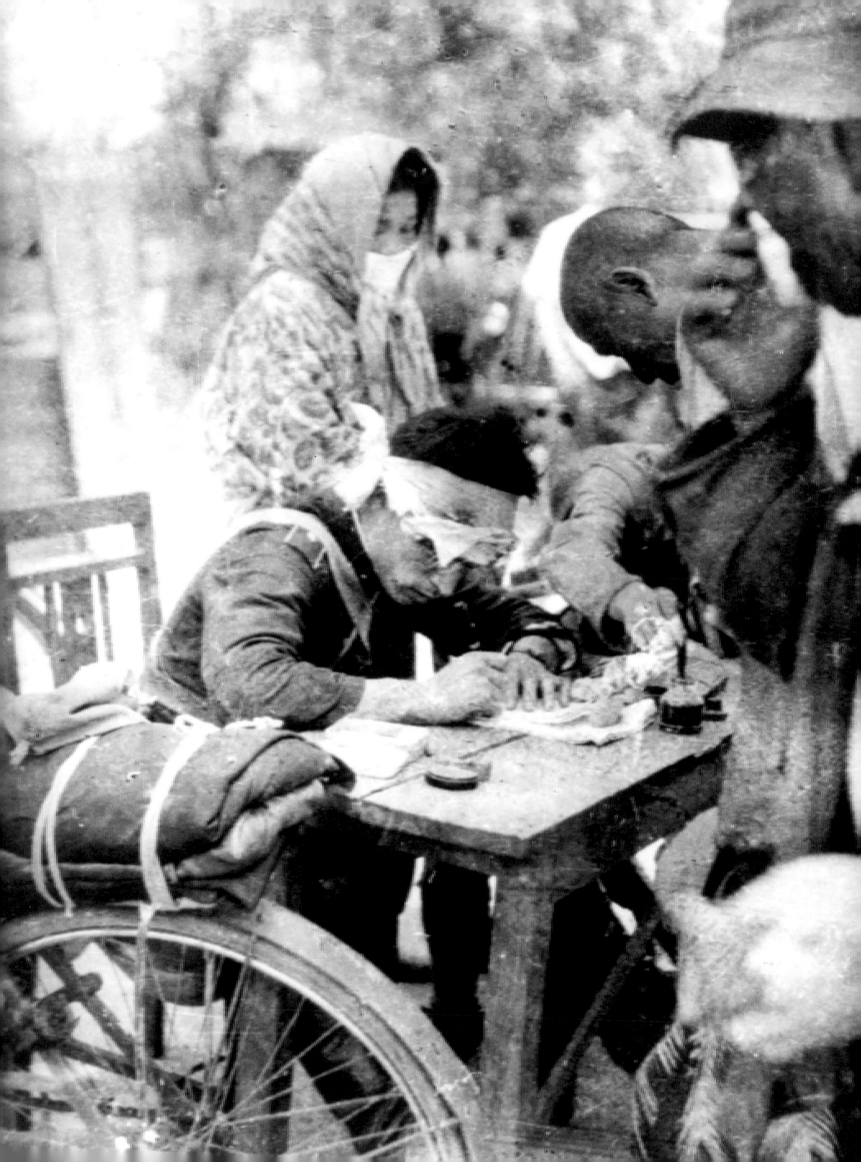

Certificates of suffering being issued to bomb victims in the street on the east end of Miyuki Bridge. AUGUST 6, 1945.

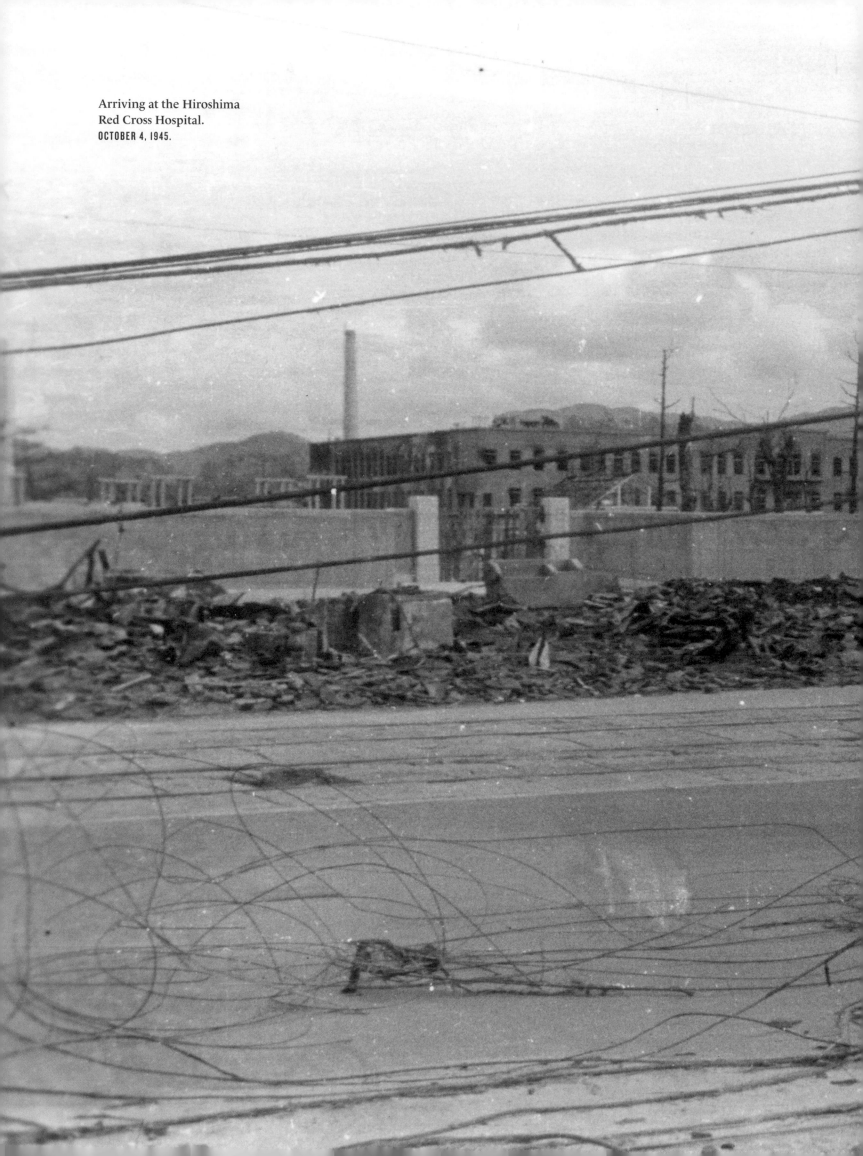

Arriving at the Hiroshima
Red Cross Hospital.
OCTOBER 4, 1945.

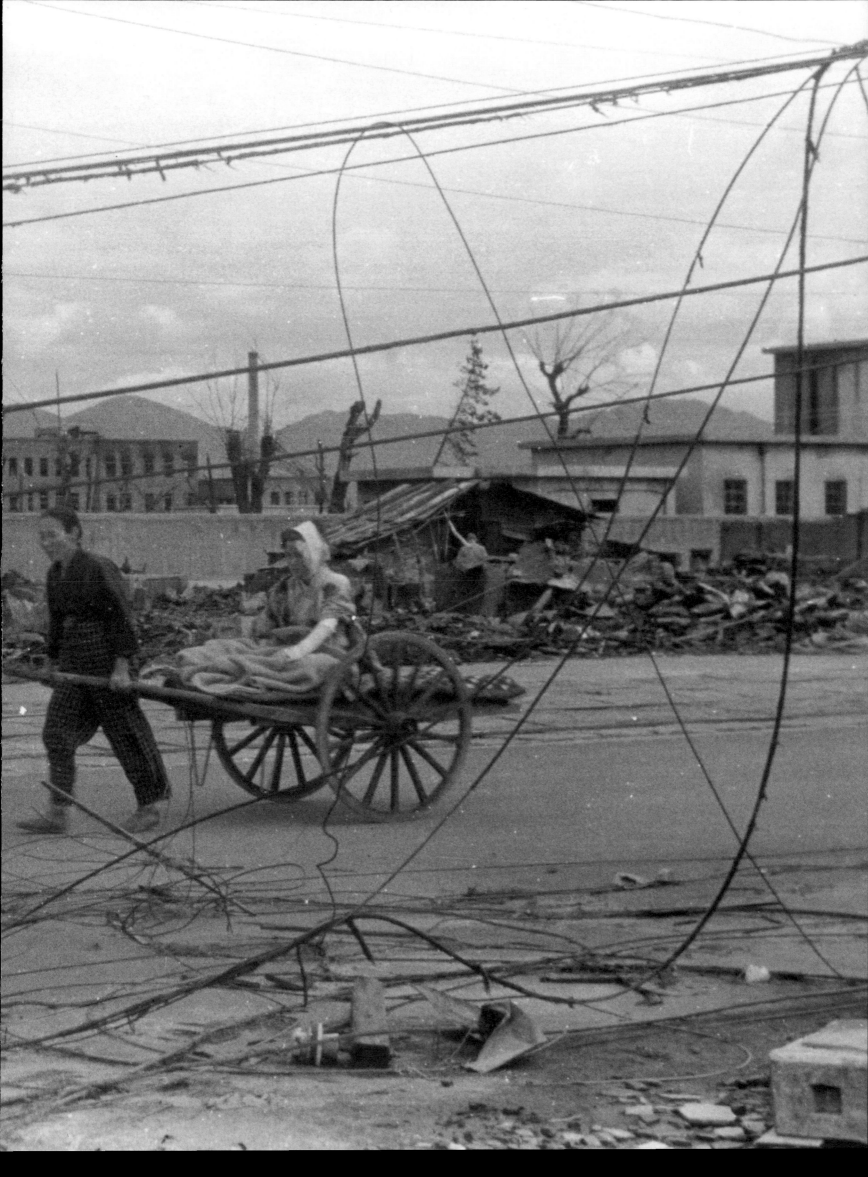

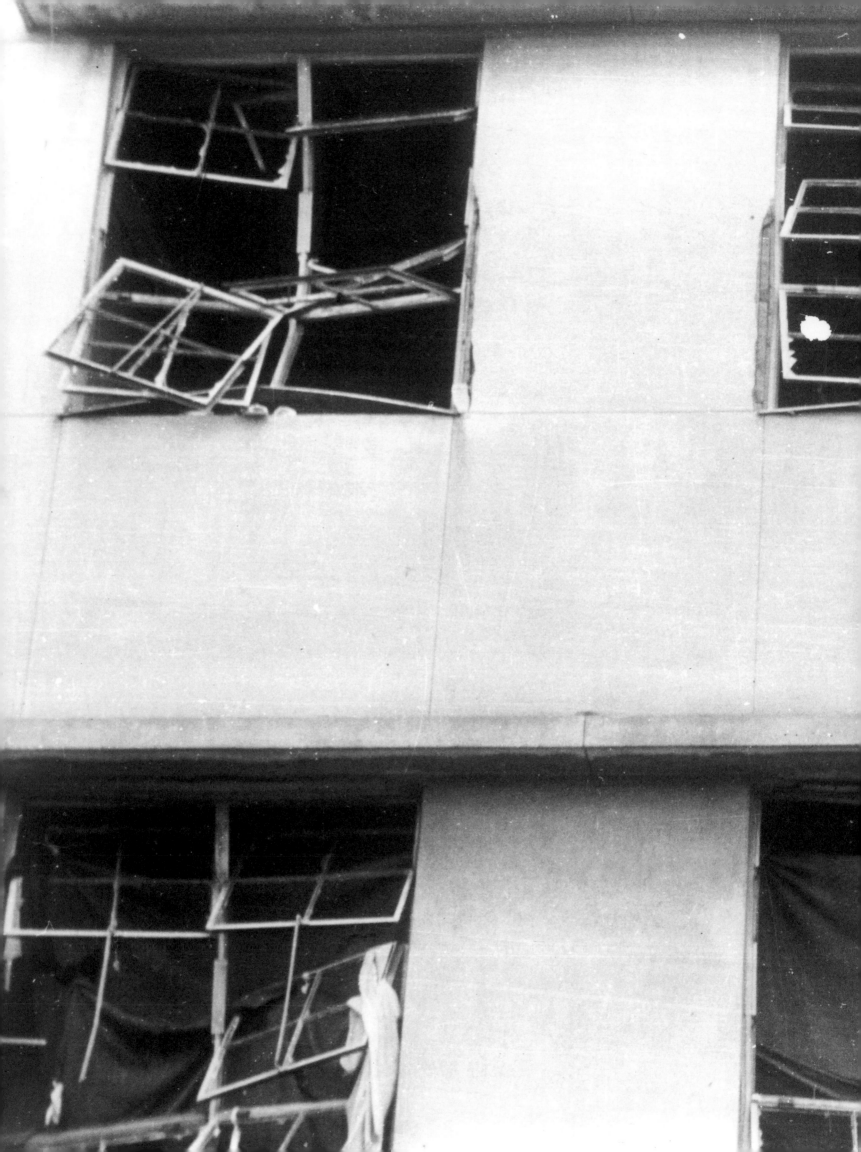

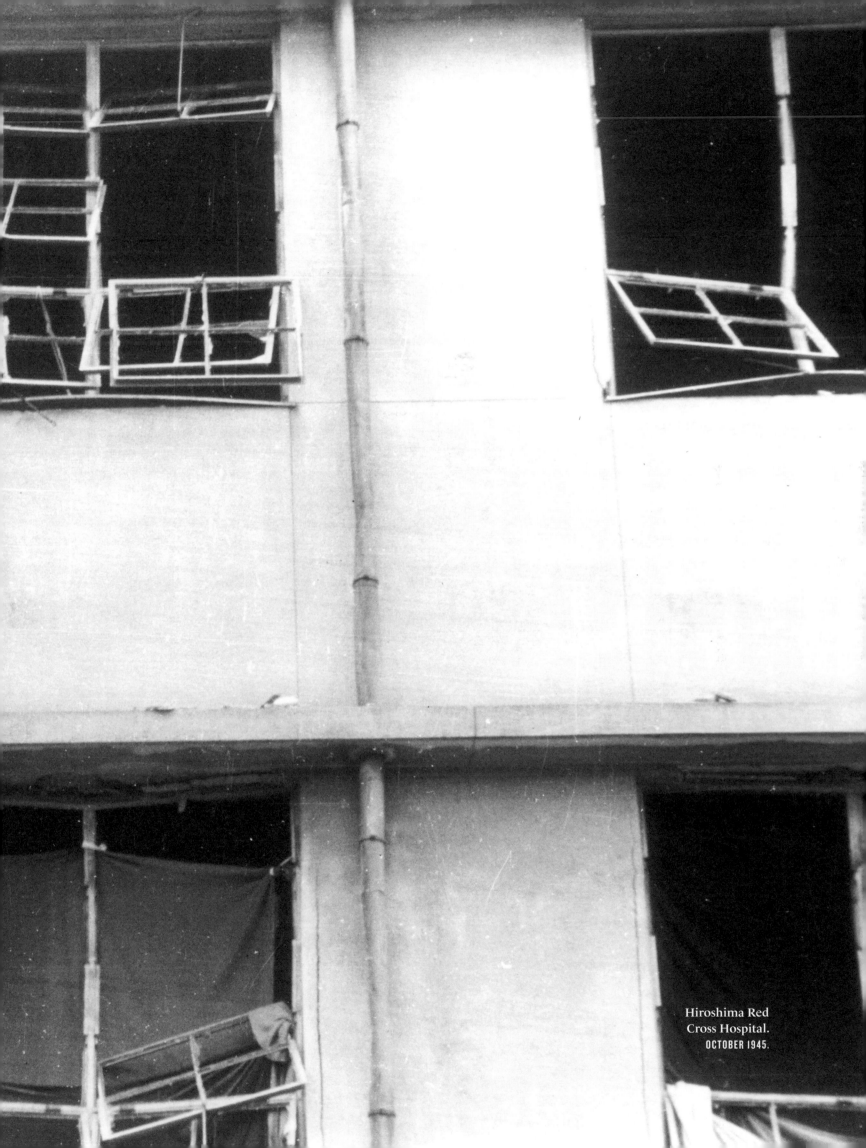

Hiroshima Red
Cross Hospital.
OCTOBER 1945.

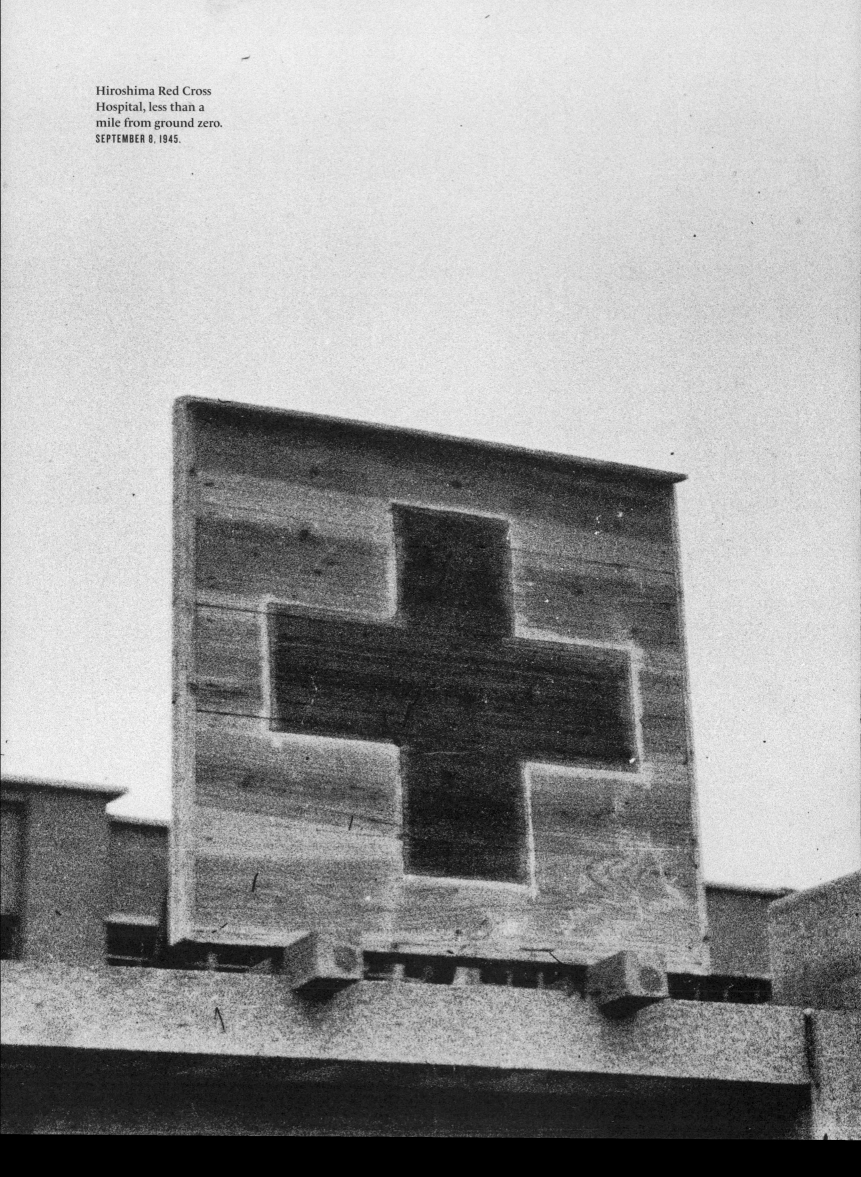

Hiroshima Red Cross
Hospital, less than a
mile from ground zero.
SEPTEMBER 8, 1945.

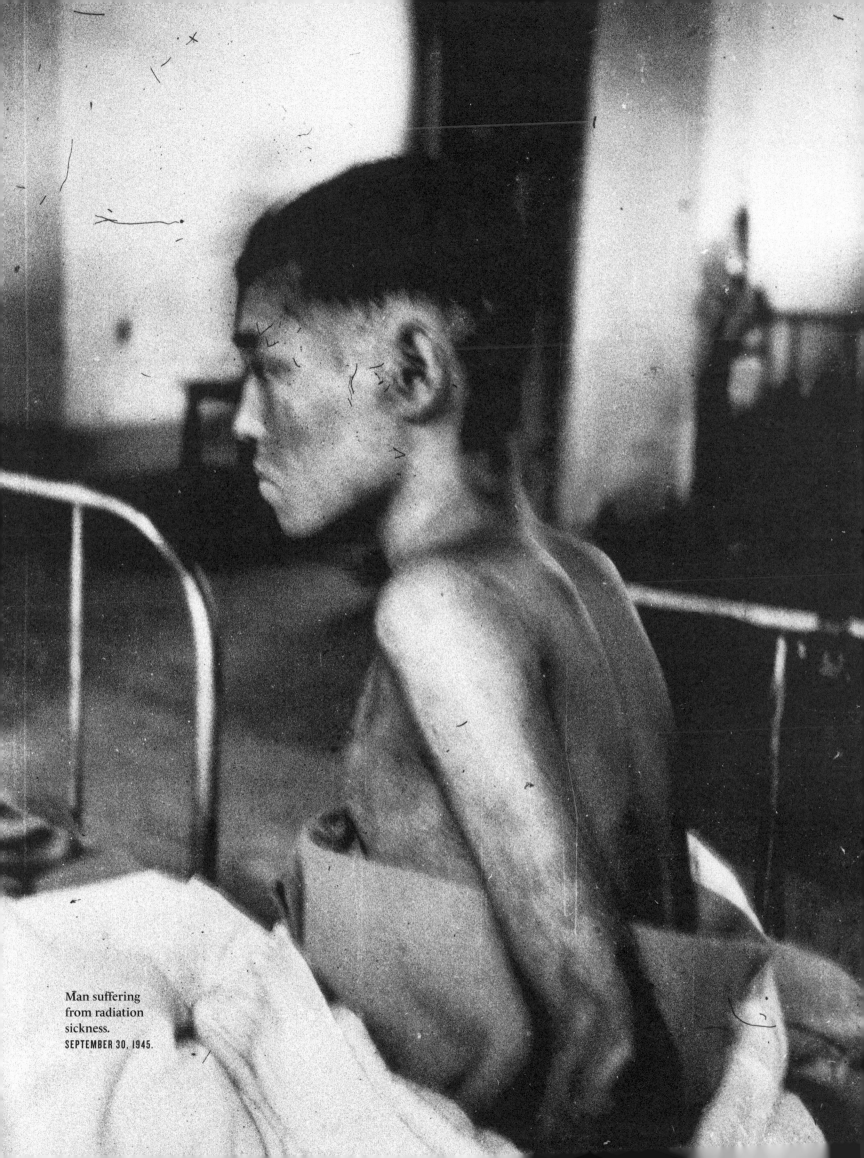

Man suffering
from radiation
sickness.
SEPTEMBER 30, 1945.

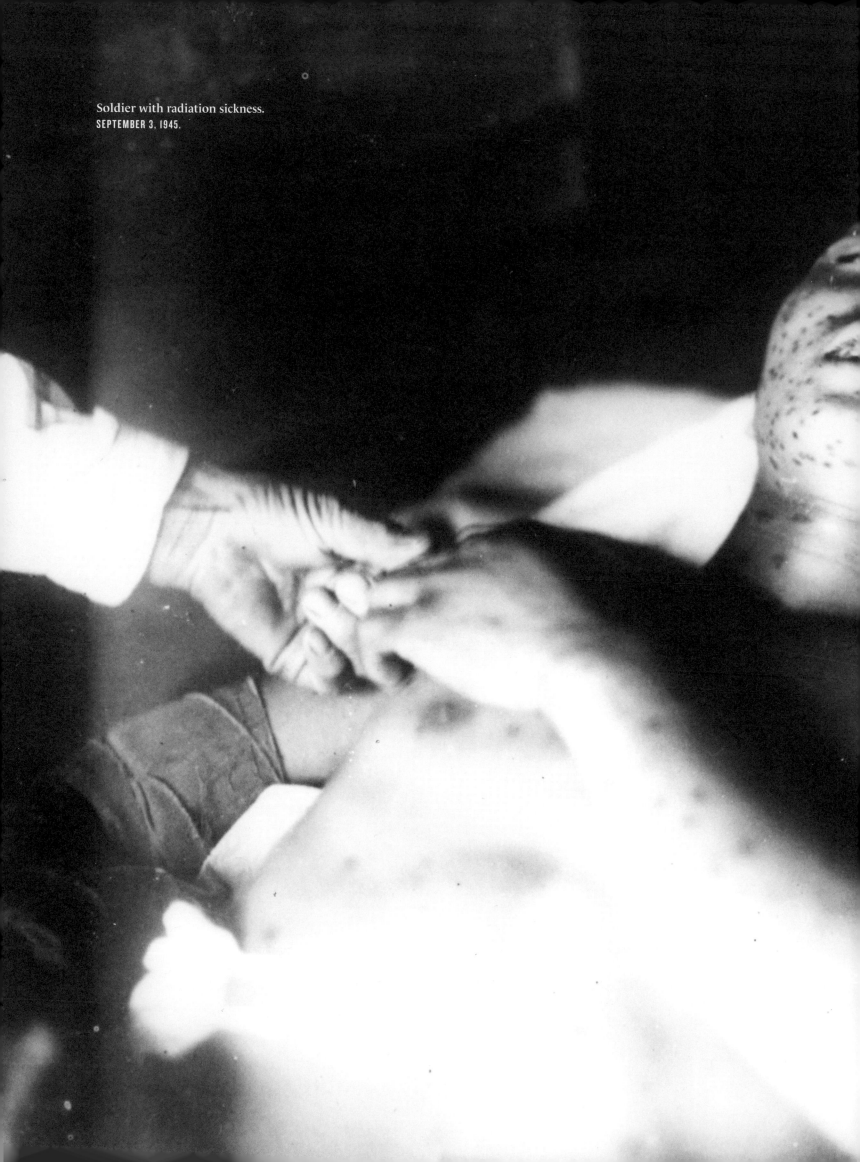

Soldier with radiation sickness.
SEPTEMBER 3, 1945.

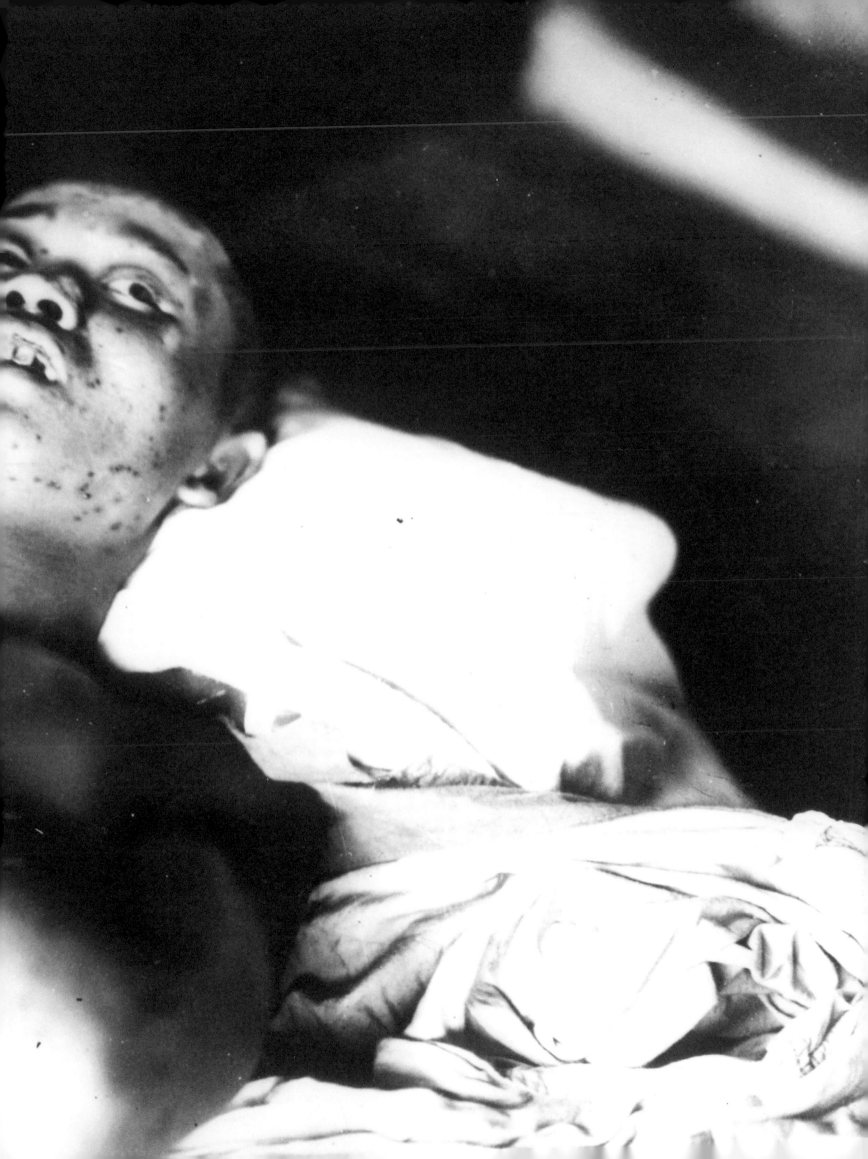

Patient at the Hiroshima
Red Cross Hospital.
OCTOBER 5 OR 6, 1945.

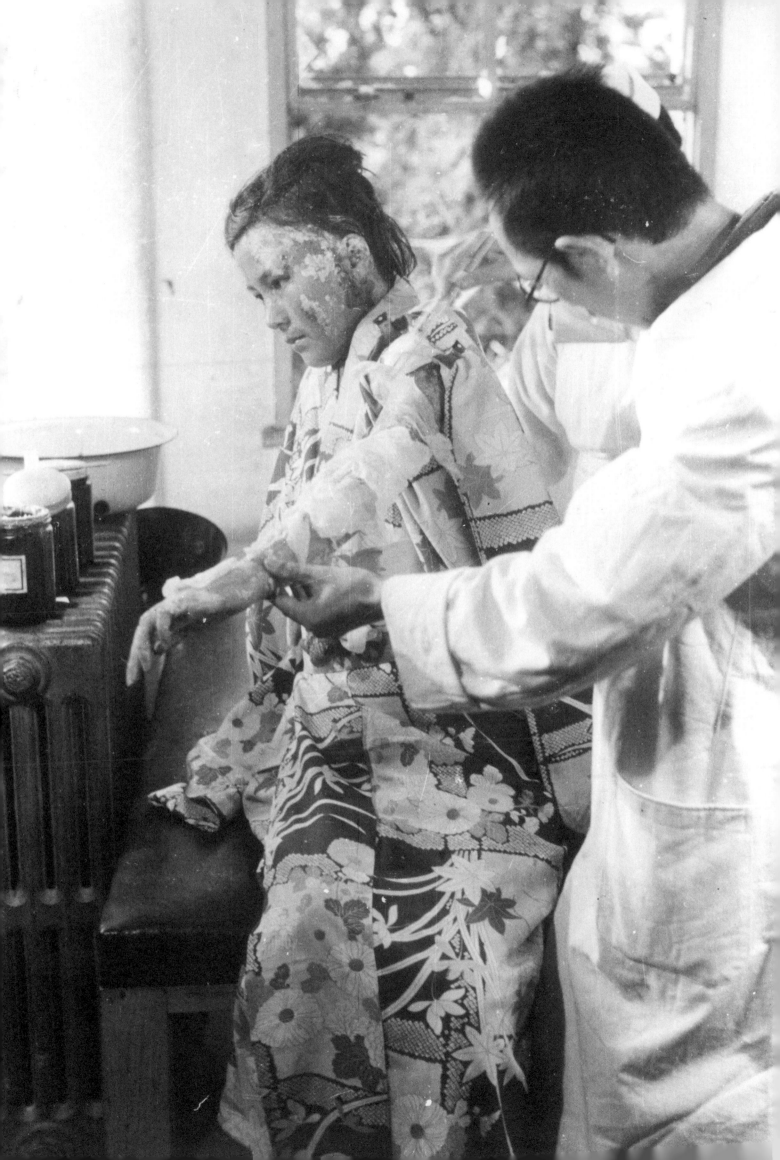

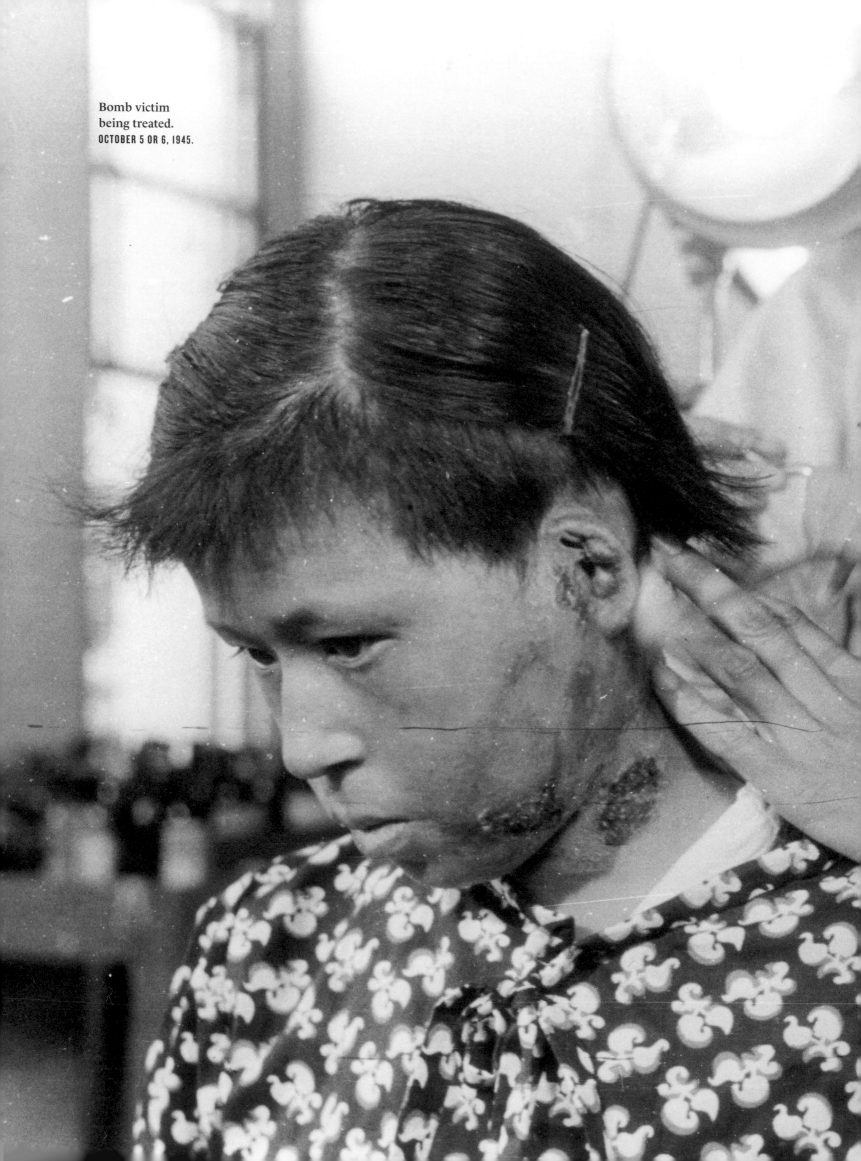

Bomb victim
being treated.
OCTOBER 5 OR 6, 1945.

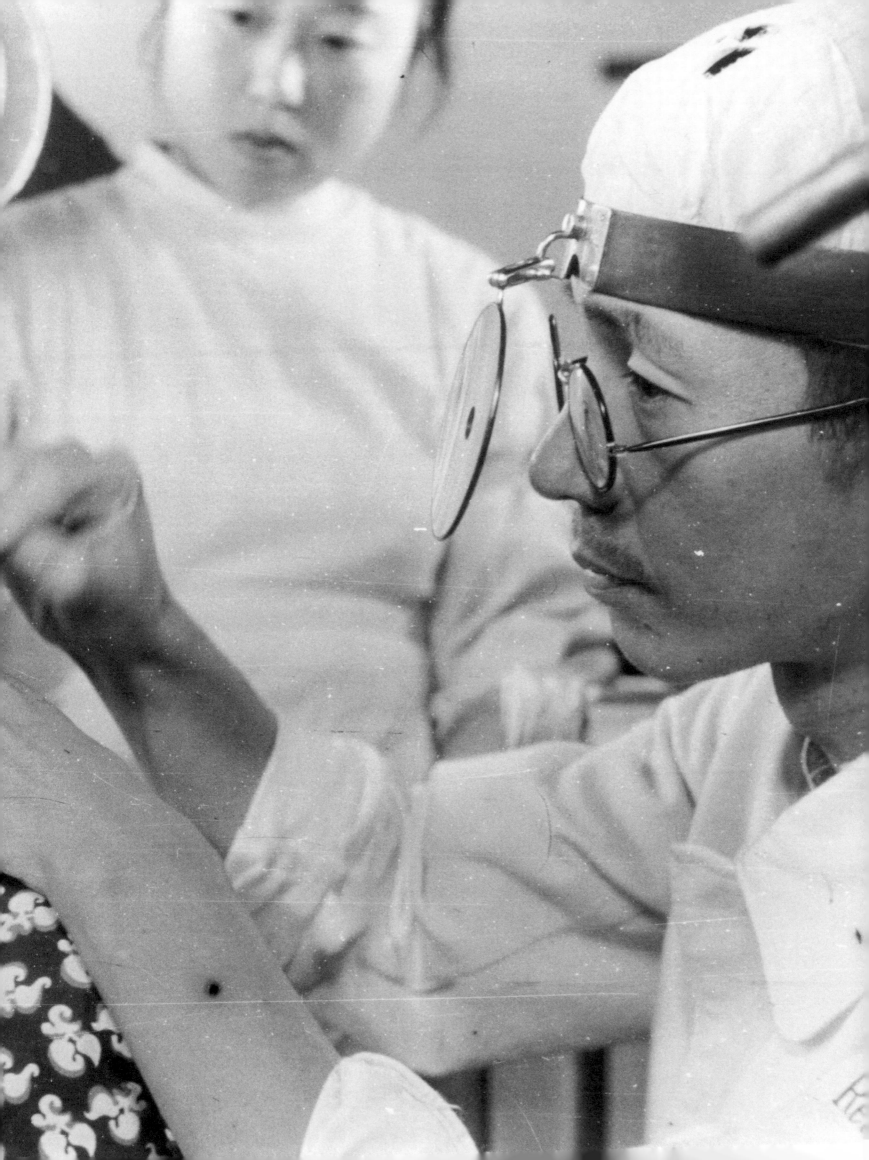

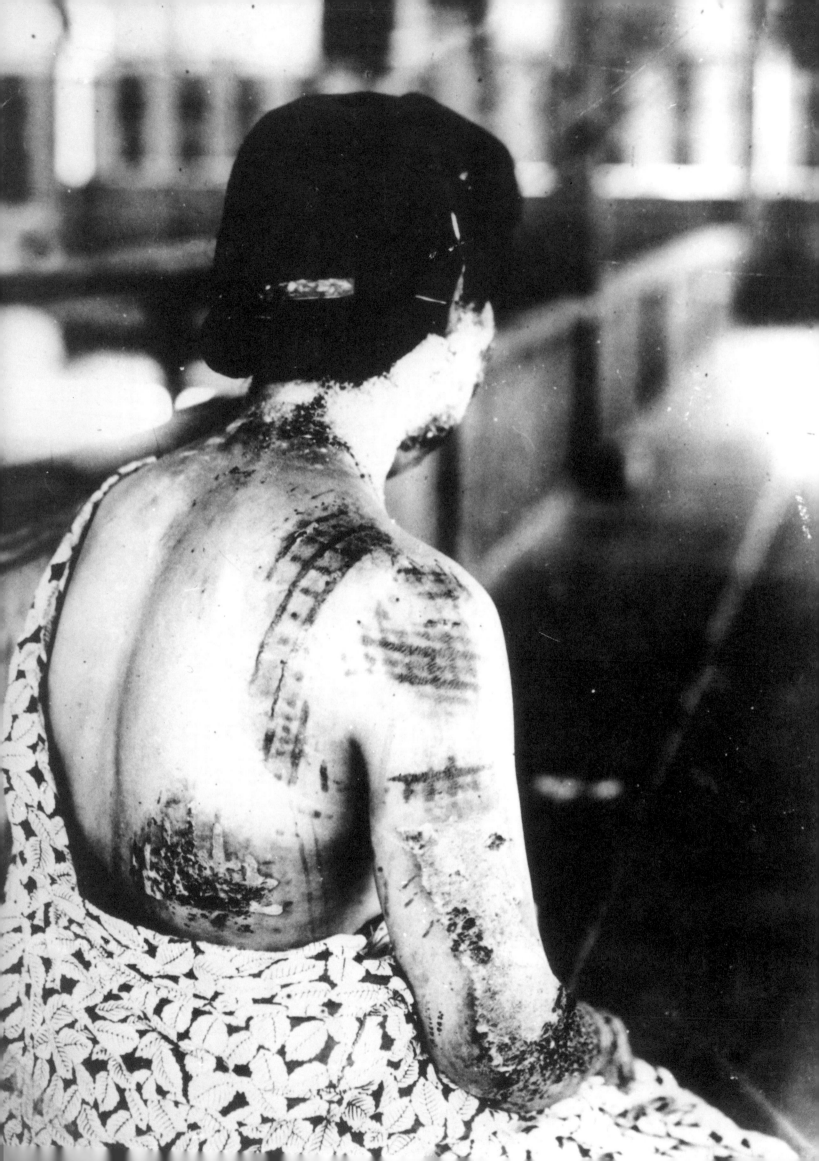

Victim of radiation
burns that made a kimono
pattern on her skin.
AUGUST 15, 1945.

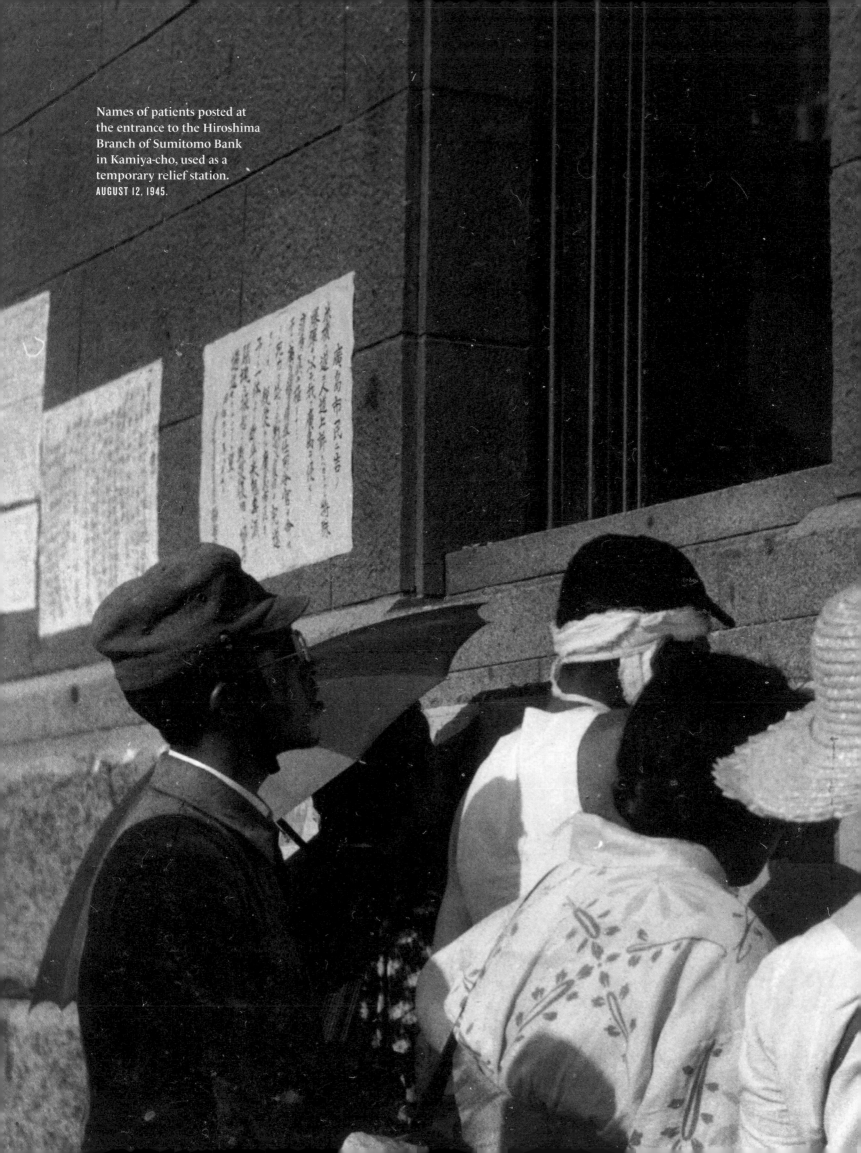

Names of patients posted at the entrance to the Hiroshima Branch of Sumitomo Bank in Kamiya-cho, used as a temporary relief station. AUGUST 12, 1945.

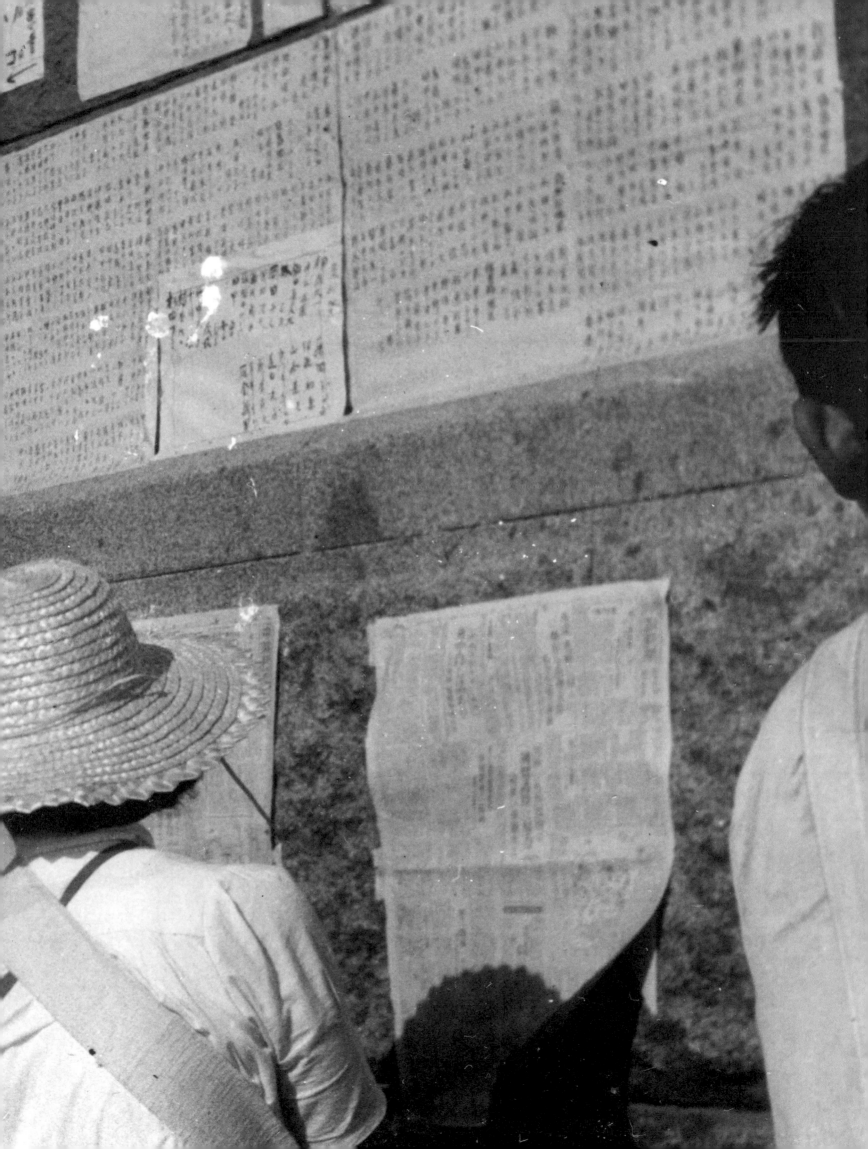

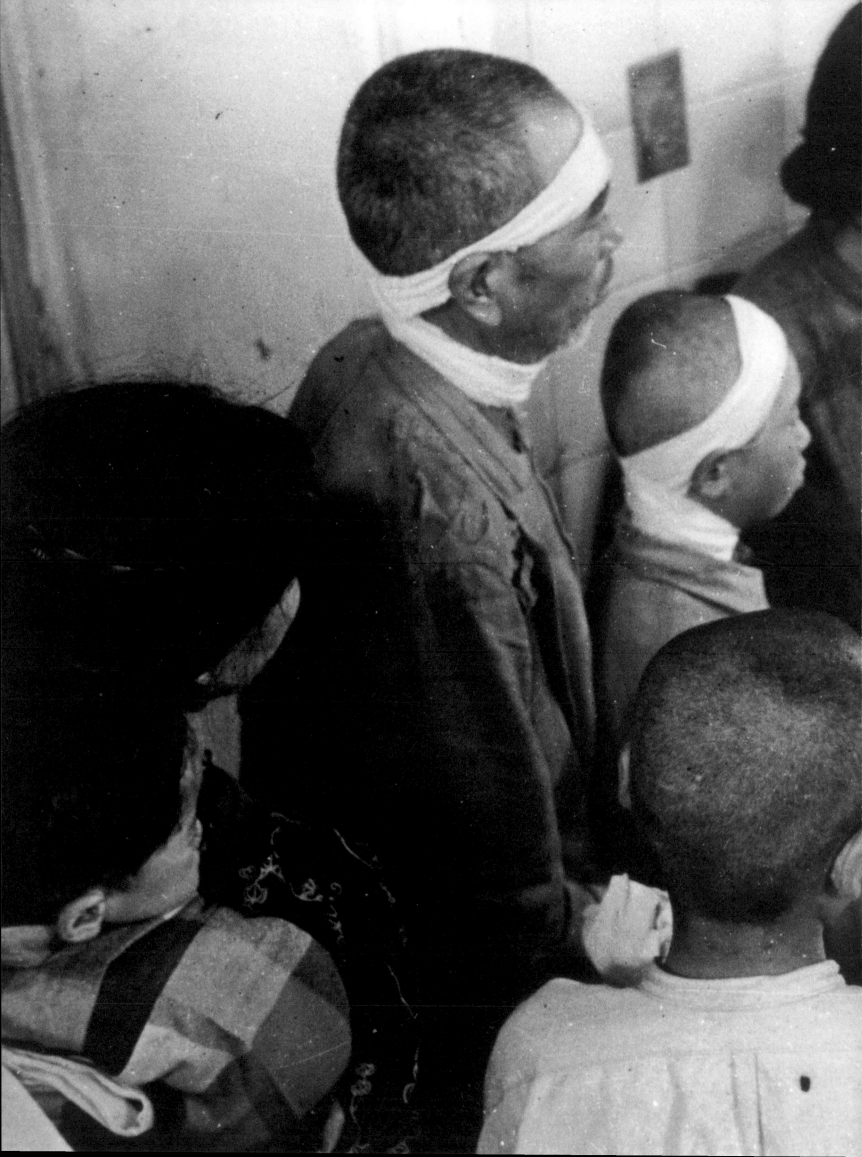

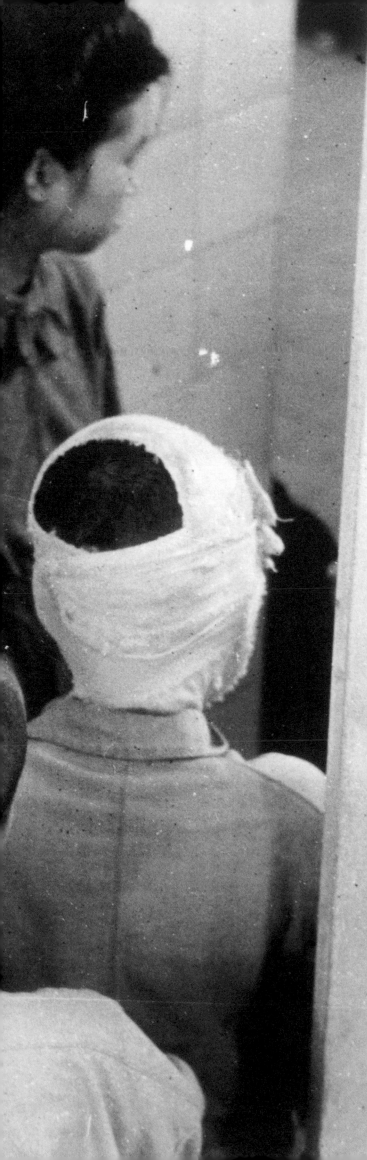

戦災患者
治療所

OCTOBER 7, 1945.

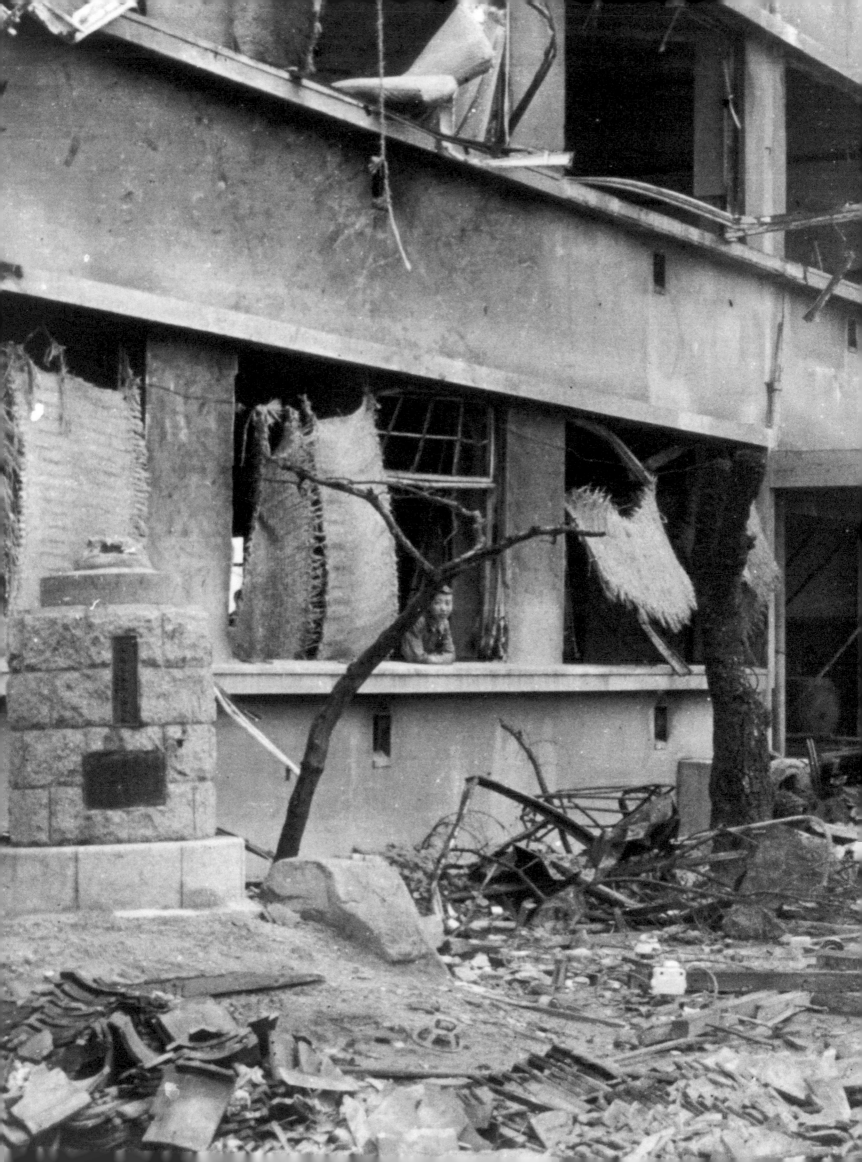

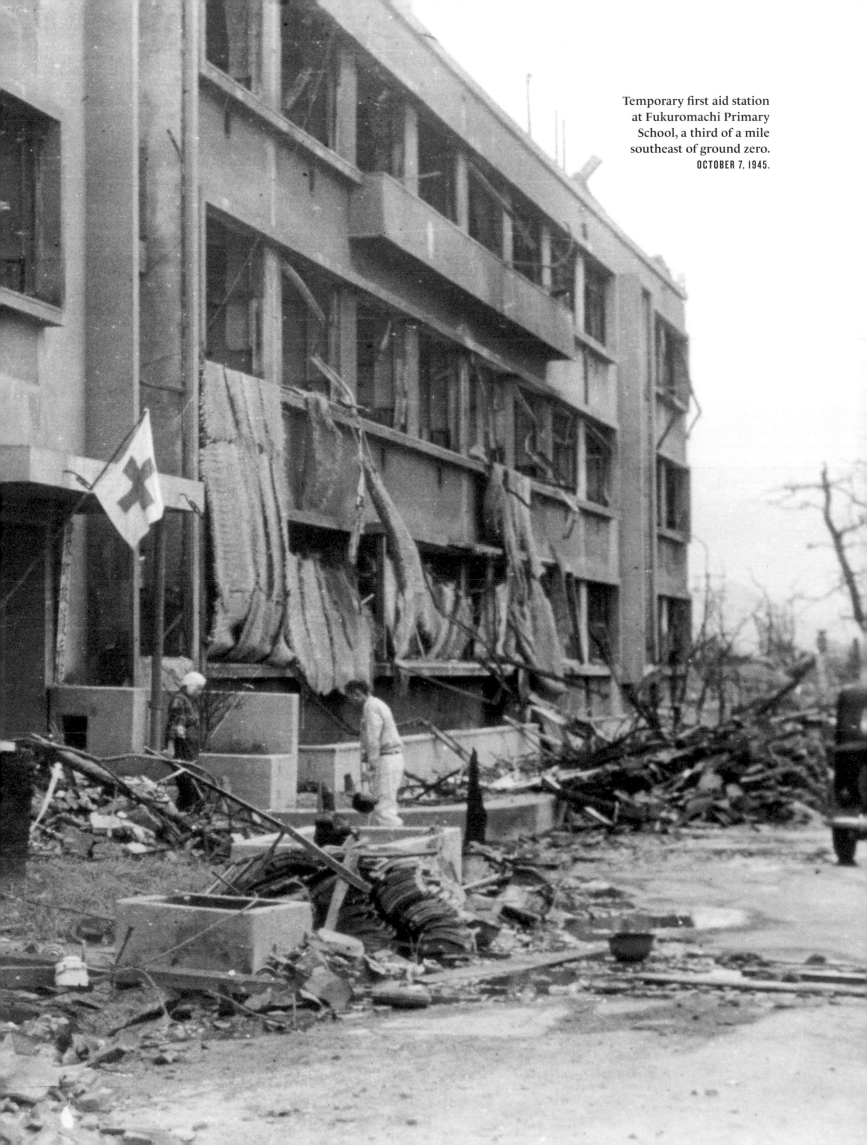

Temporary first aid station at Fukuromachi Primary School, a third of a mile southeast of ground zero.
OCTOBER 7, 1945.

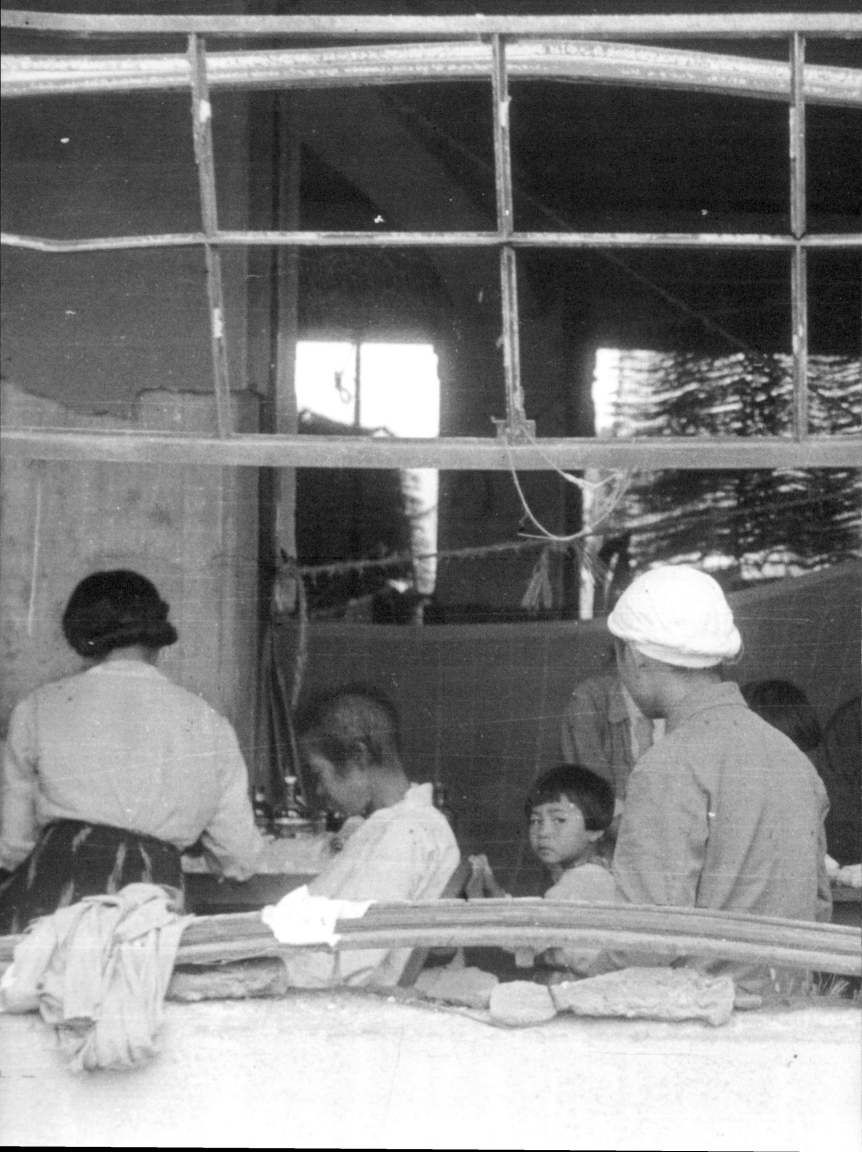

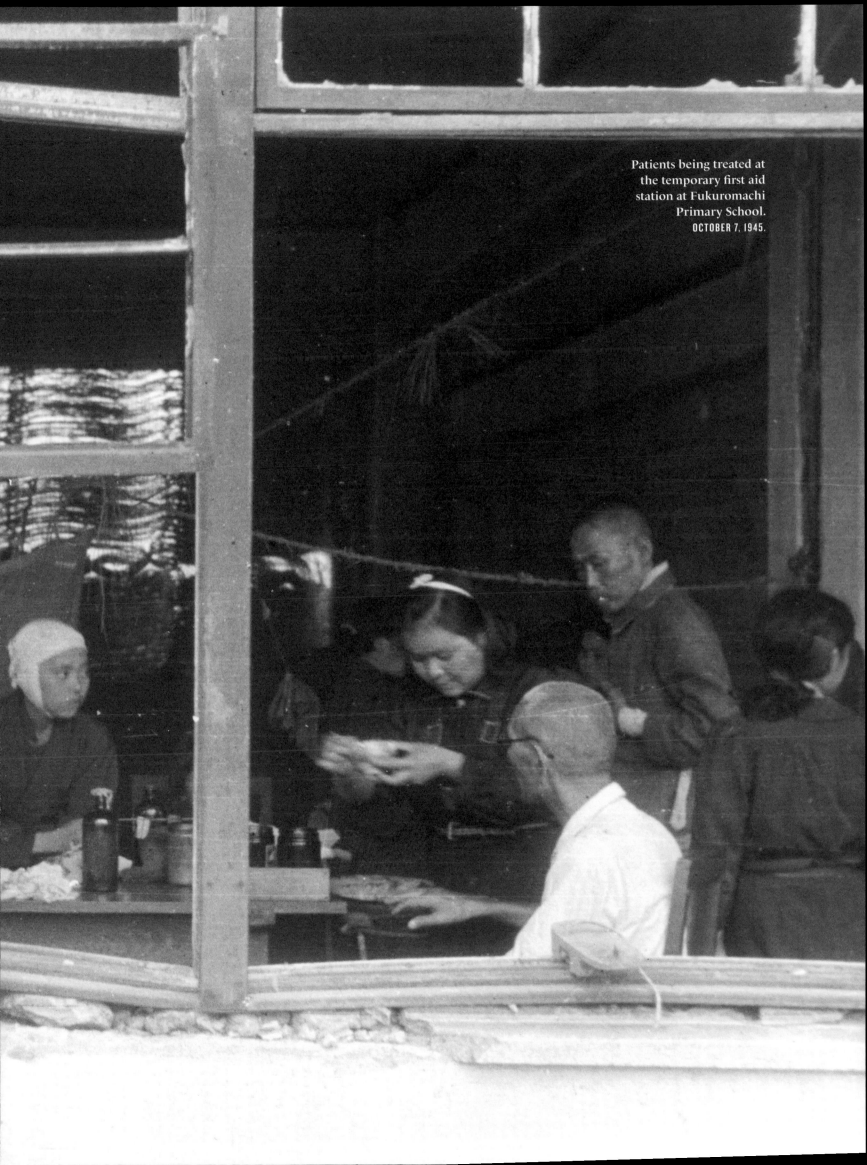

Patients being treated at the temporary first aid station at Fukuromachi Primary School.
OCTOBER 7, 1945.

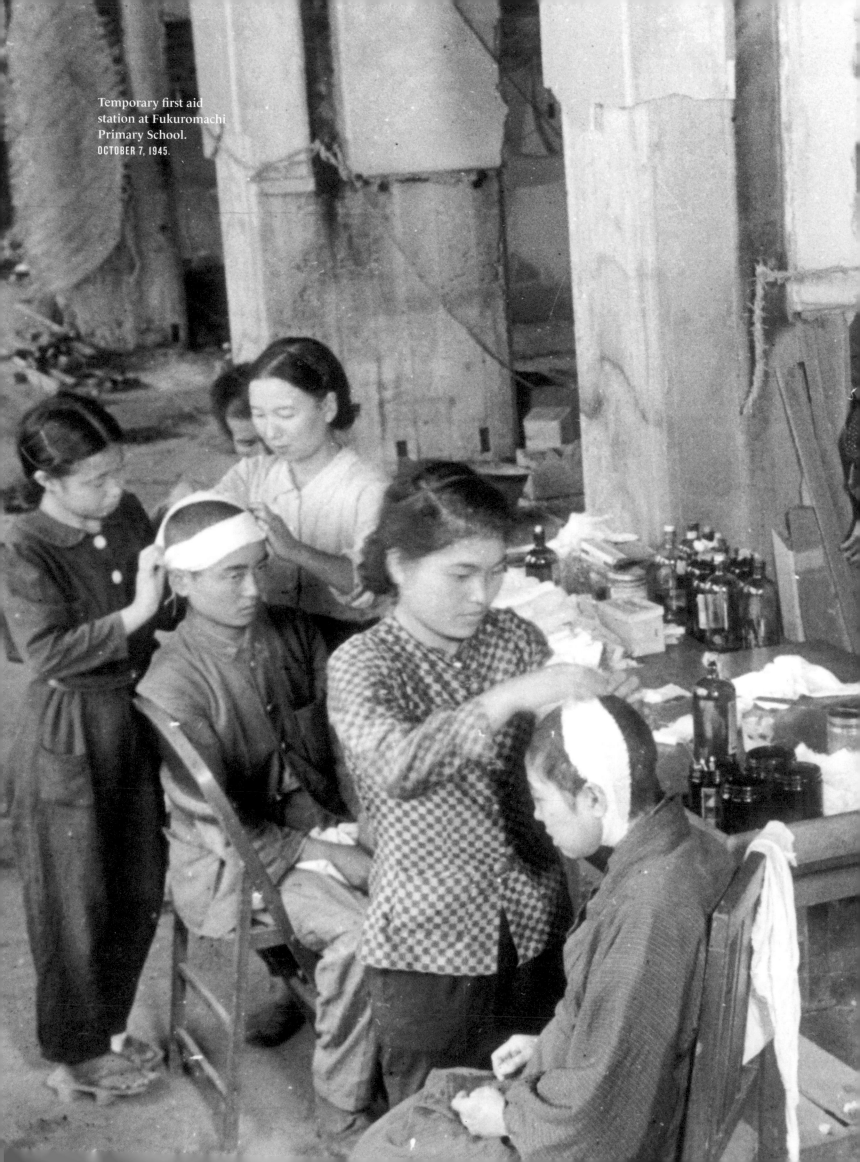

Temporary first aid
station at Fukuromachi
Primary School.
OCTOBER 7, 1945.

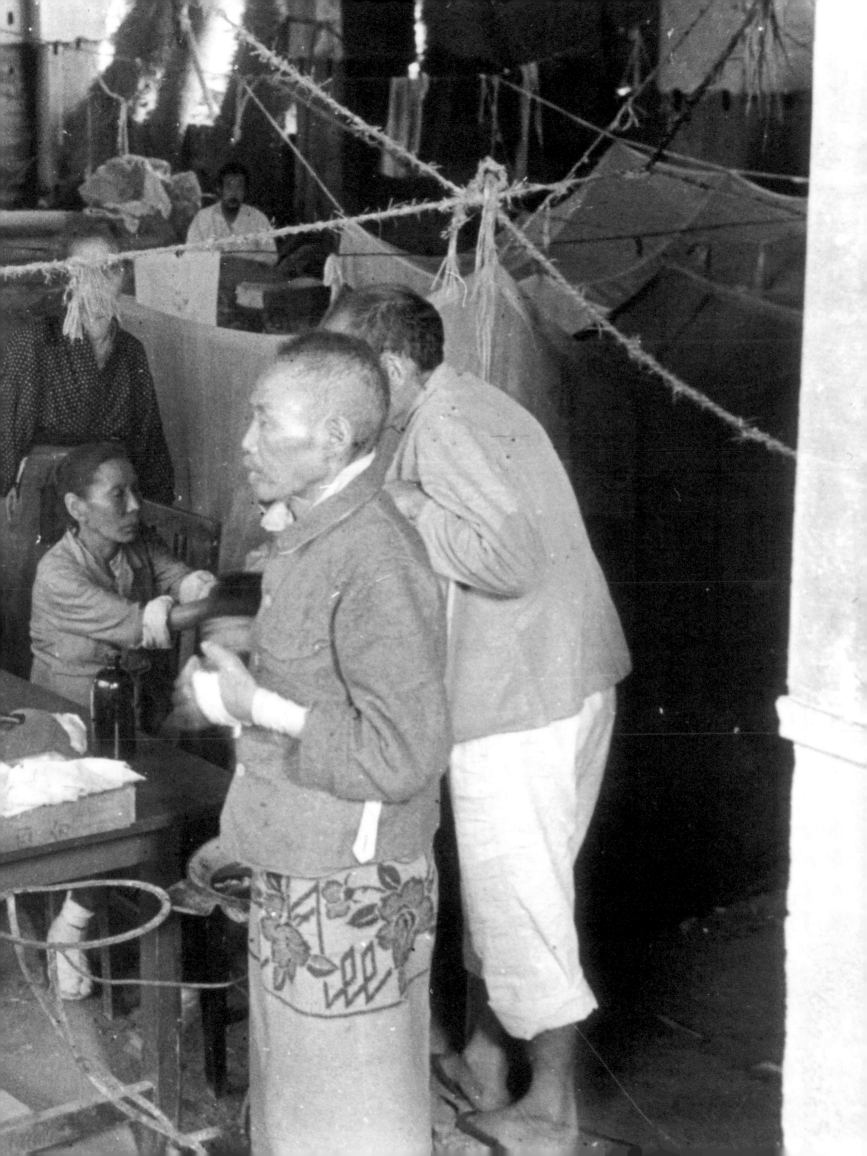

金ハ友モ持参ニテ御立替マセンカラ

右ノ通リ話ハ書ノ出来ル中

帰リ度イト思ヒマス　隊中

...との傳言あり　加藤

小林校長

八月十七日　加藤

戦災死（八月九日）
郷里ニ於テ

藤木先生へ　御傳ひ

高一瓢文子が　火傷シテ

精養軒ゆゐの治療所デ治療
ヲ受ケテヰマス

広島ニ身ヨリハナク

蒲刈下島一之瀬、櫻田了
へ行ヶ予定デス

二十三日八治療所ニ居ルカモ

兵隊サンニ元頼ンデ置キマシタ

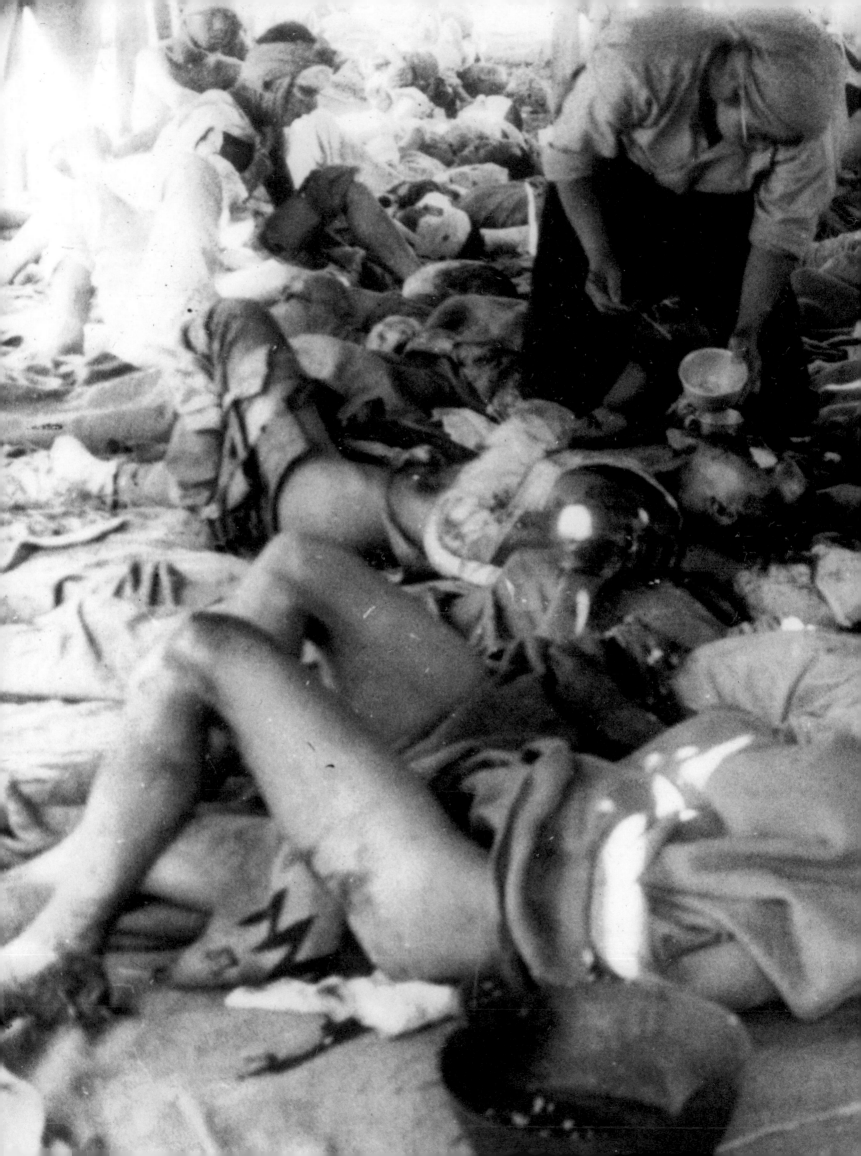

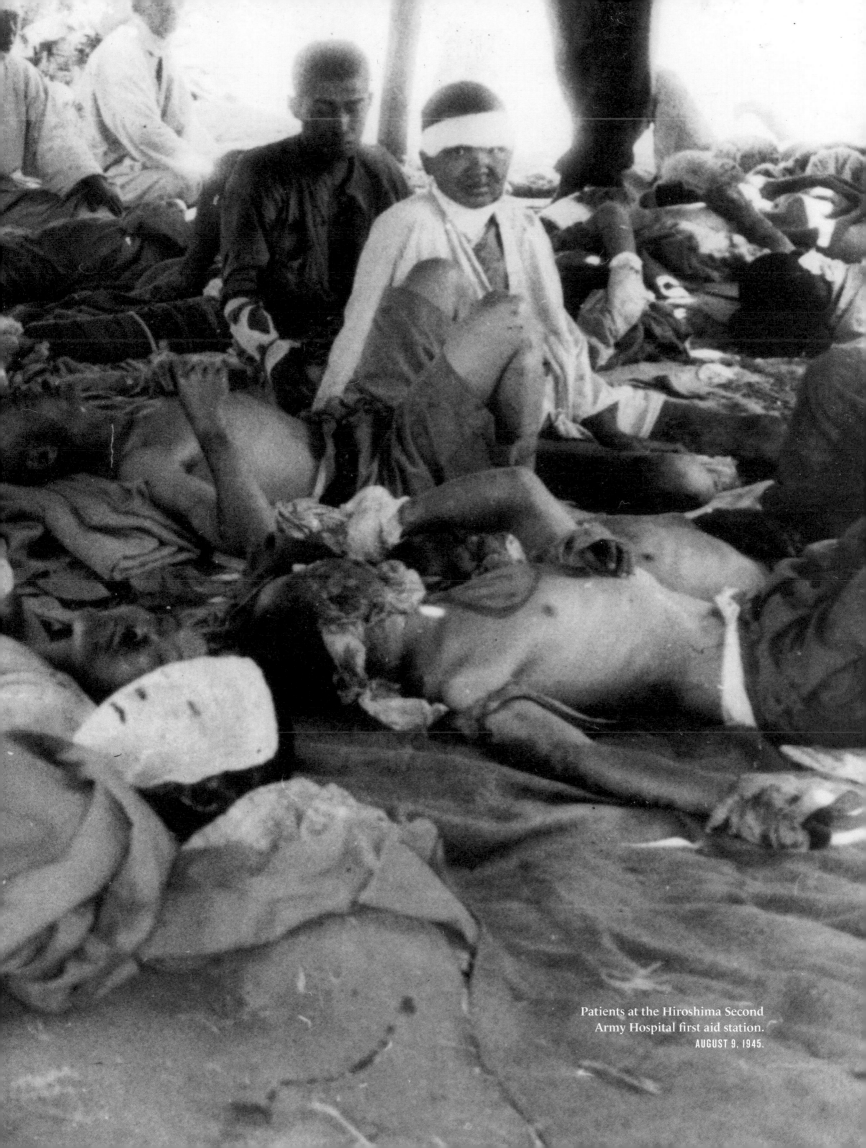

Patients at the Hiroshima Second
Army Hospital first aid station.
AUGUST 9, 1945.

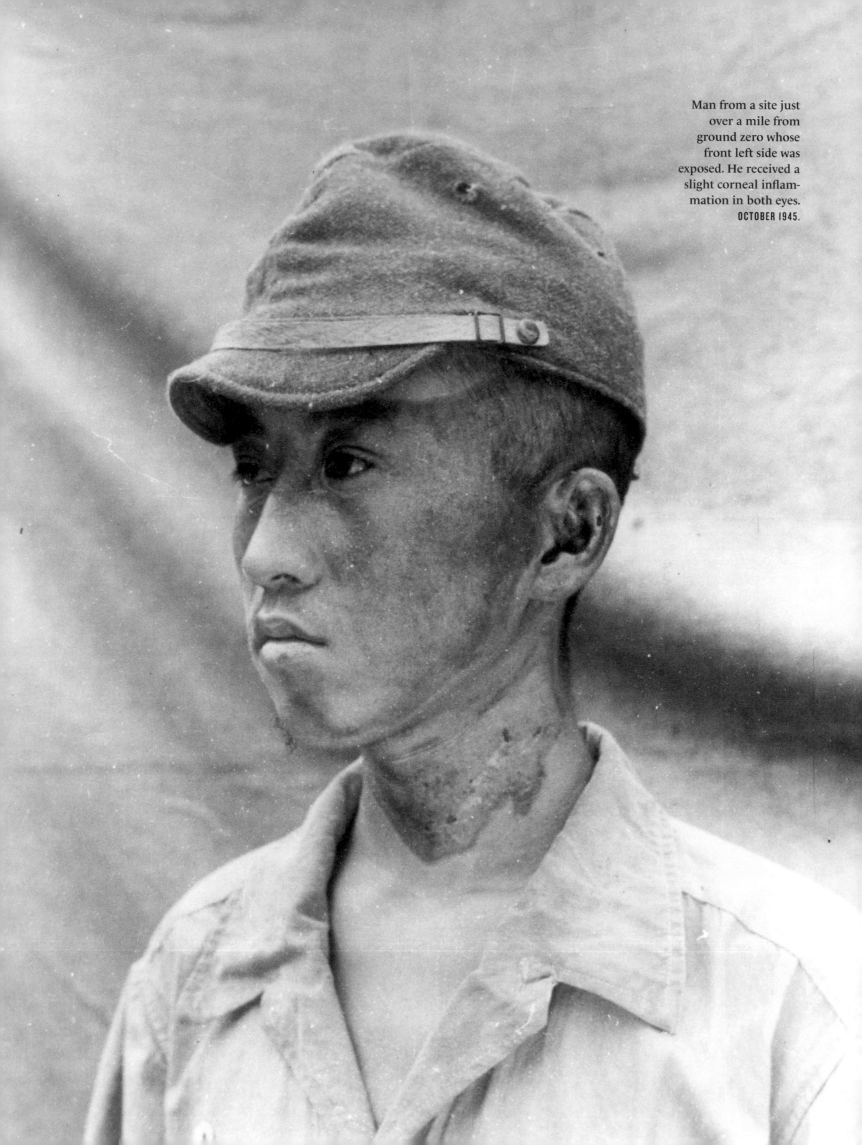

Man from a site just over a mile from ground zero whose front left side was exposed. He received a slight corneal inflammation in both eyes. OCTOBER 1945.

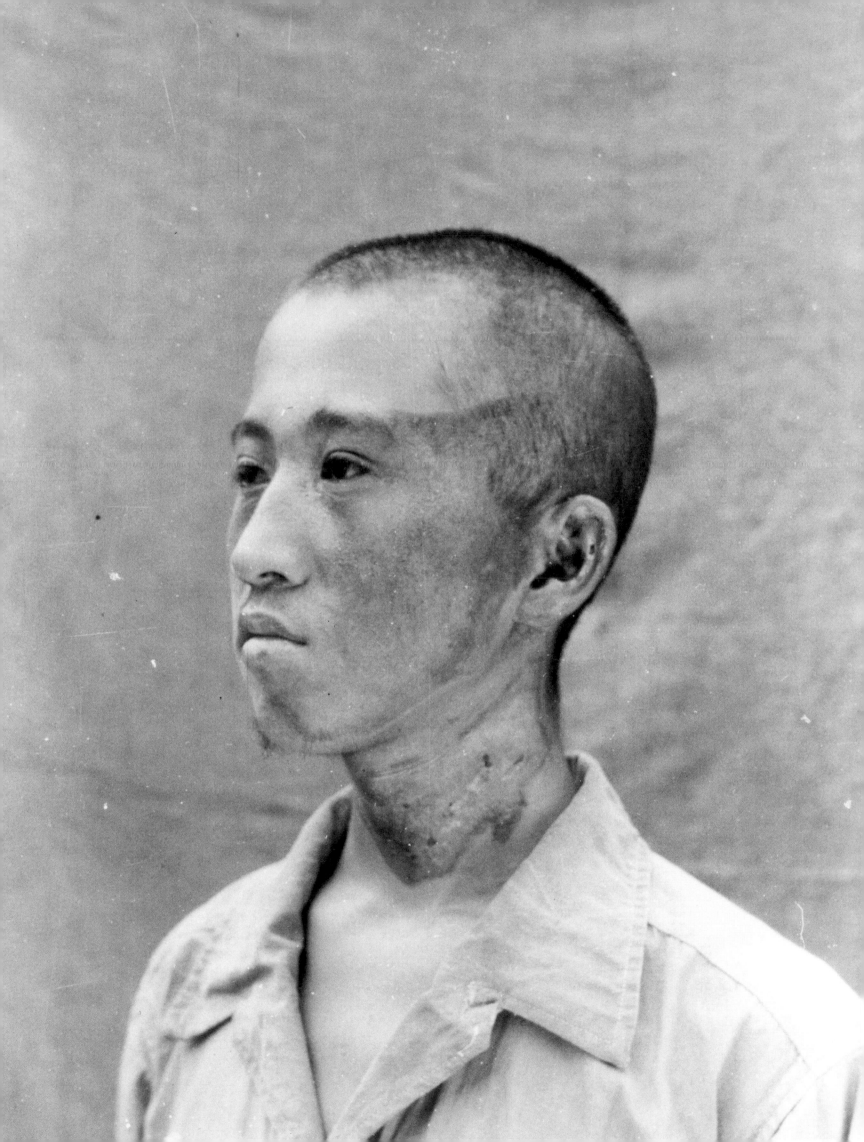

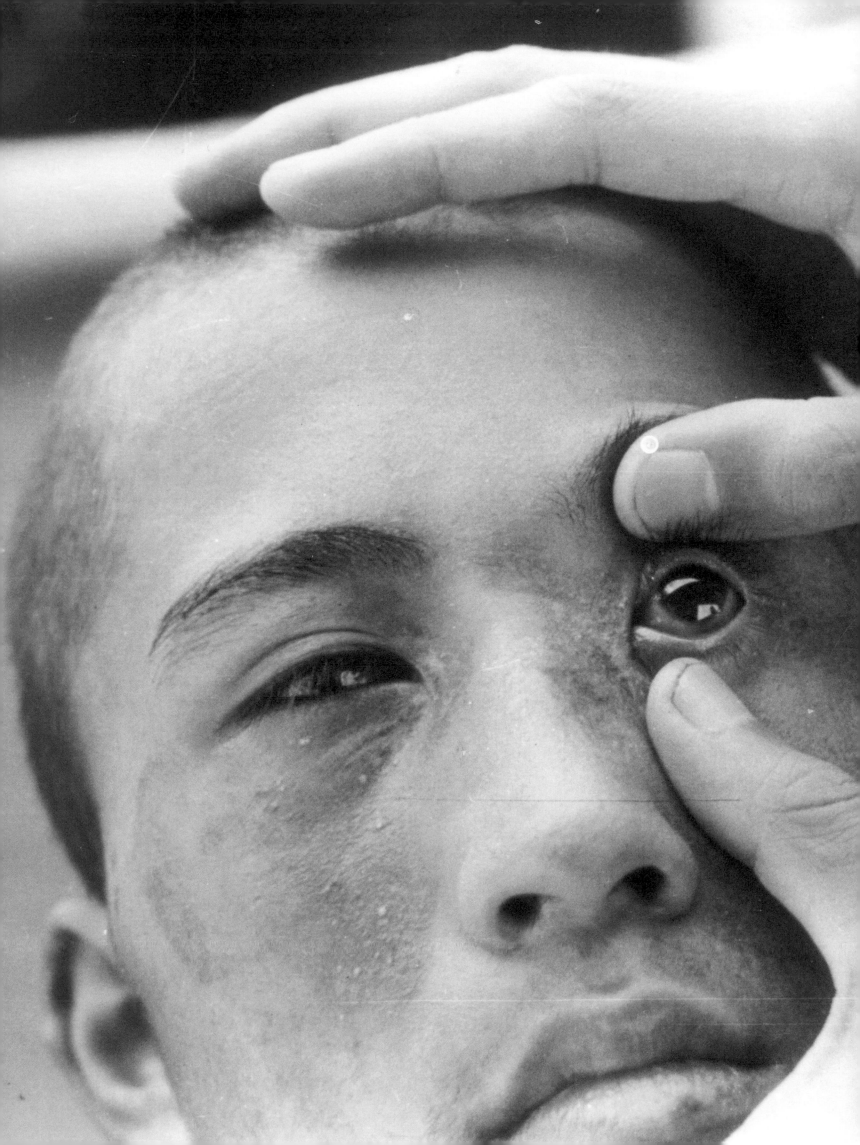

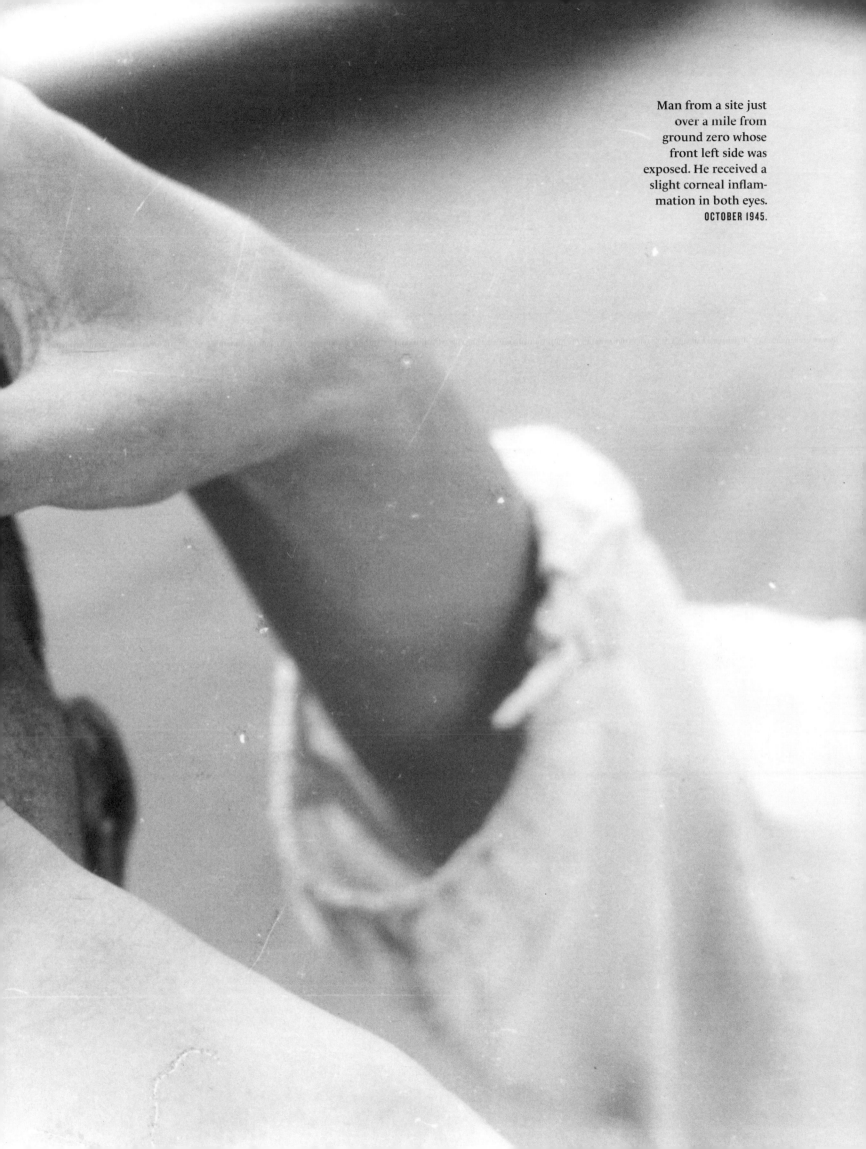

Man from a site just over a mile from ground zero whose front left side was exposed. He received a slight corneal inflammation in both eyes. OCTOBER 1945.

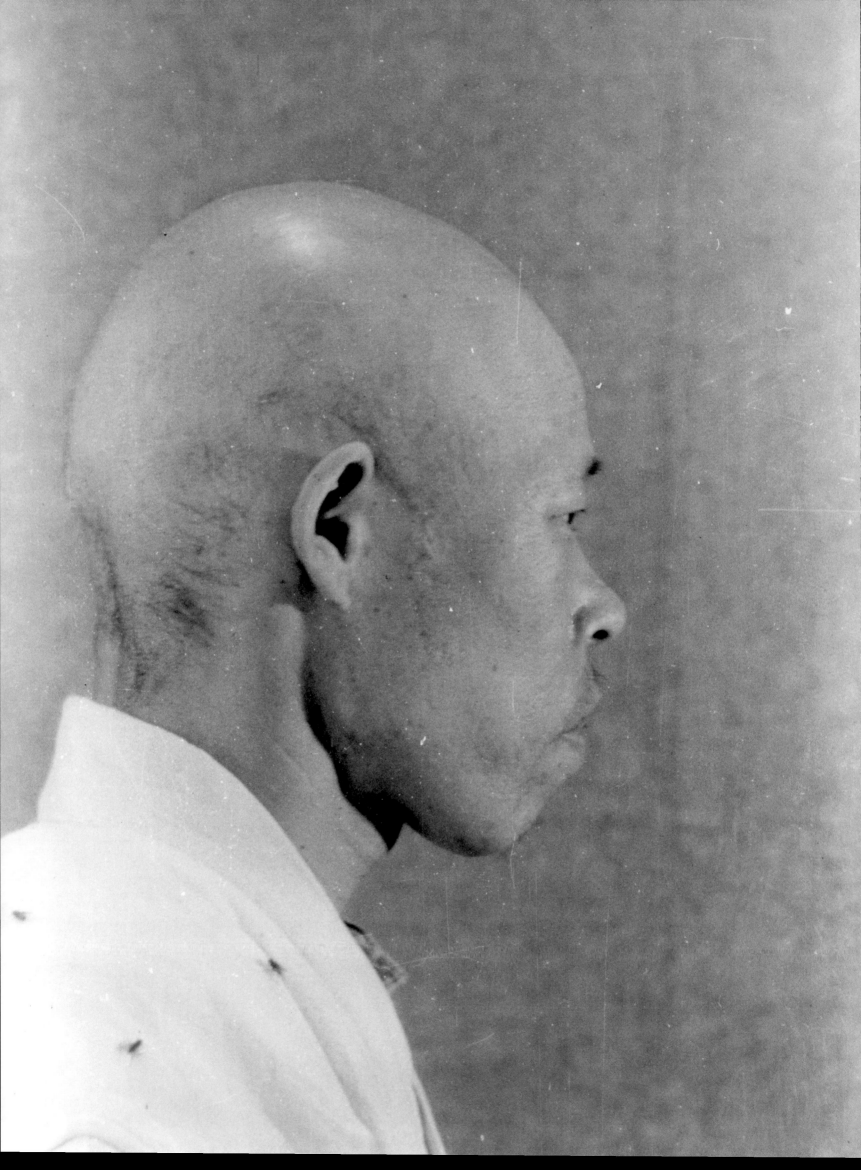

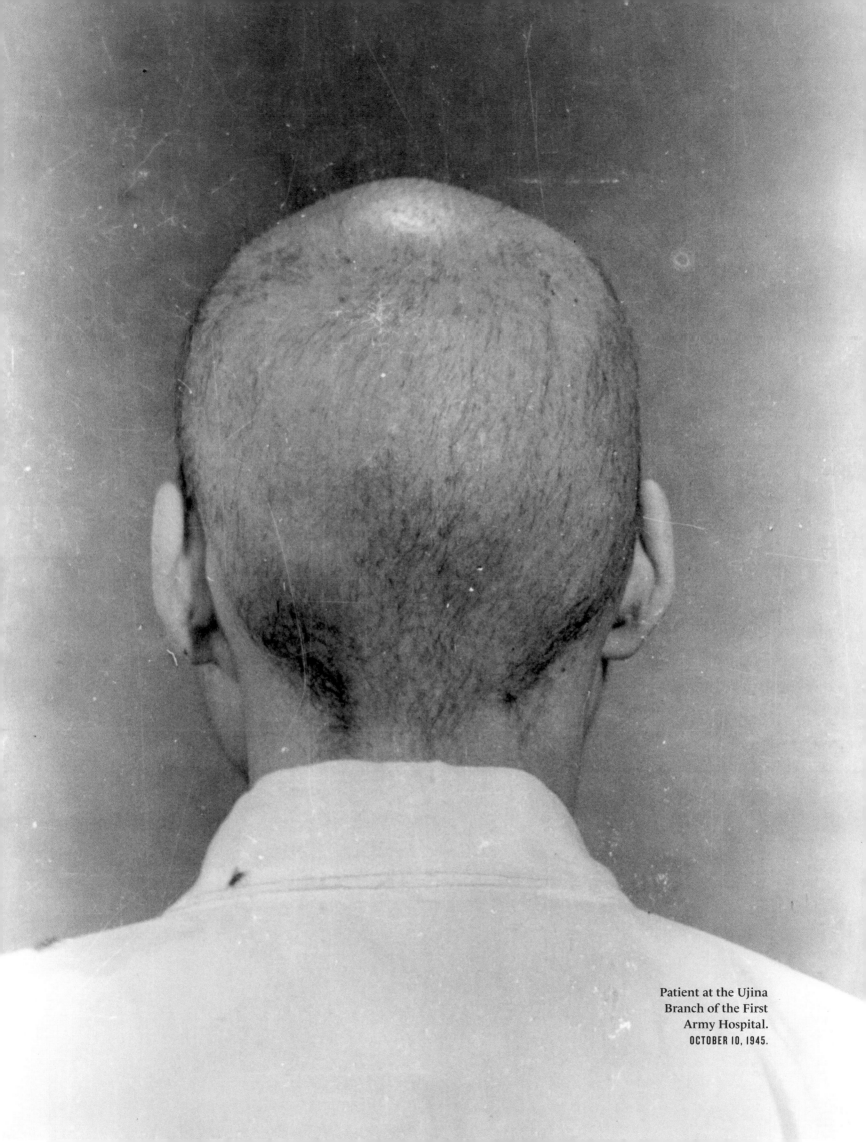

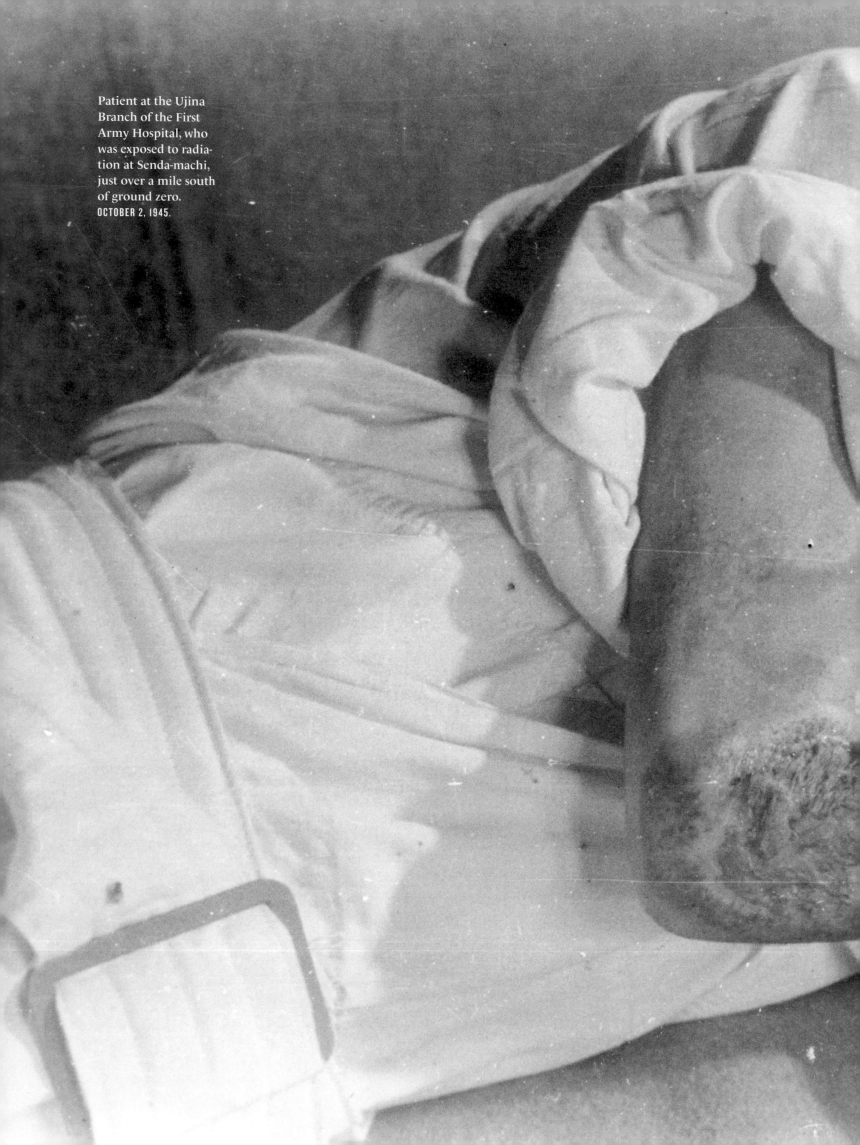

Patient at the Ujina Branch of the First Army Hospital, who was exposed to radiation at Senda-machi, just over a mile south of ground zero. OCTOBER 2, 1945.

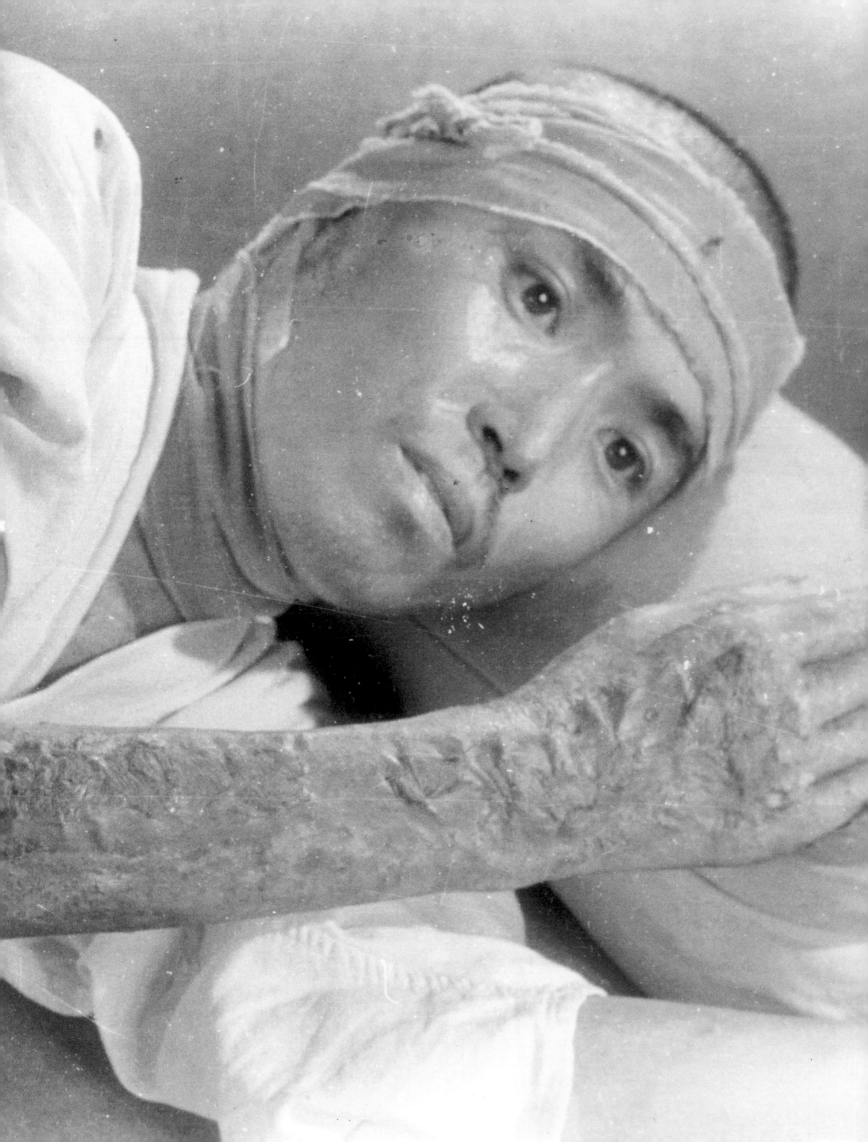

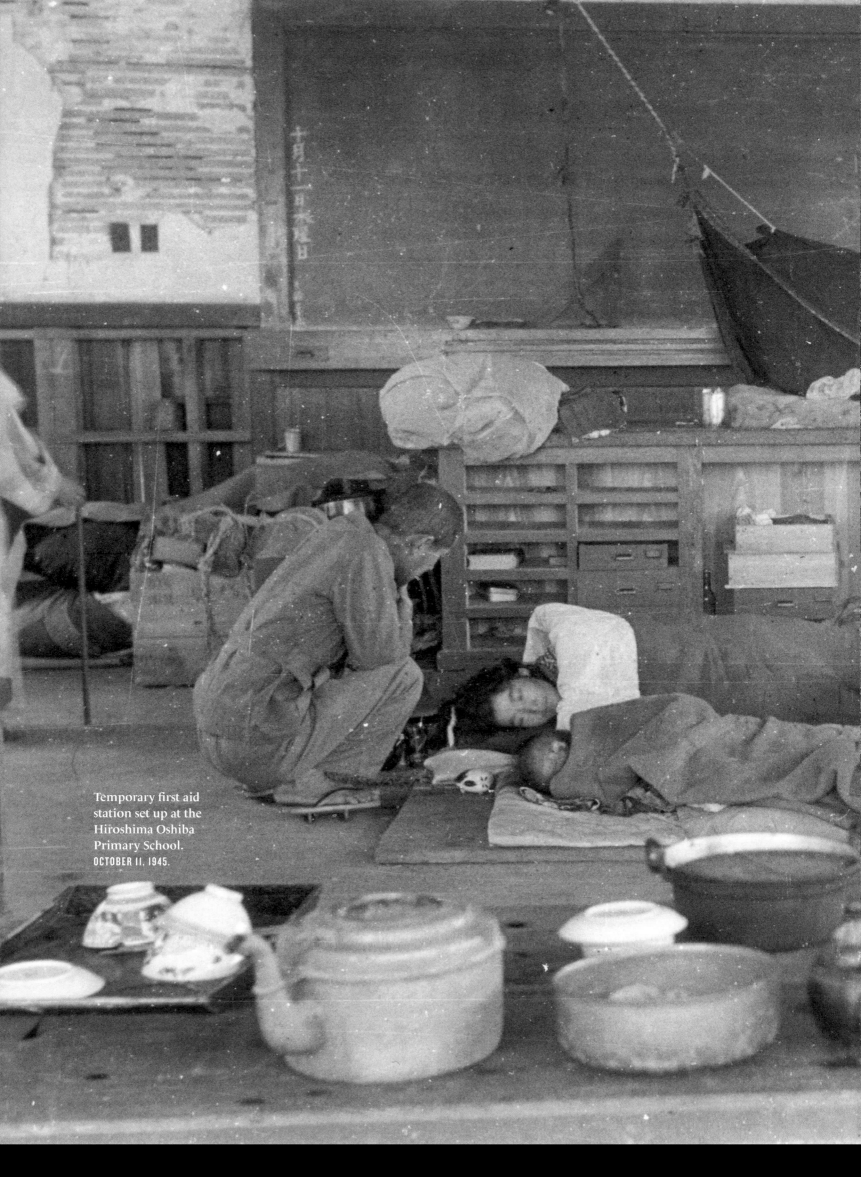

Temporary first aid
station set up at the
Hiroshima Oshiba
Primary School.
OCTOBER 11, 1945.

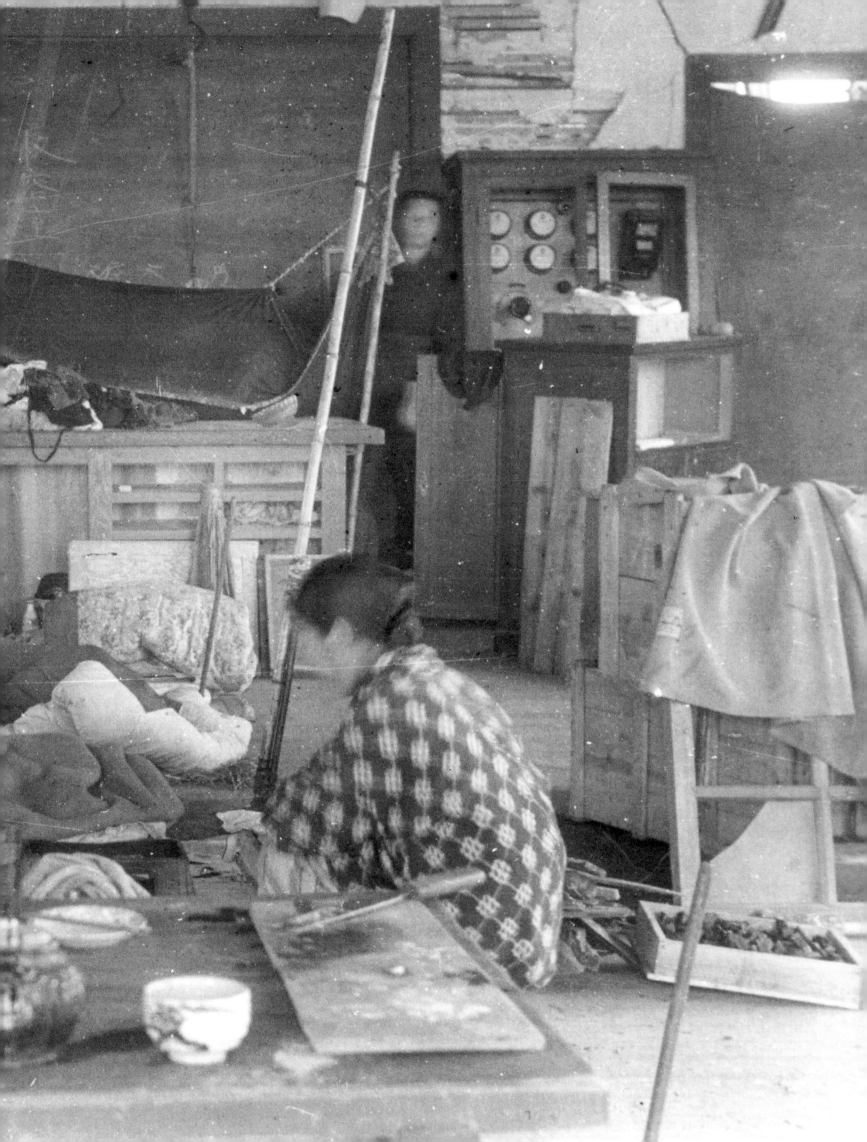

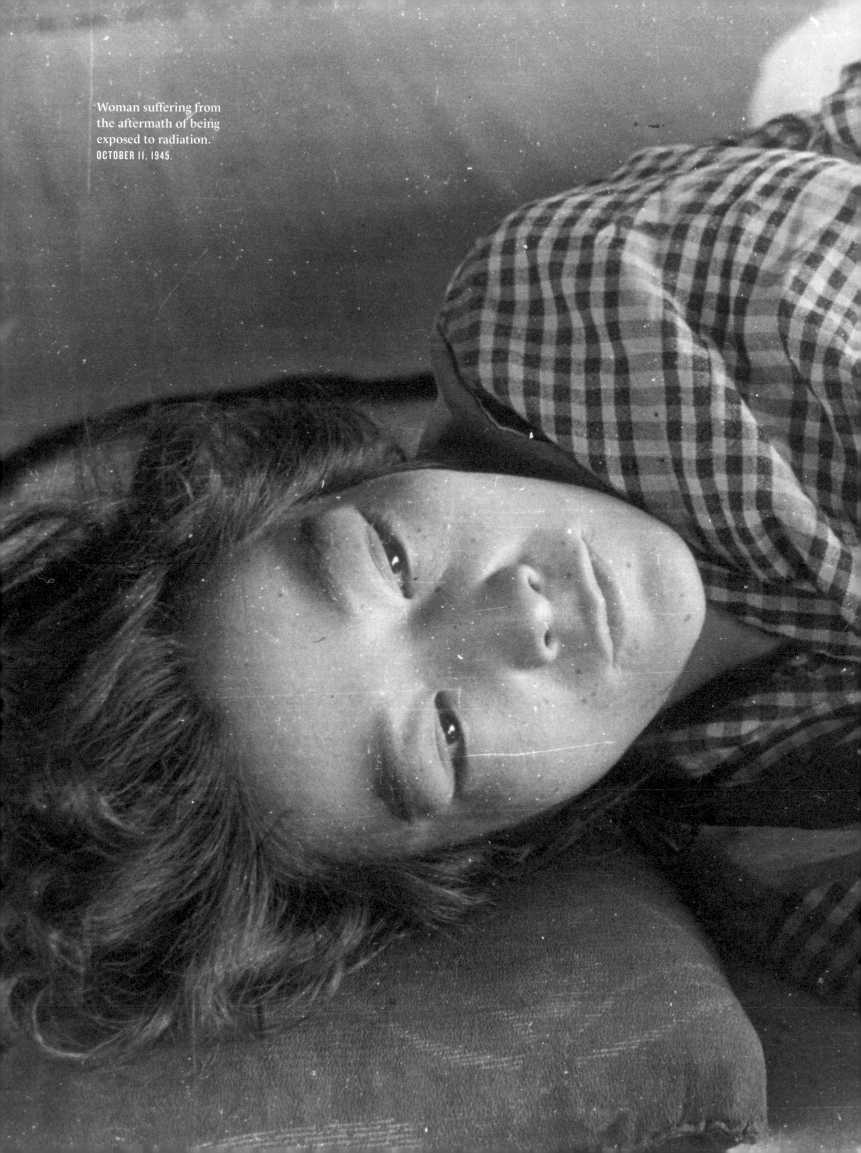

Woman suffering from
the aftermath of being
exposed to radiation.
OCTOBER 11, 1945.

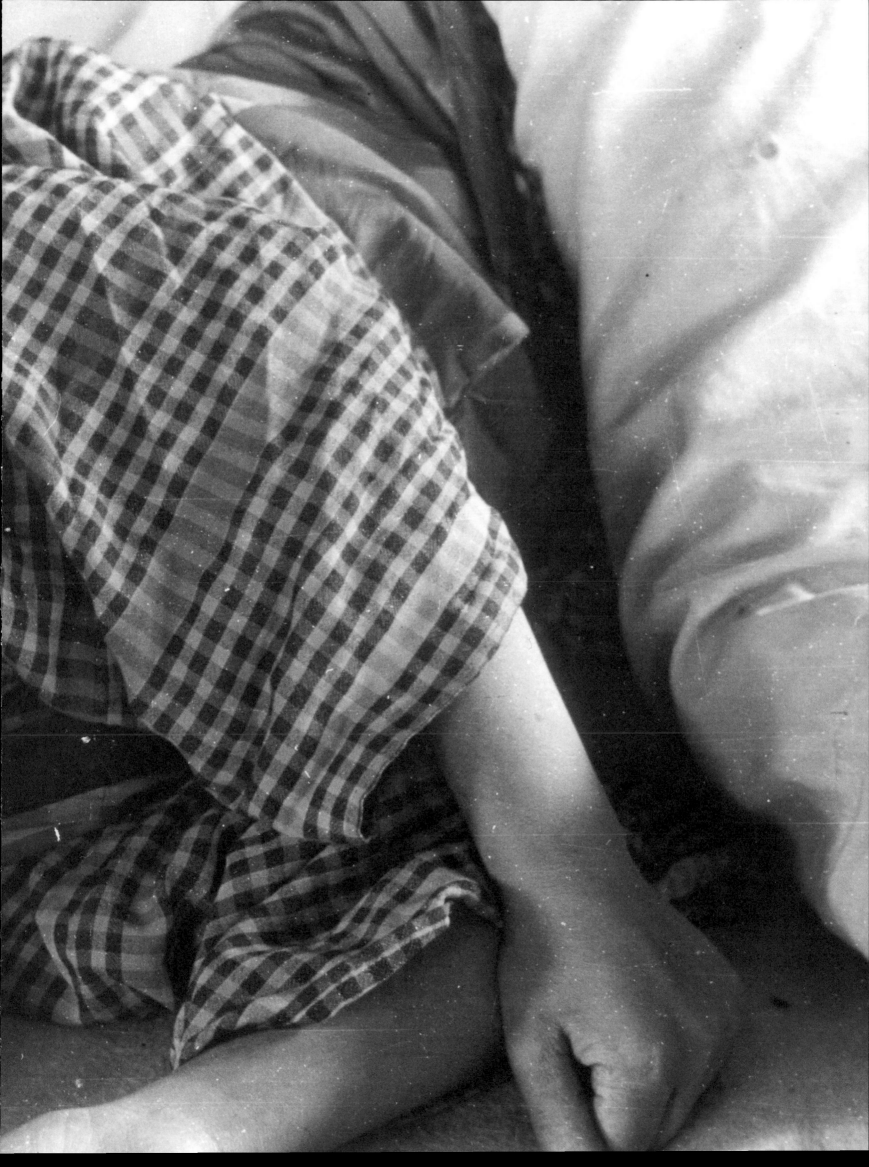

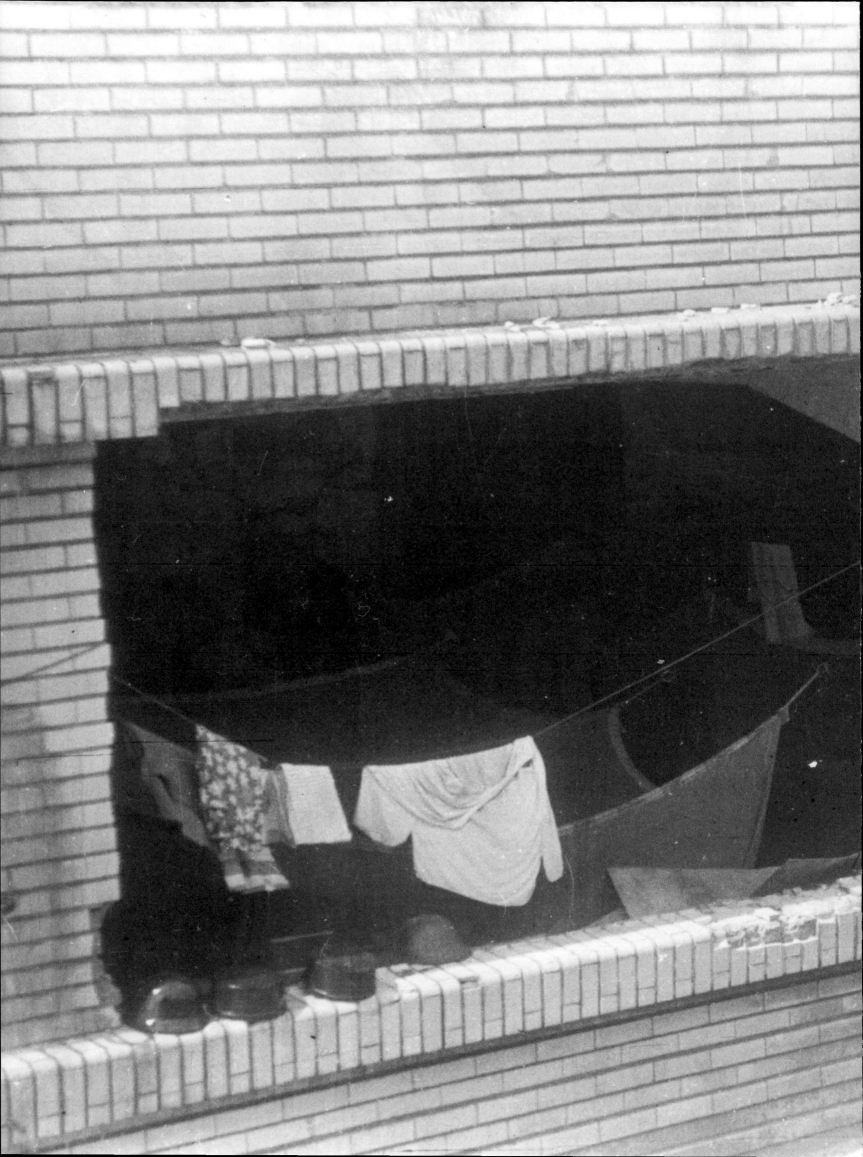

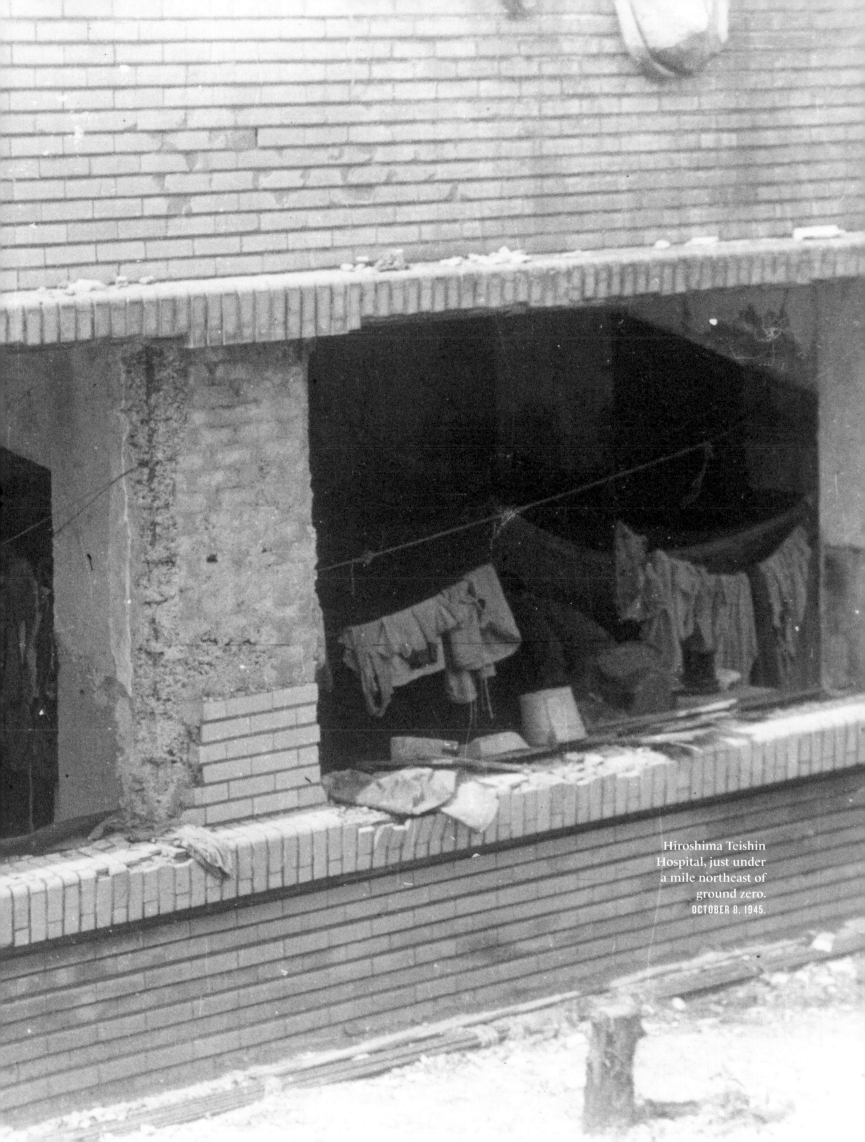

Hiroshima Teishin Hospital, just under a mile northeast of ground zero.
OCTOBER 8, 1945.

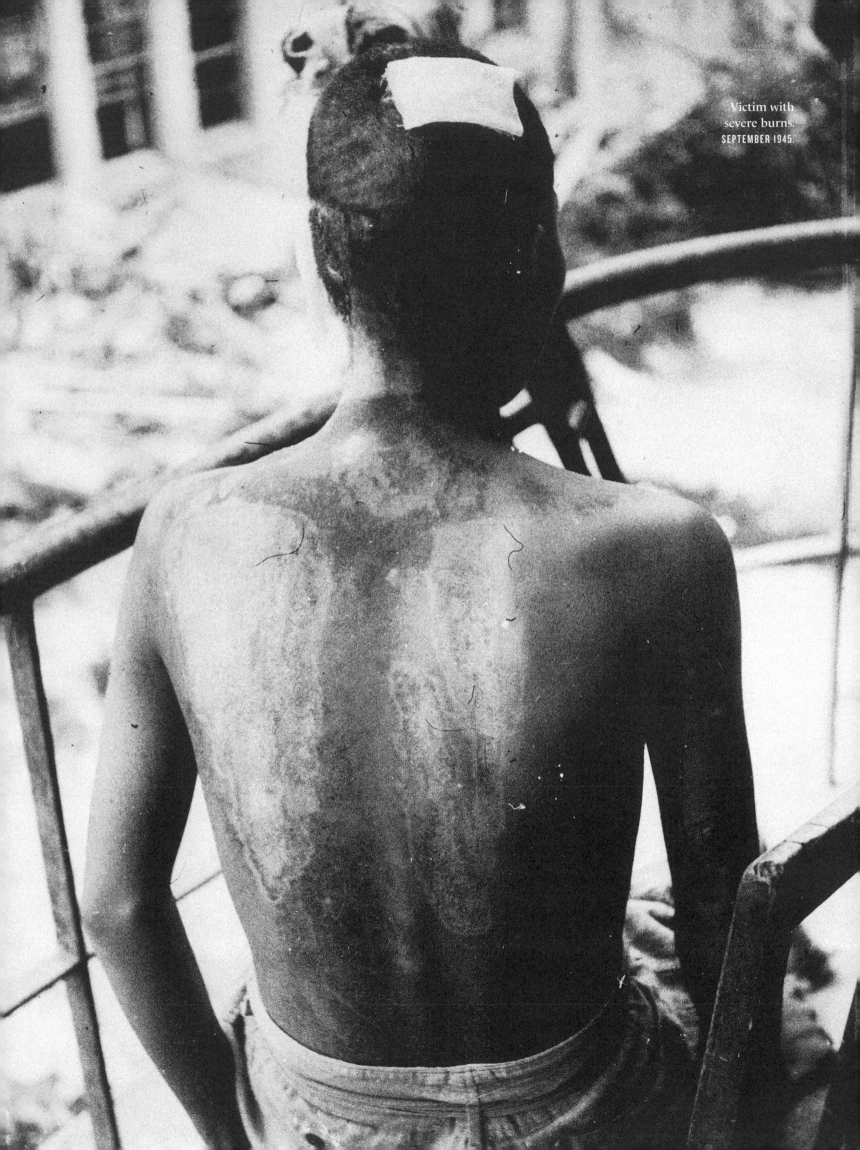

Victim with
severe burns.
SEPTEMBER 1945.

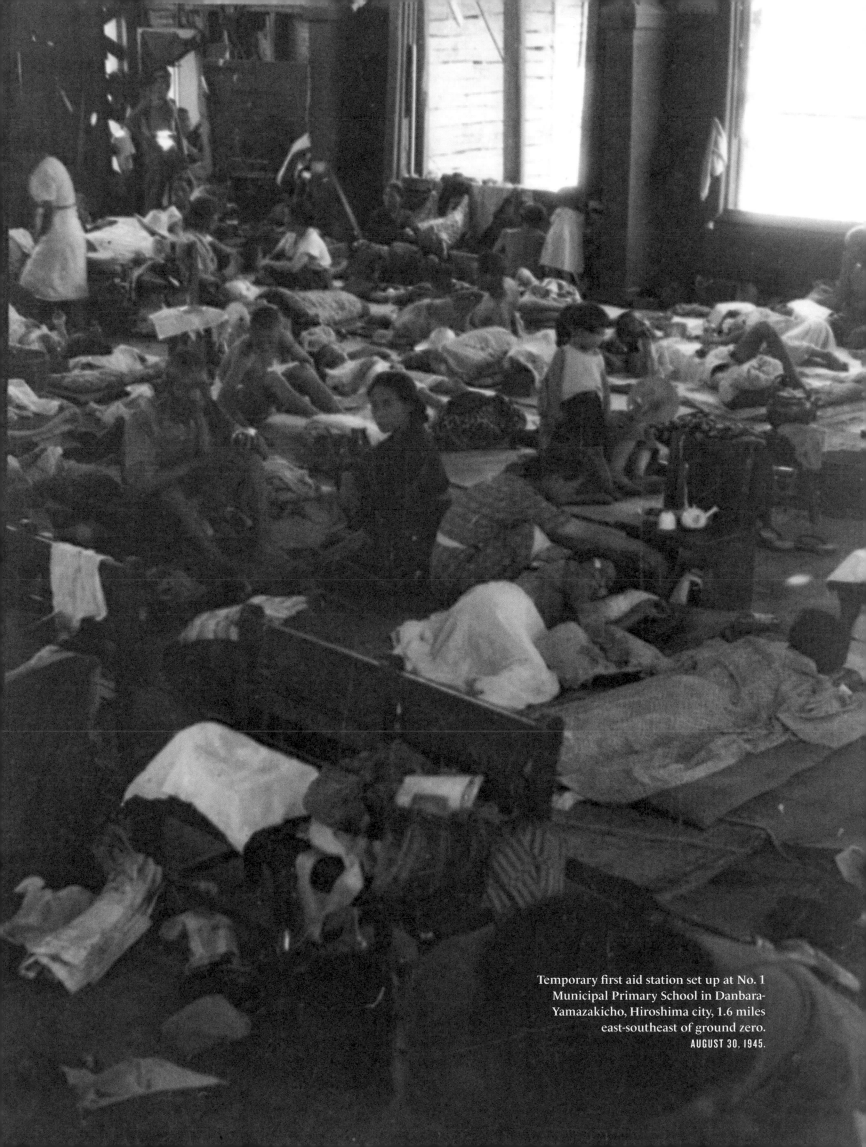

Temporary first aid station set up at No. 1 Municipal Primary School in Danbara-Yamazakicho, Hiroshima city, 1.6 miles east-southeast of ground zero. AUGUST 30, 1945.

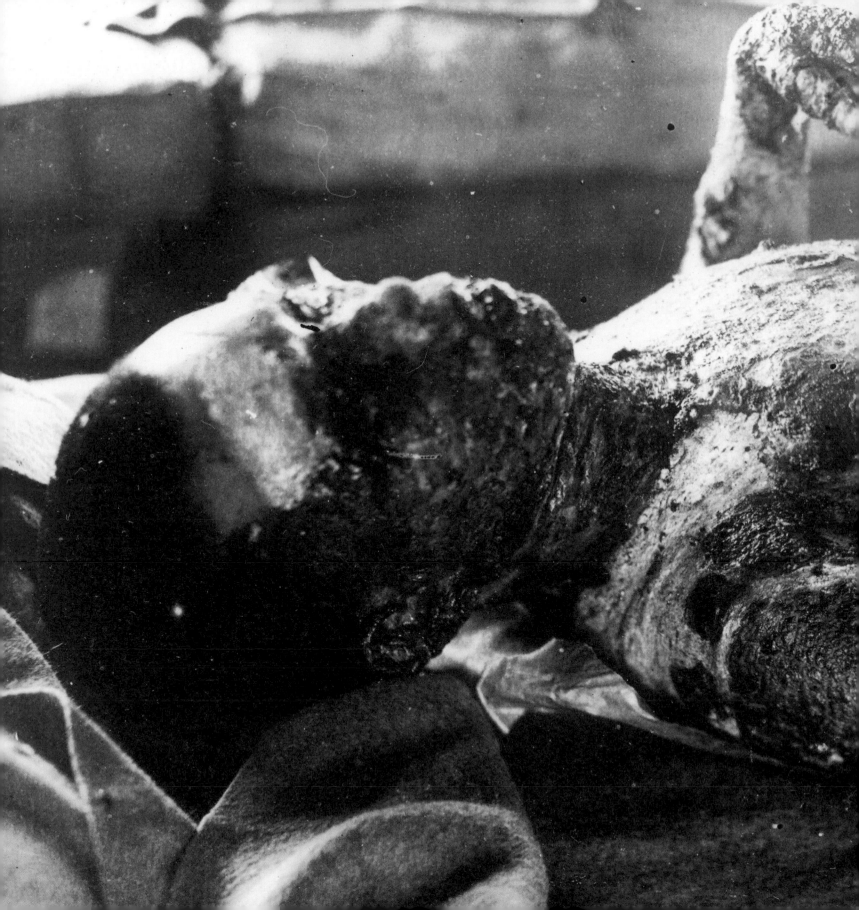

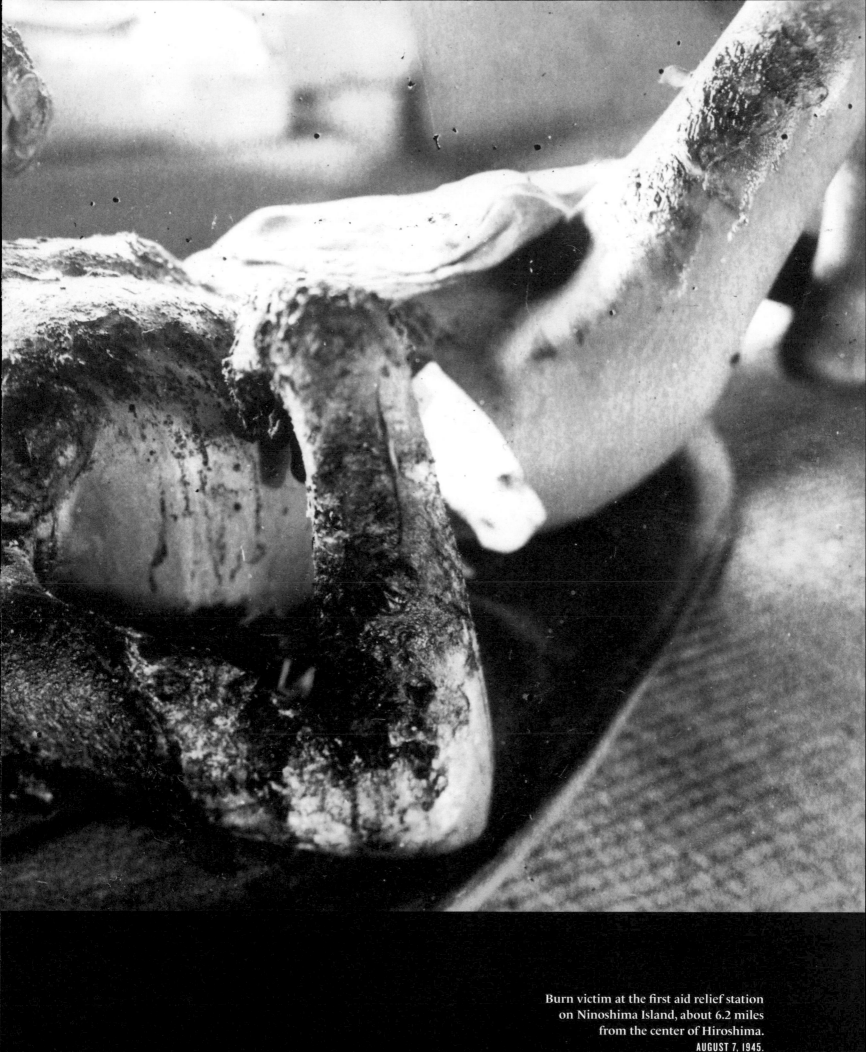

Burn victim at the first aid relief station
on Ninoshima Island, about 6.2 miles
from the center of Hiroshima.
AUGUST 7, 1945.

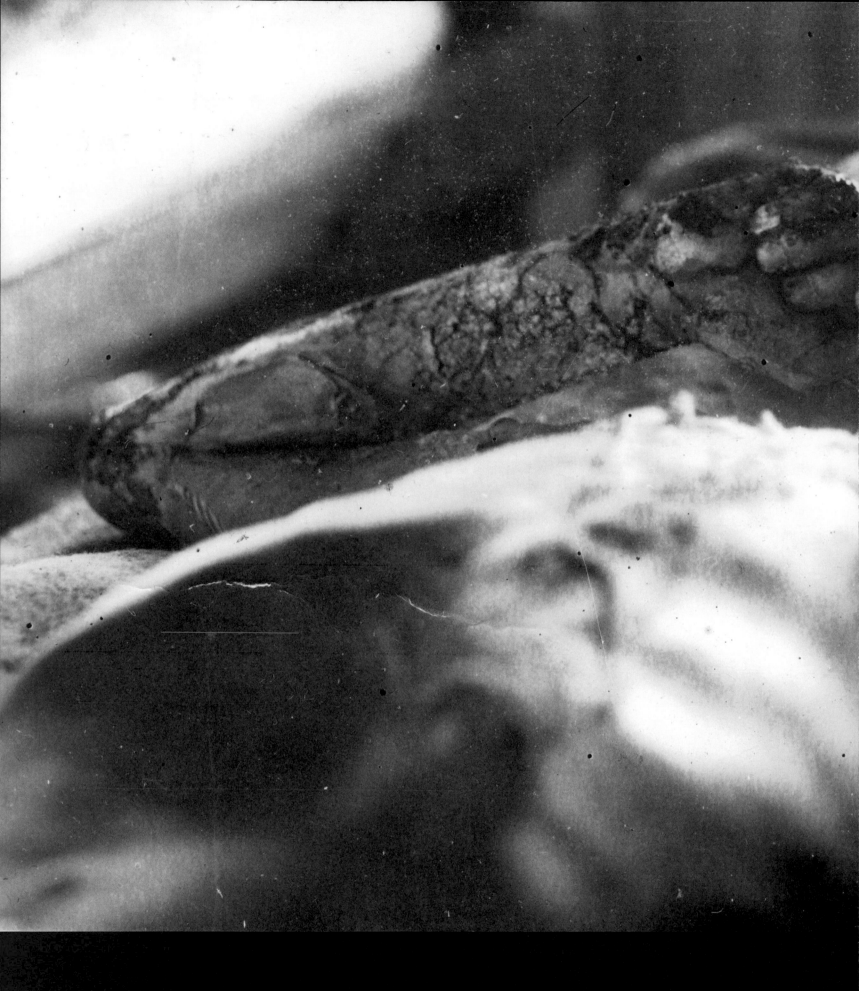

Bomb victim with burns at
Ninoshima Quarantine Office,
in Hiroshima city.
AUGUST 7, 1945.

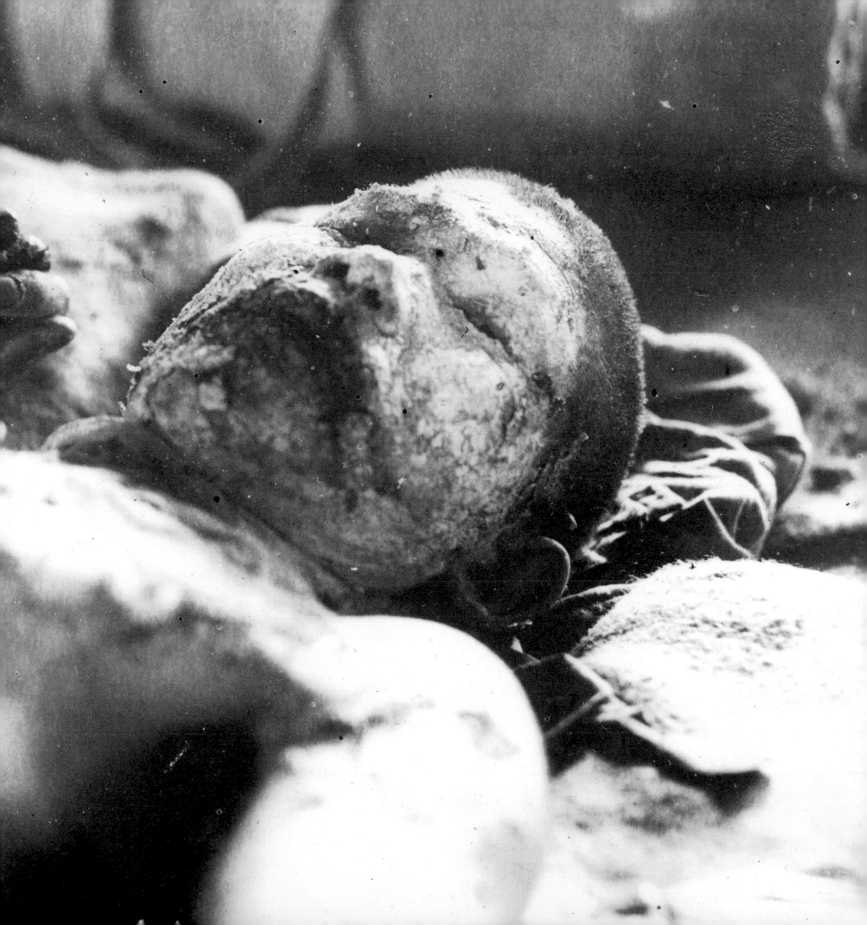

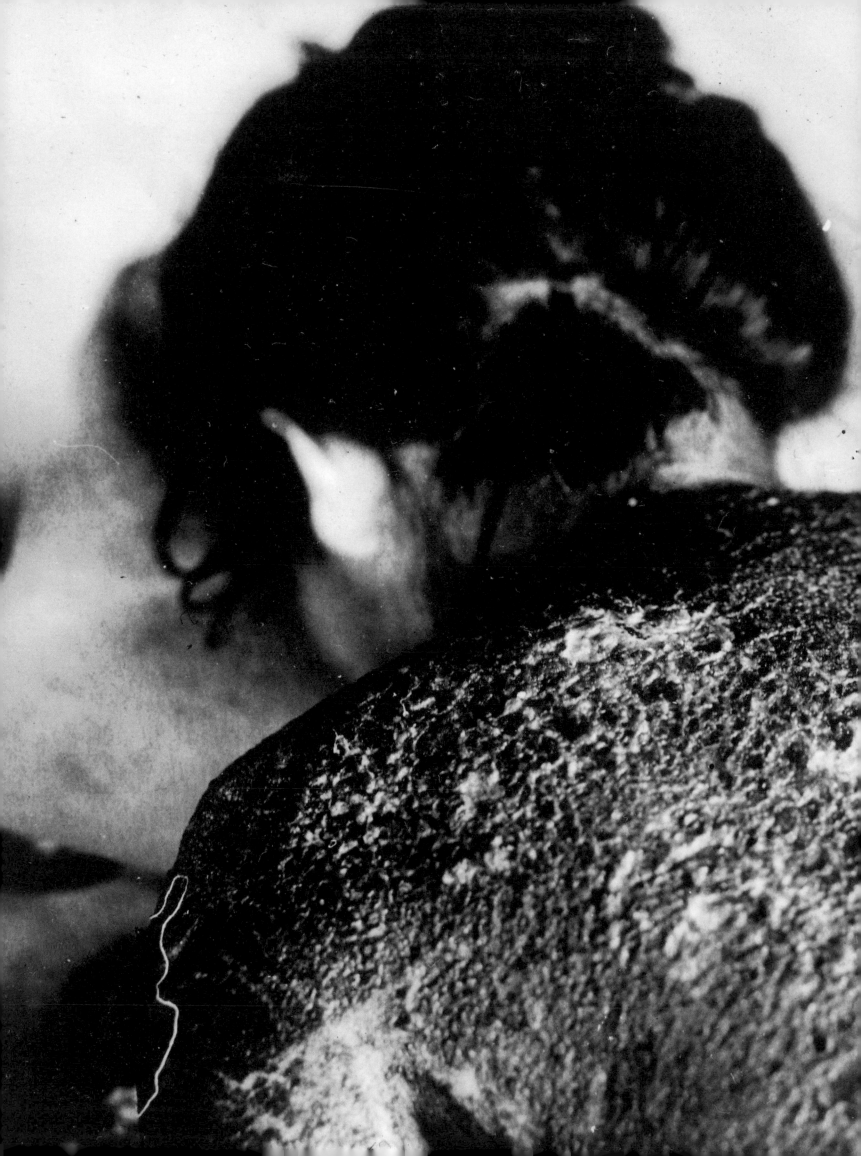

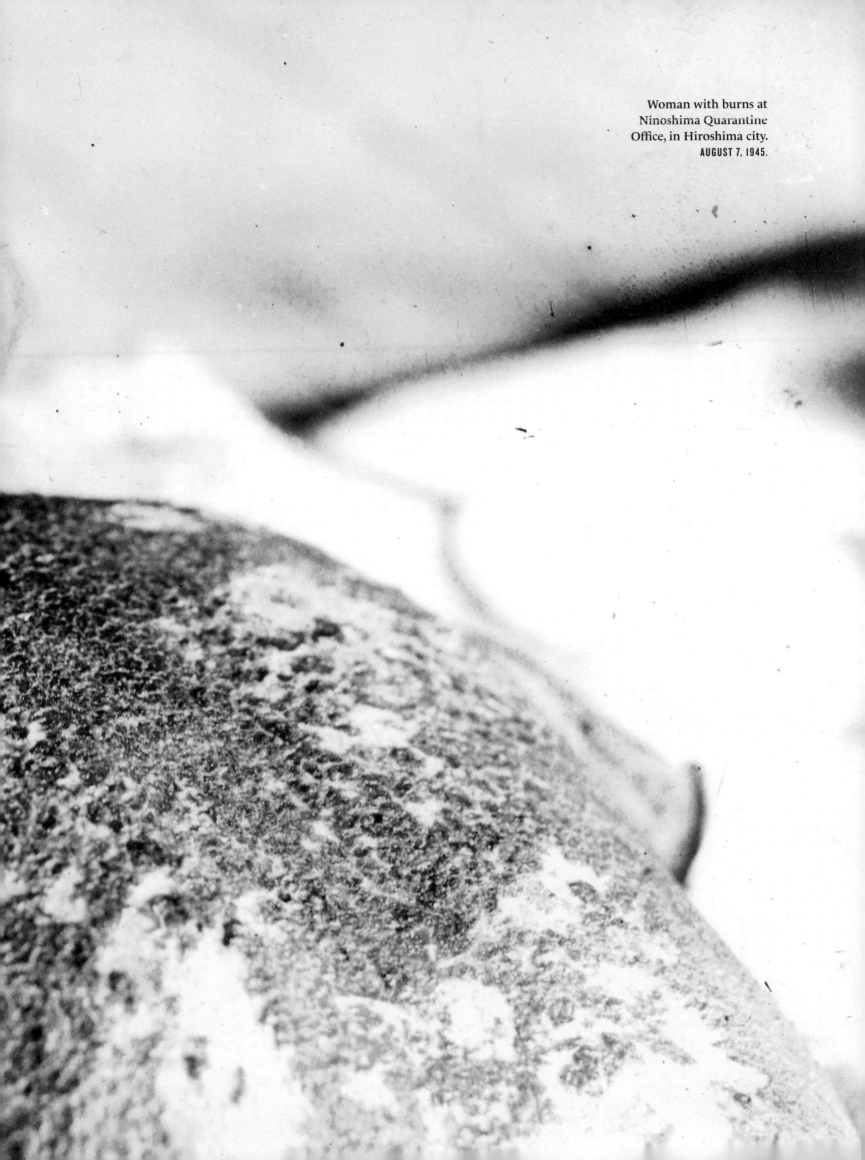

Woman with burns at
Ninoshima Quarantine
Office, in Hiroshima city.
AUGUST 7, 1945.

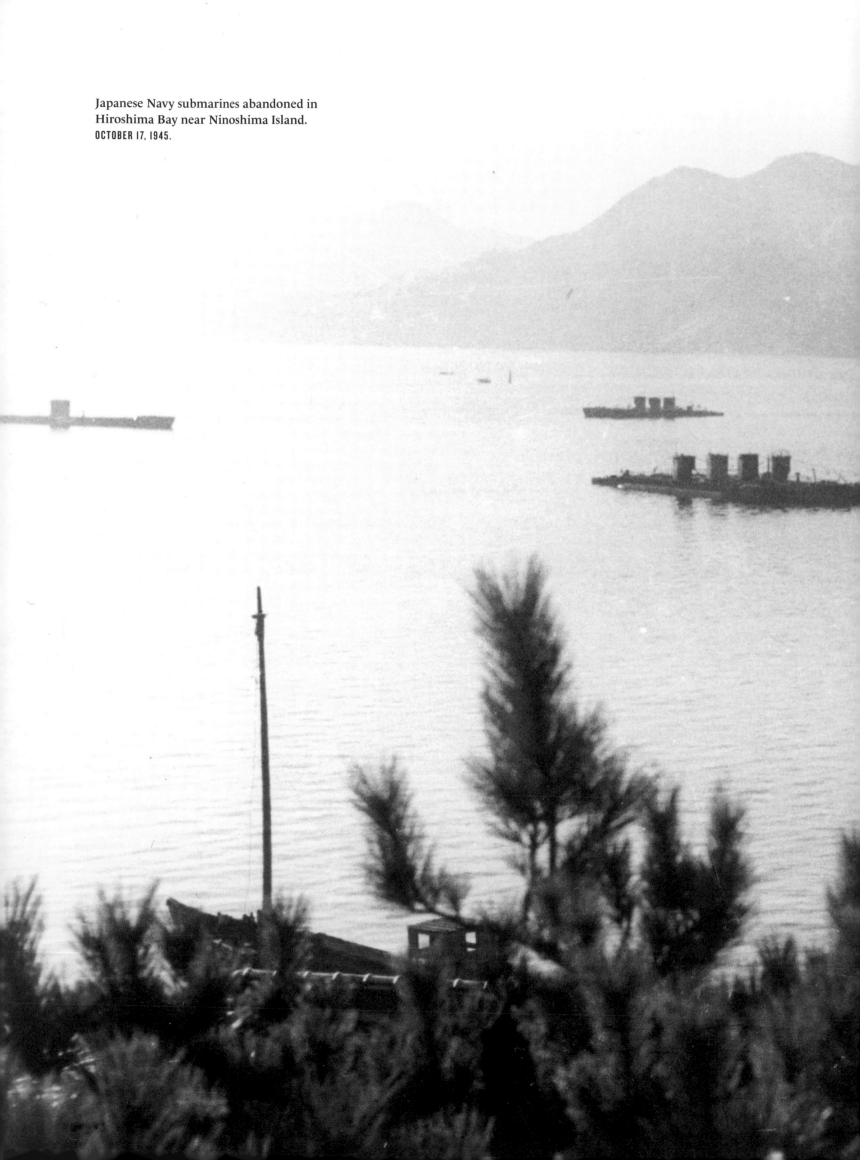

Japanese Navy submarines abandoned in
Hiroshima Bay near Ninoshima Island.
OCTOBER 17, 1945.

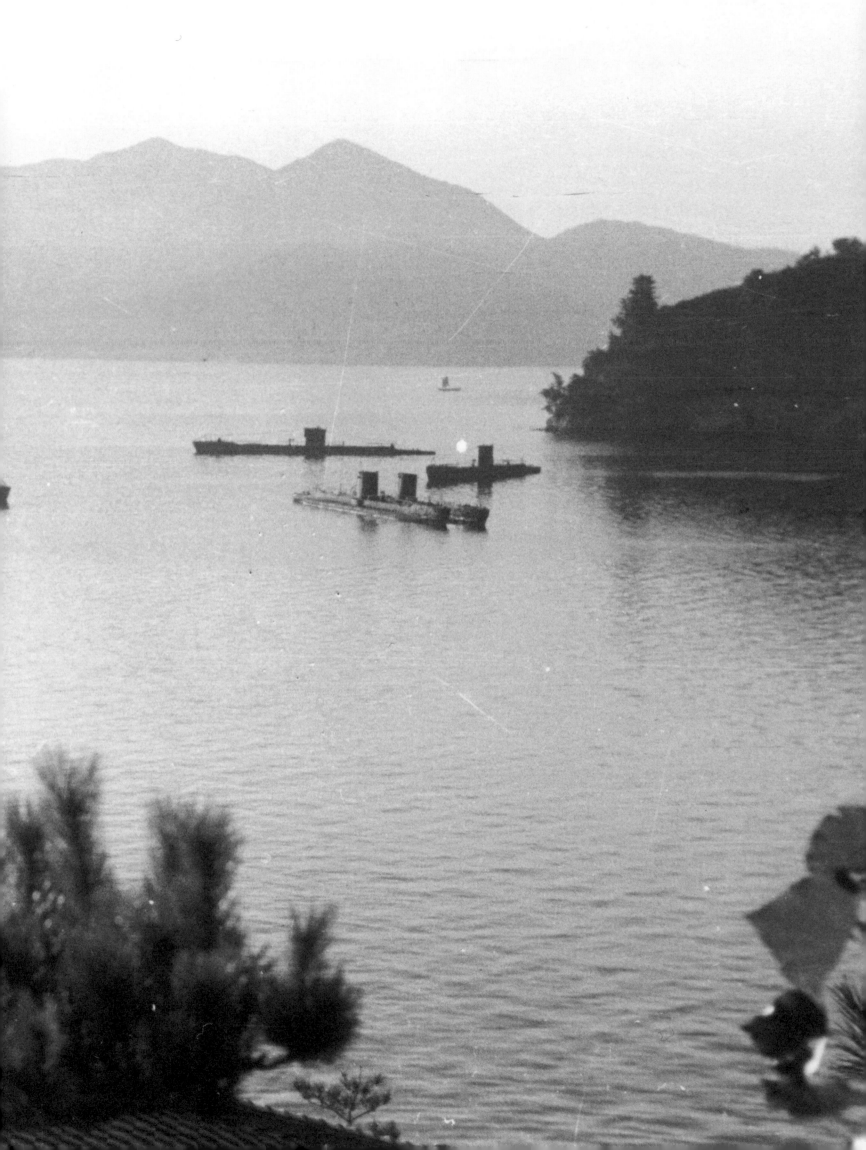

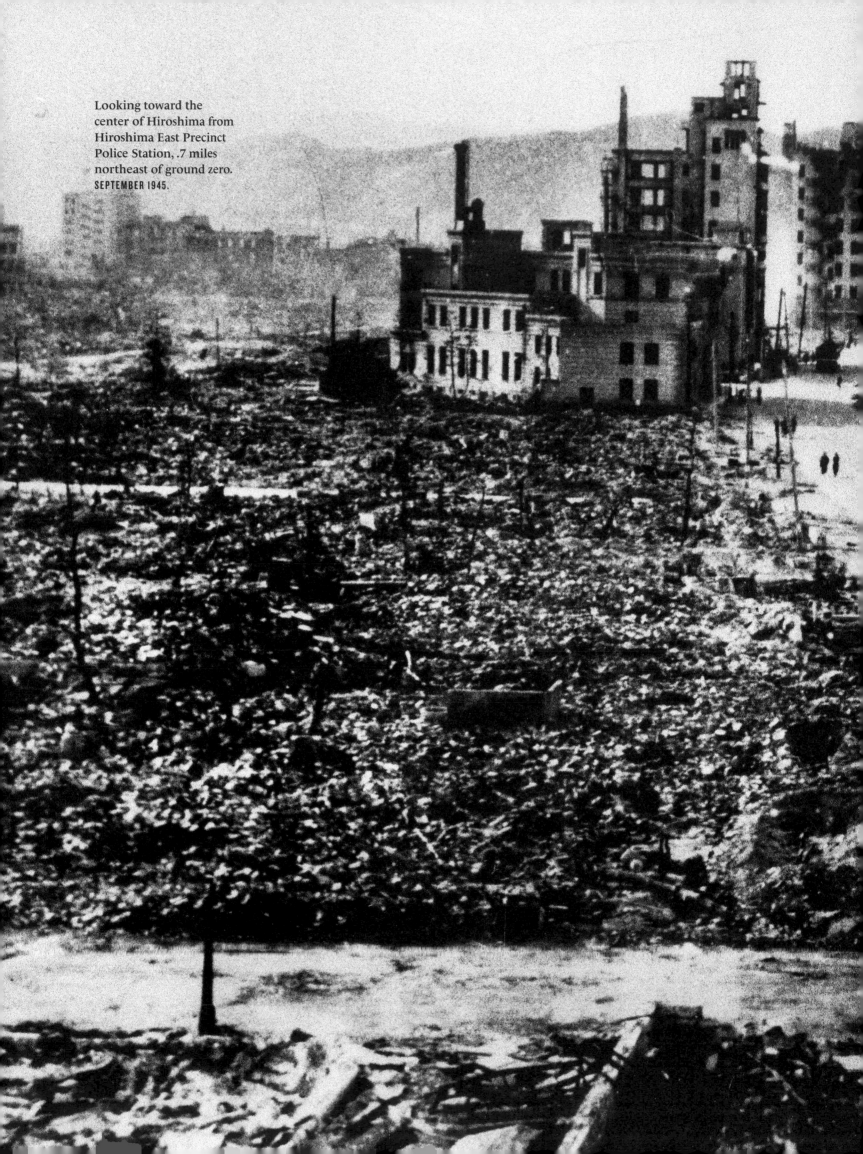

Looking toward the
center of Hiroshima from
Hiroshima East Precinct
Police Station, .7 miles
northeast of ground zero.
SEPTEMBER 1945.

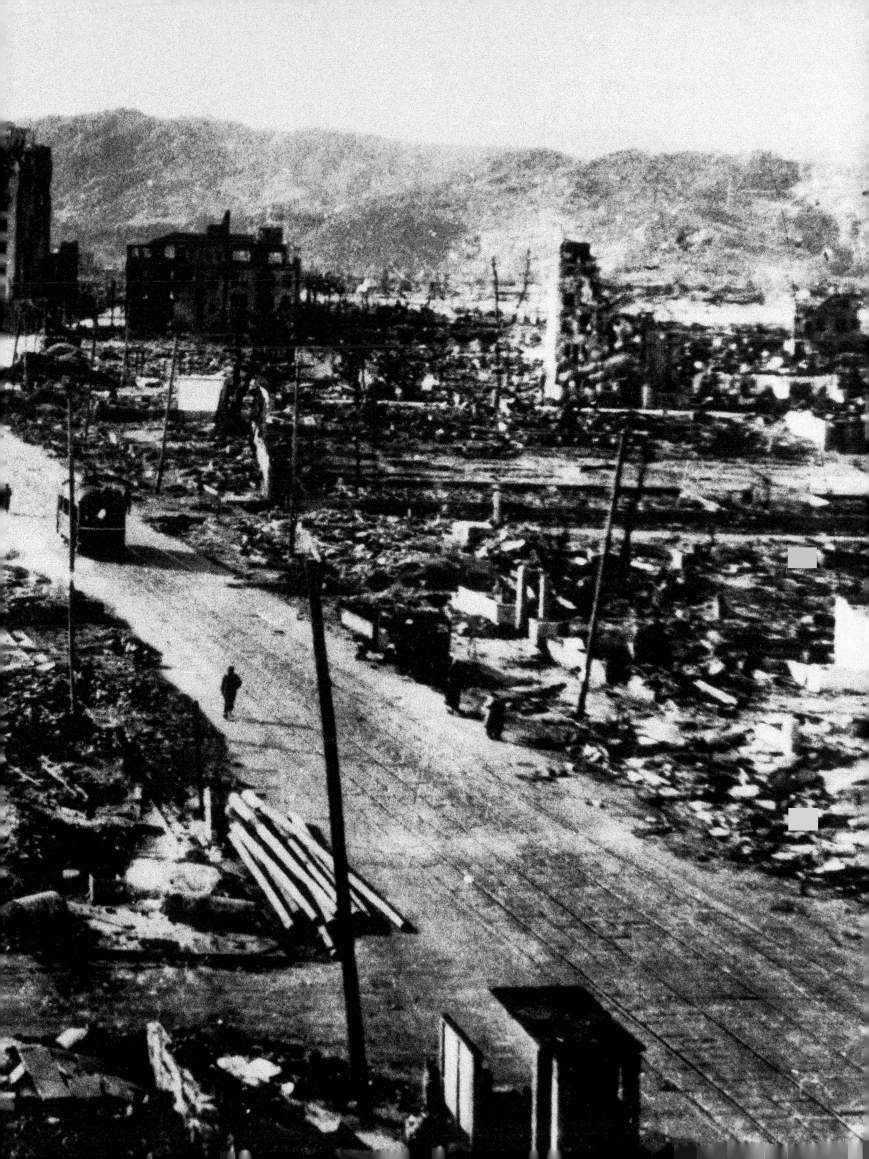

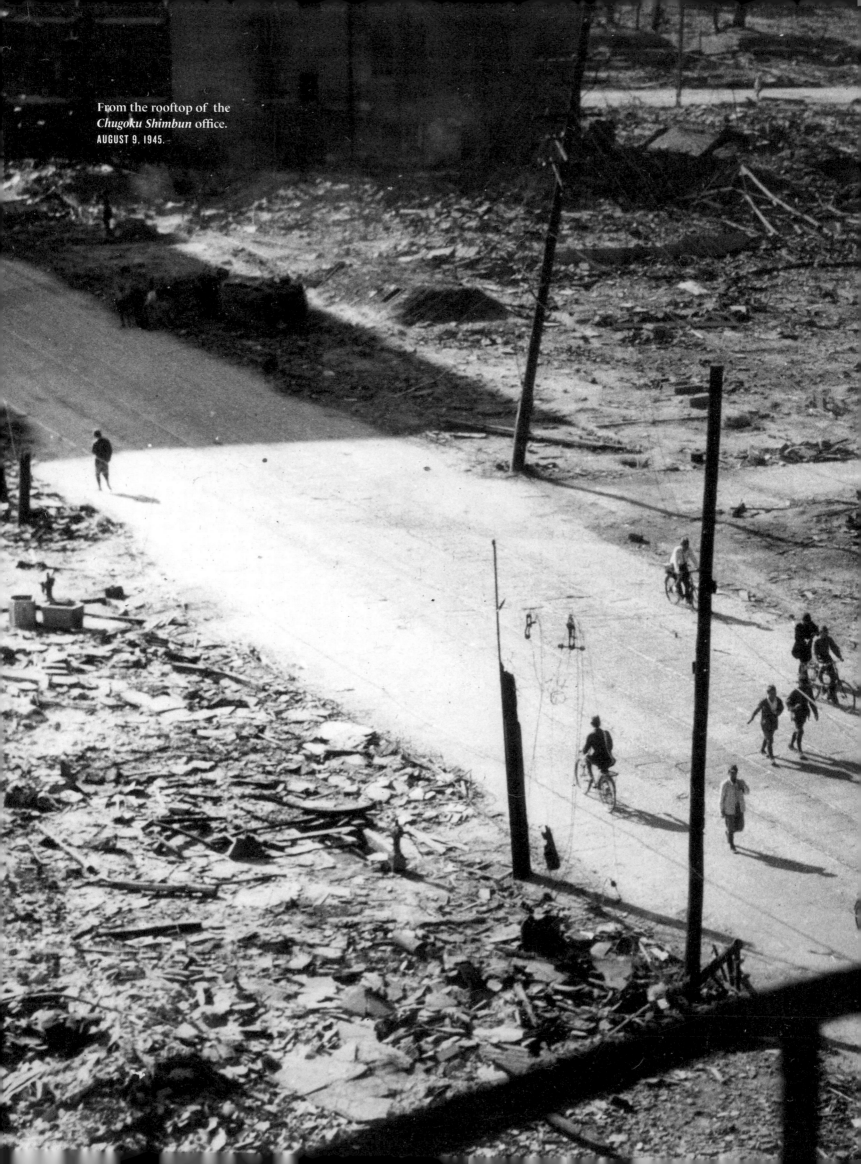

From the rooftop of the
Chugoku Shimbun office.
AUGUST 9, 1945.

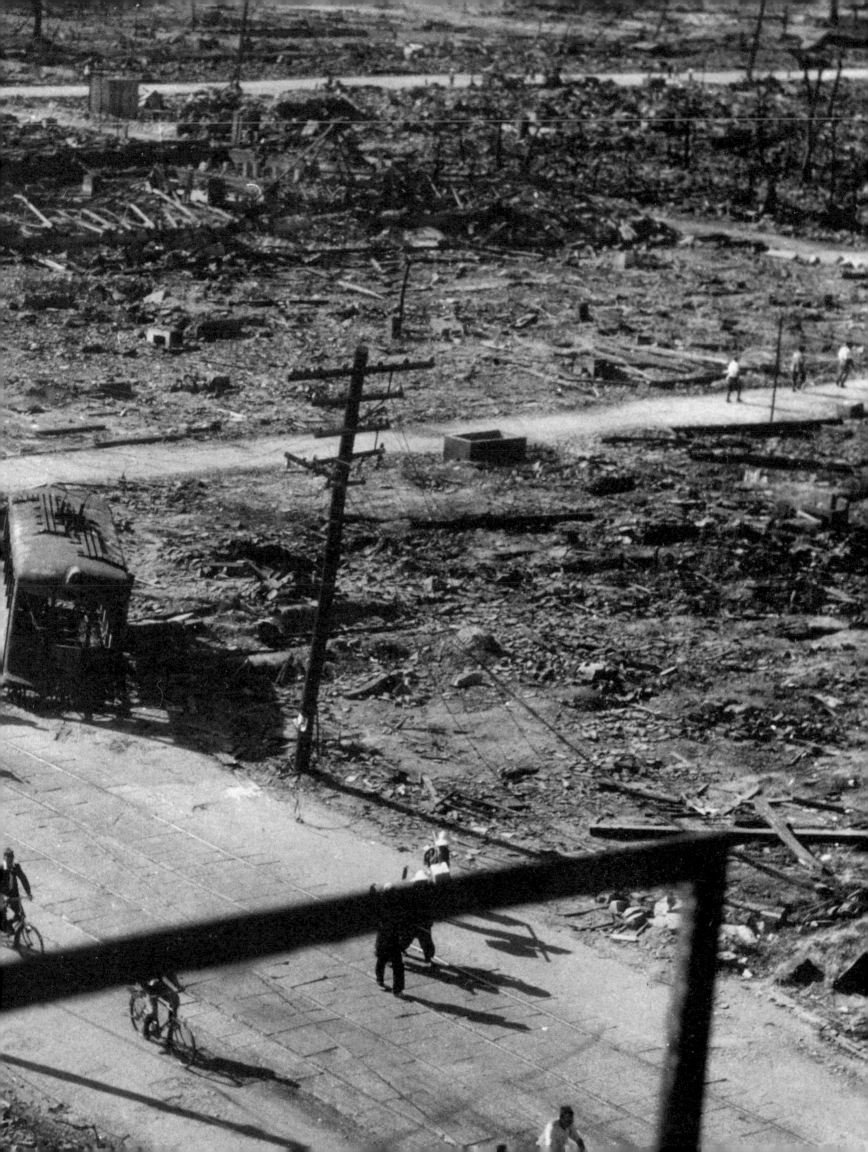

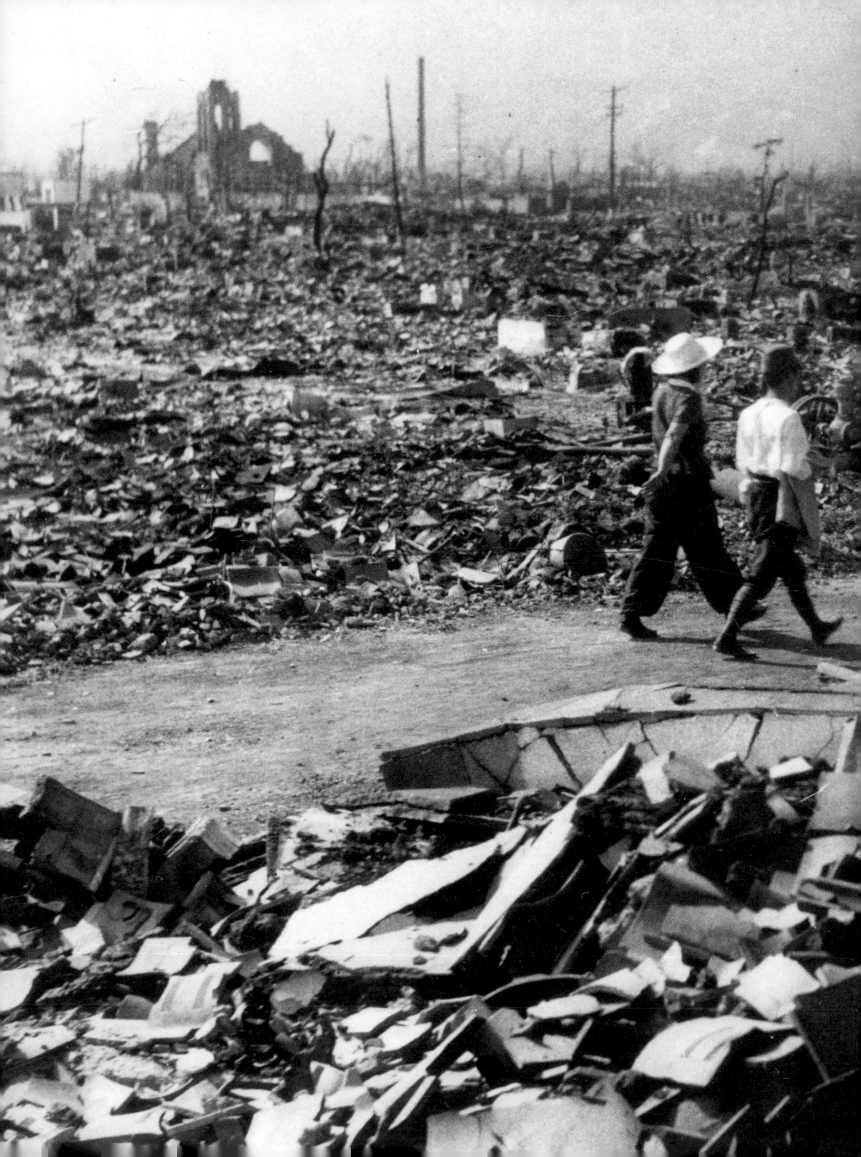

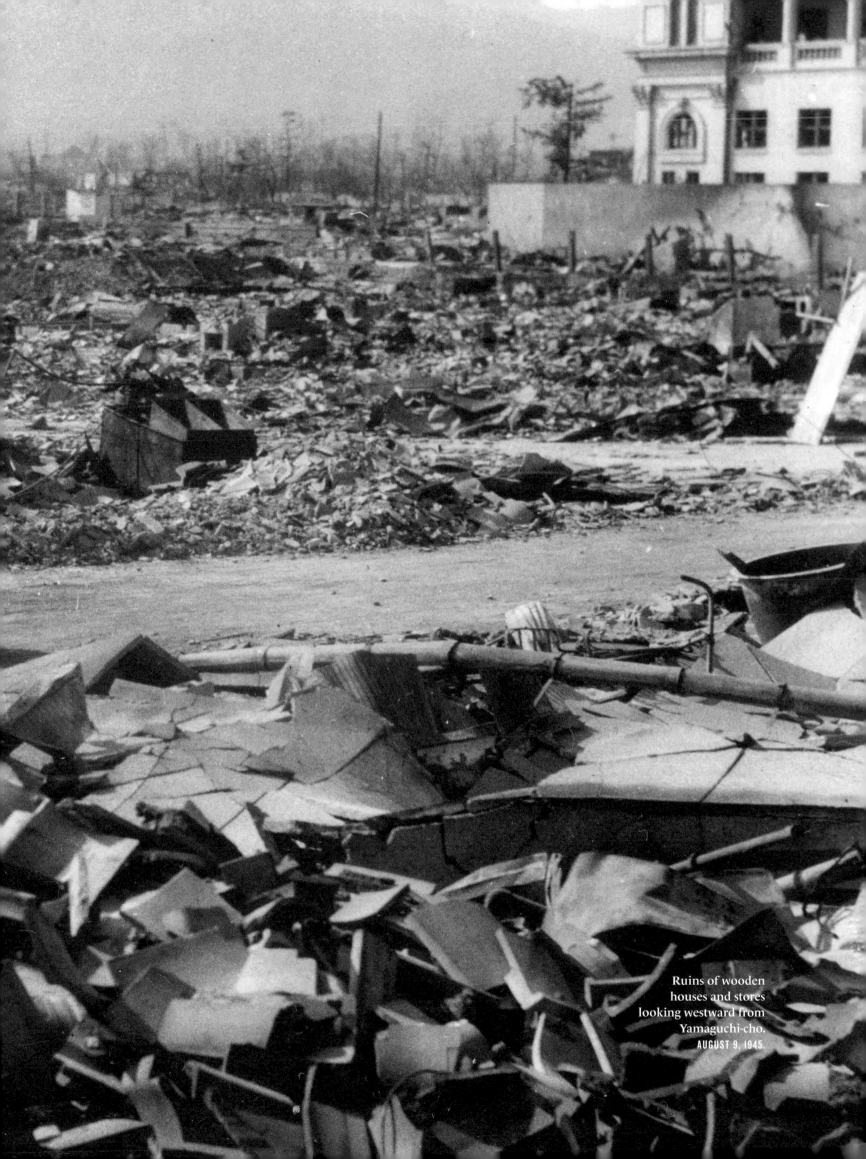

Ruins of wooden houses and stores looking westward from Yamaguchi-cho.
AUGUST 9, 1945.

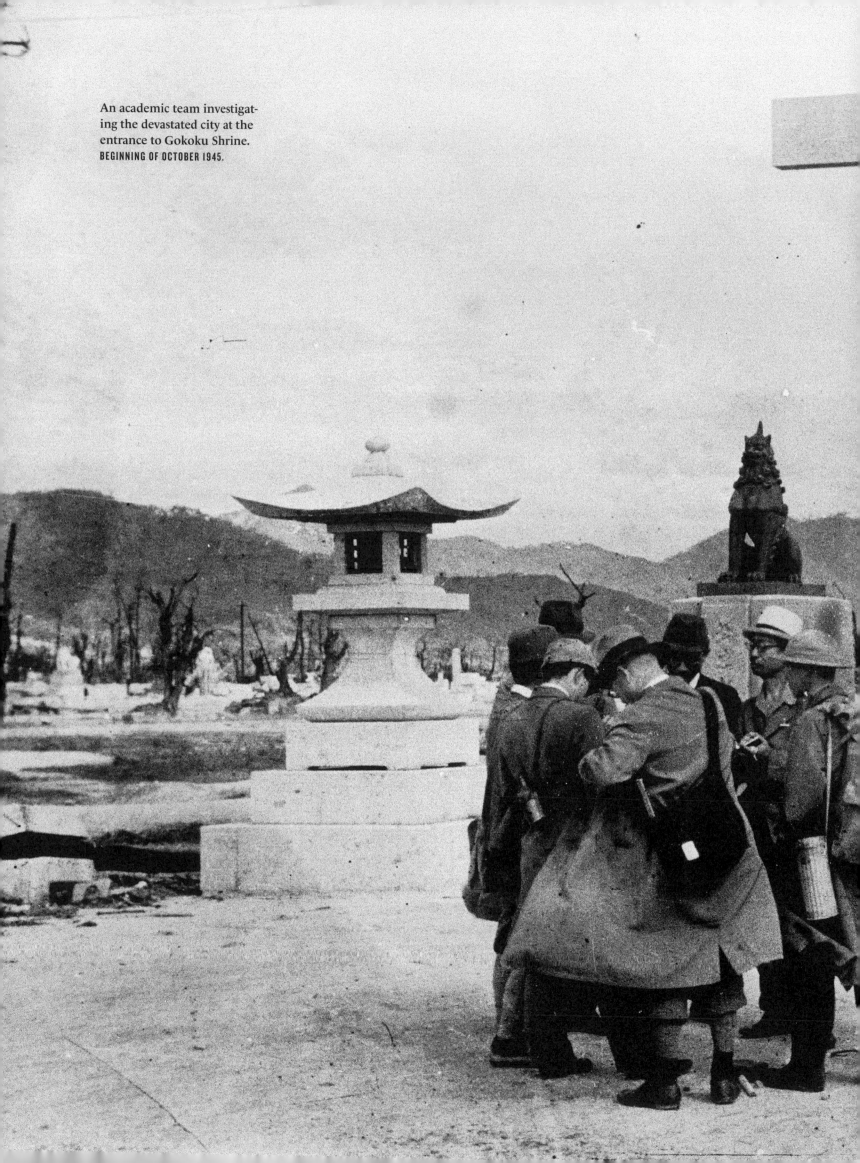

An academic team investigating the devastated city at the entrance to Gokoku Shrine.
BEGINNING OF OCTOBER 1945.

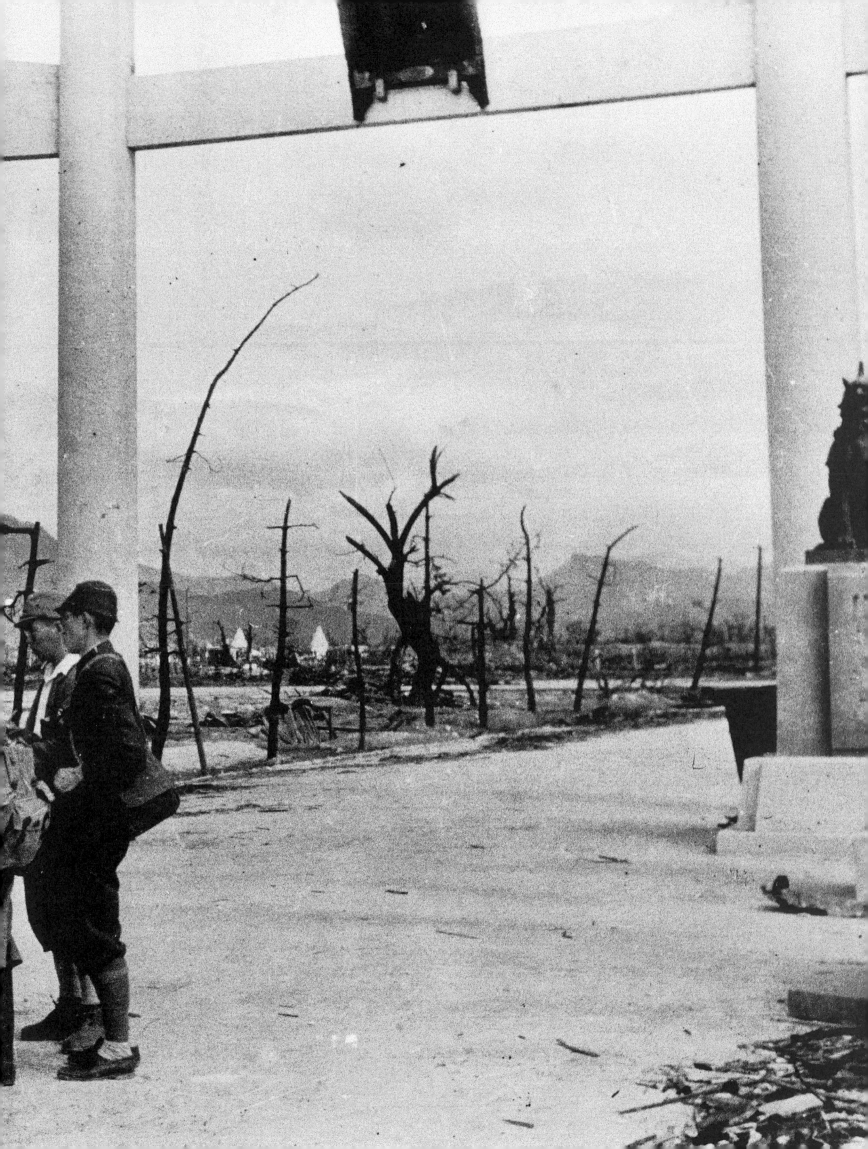

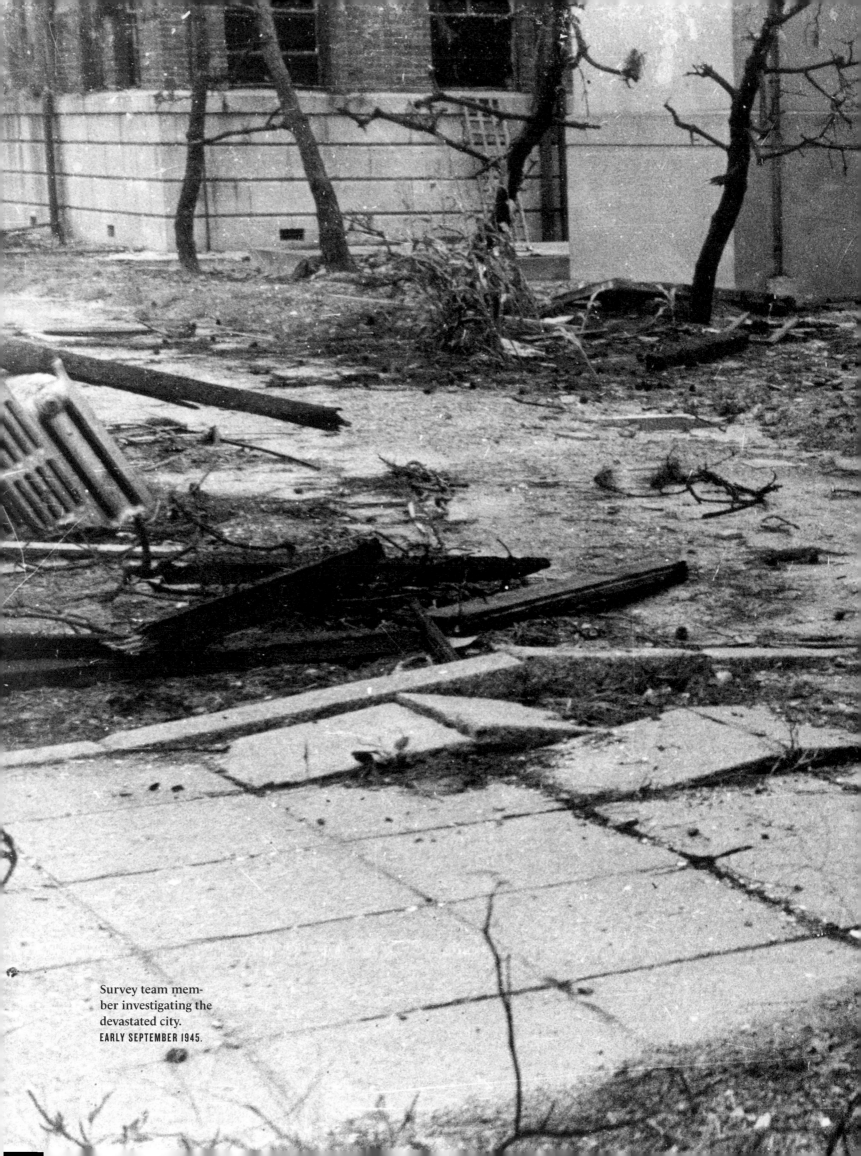

Survey team member investigating the devastated city.
EARLY SEPTEMBER 1945.

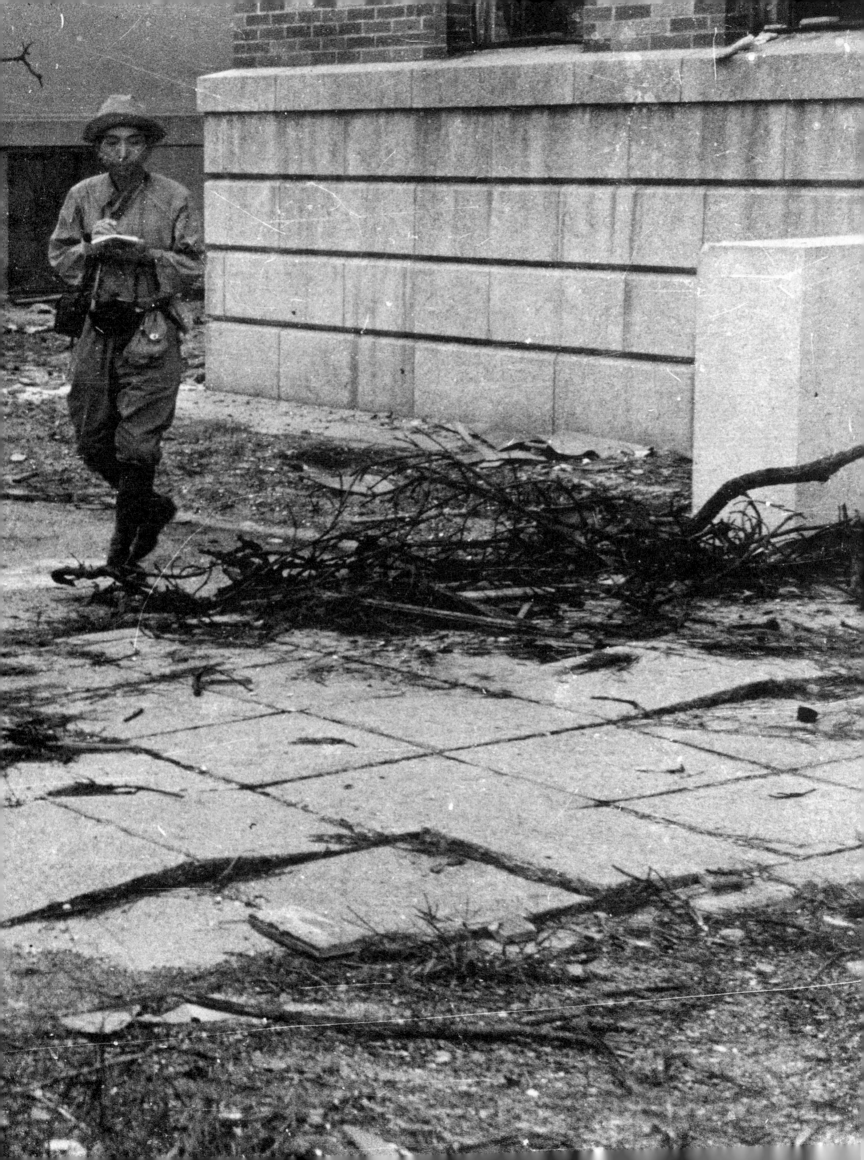

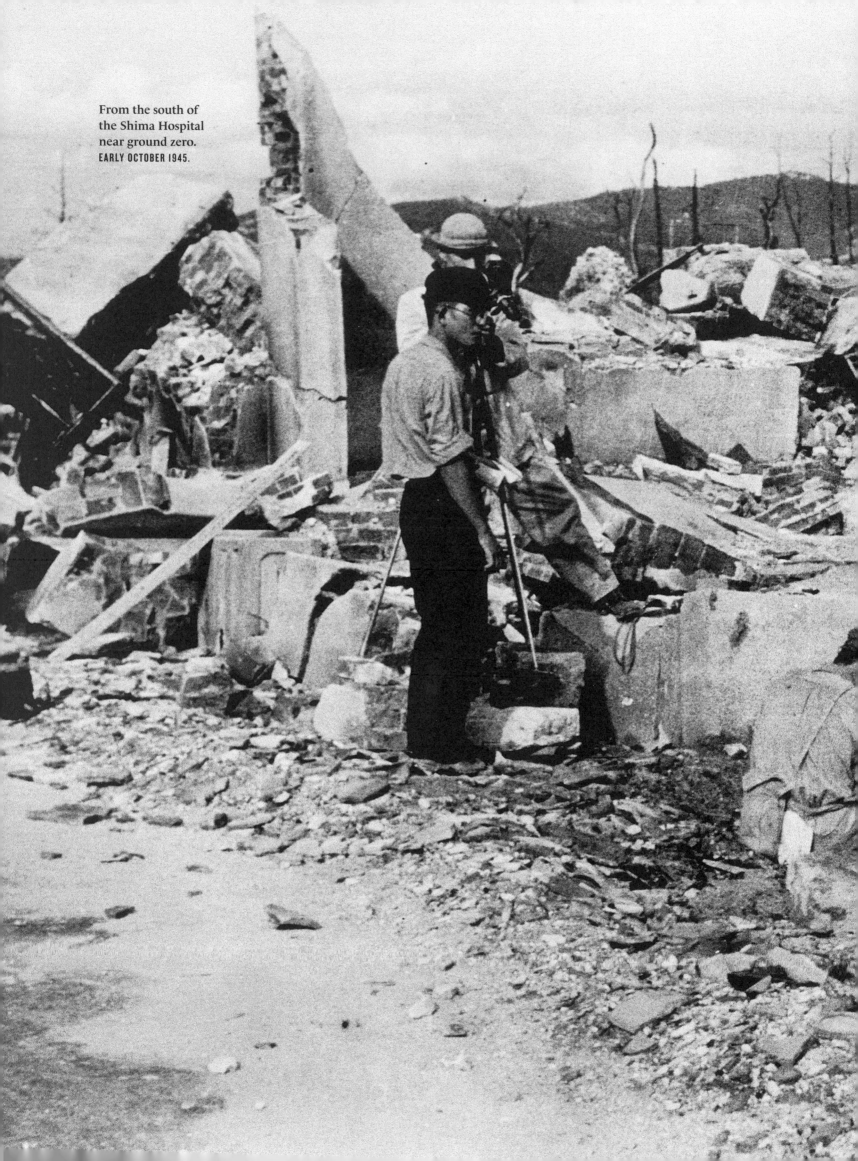

From the south of
the Shima Hospital
near ground zero.
EARLY OCTOBER 1945.

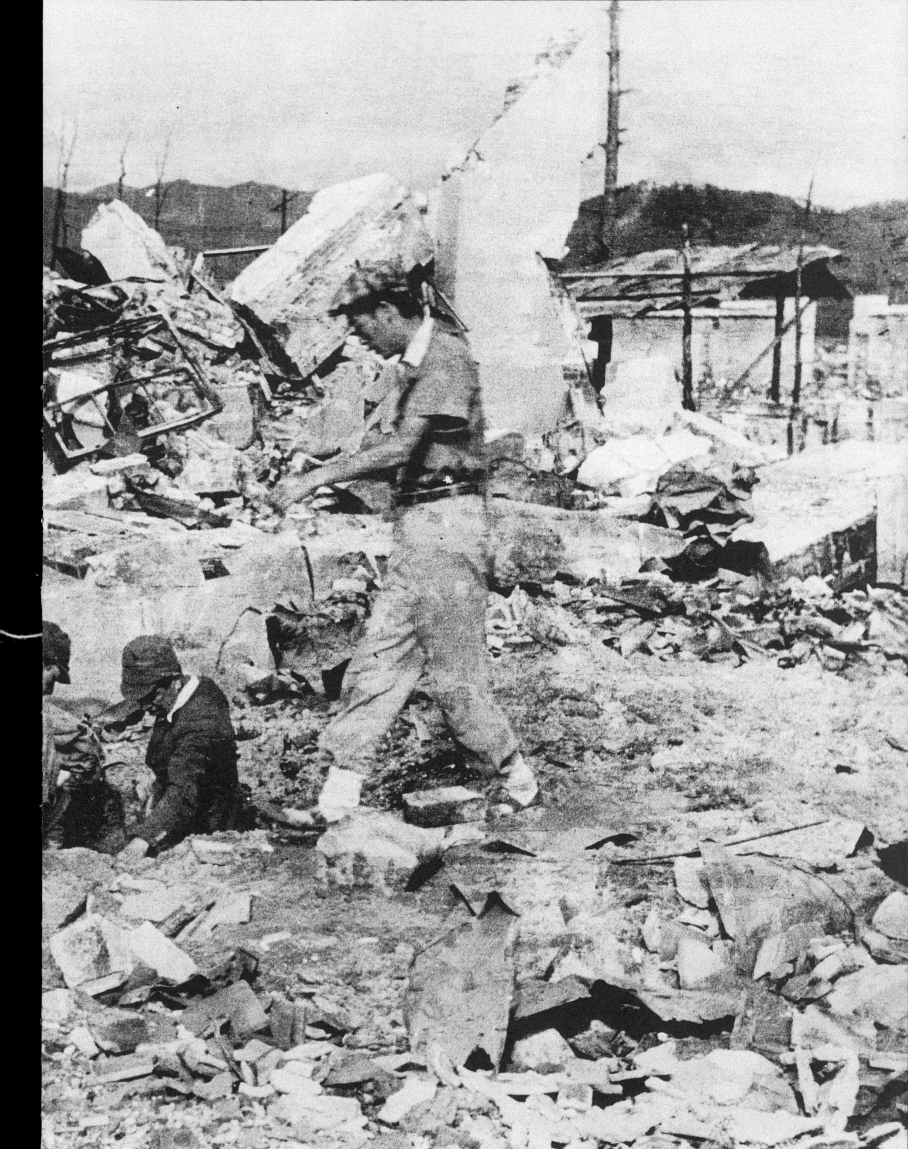

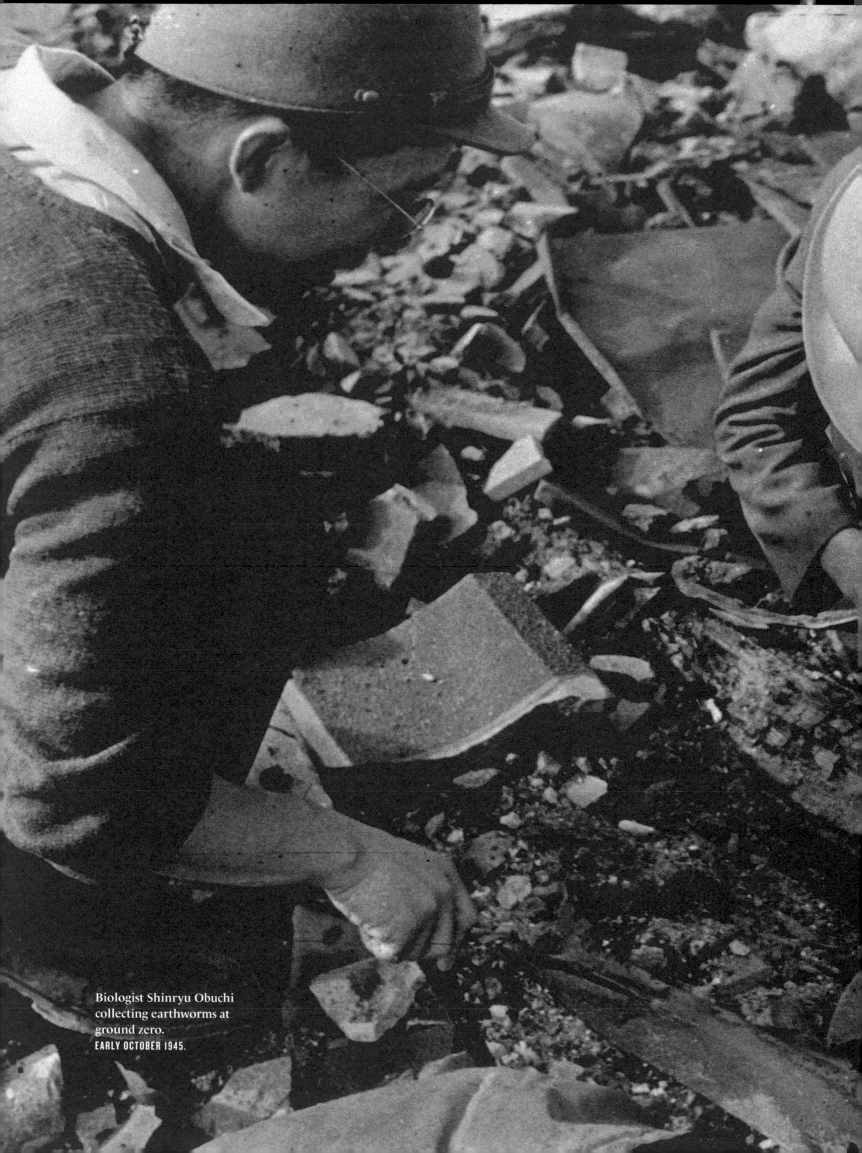

Biologist Shinryu Obuchi collecting earthworms at ground zero.
EARLY OCTOBER 1945.

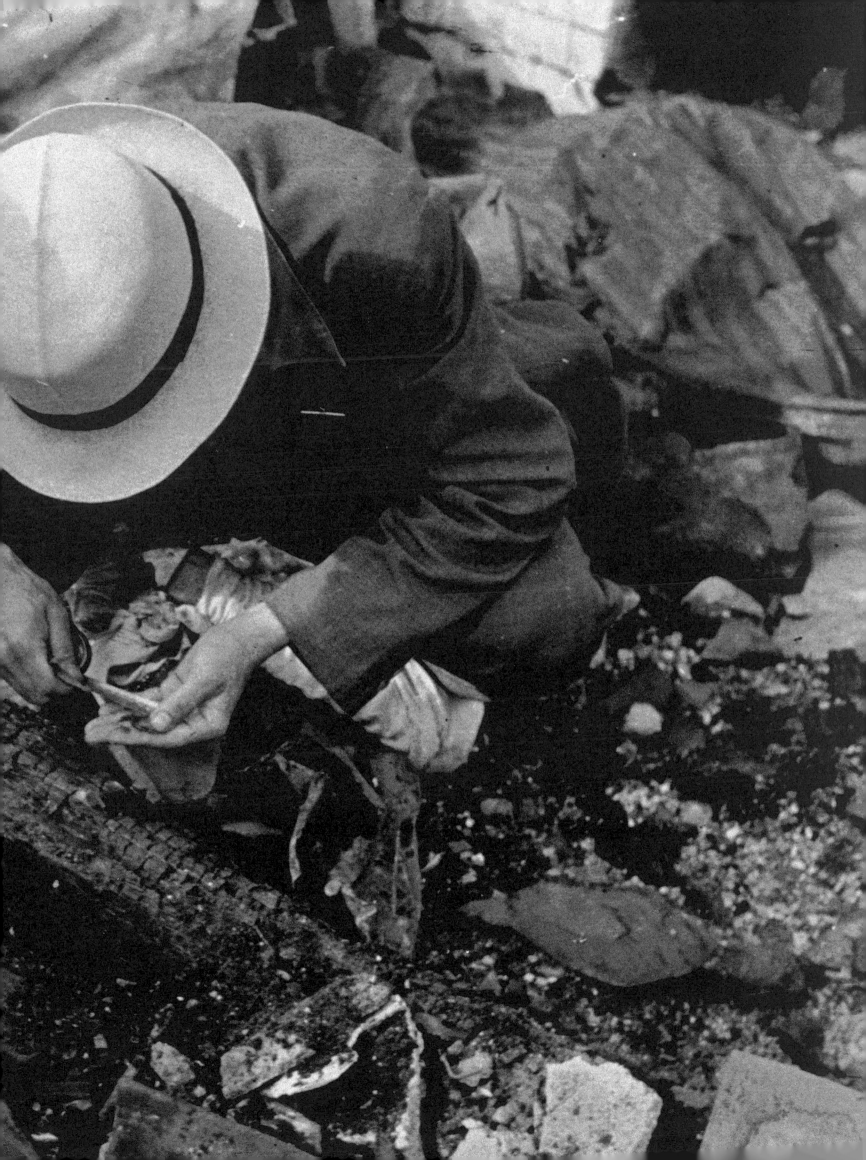

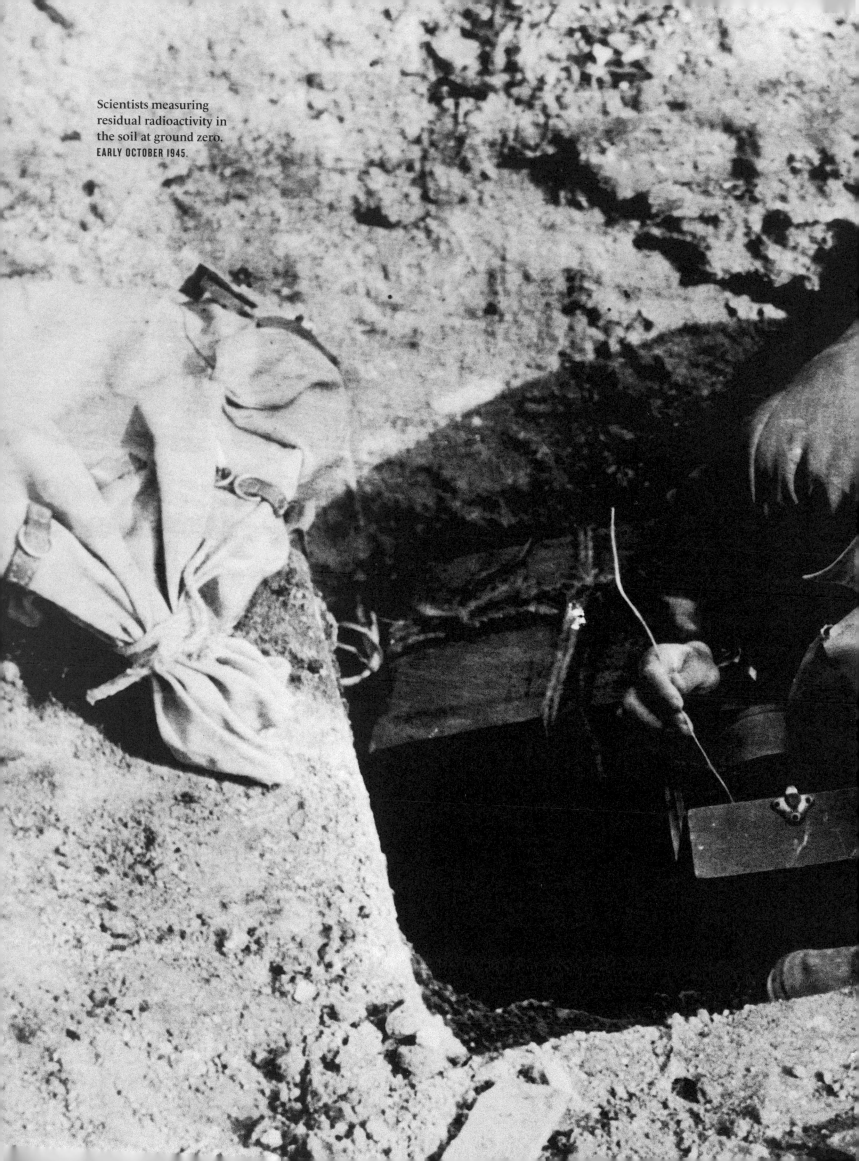

Scientists measuring
residual radioactivity in
the soil at ground zero.
EARLY OCTOBER 1945.

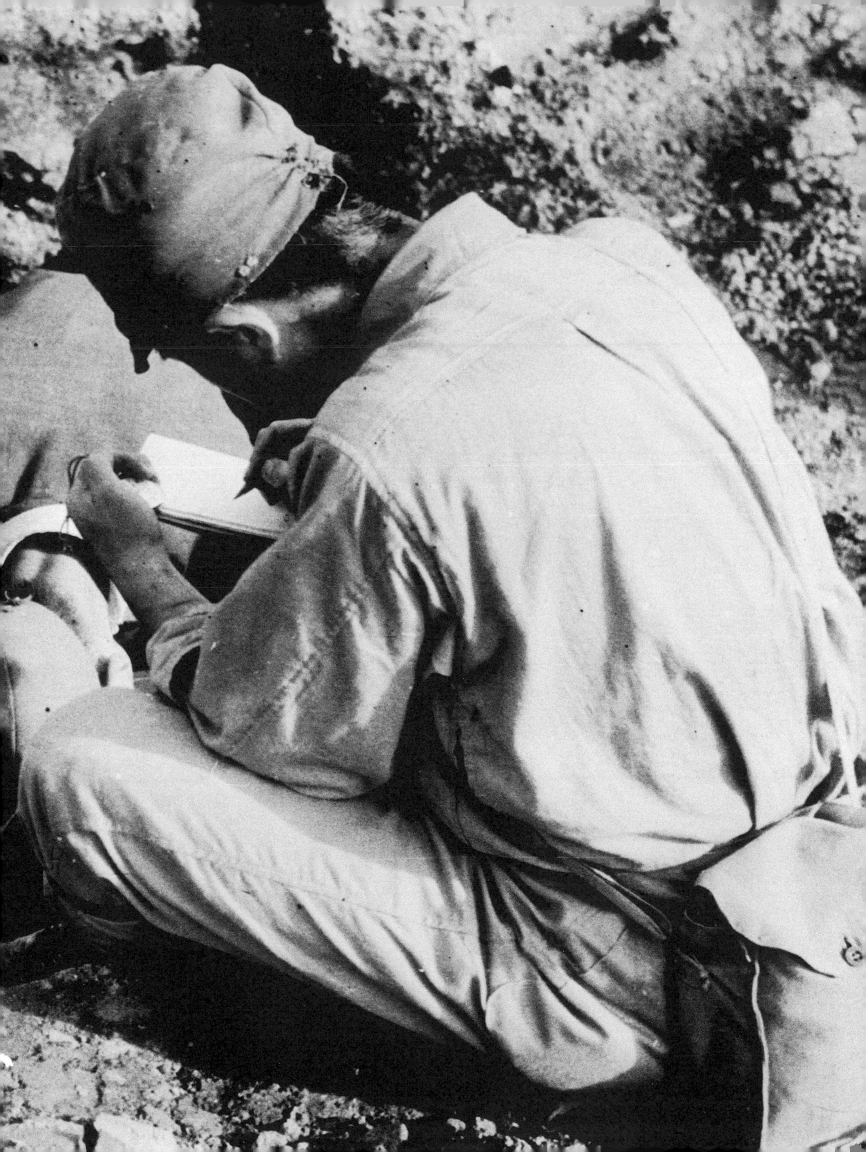

Scientist holding pants
contaminated by black rain.
EARLY OCTOBER 1945.

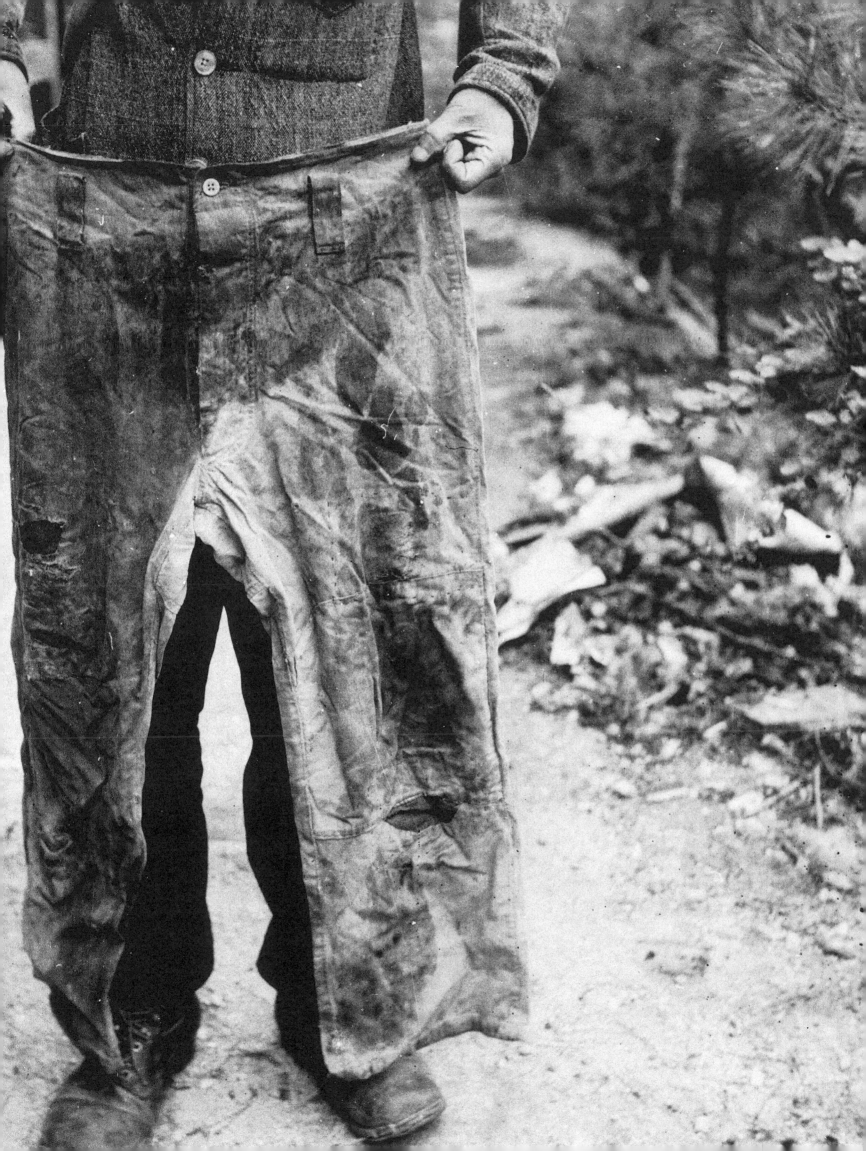

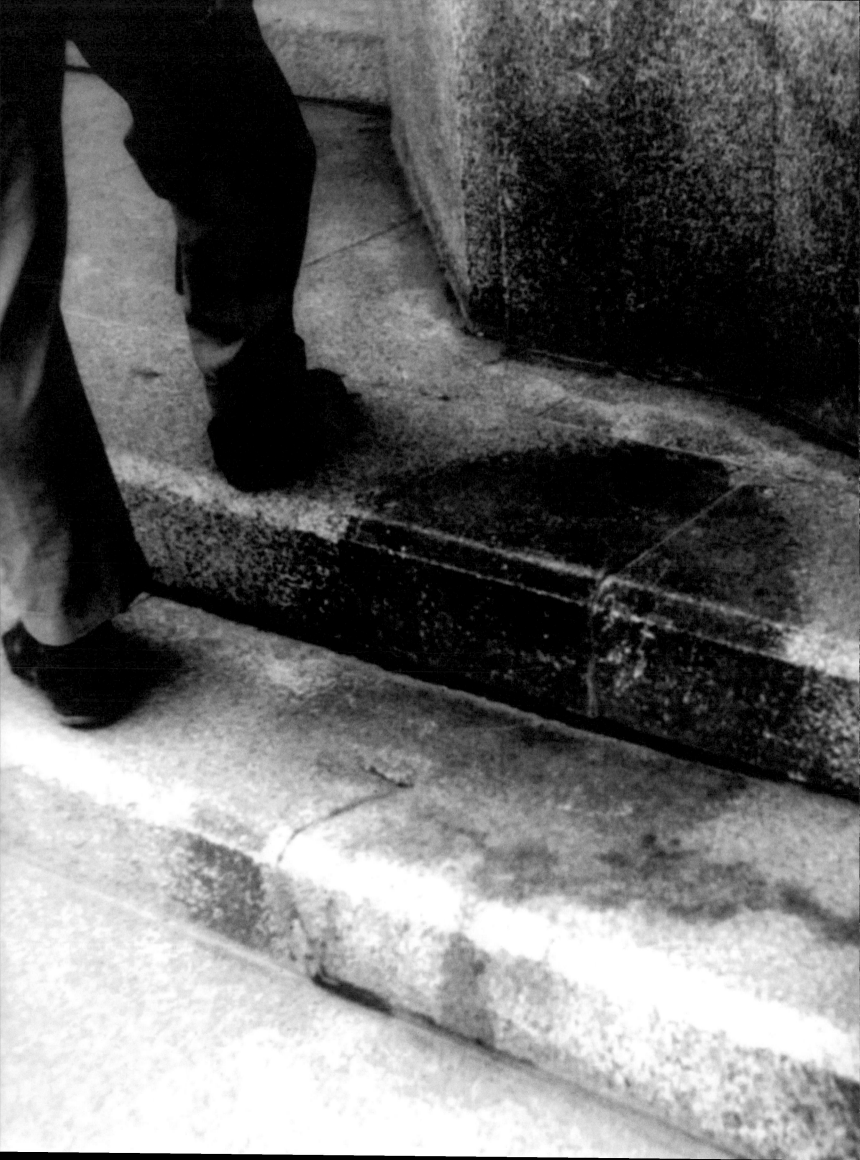

A shadow, resembling that
of a person, burned into
concrete stairs by the blast.
NOVEMBER 1945.

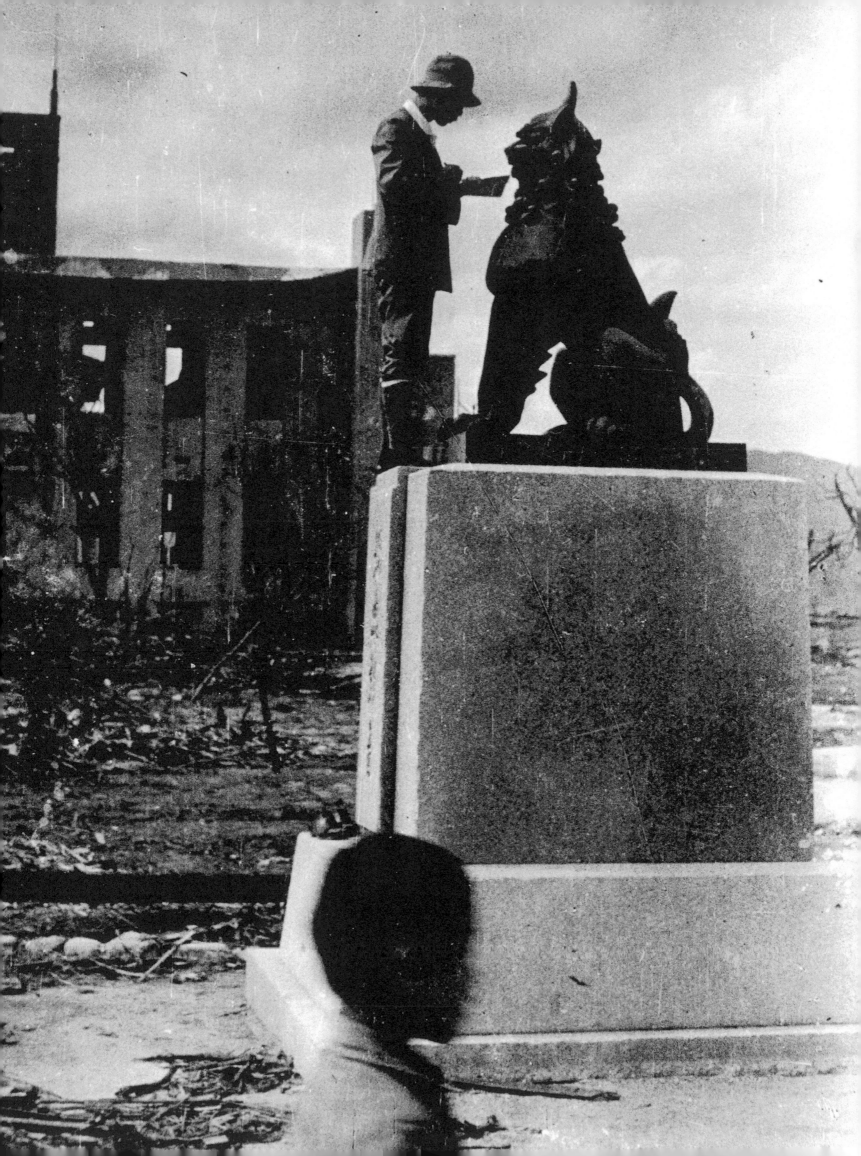

An investigator studying the
Komainu (stone-carved guard-
ian dog) that survived the blast
at Hiroshima's Gokoku Shrine.
MID-SEPTEMBER 1945.

"In this age of

nuclear weapons," wrote the Nobel Laureate Kenzaburō Ōe, "when their power gets more attention than the misery they cause, and when human events increasingly revolve around their production and proliferation, what must we Japanese try to remember? Or more pointedly, what must I myself remember and keep on remembering?"[1] Ōe wrote those words in 1965, on the twentieth anniversary of the atomic bombings of Hiroshima and Nagasaki. Five and a half decades later, on the seventy-fifth anniversary, his questions still beg for answers. *Flash of Light, Wall of Fire* offers one, for it constitutes a graphic, unforgettable record of the power and the misery the bombs caused.

The book contains some 119 images, all taken by Japanese photographers in the hours, days, months, and years following the bombings in early August 1945. They come from a collection of over 800 images recently acquired by the Dolph Briscoe Center in American History at the University of Texas at Austin. Many did not appear for years in Japan or the West, blocked from public view by the strict censorship imposed by the American occupation of Japan. While the National Archives in Washington, DC, has a rich trove of atomic-bomb photographs, most come from Americans working for the government. The pictures contained in this book constitute one of the few all-Japanese collections to appear outside of Japan. Some have rarely ever appeared in the West.

Here, we see postnuclear Hiroshima and Nagasaki, both their built environments and the people who inhabited them, through the lenses of the Japanese themselves. Yet each image captures only a moment in time, a slice of a much larger scene, reproduced through the manipulation of light and the chemistry of emulsions. The images alone do not tell us who took them or when they were taken or where or why. They reveal nothing about how they were intended to be used, and how, in fact, they have now been used. They disclose little about their subjects other than what we see on paper. Alone, they are pictures out of time and place even though they capture a specific time and place. This introduction is meant to open the camera eye to give readers a wider view of the contexts, historical and personal, within which these images were made and continue to be employed.

THE CITIES

Early in August 1945, the people of neither Hiroshima nor Nagasaki had any inkling of the atomic fate that awaited them or the terrible bond that would forever join them. Their histories had converged little over the centuries, but their similarities became more and more evident as Japan moved into the modern era. Both were prefectural capitals, industrial hubs, and important seaports that drew their sustenance from water, a special symbol of life for the Japanese.

Hiroshima lies on the western edge of the Chugoku region of Honshu, the largest of the Japanese islands. Literally translated, its name means "wide island" (*hiro* = wide, *shima* = island), perfect for a city built on a delta dissected by seven distributaries of the Ōta River. Hiroshima was the city of water and thus the city of life. With the magnificent Ujina Harbor, it became a center of military activity during the First Sino-Japanese War (1894–1895) and the place from which the Emperor Mejii conducted operations. As a sign of its rising prominence, Hiroshima was the first site of talks to end that war.[2]

By the beginning of August 1945, the city remained a center of industry, communications, and logistics as well as a key jumping-off point for soldiers fighting in Asia; it was also a port of reentry for their remains as the war drew to a close. It served as headquarters of the Second General Army, the Chugoku Regional Army, and the Army Marines. Their mission was to defend the southern islands in the Japanese archipelago. In all, their garrisons contained some 43,000 soldiers, hardly enough to qualify as a military target in a city of over 330,000.[3]

Water made Nagasaki a second city of life. It curled around a bottle-shaped bay and soon became known as the "Naples of Japan." It was the only city through which *gaijin*, or foreigners, could trade during Japan's 200 years of self-imposed isolation. The Japanese government's policy of *Sakoku*, or "closed country," lasted from the seventeenth to the nineteenth centuries. The Tokugawa shogunate created the policy to wall out Western culture and Jesuit missionaries but not the gold and goods of *gaijin*. Dutch and Chinese merchants continued to trade with Japan through the port, but only the Chinese could set foot on Japanese soil. Even then, they were confined to a small section of the city near the harbor. The Dutch were restricted to the artificial island of Dejima in Nagasaki Bay.[4]

Foreign influence imprinted itself nonetheless, with Asian and European traders carrying cultural baggage and making Nagasaki the most international city in Japan. Once the country opened its doors again in 1854, British, Russian, French, and Americans, along with the Chinese and Dutch, moved about the city and lived wherever they pleased. Nagasaki's Chinatown grew, and Roman Catholics, martyred and banned since the sixteenth century, came out of hiding to flourish once again.

THE HIROSHIMA-NAGASAKI PHOTOGRAPH COLLECTION

Professor Michael B. Stoff
UNIVERSITY OF TEXAS AT AUSTIN

The imposing Urakami Cathedral (also called the Immaculate Conception or St. Mary's Cathedral) had been completed only in 1925, brick by cherry-red brick. With its 12,000 congregants, it was the largest Catholic house of worship in all of Asia and the Pacific and a symbol of a resurgent Catholic community in Nagasaki. Its faithful numbered roughly 20,000 out of a population of approximately 270,000 in August 1945. By then, the giant Mitsubishi Shipyard and Machinery Works had already transformed the city into the world's third-largest builder of ships. It was these plants that produced the torpedoes used to attack Pearl Harbor.[5]

Since the attack on Pearl Harbor on December 7, 1941, the rhythms of both cities had slowed to a crawl. An Allied blockade of Japan's coastal waters virtually shut down their ports. Meanwhile, a shortage of power and supplies crippled factories. People still rose early and went to work, but they worried less and less about the B-29 Superfortresses, which flew overhead almost daily but never bothered to bomb them. The "B-29" as many Japanese called them, had reduced whole square miles of more than 60 Japanese cities to smoldering rubble. On the night of March 9–10 alone, nearly 300 sorties of the US Twentieth Air Force had destroyed 16 square miles of Tokyo and killed approximately 80,000 to 100,000 Japanese. More than 1 million were left homeless. It was not the first time noncombatant civilians had died in a bombing raid. The Japanese, Germans, and British employed similar techniques with similarly deadly results from the mid-1930s to the end of the war.[6]

Along with two other targeted cities, Hiroshima and Nagasaki had purposefully been spared to heighten the shock when the atomic bombs finally came.[7] Free from the massive firebombing raids, residents of both cities dreamed of glorious victories crowned by the *Ketsu-Go Sakusen*, the final decisive battle that would bring an end to a seemingly endless war. Since its invasion of Manchuria in 1931, Japan had been fighting on and off for nearly fourteen years. Despite the steady stream of propaganda touting the successes of the Imperial Army and Navy, the last two years had been ruinous. A stalemate in Asia and defeats in the Pacific were bringing the *gaijin* closer to home every day. The Allied blockade continued to choke commerce in a nation that relied on shipping to conduct its business and feed its people. Beginning in March 1945 and for the next five months, the Allied "Operation Starvation" dropped 12,000 aerial mines on Japanese coastal waters and rivers. Traffic came to a near-standstill, and production fell by two-thirds from the previous year. Fruits and vegetables were hard to find, fish harder still, and meat all but impossible. The rations for rice, a staple of the Japanese diet, fell to a paltry two cups per person per month. By early August, the malnourished Japanese were living on a meager diet of under 1,000 calories a day.[8]

Privations on a larger scale stripped the empire of two of its most precious resources: fuel oil and young men. With no indigenous reserves, Japan was forced to import its petroleum, but the Allied blockade had cut shipments from abroad. By the spring of 1945, the situation was so dire that the battleship *Yamato*, the largest in the fleet, had embarked on a suicide mission to Okinawa with only enough diesel oil for a one-way trip. The loss of over 2 million soldiers, their ashes sent home in tiny white boxes, had weakened the military on the battlefield and in the War Cabinet. In April 1945, Japanese diplomats began seeking peace. At the very least, they hoped negotiations would keep the sacred Shōwa Emperor on the Chrysanthemum Throne and enable them to avoid the unbearable burden of unconditional surrender.[9]

Whatever the hopes and dreams of their residents, both cities prepared for the worst. Battalions of schoolchildren marched out each morning to help create firebreaks by carrying away debris from buildings demolished by the authorities. The old and young formed bucket brigades and practiced dousing imaginary blazes, assuming that fire would create the greatest hazard if the city were bombed. Employees of large companies joined civilian defense workers and built shelters beneath factories, offices, government buildings, and schools. Ordinary citizens dug holes under the floors of their homes. Evacuation routes and shelters multiplied as Allied attacks intensified in the spring and summer of 1945, but in Hiroshima and Nagasaki, air-raid sirens sounded so often, and with such little consequence, that people began to ignore them.[10]

TSUTOMU YAMAGUCHI AND THE *PIKA-DON*

On August 6, 1945, Hiroshima awoke to clear skies and warm temperatures. The rainy season was over at last, but heat and humidity hung in the air like a damp shroud. In contrast to most residents, Tsutomu Yamaguchi began his day looking forward to leaving the city. He was finishing up a three-month stint designing single-piloted submarines for the Mitsubishi Company, headquartered in his home town of Nagasaki. The vessels were being used to break the Allied blockade by carrying cargo under it. Yamaguchi had designed similar craft for the Special Attack Forces but with a different purpose. Known as "human torpedoes," they were the undersea version of the deadly airborne *kamikazes*.[11]

Yamaguchi was scheduled to leave Hiroshima the next day, August 7. He missed his wife and child, and he missed Nagasaki. He was *jigemo*, a native-born citizen of the city, and had spent his whole life there. His family's roots were as international as the city and were mirrored in his father's blue eyes and Russian profile.[12] This morning, August 6, was his last day of work in Hiroshima. He and his colleagues set off from their company dormitory just before 8:00 a.m. Barely out the door, Yamaguchi realized he had forgotten something. When he returned from his room, his companions had left. He headed to the office on his own.

Yamaguchi was walking through a potato field with a woman he had only just met when the sound of a bomber caught his attention. A single B-29 was flying above him. Just beneath it, he could see a small object dropping from the belly of the plane. Whether it was the uranium bomb, nicknamed "Little Boy," or the instruments designed to measure its blast Yamaguchi could not have known. Seconds later, at precisely 8:15 and from a height of approximately 1,900 feet, a blinding light suddenly appeared in the sky, bathing everything in a bluish-white glow. Moments later, a tremendous roar ruptured Yamaguchi's left eardrum. *Pika-don*, "flash-boom," was what the Japanese who survived the nuclear explosion called it. For them, the mushroom cloud that seized the imagination of the West, symbolizing the sheer power of the weapon but devoid of its human impact, was too distant a phenomenon. Instead, *pika-don* captured the dazzling sight and thundering sound of the misery they experienced up close.[13]

A shock wave knocked Yamaguchi from his feet and deposited him in a muddy ditch. As he lost consciousness, he saw images of his wife and child as if they were projected on a movie screen. What he could not see, of course, was what was happening inside the flash. Within a millionth of a second, the temperature at the burst point jumped to several million degrees. The uranium core of the bomb was converted into ionized gas and gamma rays. After a tenth of a second, an isothermal sphere—a fireball—formed and reached almost 50 feet in diameter. Its temperature measured 540,000 degrees Fahrenheit. Five one-hundredths of a second later, the fireball expanded, growing to its maximum size of between 650 and 1,000 feet within less than a second. A shock wave radiated outward at the speed of sound. The air began to glow, and soon the hot inner core became visible for about ten seconds to anyone far enough away to see it and survive. At two-tenths of a second, the temperature at the core fell to 13,900 degrees, but the thermal heat generated by the explosion had already begun to sear the skin of the human beings who were not instantly vaporized. The pressure at the hypocenter directly below the explosion was 4.5 to 6.7 tons per square yard. Within 40 minutes, a sticky black rain began to fall, and with it, radioactive particles of dust and debris.[14]

By the time Yamaguchi awoke, the woman walking beside him had vanished. A giant mushroom cloud hung ominously overhead. Where a good portion of Hiroshima had once stood, only smoking wreckage remained. Steel structures, such as the dome of the Prefectural Industrial Promotion Hall, were skeletal shells of themselves, their windows blown out by the blast. Twisted girders and broken tiles littered the streets; blackened tree trunks, stripped of their leaves, dotted the horizon. Fires erupted everywhere. Within 30 minutes, a huge firestorm swept through 16 square miles of the city; it lasted for the next four hours.[15]

As Yamaguchi looked out on what was once a bustling Hiroshima, he barely recognized the place. The flatness of the cityscape now matched the flatness of the terrain. No natural barriers to the shock wave that had knocked him down existed. The blast had blown through the city with such force that it leveled almost everything in its path. The absence of many standing buildings struck observers as odd, especially those who had seen the firebombed cities of Europe. Even in badly damaged Dresden, the outline of church steeples and skyscrapers remained visible after the worst firestorms. Not so in Hiroshima, which looked as if a preternatural force had simply crushed a large portion of the city.[16]

More than crushing force, a nuclear explosion has transformative power. It works like an alchemist, manipulating the essence of matter to produce something new. Deep inside, at the atomic level, it transforms matter into energy, but it also transforms the world around it. Sand fused into glass was but one byproduct found at the site after the test of the plutonium-based bomb in the New Mexico desert in mid-July 1945. Nearly a month later, an airborne version of that same bomb razed Nagasaki's Urakami Valley and turned it into an "atomic wasteland."[17]

In Hiroshima, the alchemy of heat, blast, and radiation from its uranium-based bomb transformed human beings. Some people simply disappeared, atomized by the explosion and scattered like cosmic dust; others became carbon shadows of themselves baked into sidewalks, buildings, and bridges; still others were reduced to piles of smoking flesh. Their organs simply boiled away. Charred, shriveled corpses (in the bombed-out cities of Germany, they were called *Bombenbrandschrumpfleichen*, or "incendiary-bomb-shrunken bodies") lay all about. Even those far enough away to have lived through the initial blast could die from the burns they received. An invisible killer struck down others. Weeks or months later,

healthy people might suddenly break out in tiny red spots, find their hair falling out, begin vomiting and bleeding from their gums, and suffer from high fevers. They were experiencing radiation sickness, the result of transformations at the cellular level that could kill, maim, and produce cancers of the thyroid, blood, and other parts of the body, sometimes years later.[18]

Survival, at least in the immediate aftermath of the bombing, literally depended on where you stood—inside a concrete-reinforced building or outside; behind a wall or in the open; at the hypocenter near the aiming point of the Aioi Bridge or on the outskirts of the city. The closer to ground zero and the more exposed you were, the more horribly you were likely to die, but the less likely you were to be aware of it. For those vaporized near the hypocenter, the end came so quickly that their nerve endings vanished before they had time to register pain. The *Bombenbrandschrumpfleichen* could be found farther out, and farther still, dazed survivors wandered about in various states of affliction, some with skin that seemed to be melting from their bodies, or eyeballs oozing from their sockets, or limbs missing altogether. Many of those who escaped physical harm suffered from another malady, what the Japanese called *muyu-byousha*. The term signifies someone wandering about in an unconscious state of mind without any sense of direction or purpose. It is a kind of a "psychic numbing" that often revealed itself in the blank stares of survivors.[19]

When the final, imperfect count was taken, it was found that nearly 90 percent of the city's structures had been damaged or destroyed. Of the roughly 350,000 people actually present when the bomb detonated, between 80,000 and 126,000 of them had died by the end of 1945.[20] Survivors carried physical scars, often in the form of keloids from thermal burns, but also emotional ones of guilt, depression, and suicidal impulses. For decades, their fellow citizens shunned them as *hibakusha*, or "bomb-affected persons," for fear they bore a mutated genetic legacy. Some Japanese worried that radiation sickness itself was contagious.[21]

Yamaguchi was one of the lucky ones. His left ear had gone deaf, and the right side of his face and body sustained painful burns, but he escaped death by blast, fire, and rain. He was alive and determined to return to his family in Nagasaki. What remained of the city was still in flames and strewn with bodies. Survivors begged for life-giving water: "*Mizu, mizu*!" There was nothing Yamaguchi could do. A day later, on August 7, he made his way to the railroad station in hopes of catching a refugee train bound for Nagasaki. The trek of 2 or 3 miles took him through a land of the dead. The closer he got to the station, the more bodies he saw. When he reached one of the

many rivers that ran through the city, he saw corpses covering the water. They were bobbing together, he thought, like a *ningen ikada*, a "human raft." Gingerly, he tried to walk across them, only to find himself sinking into the river. With no bridges left, he located another crossing and a path to the railroad station.[22]

Yamaguchi arrived in Nagasaki on August 8, just as he had originally planned. He spent the night with his family and returned to the Mitsubishi plant in the morning to report what had happened to Hiroshima. His coworkers and boss could not believe that a single bomb had destroyed so much of the city. Nor could he convince them that it might happen in their own city until, minutes later, it did. At 11:02, at a height of 1,640 feet, a second atomic bomb, this one nicknamed "Fat Man," detonated, and Yamaguchi's luck ran out. Moments later, a sign in the sky confirmed his misfortune. Another mushroom cloud appeared overhead, his second in three days. He could not escape feeling that it had chased him from Hiroshima, as if to mock the futility of flight.[23]

A meteorological twist of fate condemned Nagasaki, a secondary target, when clouds covered the primary target at the Kokura Arsenal some 130 miles to the north. And just as a force of nature—the weather—doomed Nagasaki, the natural topography of the city—with hills and valleys—helped save it from the ruin Hiroshima had endured from a less powerful weapon. While the Hiroshima bomb exploded with a force equal to 15 kilotons of TNT, the Nagasaki bomb measured 21 kilotons, making it 40 percent more powerful.[24]

Although fewer people died in Nagasaki than in Hiroshima, the destruction was still devastating and the loss of life terrible. The bomb exploded over Matsuyama in the riverfront portion of the industrial Urakami Valley. It missed its mark by nearly 2 miles, saving the commercial and residential neighborhoods from greater damage. Blunted by the hills, the force of the blast flattened an area 2 miles long and over half a mile wide.[25] Although Nagasaki did not suffer the firestorms that had consumed so much of Hiroshima, almost a quarter of its buildings went up in flames. Not quite half the structures suffered damage of some kind, most of it total. The blast wrecked over 40 percent of all the homes in the city, killed some 40,000 people that day, and injured another 60,000. By the end of 1945, an additional 30,000 to 40,000 could be added to the list of the dead.[26]

Yamaguchi rushed home to discover his wife and child still alive before collapsing himself. He was glad to find them, despite the fact that earlier he had thought of killing them with sleeping pills if Japan lost the war. The next day, he dragged himself out of bed and scoured the city for survivors. The sights were all too

familiar—the dead and dying everywhere; the Urakami Valley flattened and scorched; the Urakami River thick with floating bodies that formed the same *ningen ikada* he had encountered in Hiroshima—only this time, the human raft stretched all the way to the harbor. He returned to his family and spent the next few weeks recuperating from injuries and fever. When he failed to show up at the office after two weeks, Mitsubishi fired him, along with any other employee who could not make it to work within fourteen days of the bombing.[27]

THE PHOTOGRAPHERS

Yamaguchi was one of over 160 people who miraculously survived both bombings. Even as these *nijū hibakusha* endured the unimaginable, photographs were already being snapped to chronicle the events. On the morning of August 6, 1945, seventeen-year-old Seiso Yamada was hiking with a friend in the Mikumari Gorge about 4 miles from the Aioi Bridge. He worked at the *Chugoku Shimbun*, a Hiroshima newspaper, and attended school at night, but he had taken the day off to enjoy the beautiful weather. He was not a professional photographer, but a sportswriter. At a little past 8:00 a.m., he spotted B-29s flying high above him. Like many residents of Hiroshima, he had seen the B29 before, but these planes behaved strangely. They banked sharply and suddenly released parachutes from their bellies. Before he could make sense of the sight, an "incredible flash" lighted the sky, "like magnesium flashing in front of my face," he later said. A "huge bang" followed, and he flattened himself on the ground, fearing that a bomb had exploded nearby. When he looked up again, "a blood red cloud began rising from the ground like the sun." He grabbed his Konica "Baby Pearl" camera and took what is likely the first photograph of the Hiroshima bomb's mushroom cloud.[28]

Approximately 1.6 miles from ground zero, Toshio Fukada, sixteen at the time, was working at the Army Weapons Supply Depot as a mobilized student. He had just returned to the depot after morning assembly when a bright light filled the building. The iron doors at the entry crumpled, and he was knocked off his feet. As he stood up, an orange glow drew him outside, where a giant cloud covered the sky. The government had banned ordinary civilians from photographing anything without permission, but like Yamada, Fukada had taken his own Baby Pearl with him that day. He rushed back inside to get it and returned to snap four pictures, the closest taken of the mushroom cloud rising from the city.[29]

In *Midori-cho*, some 1.6 miles from the hypocenter, Yoshito Matsushige had just finished his breakfast and was getting dressed for the day. He worked at the *Chugoku Shimbun*, the same newspaper where Yamada was employed. Unlike Yamada and Fukada, he was no amateur photographer but a professional photojournalist. Though he had documented the war at home, nothing prepared him for what he was about to experience. The first odd sign came from the wires in his home. Before he had even put on his shirt, they began to sparkle, as if struck by lightning. Suddenly, the room turned blindingly white, and then there was a blast powerful enough to breach the walls of his house. He felt as if "hundreds of needles were stabbing me all at once," probably the result of glass shards from his shattered windows hitting his bare chest. It took him forty minutes to get his bearings.

Matsushige pulled his camera and a set of clothes from beneath a pile of debris and headed toward the center of the city. At a police post near the Miyuki Bridge, he came upon a group of junior high school girls who had gathered outside to evacuate their buildings when the bomb struck. Fully exposed to the heat of the blast, they were covered with blisters "the size of balls" that were already bursting. Their skin hung "like rugs" from their bodies. He lifted his camera but couldn't take a picture of the pitiable sight. Twenty minutes passed before he summoned the will to press the shutter and capture the image. He moved closer and took a second shot, barely able to see through the tears that blurred his vision. All the while, he worried that his subjects might angrily condemn him for doing nothing to help them.

Some people were beyond help, as Mitsushige learned when he came upon a blackened streetcar. He peeked inside and saw fifteen or sixteen dead bodies piled on top of one another and stripped naked by the blast. He could not bring himself to photograph them. It wasn't the government's proscription against newspapers publishing pictures of the dead that stopped him. He simply refused to make their naked bodies the last depiction of their lives. The same reluctance took hold of him as he walked through the devastated central city, but he managed to snap a few photographs before giving up three hours later. Nearly three weeks passed before he was able to develop the photographs. Without proper equipment, he worked outside at night and rinsed the seven images in an irradiated stream. He hung the pictures from tree branches to dry; only five of them survived.[30]

Amateur and professional, these photographers produced the initial pictorial record of Hiroshima on the day of the bombing. In Nagasaki, nearly twenty-four hours passed before Yōsuke Yamahata arrived in the city in the early morning hours of August 10, 1945. He had just turned twenty-eight on August 6, and he was working on assignment for the Japanese News and Information Bureau. The bureau's name

belied its true purpose as a propaganda arm of the military. Yamahata had been sent to Nagasaki to provide the dramatic images the military hoped would rally the Japanese in the coming *Ketsu-Go Sakusen*. With an enemy capable of such savagery, could people do anything but fight to the bitter end? The writer Jun Higashi and the artist Eiji Yamada accompanied him to record in words and ink what he captured in photographs. Yamahata spent ten hours working his way from south to north through the city and snapped 119 images on the two cameras he carried.

Corpses still littered the streets, charred beyond recognition or covered with blood. Others were crushed beneath flattened buildings. A skull, flayed of its skin, was on the ground near a young woman who was still alive, searching forlornly for her family. Survivors roamed aimlessly through the city or simply collapsed from the ordeal. Like the survivors of Hiroshima, they cried out for water, but Yamahata did not have any. And like the observers of Hiroshima, he, too, was struck by the flatness of the cityscape, but he spent no time thinking about it. "I was completely calm and composed," he recalled years later. "Perhaps it was too much, too enormous to absorb." Only two things were on his mind that day: "the photographs I had to take and . . . how to avoid being killed if another New Style Bomb were to fall." He shot the physical ruination of the city but also its people, living and dead, and anything that struck him as "unusual." So much did, including the smashed roof tiles everywhere. "If this had been a regular bomb," he observed, "the tiles would not have been broken except in the area of the direct hit." "It was truly hell on earth," he concluded. When he returned to his base in Hakata that night, he felt nothing, except perhaps shame at having thought only of himself and his assignment and of having no feelings afterward. The trauma induced by what he saw left him numb, like the survivors whose pictures he had taken.[31]

In the coming days, months, and years, other photographers traveled to Hiroshima and Nagasaki. Shigeo Hayashi and Eiichi Matsumoto went to both cities but on different missions. Twenty-seven-year-old Hayashi landed in Hiroshima on October 1, 1945, as part of the Special Committee for the Investigation of A-Bomb Damages (SCIA) created by the Ministry of Education in mid-September. Composed of Japanese scientists, physicians, engineers, and photographers, it conducted in-depth surveys of the two cities in the months following the blasts. Hayashi had to keep his natural instinct to focus on "human faces and figures" in check. His job was to concentrate on the physical wreckage for the research team. It was not easy. Without water or much food, he found himself quickly exhausted and barely able to cover an area

6 miles from the hypocenter. After eleven days in Hiroshima, he moved on to Nagasaki, where he spent almost two weeks shooting pictures.

Still, the work was a vast improvement over what he had done during the war, when, like Yamahata, Hayashi had served in a military-affiliated organization that produced nothing but propaganda. In one of his previous montages, Japanese planes fly over India to show the reach of the empire—but it had never happened. "A photograph should never be manipulated and ought to be a sheer representation of a mental image of the photographer," he said later. "I was engaged in a mean and despicable type of work." At least this work had scientific value, even if it cut against Hayashi's inclination to shoot people instead of things.[32]

Unlike Hayashi, Eiichi Matsumoto worked for the *Asahi Shimbun* and was sent to the cities by its editors. For him, it was more than an assignment: it was his "destiny as a news photographer," he later declared. He arrived in Nagasaki on August 25 and stayed for almost three weeks before leaving for Hiroshima in mid-September. On his way from one city to the other, the Makurazaki typhoon struck, forcing him to abandon his train and make the rest of the journey by boat and on foot. Almost all of his photographs were of damaged buildings, in keeping with the requirements of his scientifically minded editor and the wartime and postwar prohibitions against showing human remains. A few pictures of survivors nevertheless found their way onto his film rolls. In each case, he made sure to avoid embarrassing his subjects. "I beg you to allow me to take pictures of your utmost sufferings," he remembered saying. "I am determined to let people in this world know without speaking a word what kind of apocalyptic tragedies you have been through."[33]

When Matsumoto first set foot in Nagasaki at the end of August, the putrid smell of the dead and dying was still wafting through the city. Decaying bodies lay on the ground, and he had to walk carefully to avoid stepping on them. Virtually every day, he could see bonfires at sunset and assumed they were set by survivors who were cooking meals outdoors. He was wrong, as he learned when he approached the areas in full sunlight. "I found quite a few numbers of human skulls and bones left everywhere," he recalled years later. It was then that he realized the fires were funeral pyres to dispose of the dead.

Another moment of clarity came in a follow-up interview with someone he had spoken to inside one of the Mitsubishi arms manufacturing plants. He returned two or three days later to find that the person had died, "severely bleeding from the gum and suffering from tremendously high fever." He recognized the symptoms: acute leukemia from exposure to radiation. "It was the

first moment I truly realized the deadly significance of the bombing," he confessed. It was what his camera could not capture that was now killing people. Hayashi put the photographers' dilemma this way: "Since the nuclear radiation cannot be made visible on photography, we were fighting a sort of winless struggle to find a way to visualize it."[34]

Over time, more than fifty Japanese photographers took thousands of pictures in the two cities. Some, like Yōsuke Yamahata, died young, in his case at the age of forty-eight from cancer of the duodenum. Others, like Hayahsi and Matsumoto, lived long lives without suffering from radiation-induced disease. All too quickly, however, they lost control of the photographs they had taken. The clamp of censorship imposed by the Allied occupation prevented most of their work from reaching public view for years.[35]

THE PHOTOGRAPHS

Almost as soon as the American occupiers arrived, the photographs—and the research done by Japanese scientists—came under American control. Within weeks of the official surrender of Japan on September 2, 1945, General Douglas MacArthur, Supreme Commander for the Allied Powers (SCAP), strictly limited all news reporting. Ostensibly, American authorities wanted to avoid anything that might inflame Japanese resentment. Perhaps as important, they were also concerned, as Secretary of War Henry Stimson told President Harry Truman during the firebombing campaign in the spring of 1945, that any depictions of human carnage might give the United States "the reputation for outdoing Hitler in atrocities."[36]

The restrictions soon included all coverage of the atomic bombs and the effects of radiation. Although Japanese authorities continued to collect data in Hiroshima and Nagasaki—sometimes on their own, sometimes in forced collaboration with their American occupiers—none of that material, including photographs and films, could be released to the public. Much of it was confiscated, though some of the photographers were able to hide their work. Matsumoto secreted his prints away in a locker at his newspaper office. Another photojournalist stuck his under his porch, where they remained for seven years. "We were not allowed to write about the atomic bomb during the Occupation," the Hiroshima poet Sadako Kurihara recalled. "We were not even allowed to say that we were not allowed to write about the atomic bomb."[37] SCAP enforced a near-blackout of news from the cities and permitted no reporters to enter them, except under the watchful eyes of official minders.[38]

Some of the photographs did make it out. When Yamahata returned to Tokyo in late August with his pictures in hand, his father encouraged him to publish them as soon as possible without the approval of the Japanese military. Within days, several of them appeared in four Japanese dailies: the *Asahi*, *Mainichi*, *Tokyo*, and *Yomiuri Shimbun*. Yamahata kept the rest. Years later, he reflected back on his decision not to turn over his film: "One blessing, among those unfortunate circumstances, is that the resulting photographs were never used by the Japanese army— then struggling to resist defeat—in one last misguided attempt to rouse popular support for the continuation of warfare."[39] On the black market, free from censorship, postcards of some of the Hiroshima-Nagasaki images were sold under titles such as "Terrible Sight." They sometimes still show up for purchase online.

Not until the end of the occupation in April 1952 did the photographs begin to reach a broader audience. On August 6, 1952, seven years to the day of the Hiroshima bombing, the Japanese magazine *Asahi Graph* released a special edition: "First Exposé of A-Bomb Damage." The issue sold out almost immediately, and the photographs of the destruction— human and material—left Japanese readers reeling. Four more printings rolled off the presses to meet the demand, eventually reaching sales of 700,000 copies. In September, *Life* magazine reprinted some of the photographs in a seven-page spread under the sensational headline "When the Atomic Bomb Struck— Uncensored." It was the first time American audiences saw the effects of the bombs from the ground, including ten of Yamahata's images.[40] That same year, he published almost all of his own photographs in *Atomized Nagasaki: The Bombing of Nagasaki—A Photographic Record*, to avoid losing control of his work. "Documentary photographs are especially vulnerable to manipulation, depending on how they are presented," he explained. "At first, people's motives in the antinuclear movement were good and seemed very pure, but after a certain point, I began to see varying degrees of bias."[41] More magazines and books followed over the next seventy years, along with exhibits and documentaries, which finally sent some of the most evocative and poignant pictures of these intrepid Japanese photographers beyond the borders of Japan.

The images in this book and the collection from which they are drawn represent another step in that direction. The collection comes to us from the Anti-Nuclear Photographers' Movement, founded in 1982 with the support of some 550 well-known Japanese photographers. Most had not shot scenes of Hiroshima or Nagasaki themselves, but all endorsed the mission of the movement to eliminate nuclear weapons and reduce arms. The images that appear in these pages are arranged in the form of a visual narrative that moves viewers from the outskirts of the

cities to their centers and from the physical damage to the human costs of nuclear warfare. They show not only the unbridled power of the weapons to destroy large parts of each city but also the misery inflicted on their inhabitants. Some are blurred and grainy, taken in haste by amateurs in the heat of a terrible moment, stunned by the sight of so much destruction and suffering, their vision clouded, like Matsushige's, by tears. Still others are sharper, more balanced, and carefully shot, but rarely posed. Some have a horrific beauty about them; others are simply horrific.

What, then, are we to make of these images? Surely, they are representations of a fixed past—but they are not the past, only reflections of it, no matter how detailed and exact. Just as surely, they evoke feelings, perhaps of horror, perhaps of empathy, perhaps, with enough exposure, a numbness—like *muyu-byou-sha*—at the ravages of nuclear war. Each photograph reproduces a sliver of that reality, but photographs tell us little of what goes on outside the frame and beyond the moment. Nor can we experience the destructive power and agonizing pain of what we see in photographs, or the reaction of the photographers at what they saw. The meaning of each image remains intimate and personal, the possession of the viewer and beyond the control of those who produced it, whether subject or photographer.

Take, for example, the shot of submarines floating in a bay (p. 104). They could be symbols of an aggressive power, perhaps ready to launch an attack on an unseen enemy, or lying at rest after accomplishing their mission. We have no idea whose submarines they are, let alone what their mission may be. We cannot tell who took the photograph, when it was taken, even where, and certainly not for what purpose. In other words, each image raises more questions than it answers and carries multiple meanings, depending upon how much is known about it and who is doing the seeing. As Susan Sontag pointed out, photographs are simply "invitations to deduction, speculation, and fantasy," all shaped by the knowledge and predilections of the viewer.[42]

In the case of the submarines, digging deeper reveals them to be abandoned vessels of the Imperial Japanese Navy. They are sitting in Hiroshima Bay near Ninoshima Island, 6 miles from ground zero. The photographer was Shunkichi Kikuchi, and he was there to take stills for a documentary film produced by the Japan Film Corporation. Kikuchi snapped this picture in mid-October 1945, more than a month after the surrender of Japan. It is one of almost 900 he produced in Hiroshima in just under three weeks he spent there.[43]

Armed with that information, we can now see the photograph in a richer light, but the black-and-white image still defies easy understanding. Deserted and anchored, silhouetted against a hazy landscape, are the submarines symbols of submission rather than aggression, of a once great cause lost? Could they be signs of a slumbering military giant, down but not destroyed, awaiting only the next opportunity to strike? Or maybe they signify the futility of war. No photograph, Sontag cautions, can make us understand; only words can. Even then, understanding can never be singular and absolute, but instead must necessarily reflect the variety of viewing perspectives that govern it.

The images nonetheless have a cumulative effect that is undeniable. They show us, more than words can tell, what the atomic wastelands of Hiroshima and Nagasaki looked like and how the people, living and dead, appeared in the aftermath of the blast. They cannot, of course, show us what cannot be seen: the invisible rays that penetrated human bodies and wreaked havoc on a cellular level, or the psychological toll over time. But they serve as more than a pathway to the past, however fraught with meaning. They are Janus-faced, looking both backward and forward, depicting a world long gone and a world yet to come if we are not careful.

The *pika-don* and the shock wave that followed took only minutes to roll across Hiroshima and Nagasaki. The fires that consumed both cities lasted for days and the radiation for years, although at levels far less toxic than the initial discharge that bathed inhabitants in gamma rays, or the "black rain" that drenched them in radioactive fallout. For survivors, it must have been impossible to forget those two days in August. What the rest of us should remember, and how we ought to remember it, are questions still worth asking. "The ultimate defeat," Kenzaburō Ōe reminded his fellow Japanese, "is to forget."[44]

The photographs here and in the larger collection offer us a graphic way of remembering the past. They raise but do not resolve the most salient question facing us: What are we to do about it? In 1945, a Western writer was contemplating just such matters by exploring the "terrible implications" of the war. George Orwell looked not to the past but into the future. He envisioned a world of tomorrow where history was malleable, power crushing, and human misery of little account. Published four years later, his *Nineteen Eighty-Four* made a totalitarian dystopia of his worst fears—the triumph of authoritarianism, the waging of perpetual war, the desecration of truth, and the omnipresence of a tyrannical and all-seeing "Big Brother." When asked what moral should be drawn from his book, Orwell answered, "Don't let it happen. It depends on you."[45] In that simple directive lies the collective moral of these photographs. We must not let it happen again, and there is no one who can stop it but us.

Notes

The author would like to thank Hank Nagashima, aided by Masami Nishimoto and Hironobu Ochiba, for invaluable suggestions that have helped to avoid errors of fact and translation.

1. Kenzaburō Ōe, *Hiroshima Notes* (New York: Grove Press, 1996), 97. Japanese writers are cited using the Western format for their names (i.e., given name followed by surname), since that is the way they appear in their translated books and articles. In Japanese, the surname would be first and followed by the given name.

2. S. C. M. Payne, *The Sino-Japanese War of 1894–1895: Perceptions, Power, and Primacy* (Cambridge: Cambridge University Press, 2003), 79–80, 262–263, 271–277.

3. The exact number of people living in Hiroshima and Nagasaki at the time of the bombings is notoriously difficult to ascertain given their movement in and out of the cities during the war. I have relied on the most careful estimates we have, namely those calculated by the Committee for the Compilation of Materials on the Damage Caused by the Atomic Bombs in Hiroshima and Nagasaki. For Hiroshima, the pre-bomb estimates of resident population range from 280,000 to 290,000 and from 300,000 to 310,000 for those actually present when the bomb dropped. An additional 43,000 soldiers of the Second Army bring that total to approximately 330,000. In Nagasaki, estimates place the number of people there on the day of the bombing at 270,000. See Committee for the Compilation of Materials on the Damage Caused by the Atomic Bombs in Hiroshima and Nagasaki, *Hiroshima and Nagasaki: The Physical, Medical, and Society Effects of the Atomic Bombings* (New York: Basic Books, 1987), 352, 354.

4. Brian Burke-Gaffney, *Nagasaki: The British Experience, 1854–1945* (Leiden: Brill / Global Oriental, 2009), 26, 47, 103.

5. Susan Southard, *Nagasaki: Life After Nuclear War* (New York: Penguin, 2015), 3–4, 9. On Nagasaki's population, see Chad R. Diehl, *Resurrecting Nagasaki: Reconstruction and the Formation of Atomic Narratives* (Ithaca, NY: Cornell University Press, 2018), 39. See also Garry G. Kohls, "Christianity and the Nagasaki Bomb," *Consortium News*, August 6, 2016, consortiumnews.com/2016/08/09/christianity-and-the-nagasaki-bomb.

6. See, for example, Richard Overy, *The Bombers and the Bombed: Allied Air War over Europe, 1940–1945* (New York: Penguin, 2013), 47–60; Michael Bess, *Choices Under Fire: Moral Dimensions of World War II* (New York: Vintage, 2006), 89–110.

7. Nagasaki had been hit with conventional bombs some five times in the spring and summer of 1945, killing more than 300 people. See Southard, *Nagasaki*, 25–27.

8. Wesley F. Craven and James L. Cates, eds., *The Army Air Forces in World War II, vol. 5, The Pacific: Matterhorn to Nagasaki, June 1944 to August 1945* (Chicago: University of Chicago Press, 1953), 662–673; "Japan Targeted for Starvation," *The Daily Chronicles of World War II*, n.d., ww2days.com/japan-targeted-for-starvation-2.html; Southard, *Nagasaki*, 7.

9. Tsuyoshi Hasegawa, *Racing the Enemy: Stalin, Truman, and the Surrender of Japan* (Cambridge, MA: Belknap Press of Harvard University Press, 2005), 89–129.

10. Southard, *Nagasaki*, 17–18.

11. Chad Diehl, ed., *And the River Flowed as a Raft of Corpses: The Poetry of Yamaguchi Tsutomu, Survivor of Both Hiroshima and Nagasaki* (New York: Excogitating Over Coffee Publishers, 2010), 7.

12. Ibid., 6.

13. Ibid., 7.

14. Committee for the Compilation of Materials, *Hiroshima and Nagasaki*, 33–34.

15. Diehl, *Raft of Corpses*, 7–8.

16. The Australian journalist Wilfred Burchett entered Hiroshima less than a month after the bombing. Under the name "Peter Burchett," he wrote the first newspaper article by a foreign journalist detailing the effects of the atomic bomb on a Japanese city. It appeared in London's *Daily Express* on September 5, 1945. Looking at the Hiroshima cityscape, Burchett was struck by the flatness of the bombed-out areas. Peter Burchett, "The Atomic Plague," *Daily Express*, September 5, 1945, 1.

17. Takashi Nagai, *We of Nagasaki: The Story of Survivors in an Atomic Wasteland* (New York: Duell, Sloan and Pearce, 1951).

18. Committee for the Compilation of Materials, *Hiroshima and Nagasaki*, 117–185.

19. Robert Jay Lifton, *Death in Life: Survivors of Hiroshima* (New York: Random House, 1968), 26, and his *Future of Immortality and Other Essays for a Nuclear Age* (New York: Basic Books, 1987), 53, 231–243.

20. Committee for the Compilation of Materials, *Hiroshima and Nagasaki*, 113. The exact number of dead is difficult to figure, with some counts running as high as 140,000 or more.

21. David Lowe, Cassandra Atherton, and Alyson Miller, eds., *The Unfinished Atomic Bomb: Shadows and Reflections* (Lanham, MD: Lexington Books, 2019), contains several insightful essays on the *hibakusha*. For a fictionalized account of their lives, see Masuji Ibuse's classic novel *Black Rain* (Tokyo: Kondasha International, 1969).

22. Diehl, *Raft of Corpses*, 8.

23. Ibid., 9–11.

24. Committee for the Compilation of Materials, *Hiroshima and Nagasaki*, 30.

25. Takashi Nagai, *We of Nagasaki* (New York: E. P. Dutton, 1951), xii.

26. Committee for the Compilation of Materials, *Hiroshima and Nagasaki*, 113–114; US Department of Energy, "The Atomic Bombing of Nagasaki," n.d., osti.gov/opennet/manhattan-project-history/Events/1945/nagasaki.htm.

27. "Tsutomu Yamaguchi," *Telegraph*, January 6, 2010, telegraph.co.uk/news/obituaries/6943088/Tsutomu-Yamaguchi.html; Diehl, *Raft of Corpses*, 6–11.

28. "The Mushroom Cloud Photographed by Seiso Yamada," Interview with Seiso Yamada, *Chugoku Shimbun*, January 3, 2008, hiroshimapeacemedia.jp/?p=19426; Misami Nishimoto, "Record of Hiroshima: Images of the Atomic Bombing," *Chugoku Shimbun*, August 2, 2005, hiroshimapeacemedia.jp/?gallery=20110613141546676_en.

29. Nishimoto, "Record of Hiroshima."

30. "Yoshito Matsushige's Account of the Hiroshima Bombing," *American Heritage Foundation*, n.d., atomicheritage.org/key-documents/yoshito-matsushiges-account-hiroshima-bombing.

31. Yōsuke Yamahata, "Photographing the Bomb—A Memo (1952)," and "Meet Yōsuke Yamahata (1962), Interview by Hidezoh Kondo First Published in *Yomiuri Weekly*, August 20, 1962," in Rupert Jenkins, ed., *Nagasaki Journey: The Photographs of Yōsuke Yamahata, August 10, 1945* (San Francisco: Pomegranate Artbooks, 1995), 44–45, 102–105.

32. "Words by Photographers Who Captured Apocalyptic Scenes of Atomic Bomb Explosions," interview of Eiichi Matsumoto and Shigeo Hayashi conducted by Kenichi Komatsu, 1991, for the Japan Photographers Association Newsletter (no. 88), translation drafted by Hank Nagashima, reviewed and corrected by Tsukasa Yokoyama. The author is grateful to Benjamin Wright for providing a translated copy of the interviews.

33. Ibid.

34. Ibid.

35. Ibid.

36. Diary of Henry L. Stimson, June 6, 1945, Papers of Henry L. Stimson, Sterling Memorial Library, Yale University, New Haven, Connecticut.

37. Monica Braw, *The Atomic Bomb Suppressed: American Censorship in Japan, 1945–1948* (Tokyo: Liber Forlag, 1986), 14. The author interviewed Kurihara in 1978.

38. Southard, *Nagasaki*, 109–110.

39. Jenkins, *Nagasaki Journey*, 45.

40. "When the Atom Bomb Struck—Uncensored," *Life*, September 29, 1952, 19–25; "First Exposé of A-Bomb Damage," *Asahi Graph* special issue, August 6, 1952.

41. Jenkins, *Nagasaki Journey*, 105.

42. Susan Sontag, *On Photography* (New York: Picador, 1973), 123, and her *Regarding the Pain of Others* (New York: Picador, 2003), 89. For a thoughtful retort to Sontag's assertions here, see Susie Linfield, *The Cruel Radiance: Photography and Political Violence* (Chicago: University of Chicago Press, 2010).

43. Masami Nishimoto, "The Atomic Bomb Photographs of Shunkichi Kikuchi, Part I: 783 Photographs Returned to Hiroshima," *Chugoku Shimbun*, January 17, 2007, hiroshimapeacemedia.jp/?gallery=20080704201603850_en.

44. Ōe, *Hiroshima Notes*, 112.

45. A video of Orwell, shortly before he died, saying these words in a ca. 1949/1950 BBC program can be found at "George Orwell: Don't Let It Happen. It Depends on You," YouTube, posted December 27, 2015, youtube.com/watch?v=usVBMq7lkVc.

NAGASAKI

POPULATION AT THE TIME
OF THE BOMBING:

approximately
240,000

ESTIMATED DEATH TOLL:

73,884

NUMBER OF INJURED:

74,909

RATIO OF VICTIMS
TO POPULATION:
Approximately
62 percent

NUMBER OF HOUSES
AFFLICTED:
18,409

TOTAL AREA CONSUMED
BY FIRE:
2.6 square miles

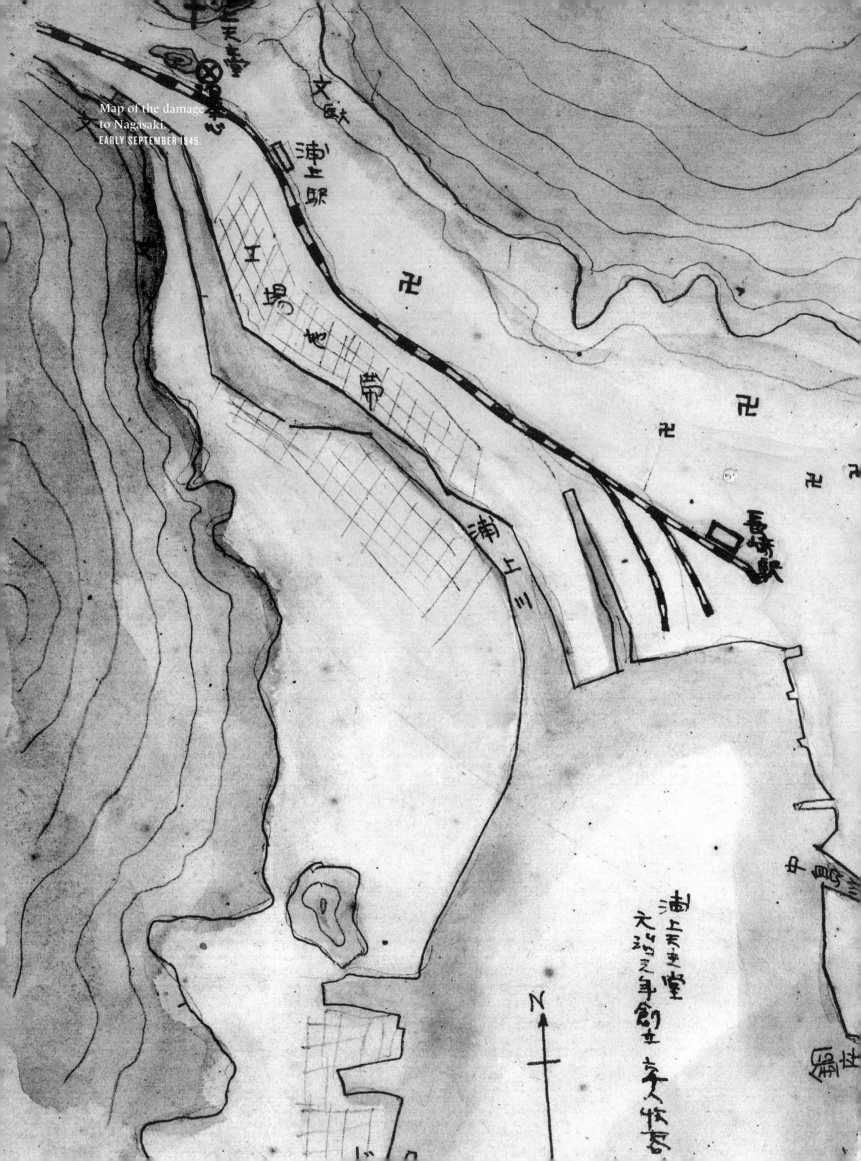

Map of the damage
to Nagasaki.
EARLY SEPTEMBER 1945.

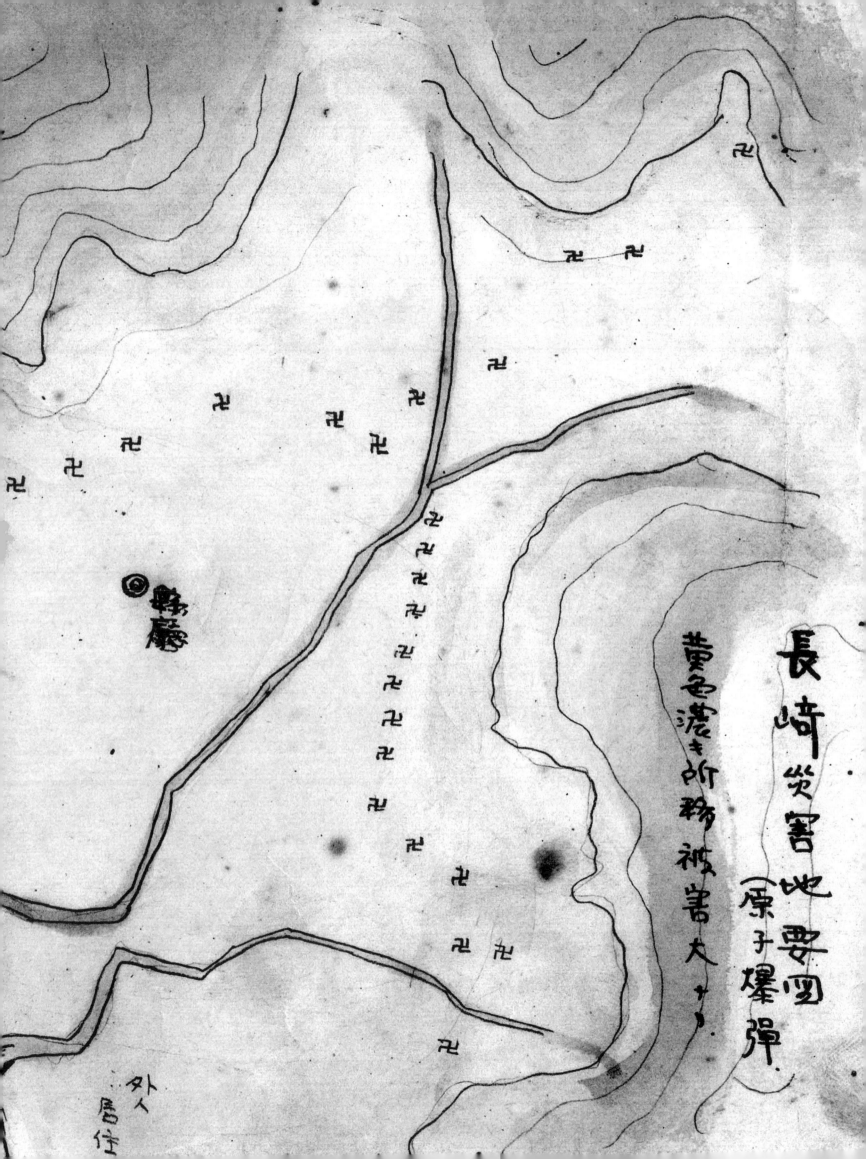

長崎災害地要図（原子爆弾）

黄色港ヶ所務被害大

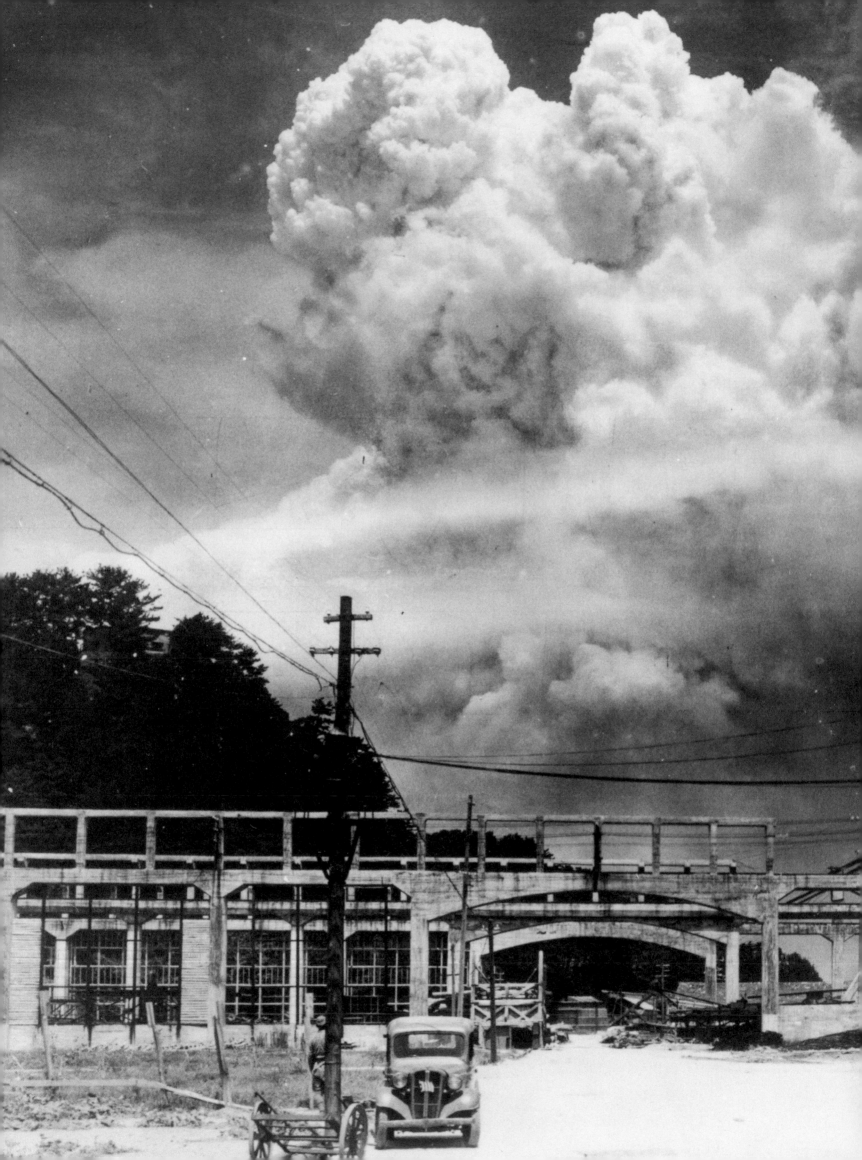

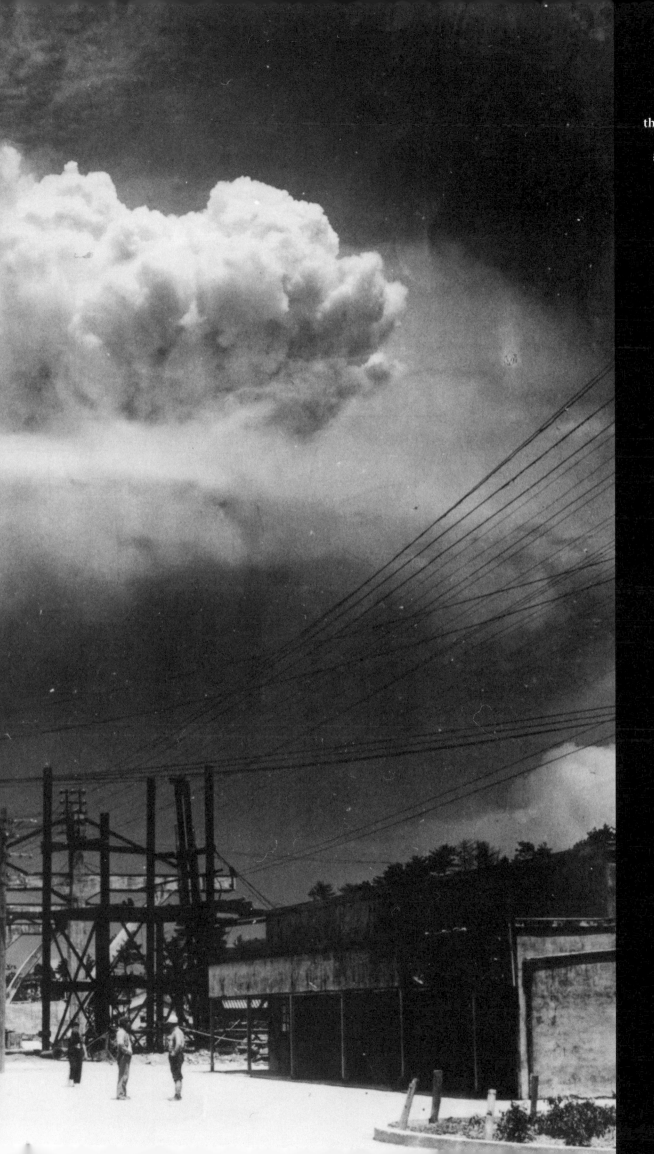

The first photo of
the mushroom cloud
taken from the
ground, 15 minutes
after the explosion
AUGUST 9, 1945.

143

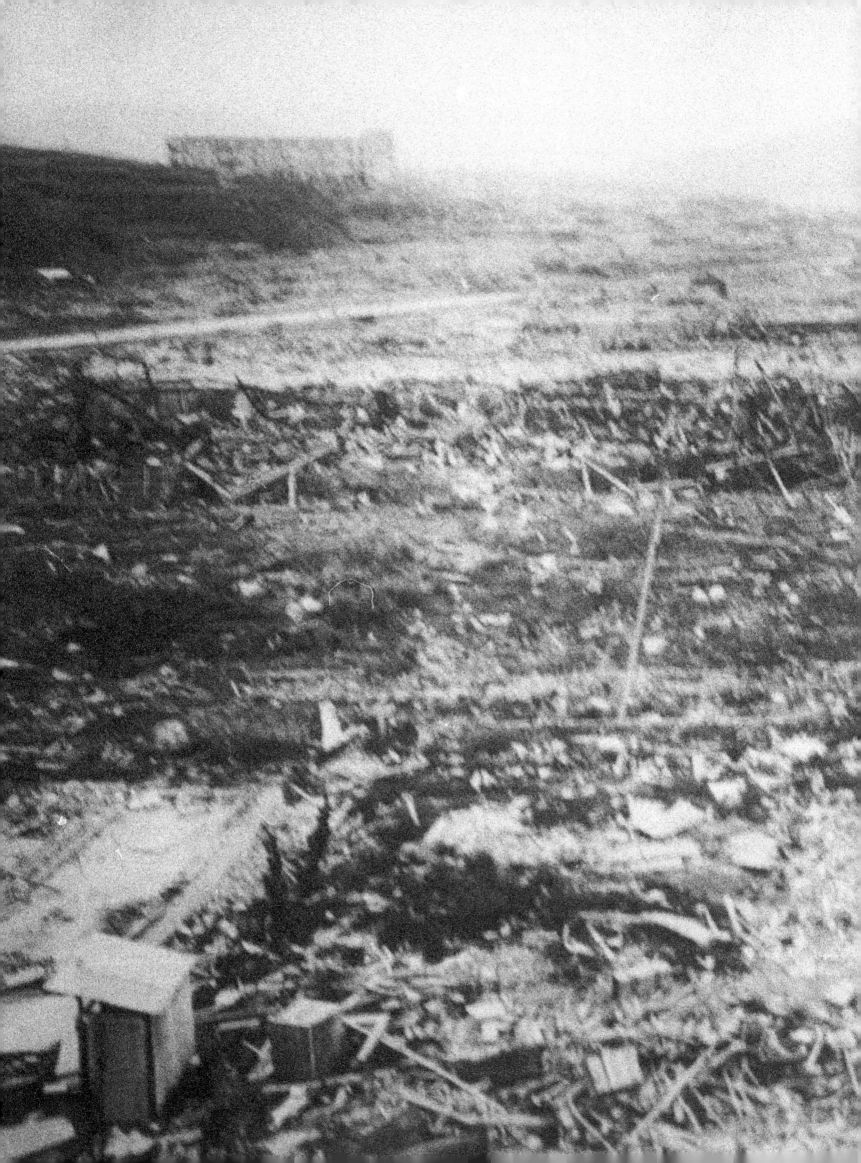

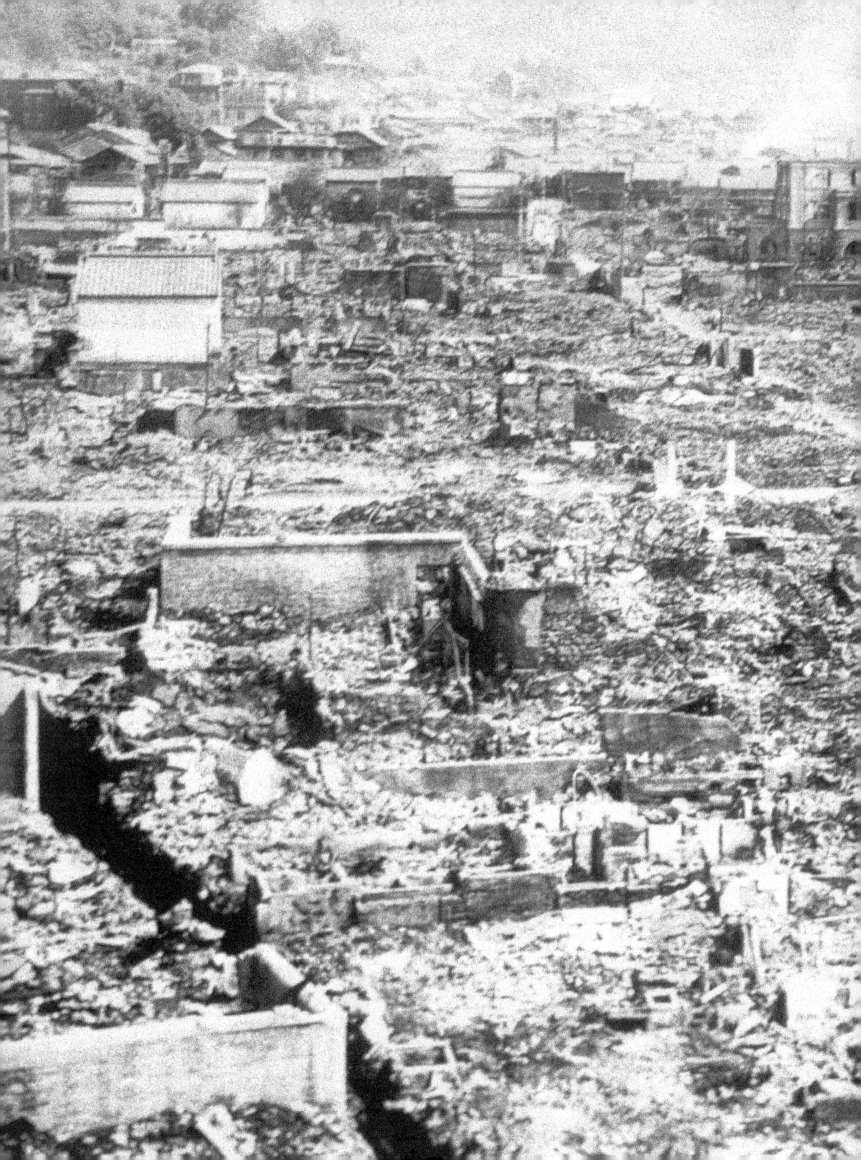

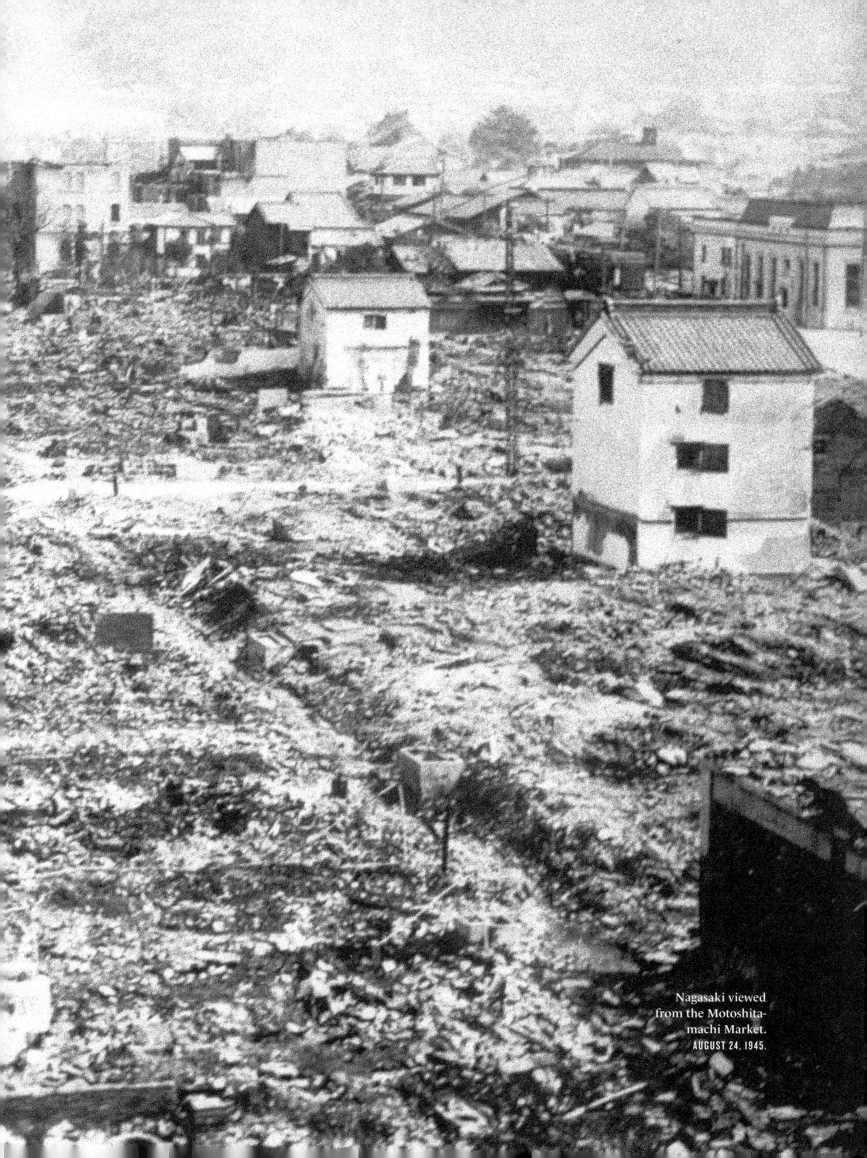

Nagasaki viewed
from the Motoshita-
machi Market.
AUGUST 24, 1945.

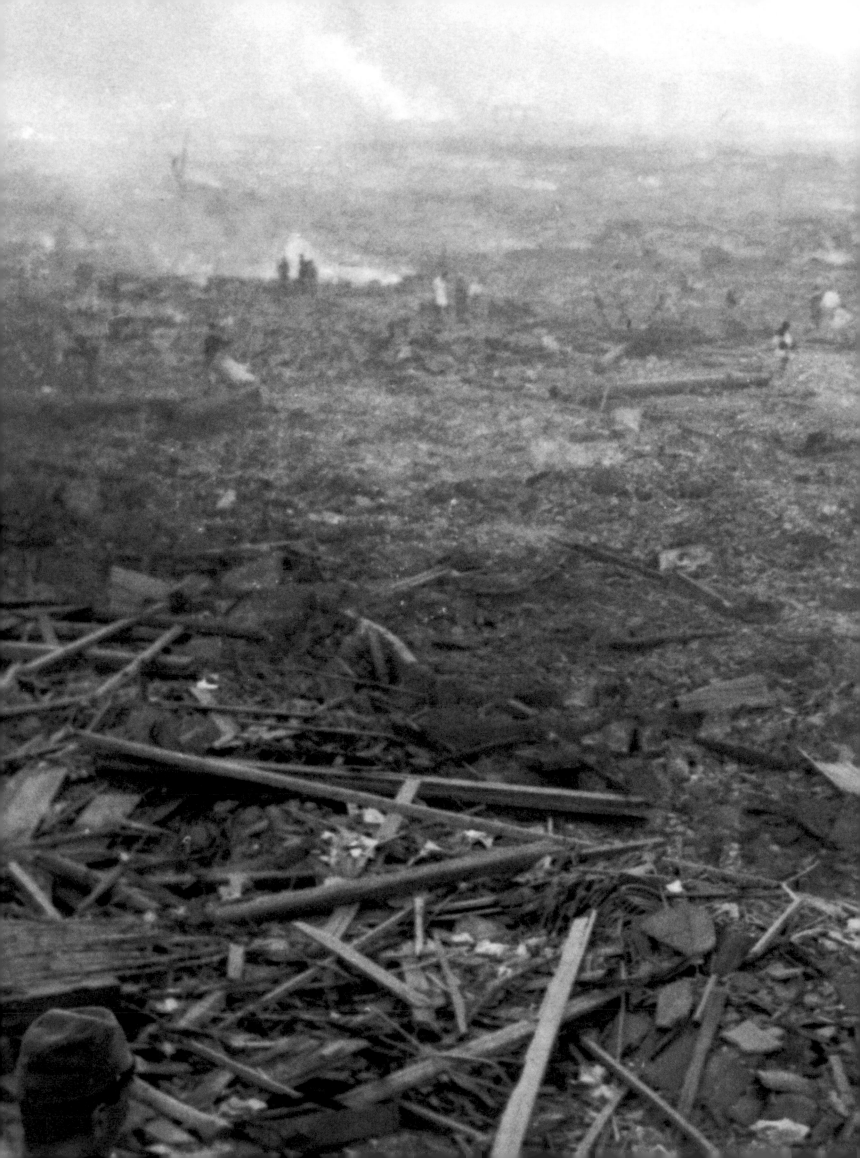

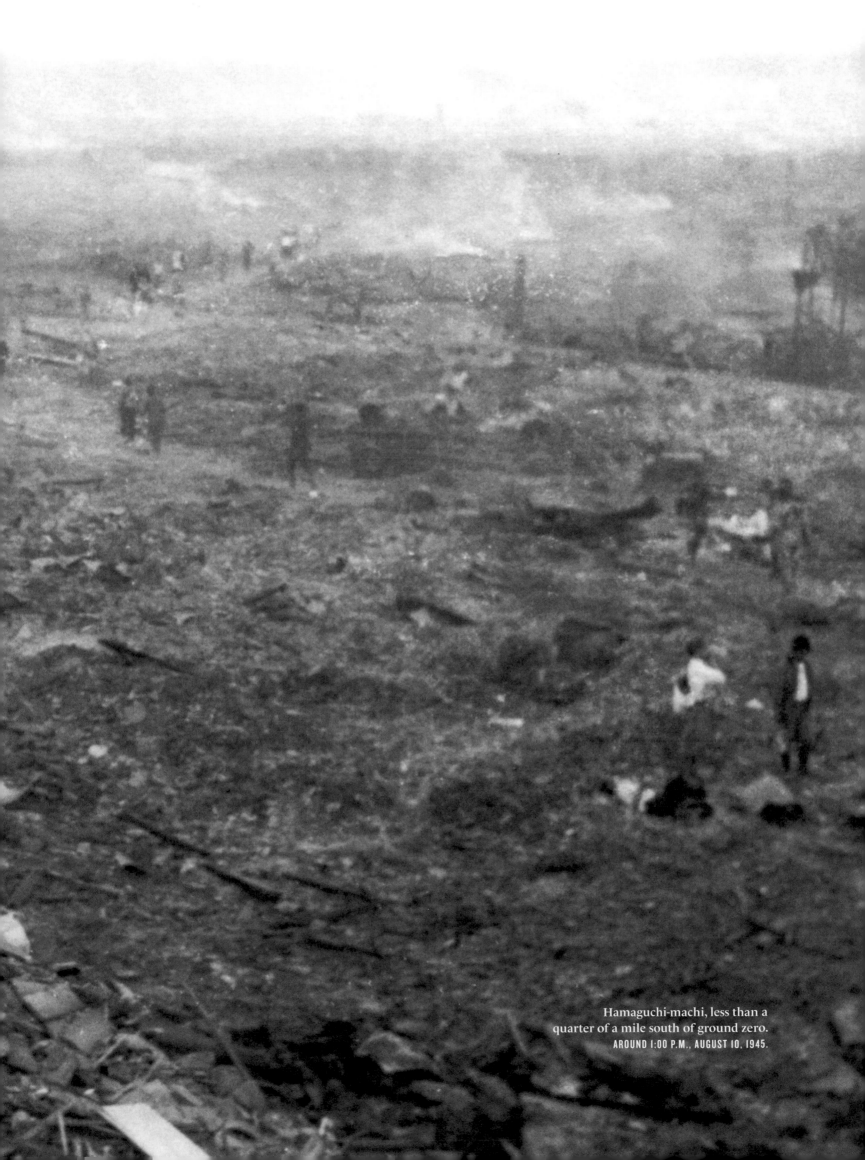

Hamaguchi-machi, less than a
quarter of a mile south of ground zero.
AROUND 1:00 P.M., AUGUST 10, 1945.

Hamaguchi-machi, less than a
quarter of a mile south of ground zero.
AROUND 1:00 P.M., AUGUST 10, 1945.

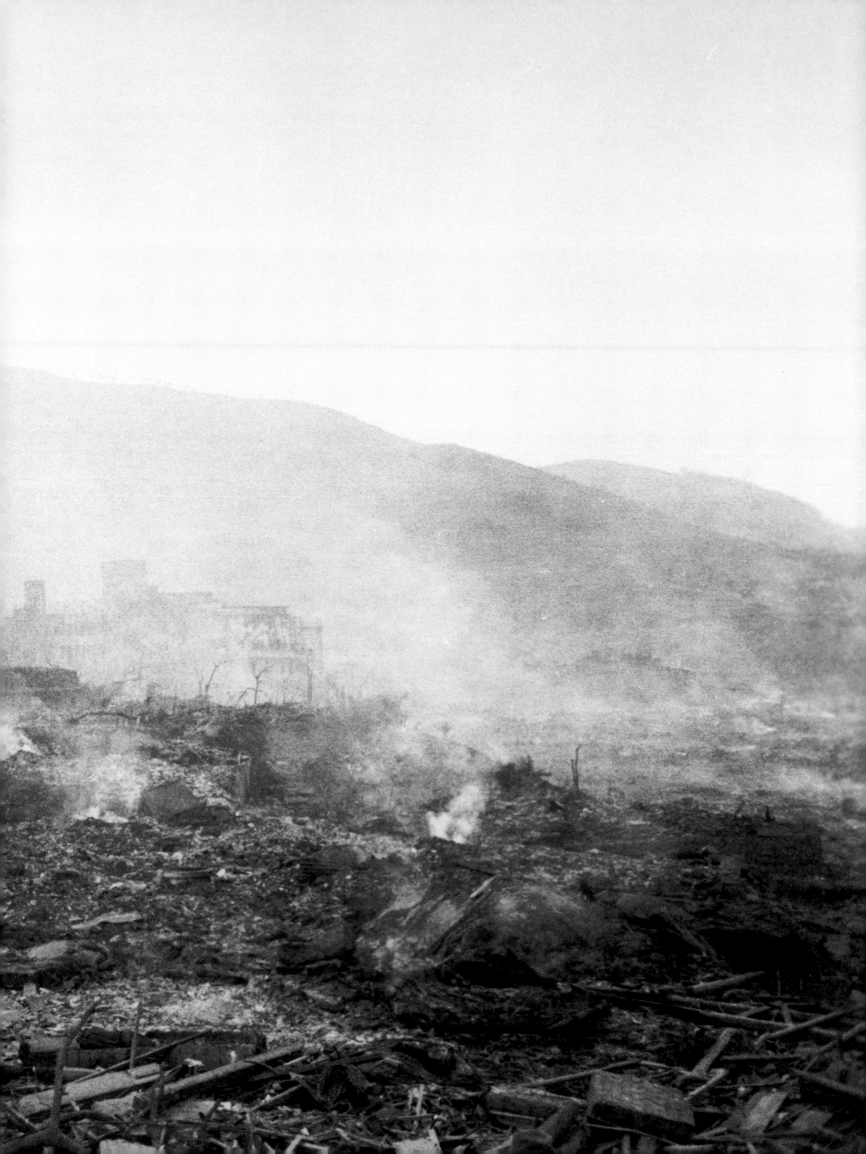

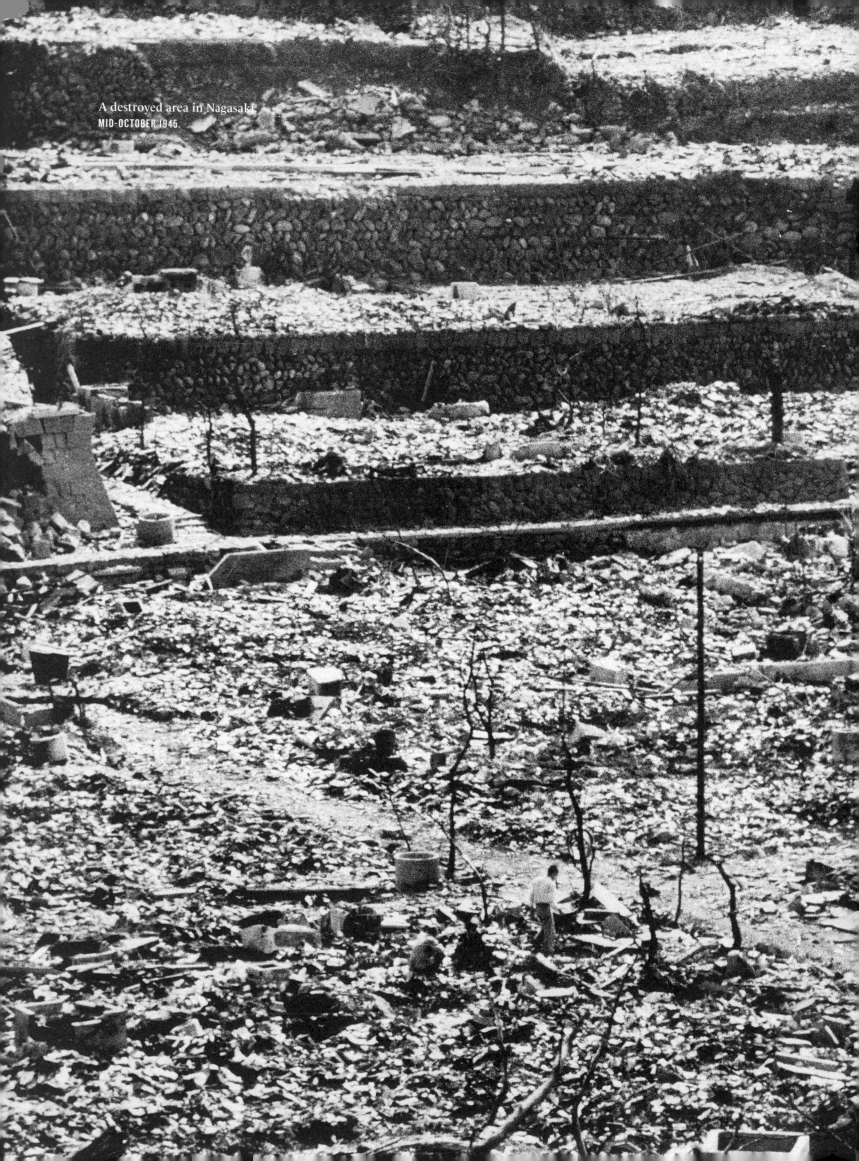
A destroyed area in Nagasaki
MID-OCTOBER 1945.

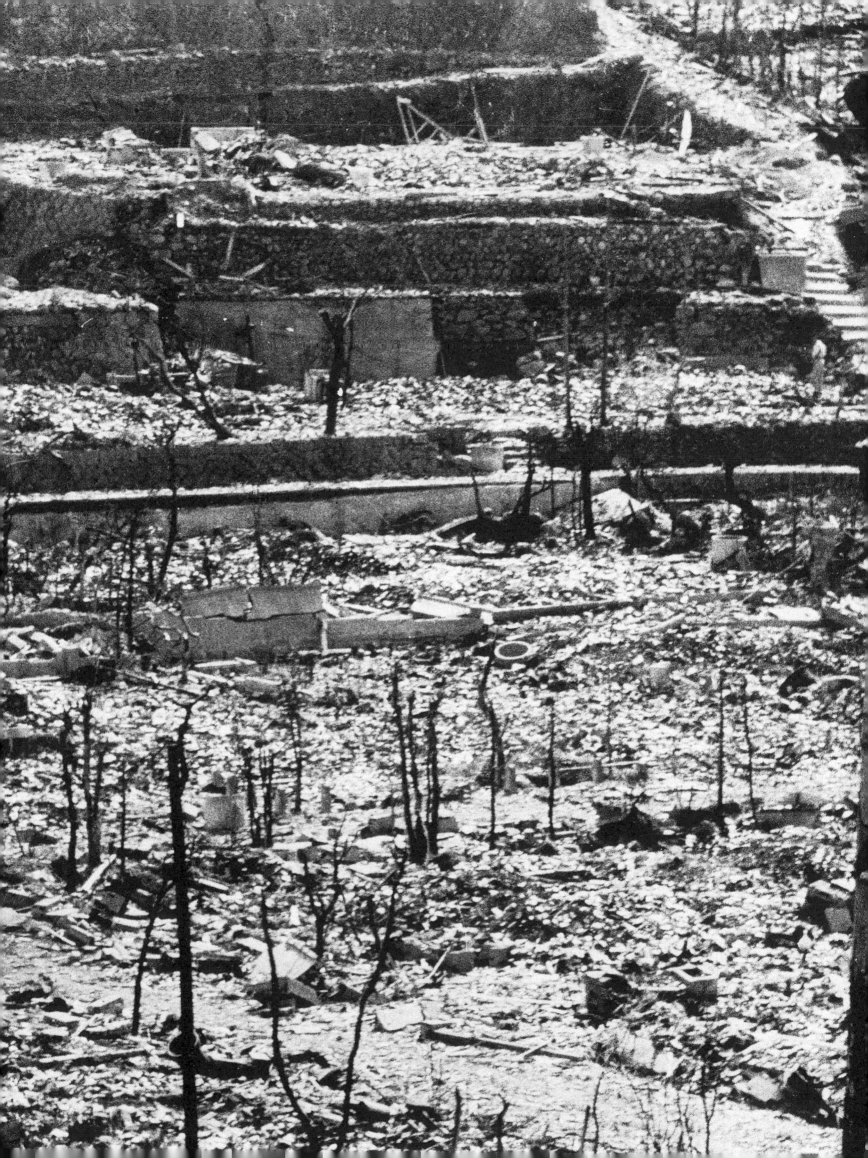

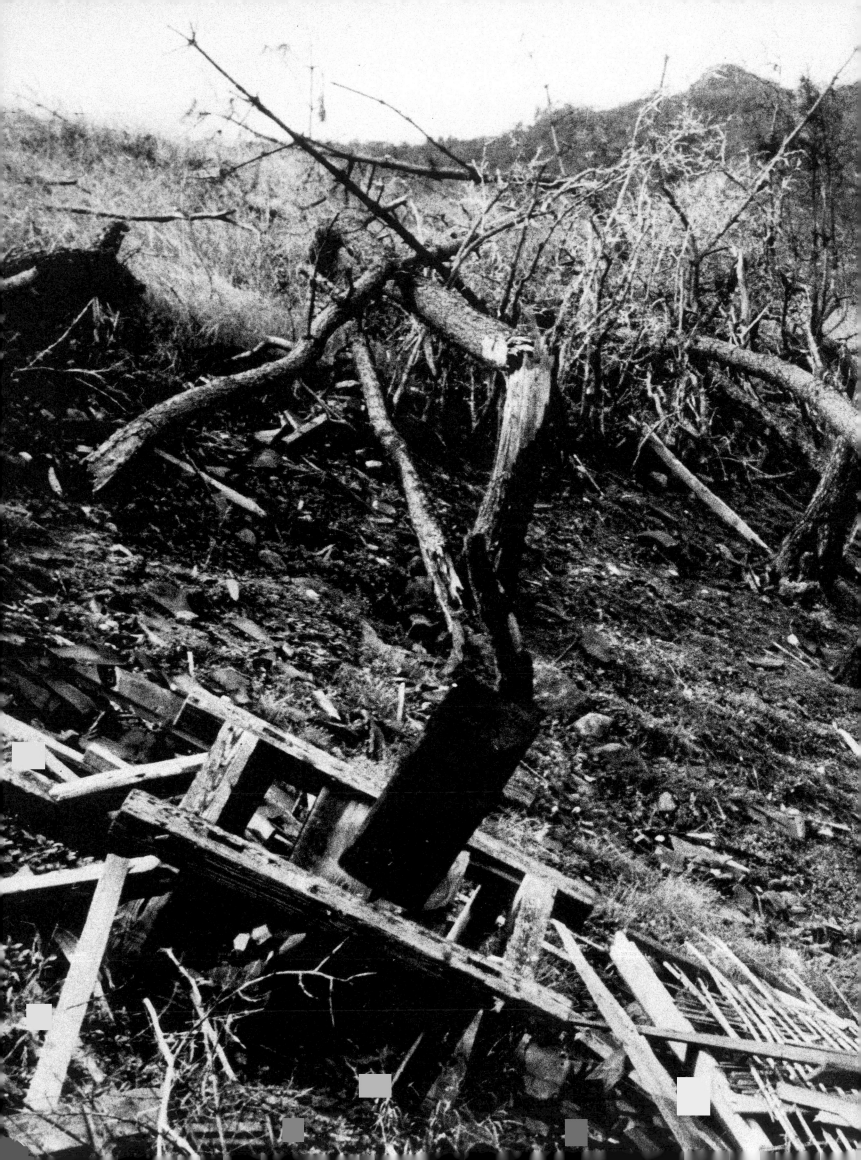

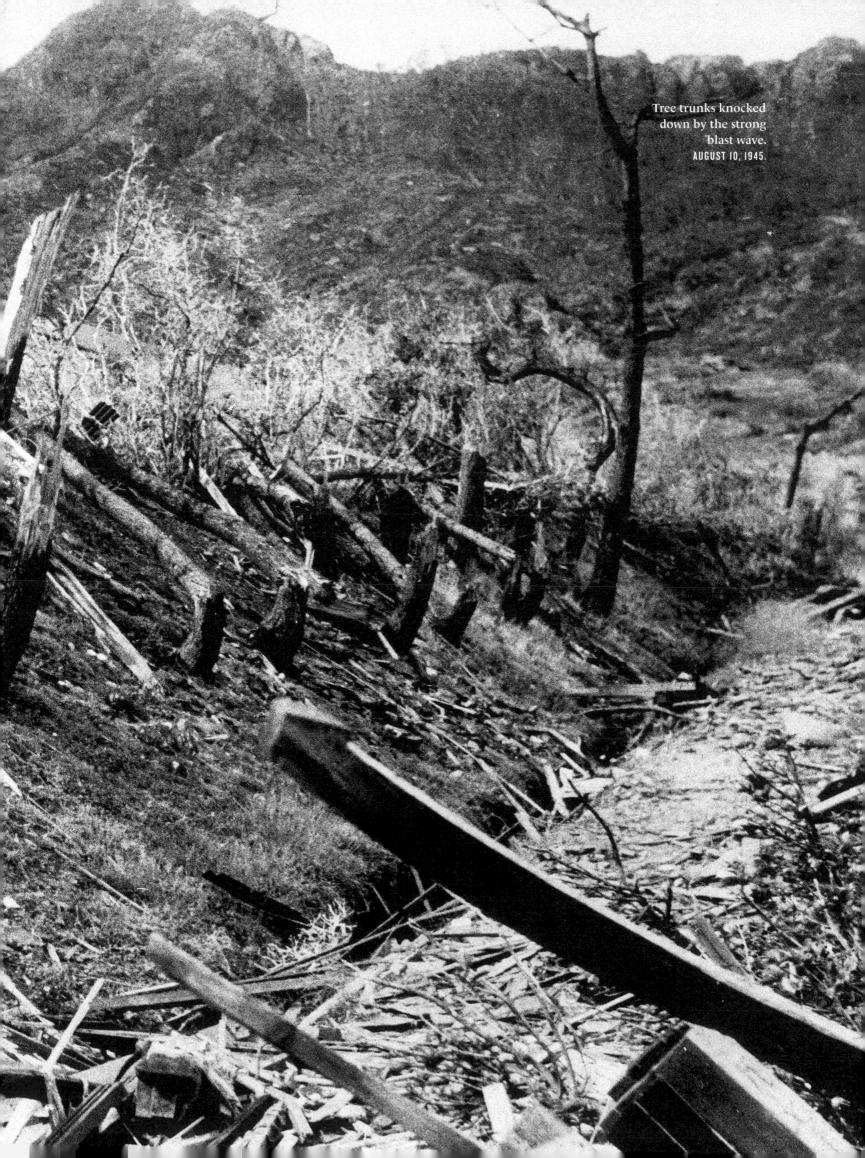

Tree trunks knocked
down by the strong
blast wave.
AUGUST 10, 1945.

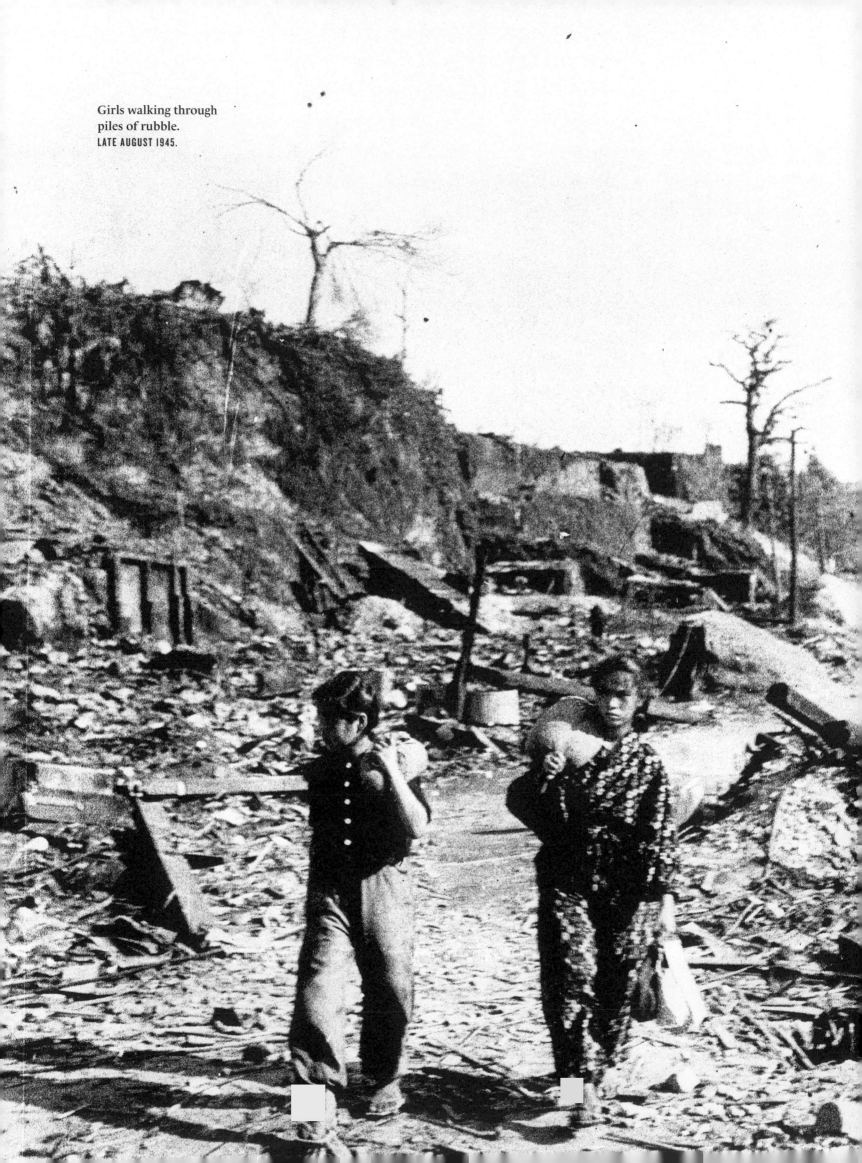

Girls walking through piles of rubble.
LATE AUGUST 1945.

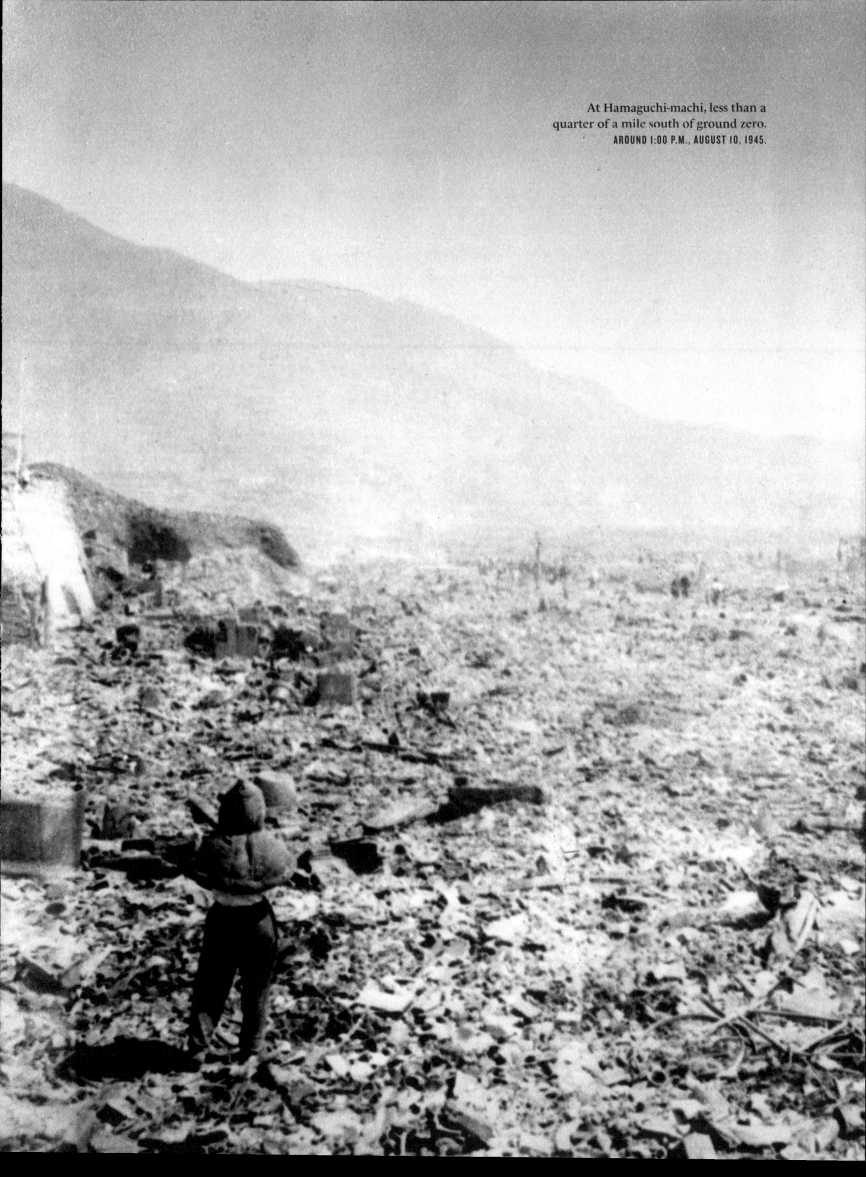

At Hamaguchi-machi, less than a
quarter of a mile south of ground zero.
AROUND 1:00 P.M., AUGUST 10, 1945.

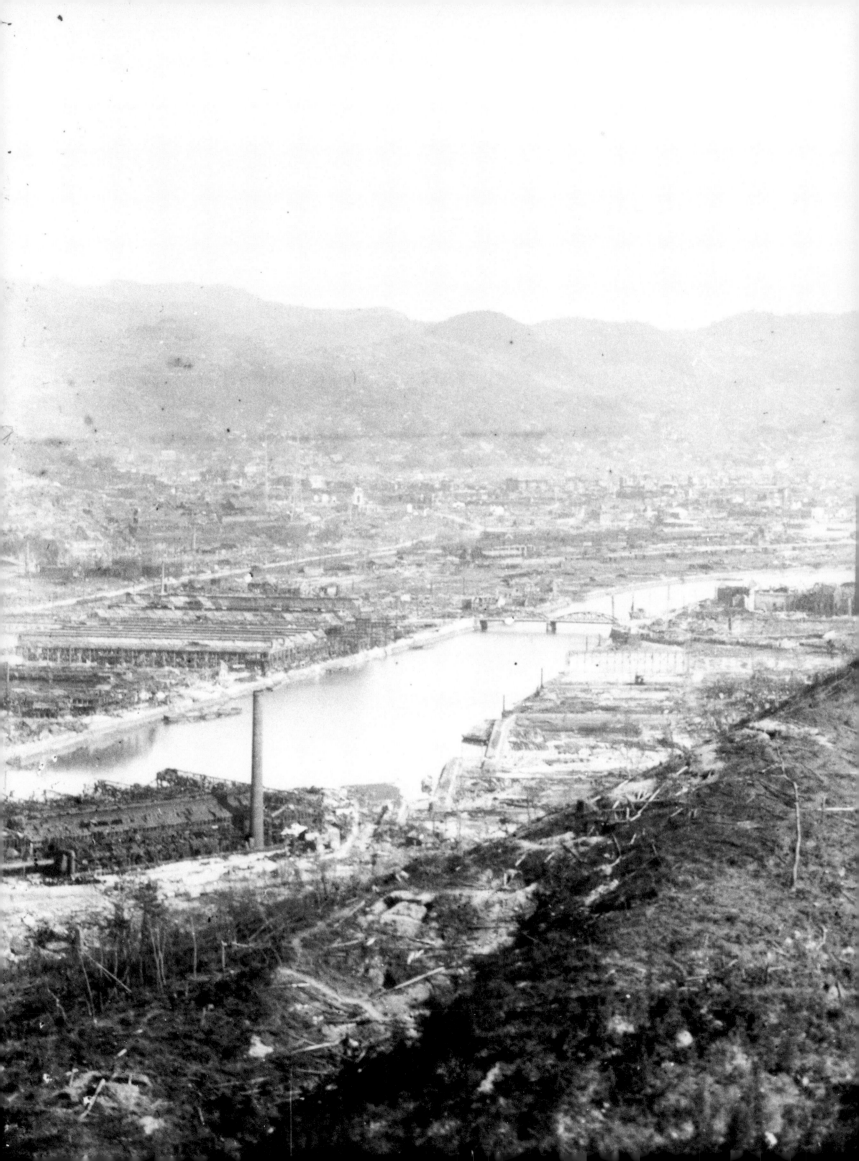

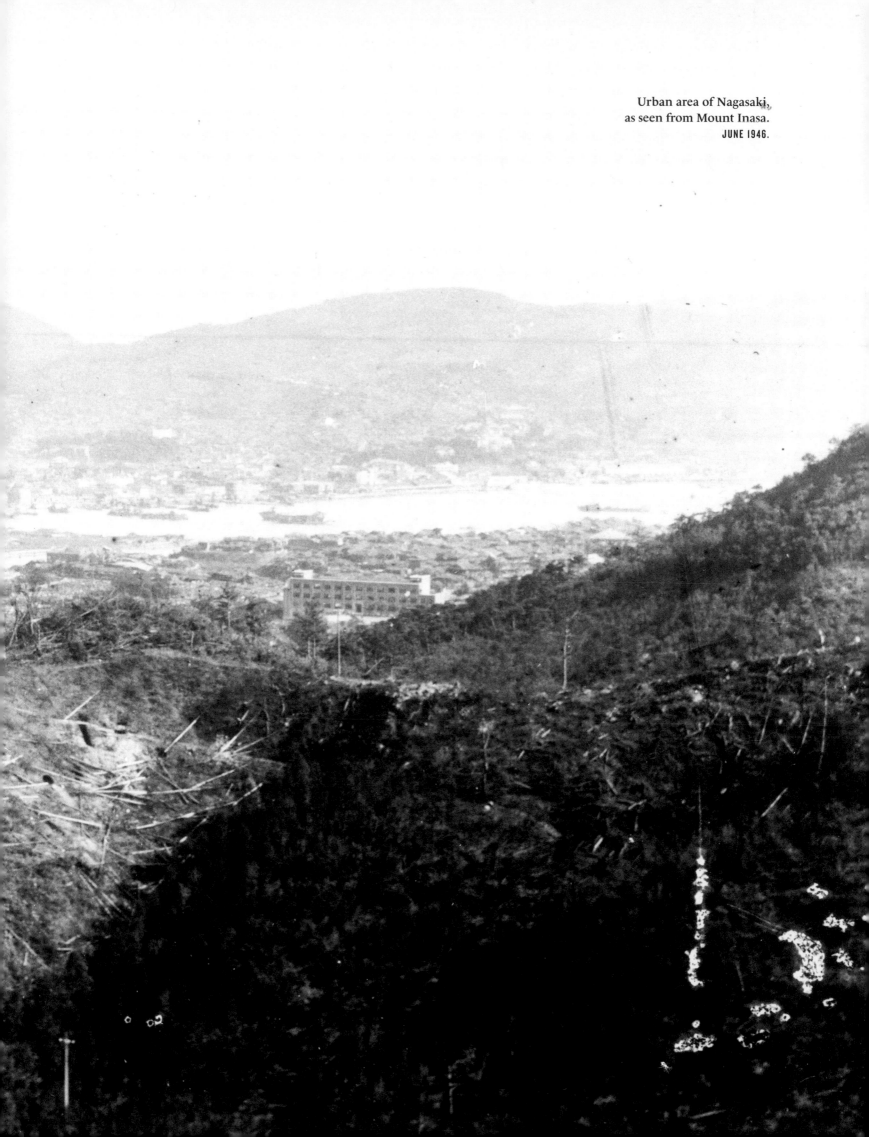

Urban area of Nagasaki,
as seen from Mount Inasa.
JUNE 1946.

Water spraying from
a ruptured pipe in front
of Shotoku Temple.
AUGUST 10, 1945.

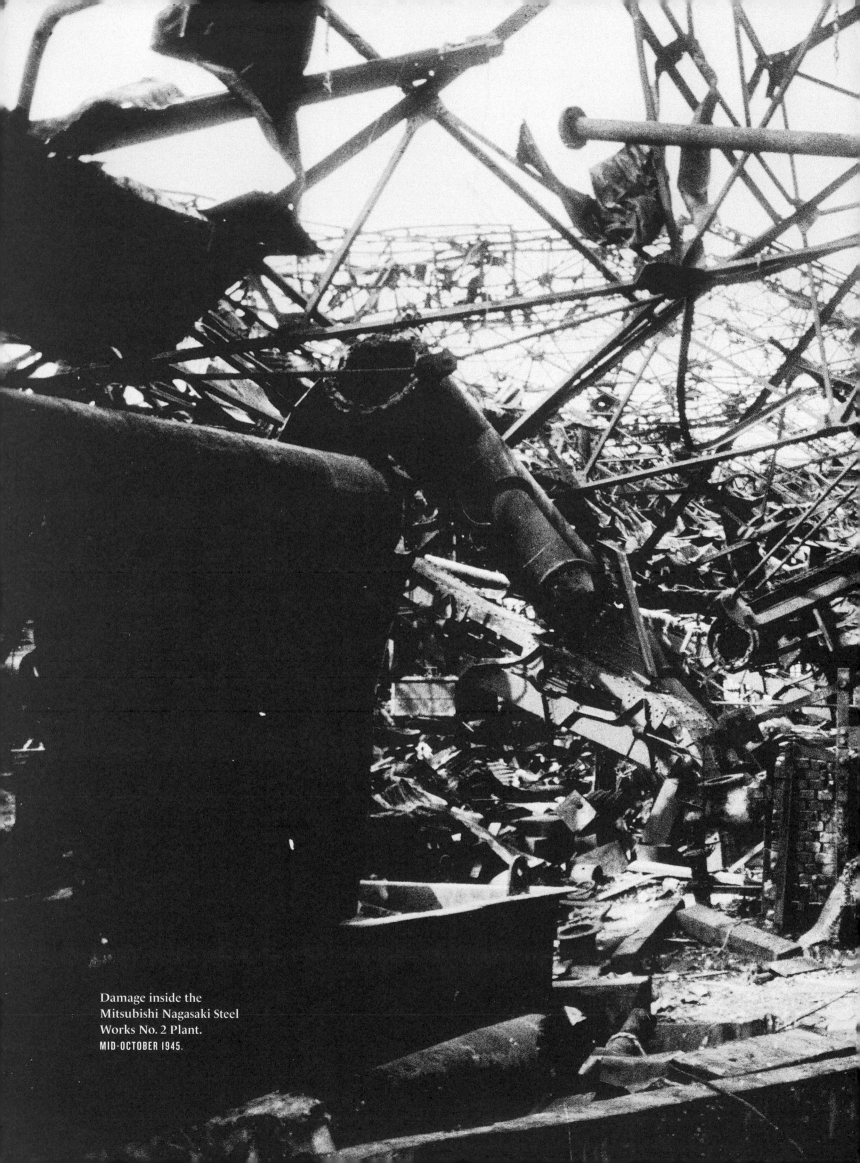

Damage inside the
Mitsubishi Nagasaki Steel
Works No. 2 Plant.
MID-OCTOBER 1945.

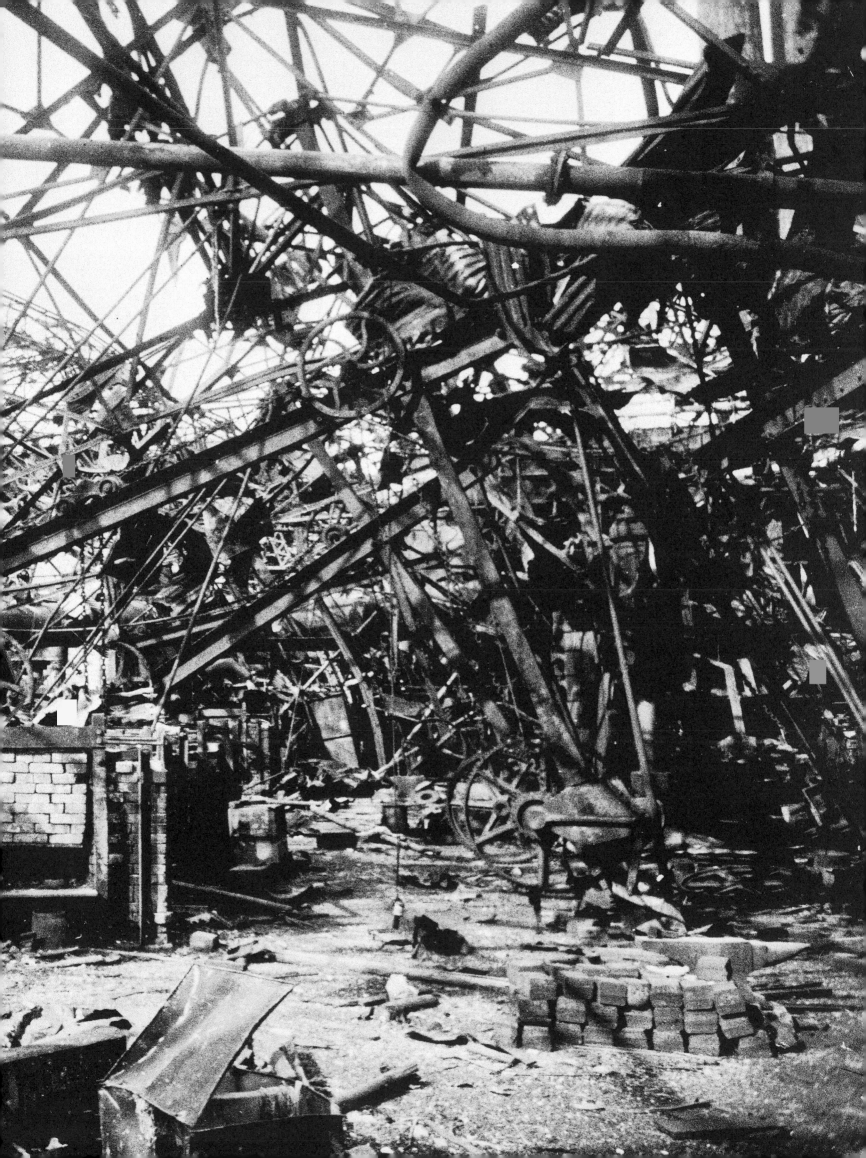

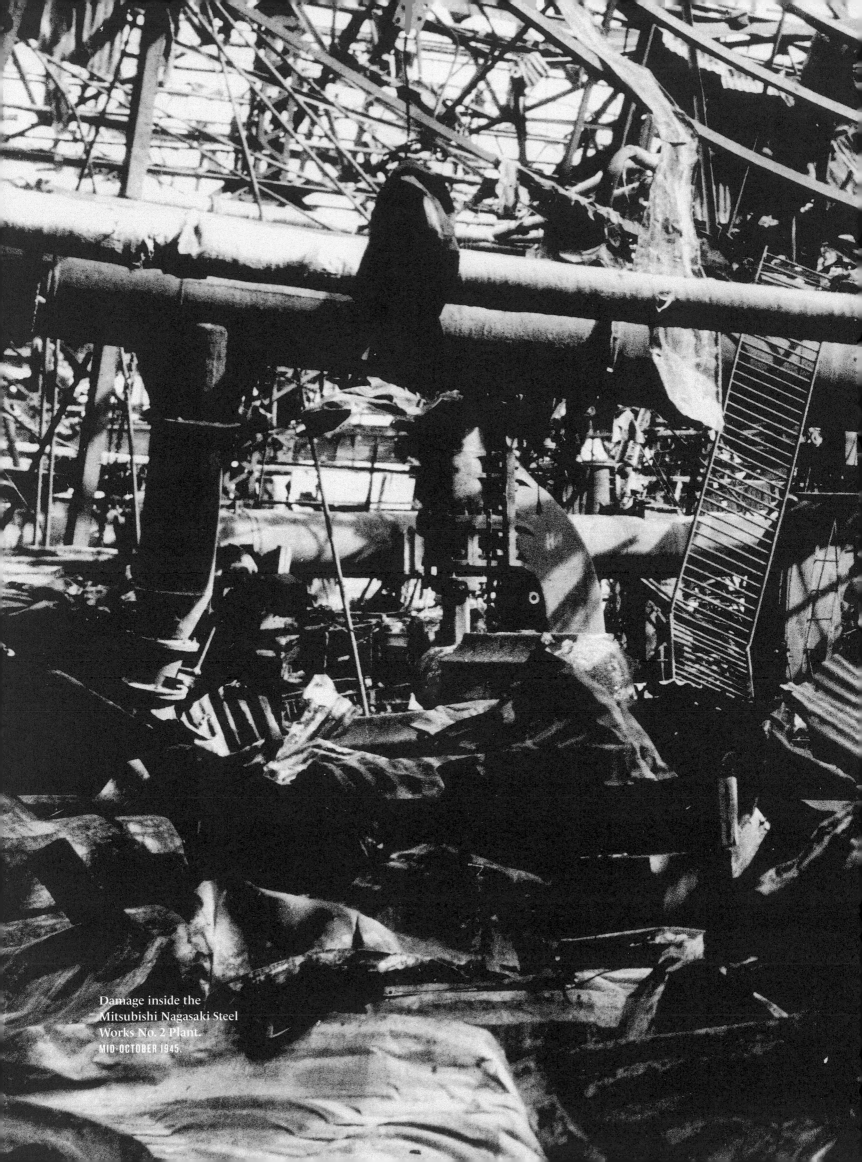

Damage inside the
Mitsubishi Nagasaki Steel
Works No. 2 Plant.
MID-OCTOBER 1945.

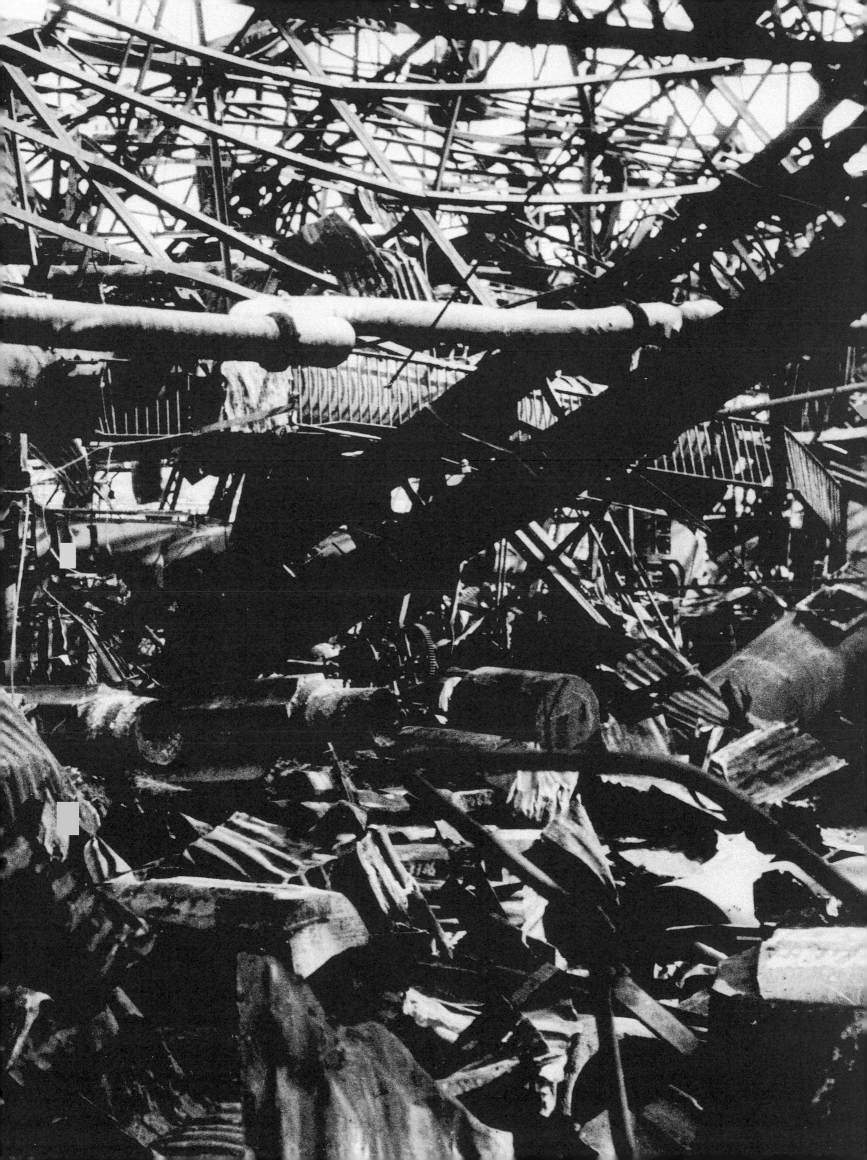

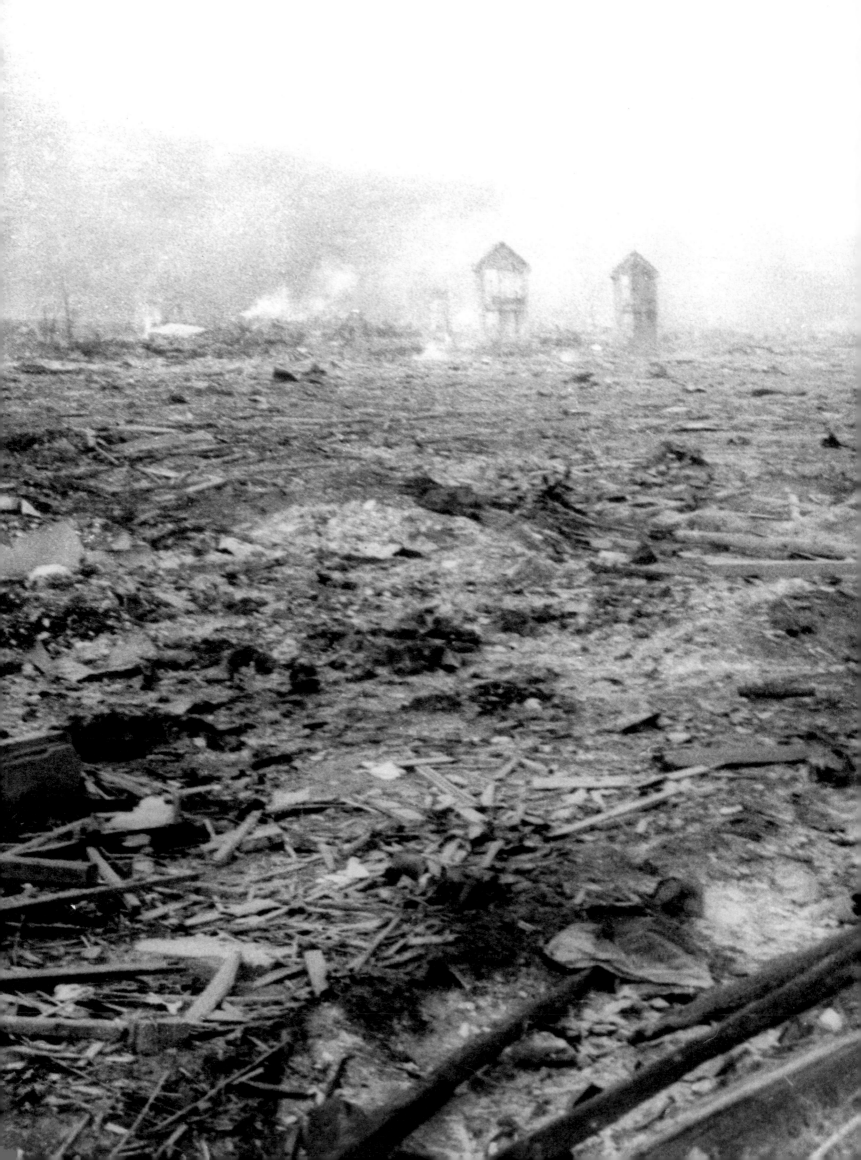

A quarter of a mile south-south-
west of ground zero.
1:00 TO 2:00 P.M., AUGUST 10, 1945.

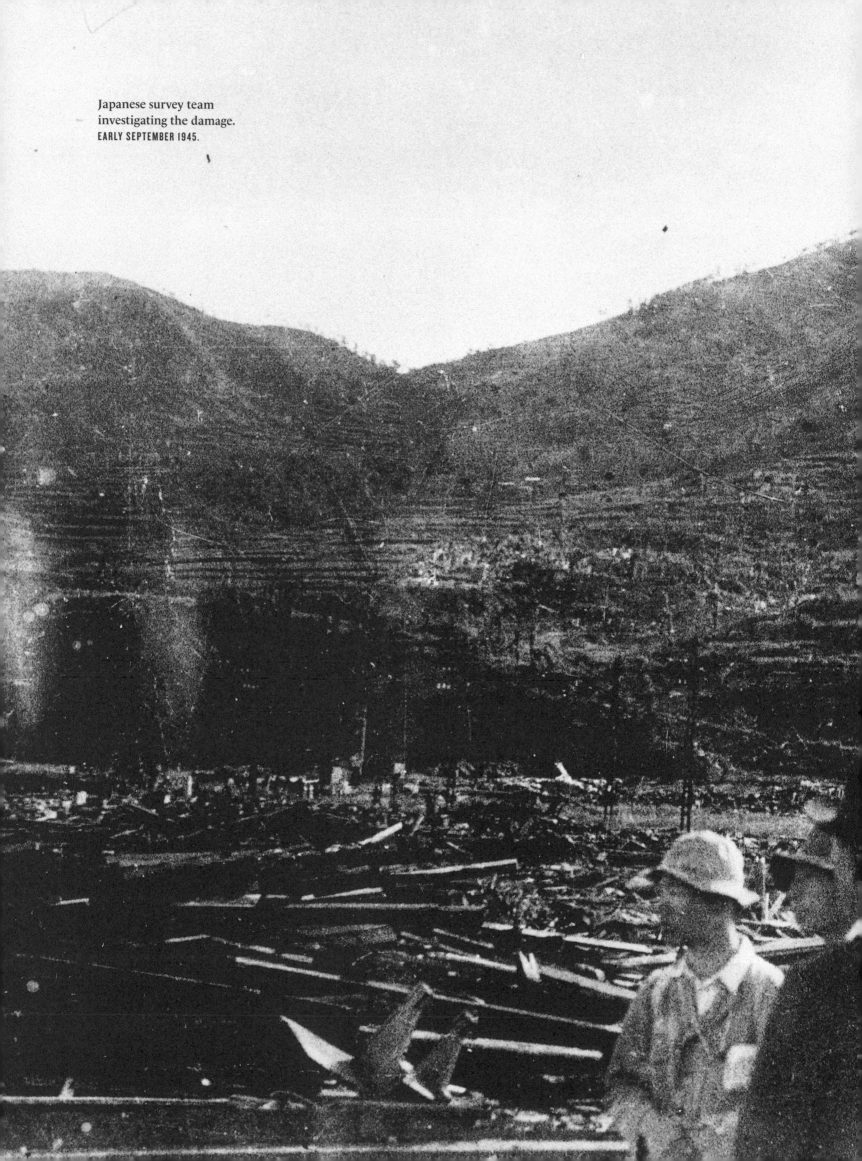

Japanese survey team
investigating the damage.
EARLY SEPTEMBER 1945.

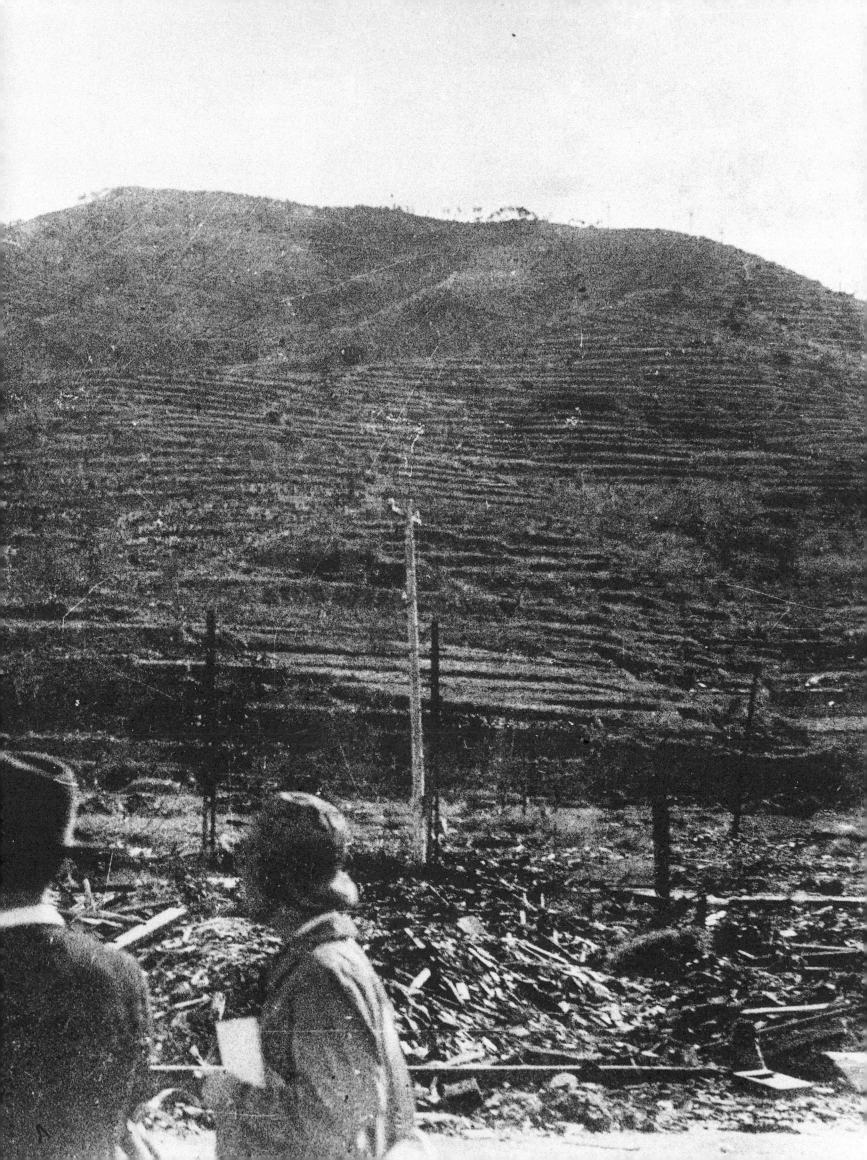

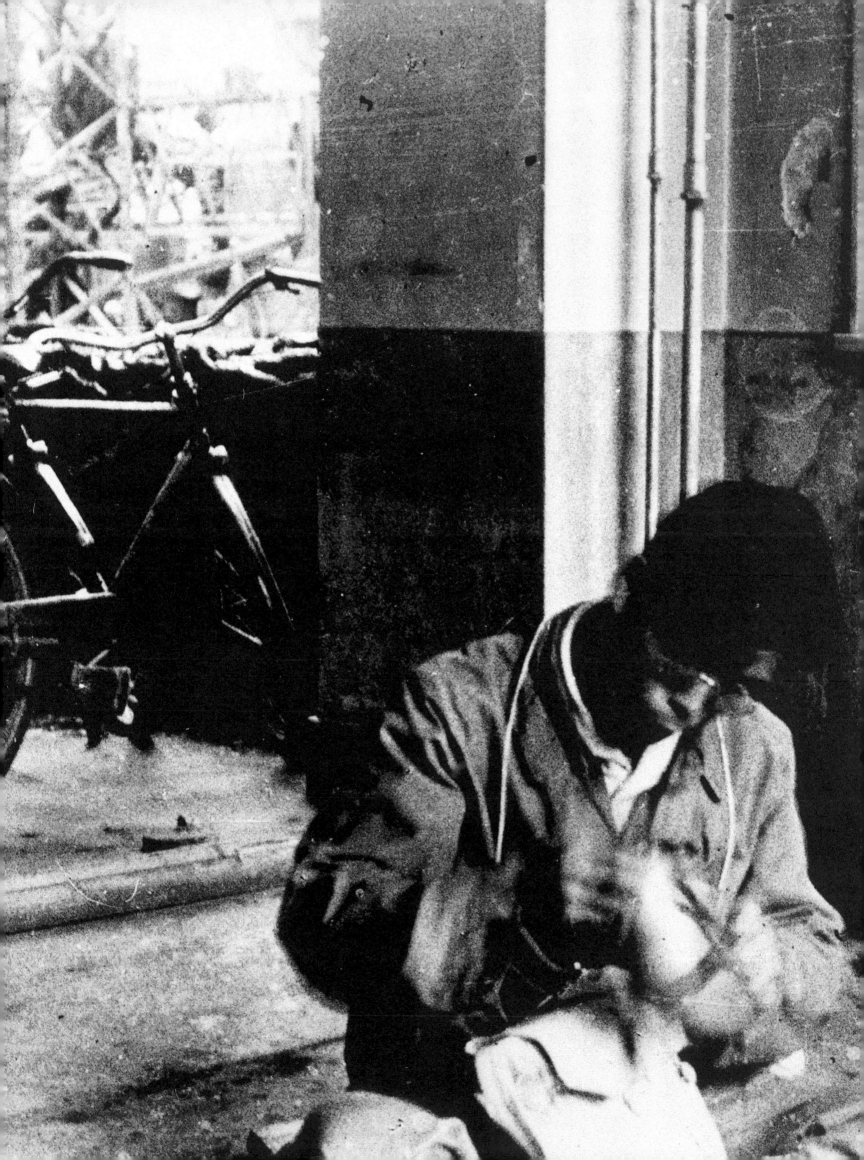

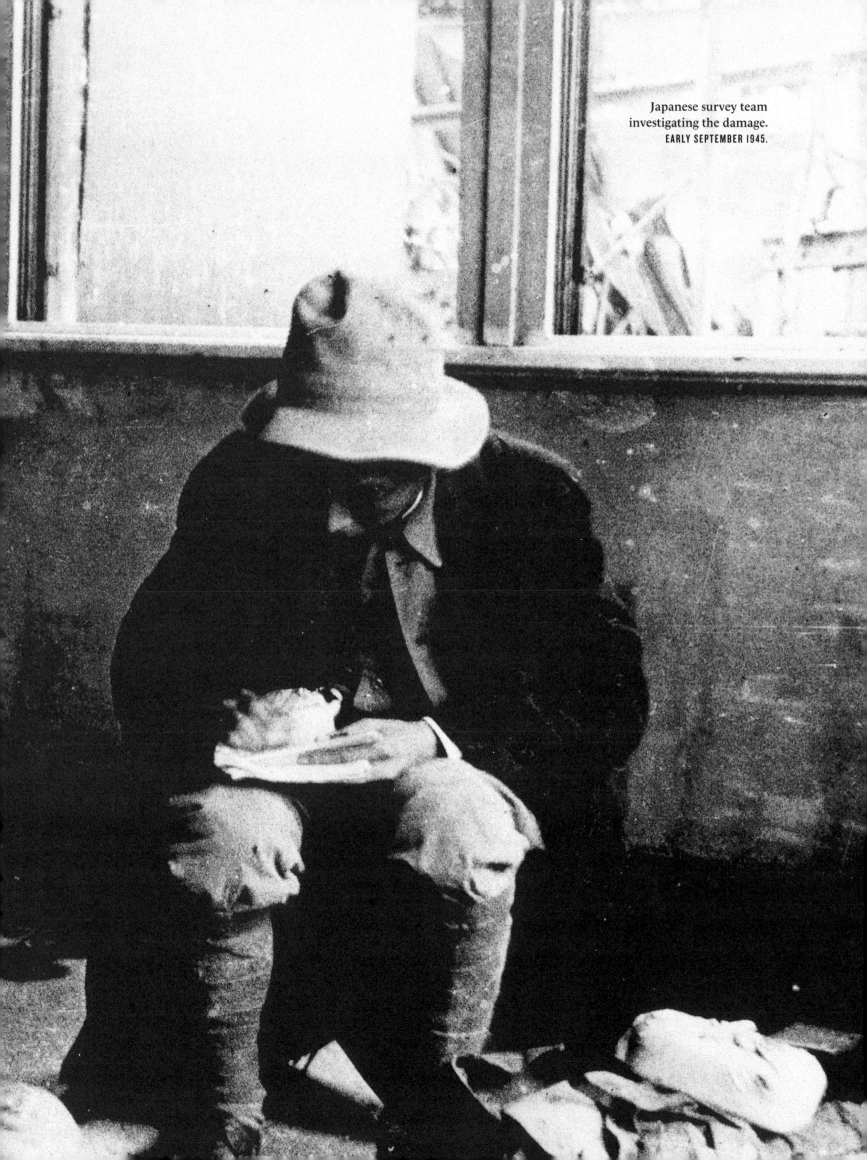

Japanese survey team
investigating the damage.
EARLY SEPTEMBER 1945.

The atomic bomb exploded
about a third of a mile above
this location, the Matsuyama-
machi intersection.
AROUND 2:00 P.M., AUGUST 10, 1945.

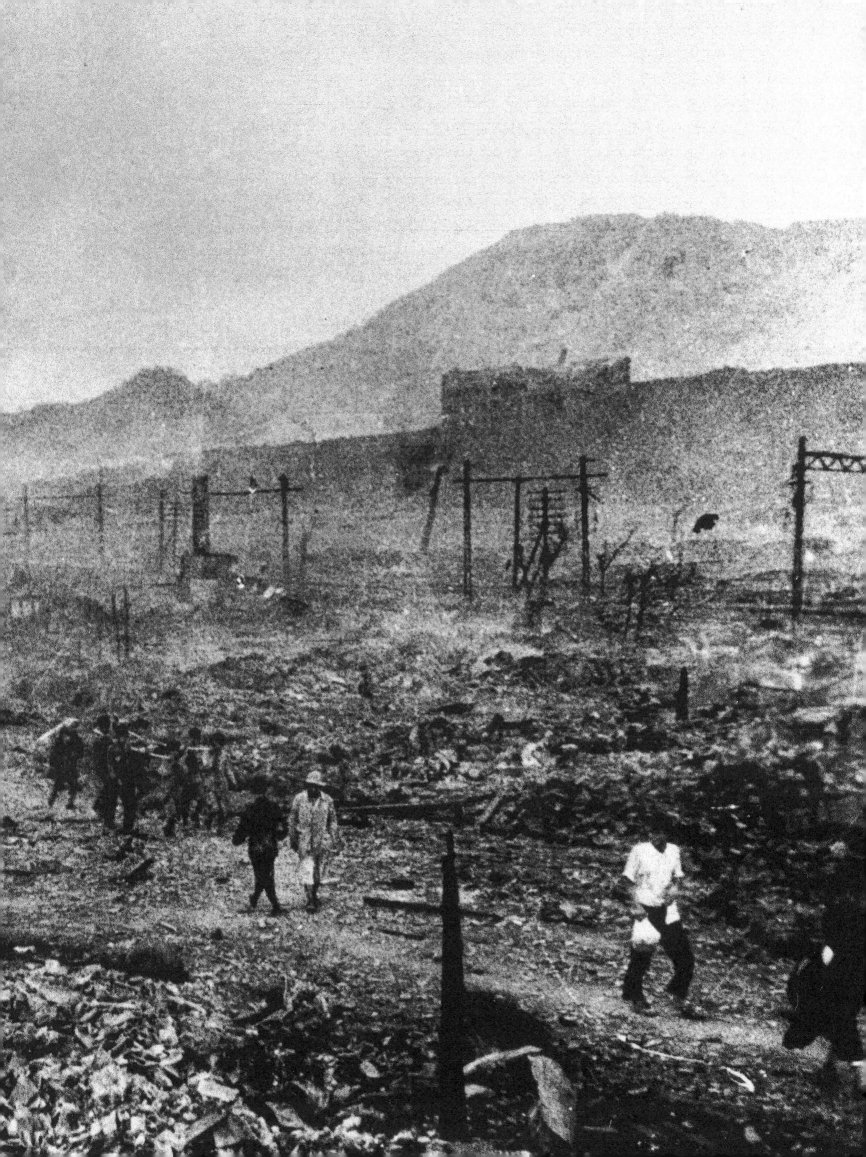

Looking north, just under half
a mile south of ground zero.
AFTERNOON, AUGUST 10, 1945.

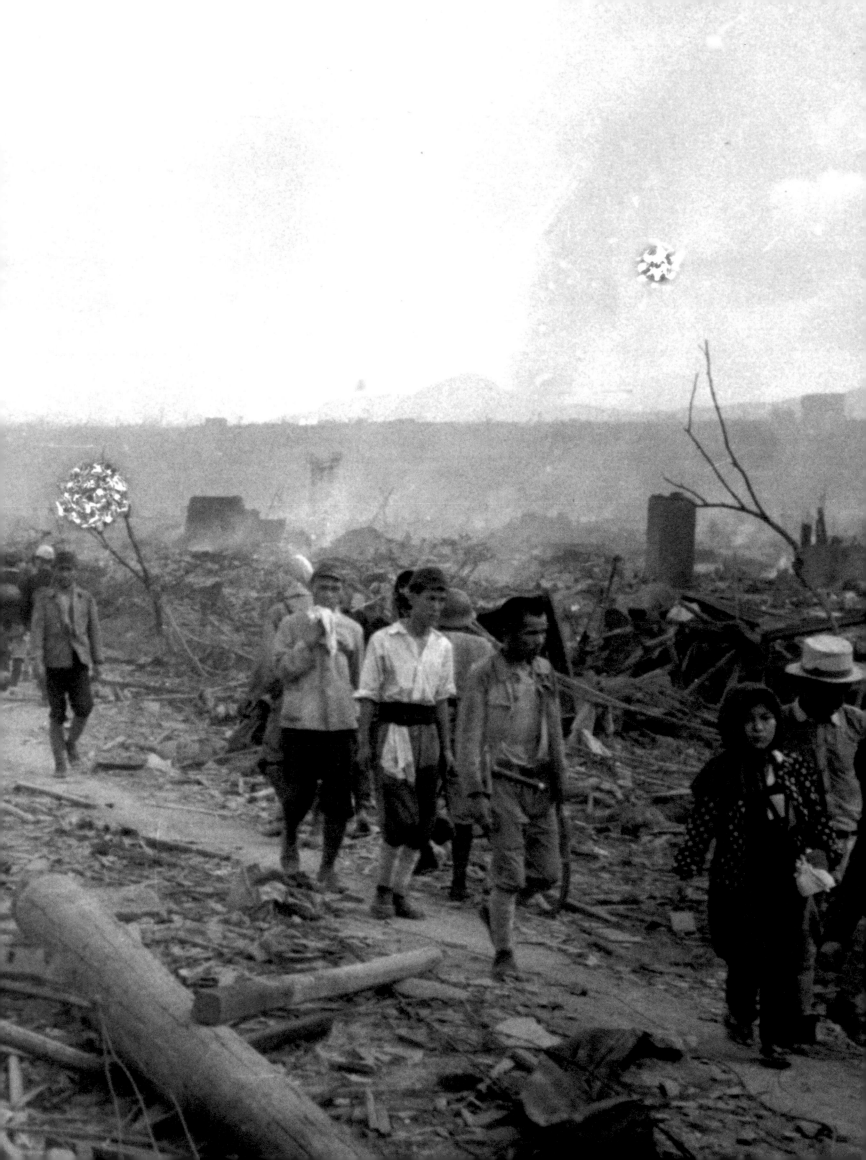

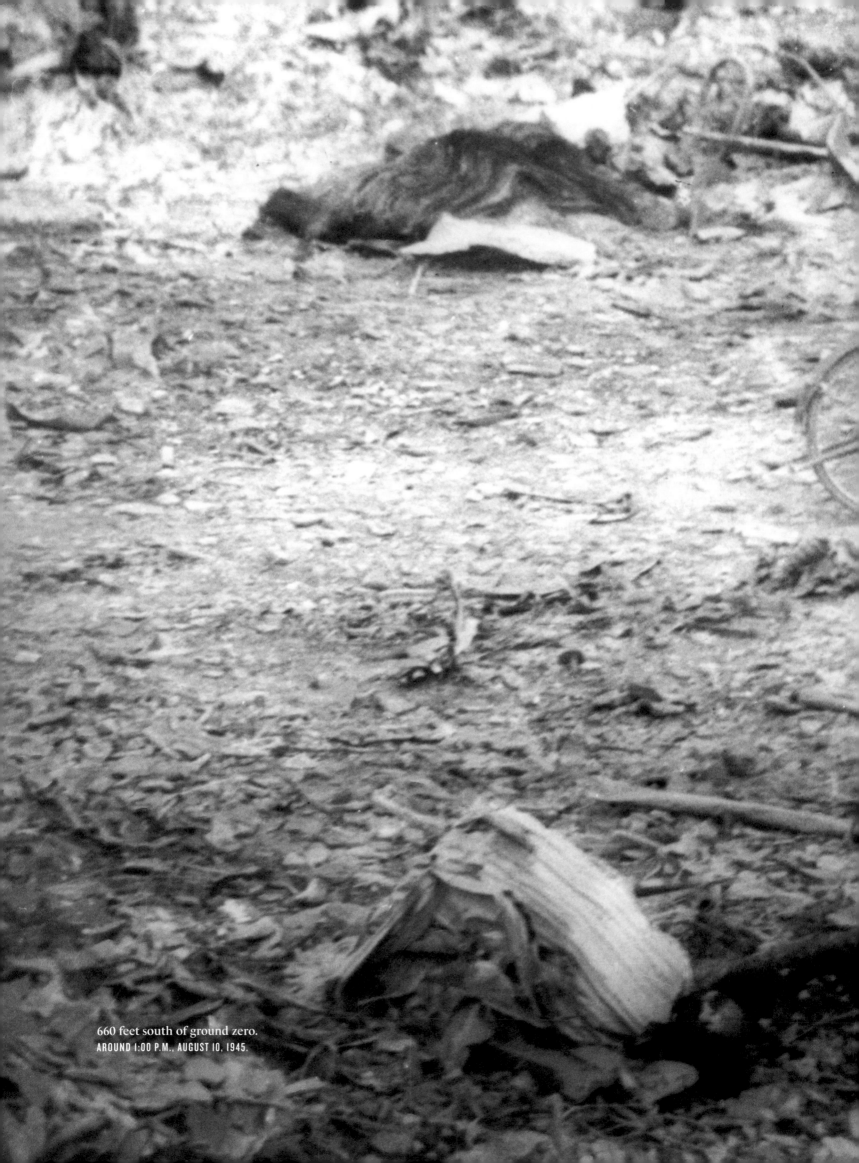

660 feet south of ground zero.
AROUND 1:00 P.M., AUGUST 10, 1945.

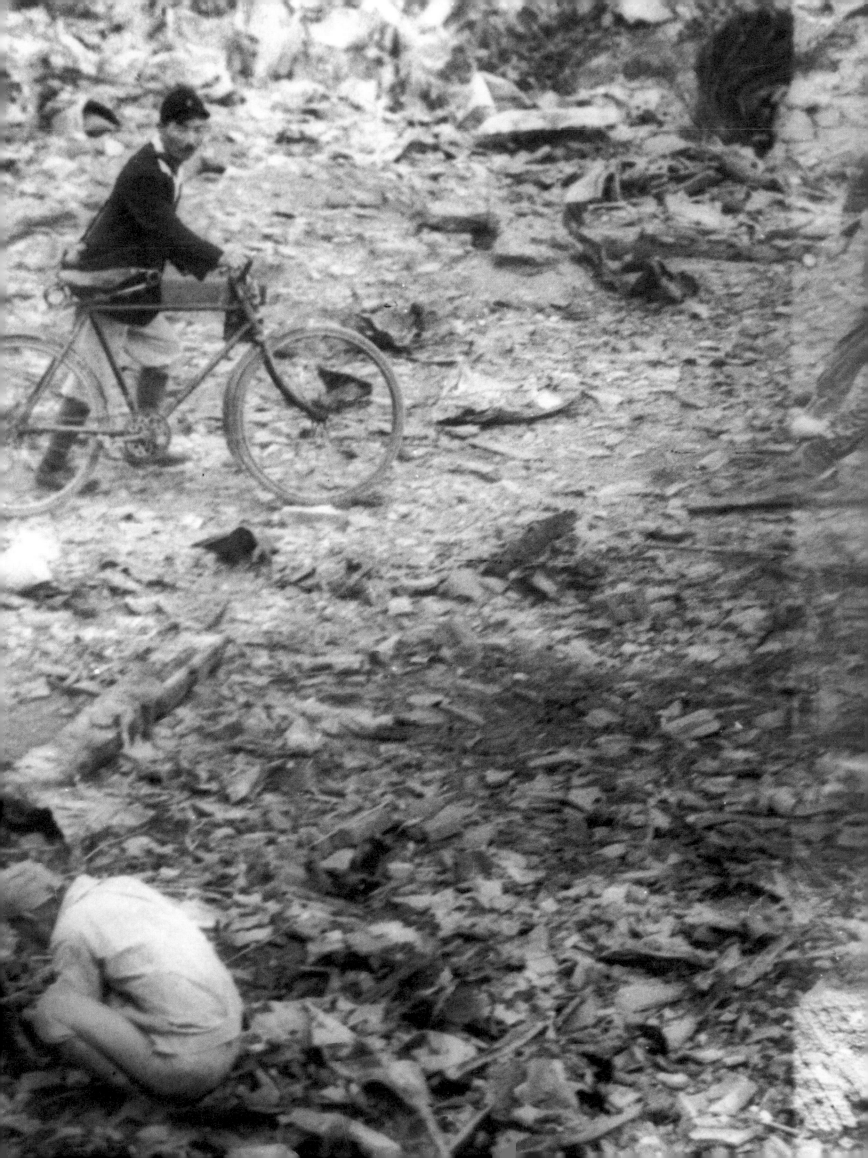

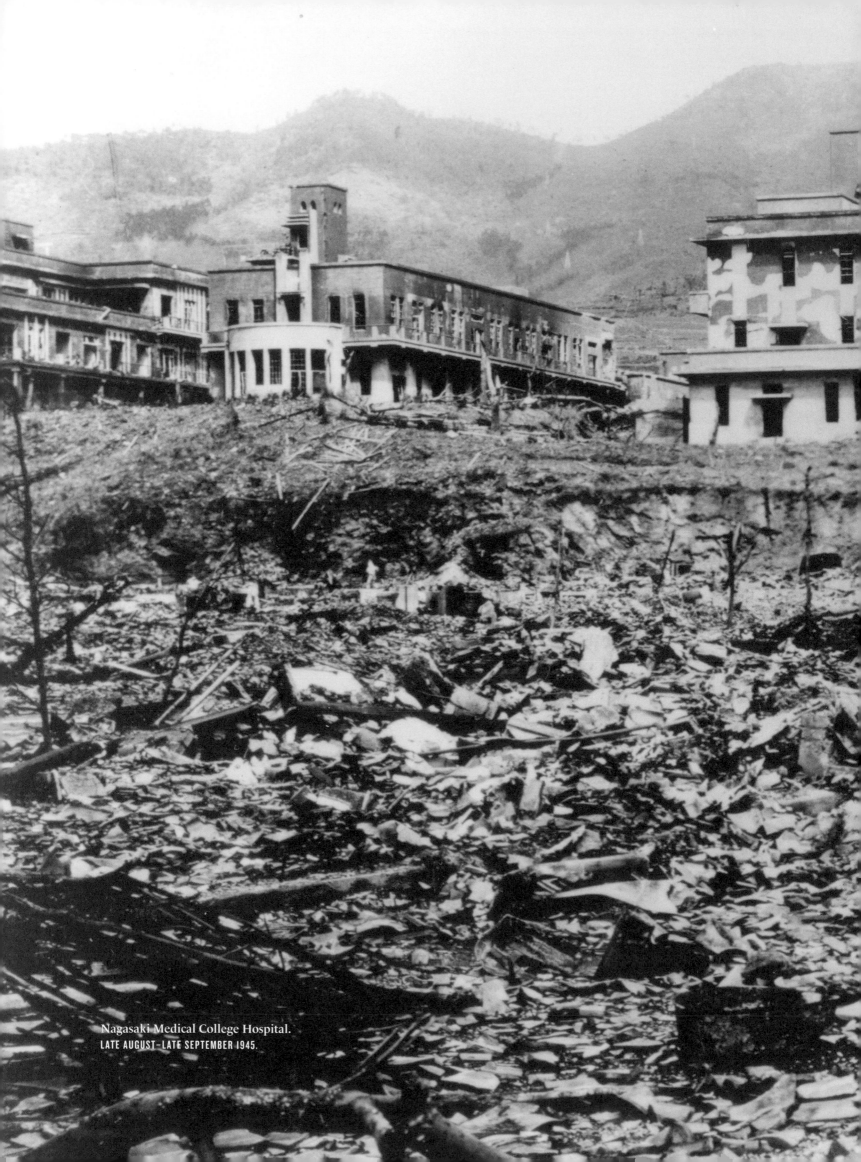

Nagasaki Medical College Hospital.
LATE AUGUST–LATE SEPTEMBER 1945.

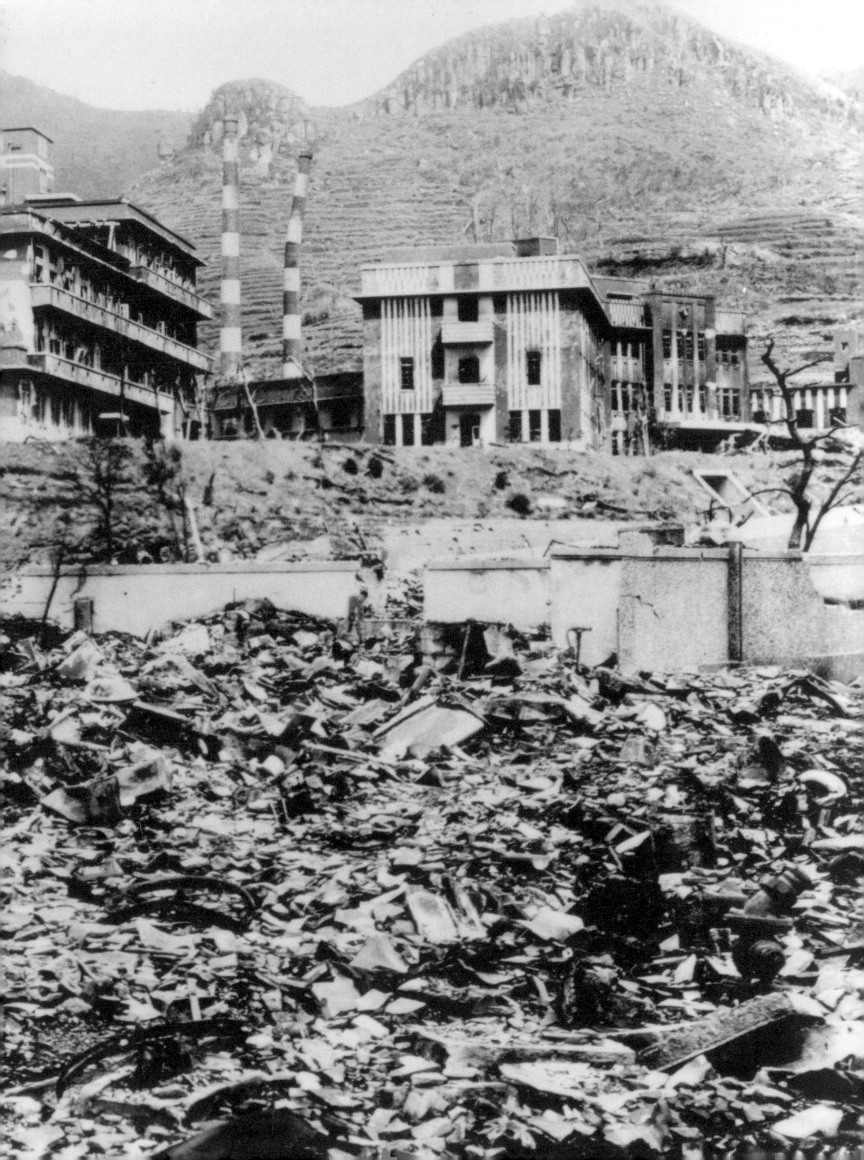

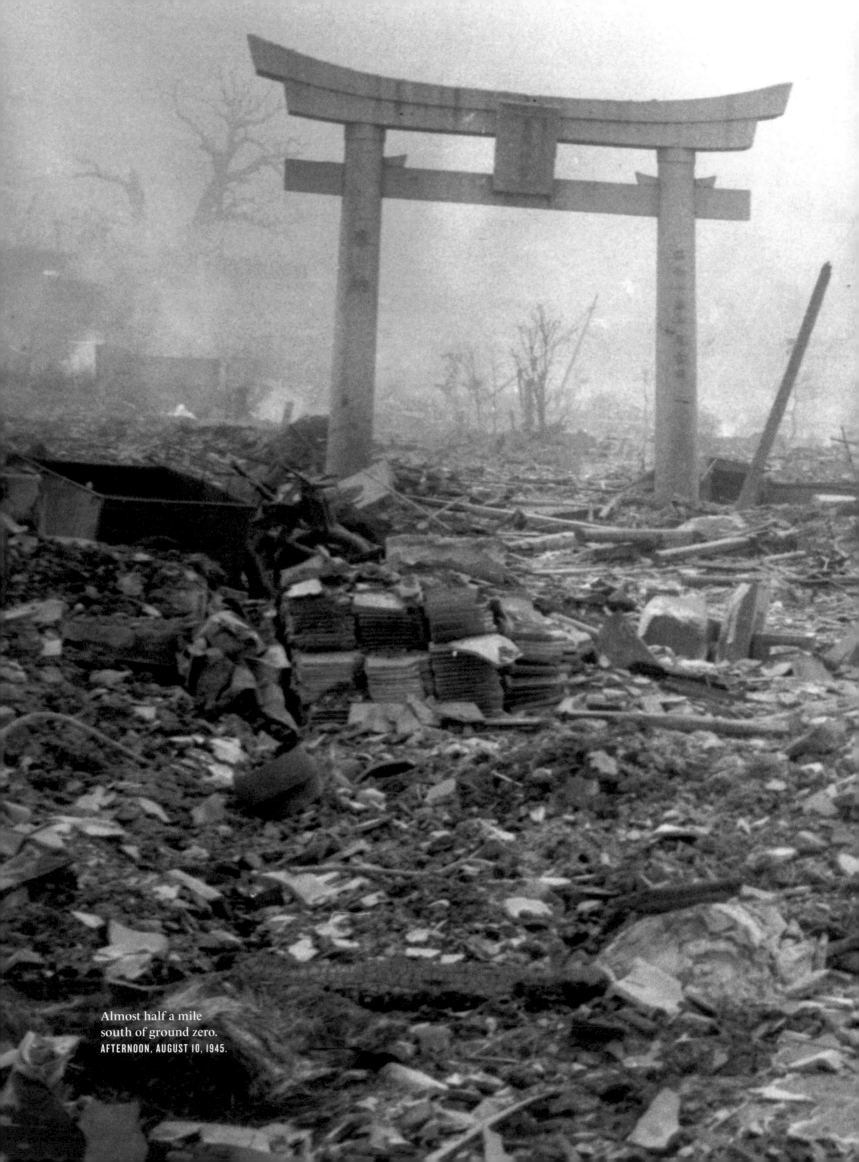

Almost half a mile
south of ground zero.
AFTERNOON, AUGUST 10, 1945.

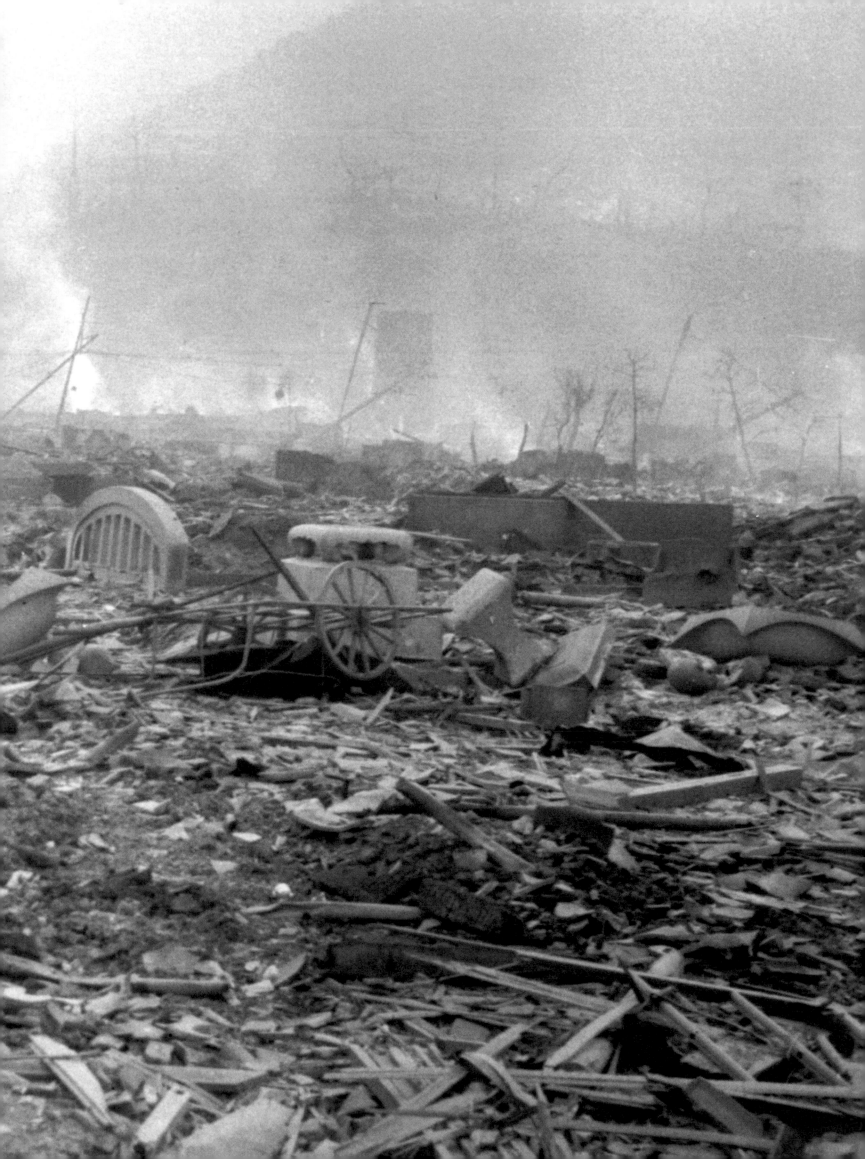

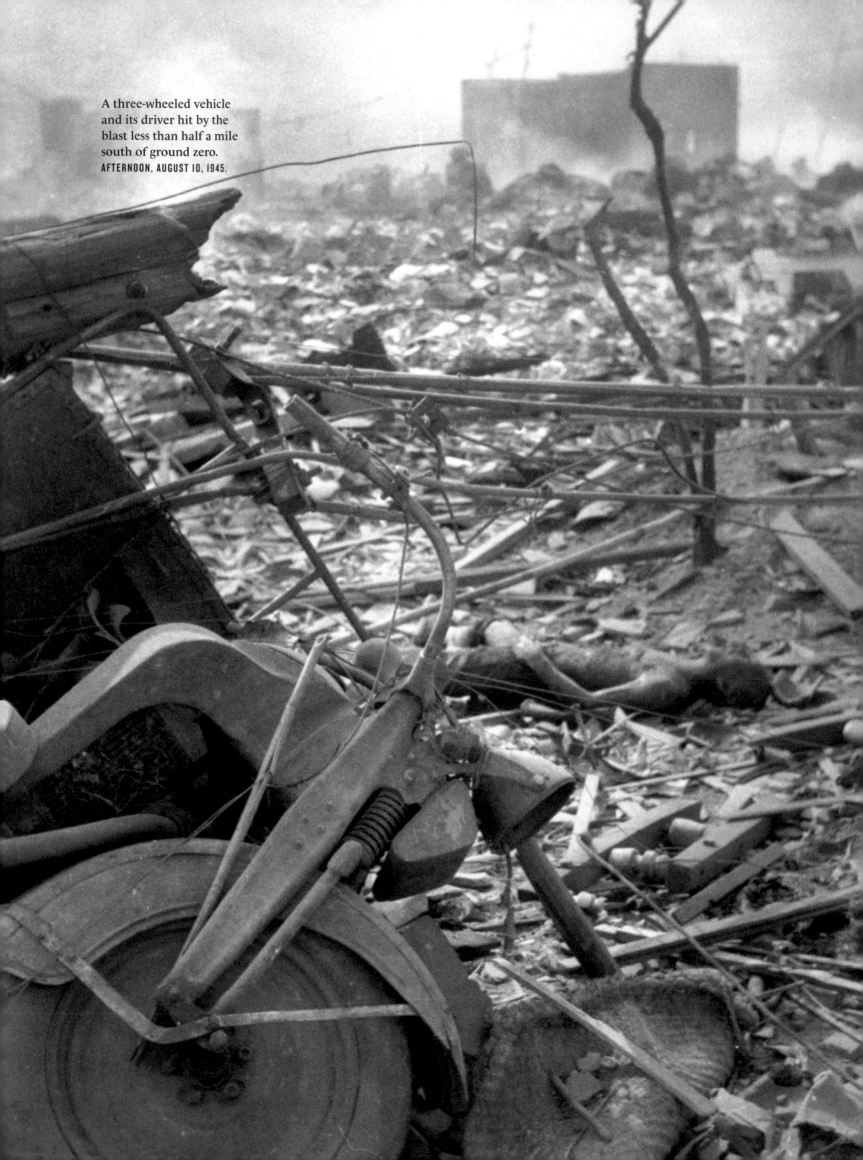

A three-wheeled vehicle and its driver hit by the blast less than half a mile south of ground zero. AFTERNOON, AUGUST 10, 1945.

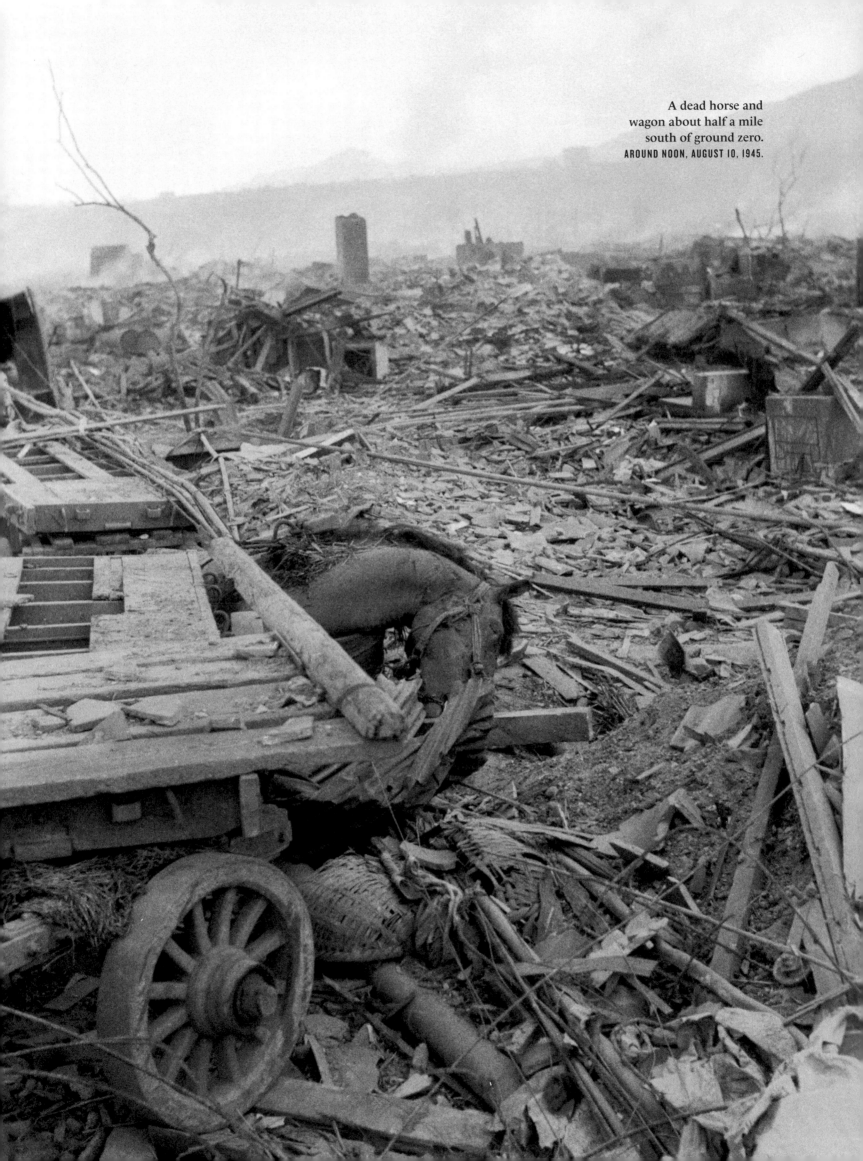

A dead horse and
wagon about half a mile
south of ground zero.
AROUND NOON, AUGUST 10, 1945.

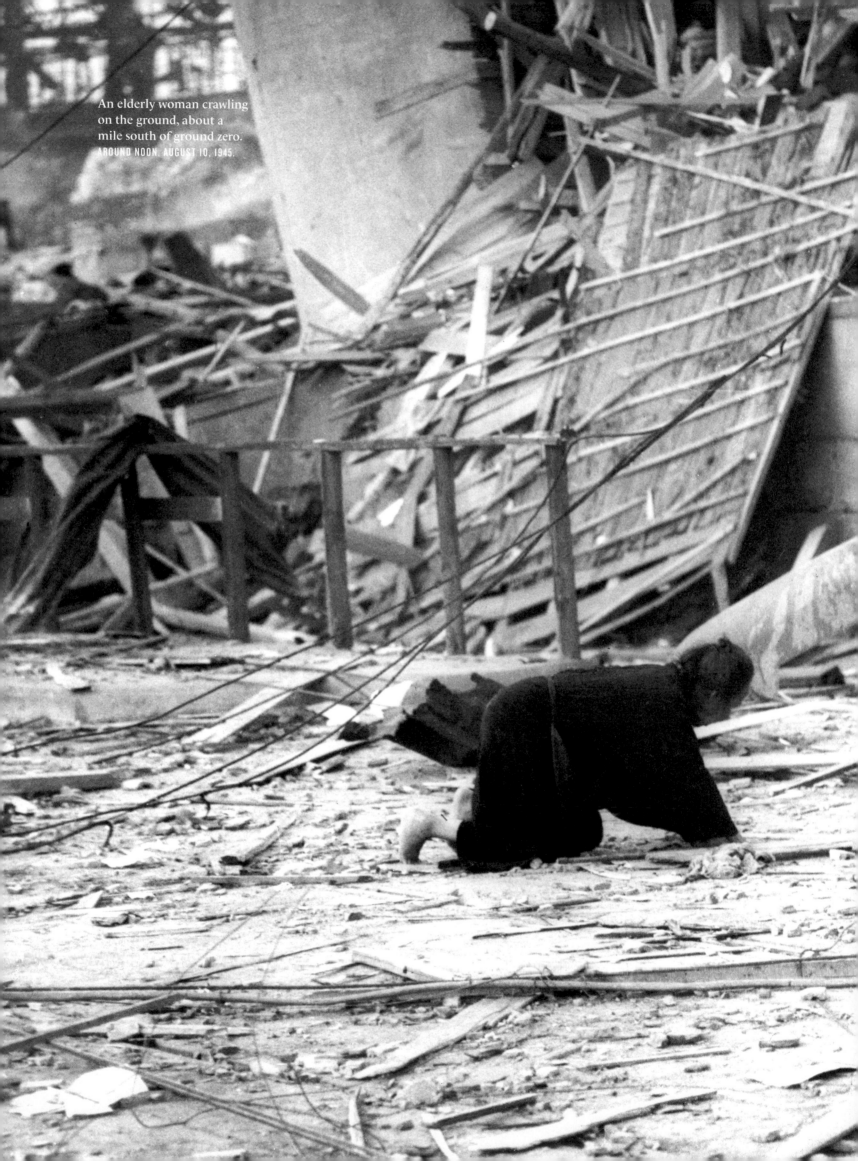

An elderly woman crawling on the ground, about a mile south of ground zero.
AROUND NOON, AUGUST 10, 1945.

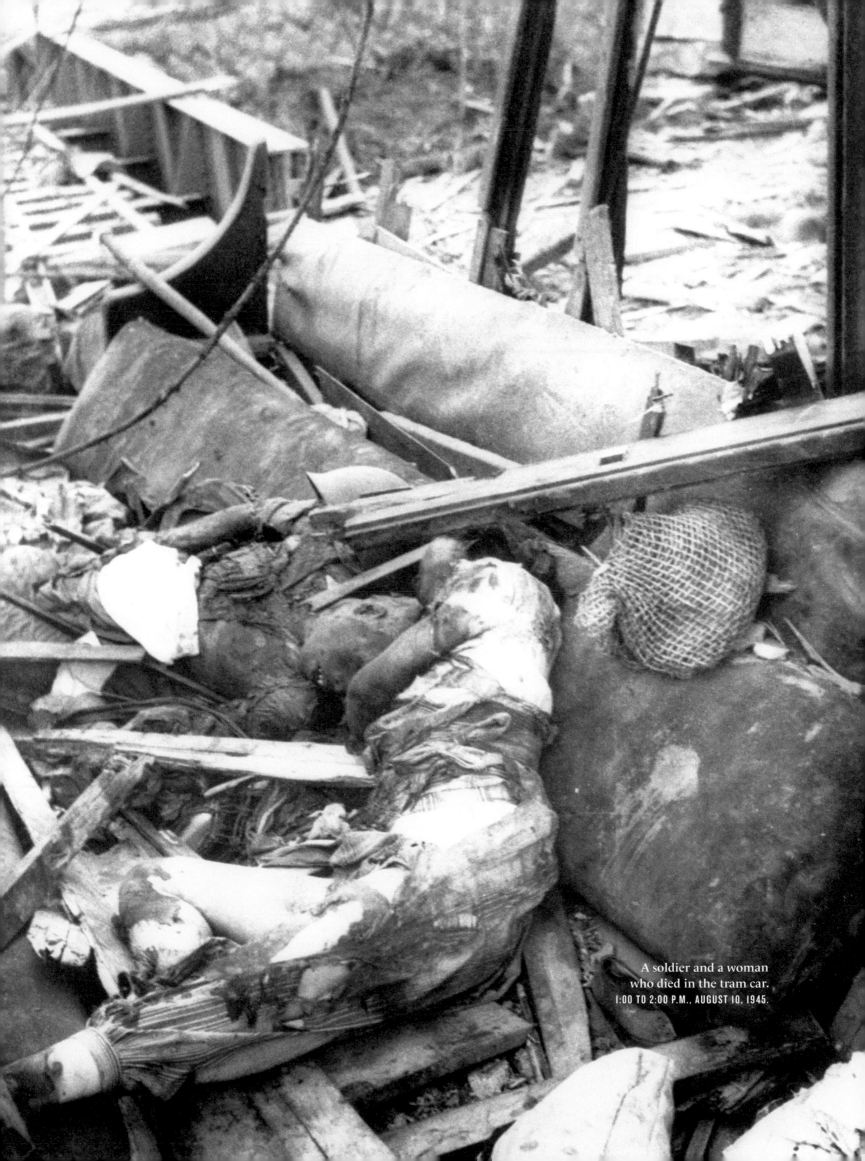

A soldier and a woman
who died in the tram car.
1:00 TO 2:00 P.M., AUGUST 10, 1945.

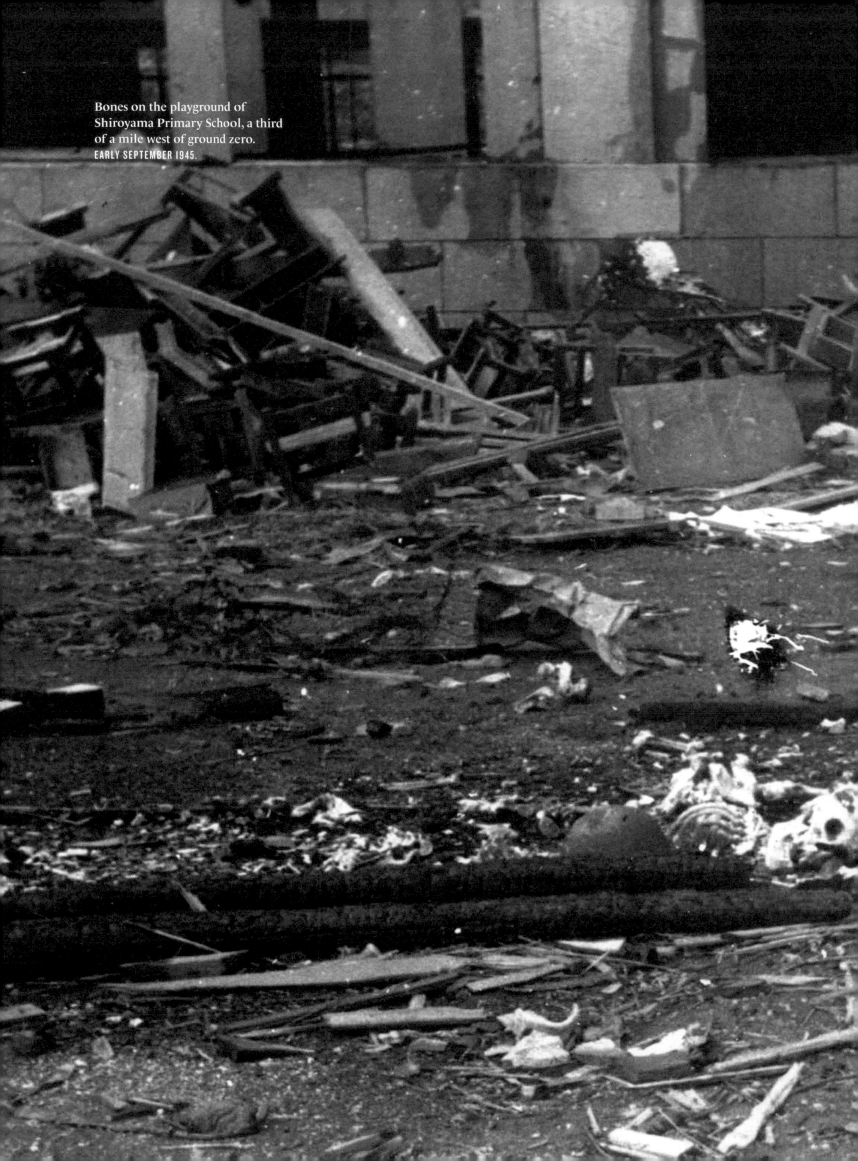

Bones on the playground of Shiroyama Primary School, a third of a mile west of ground zero.
EARLY SEPTEMBER 1945.

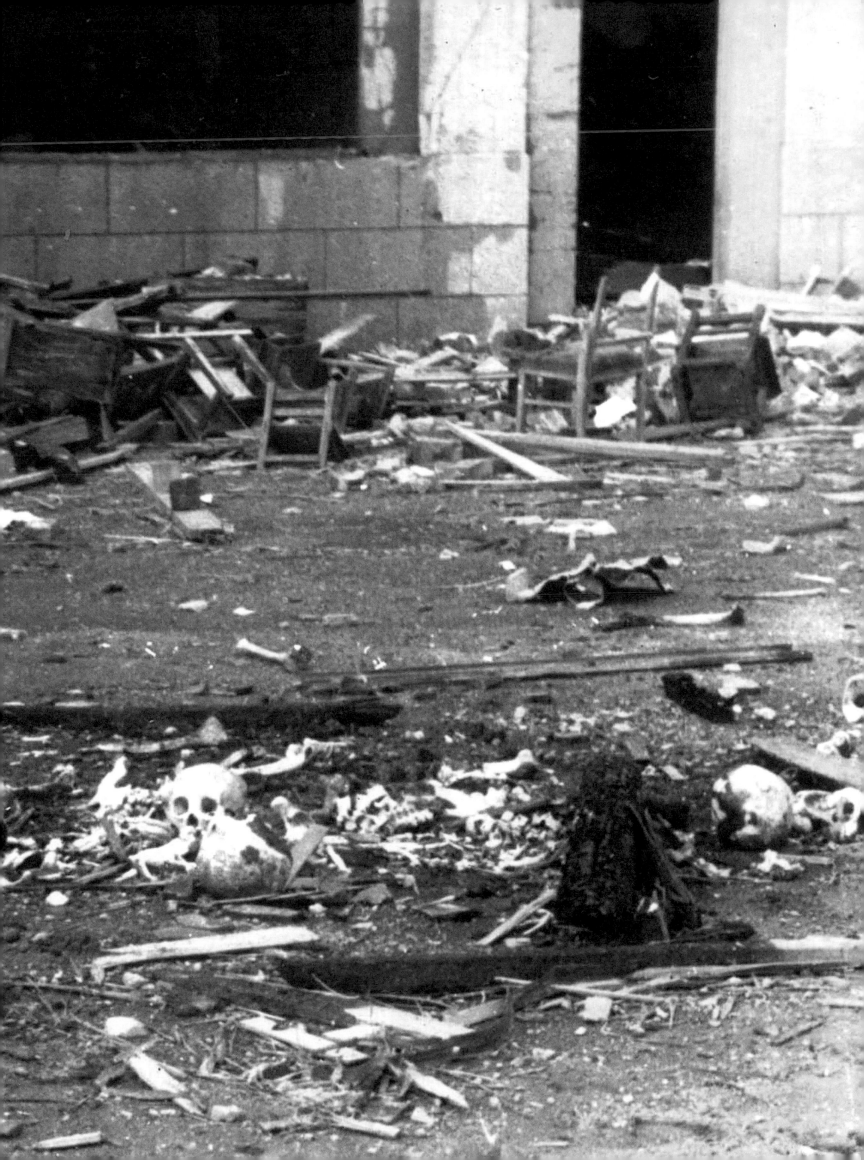

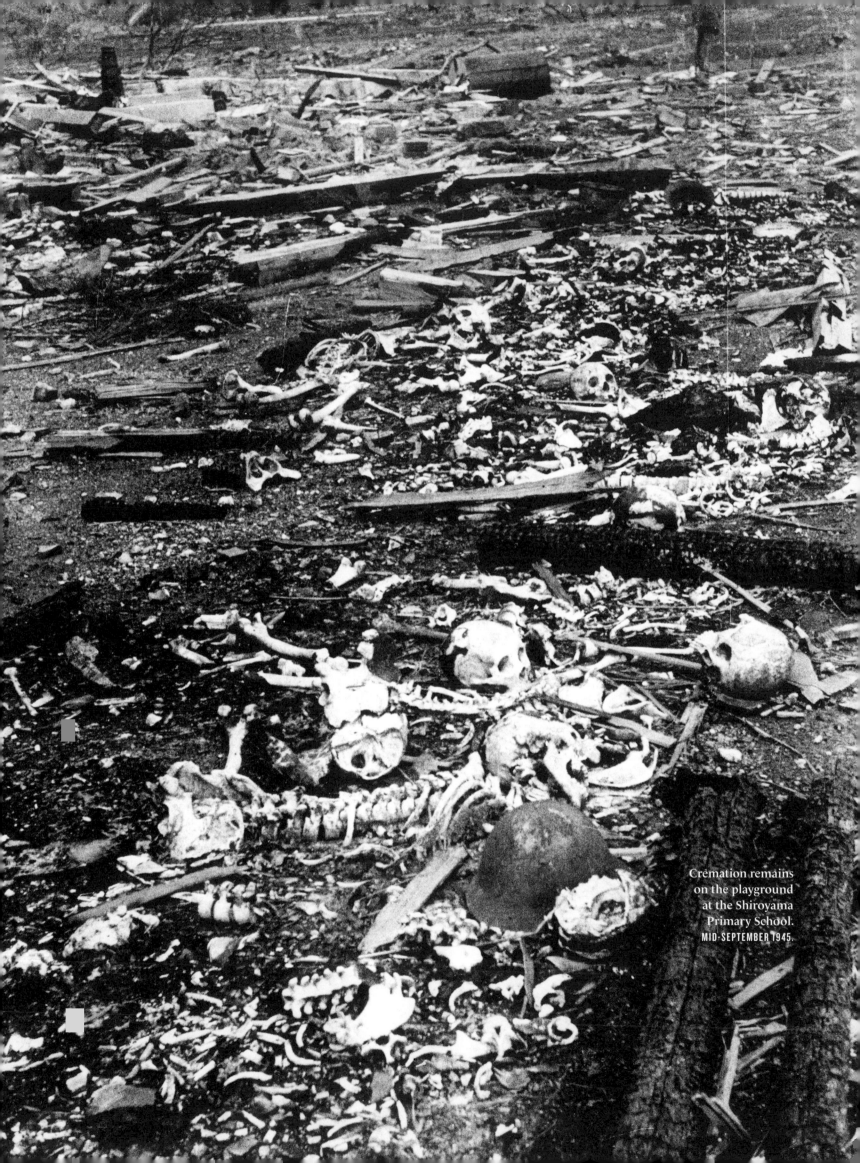

Cremation remains
on the playground
at the Shiroyama
Primary School.
MID-SEPTEMBER 1945.

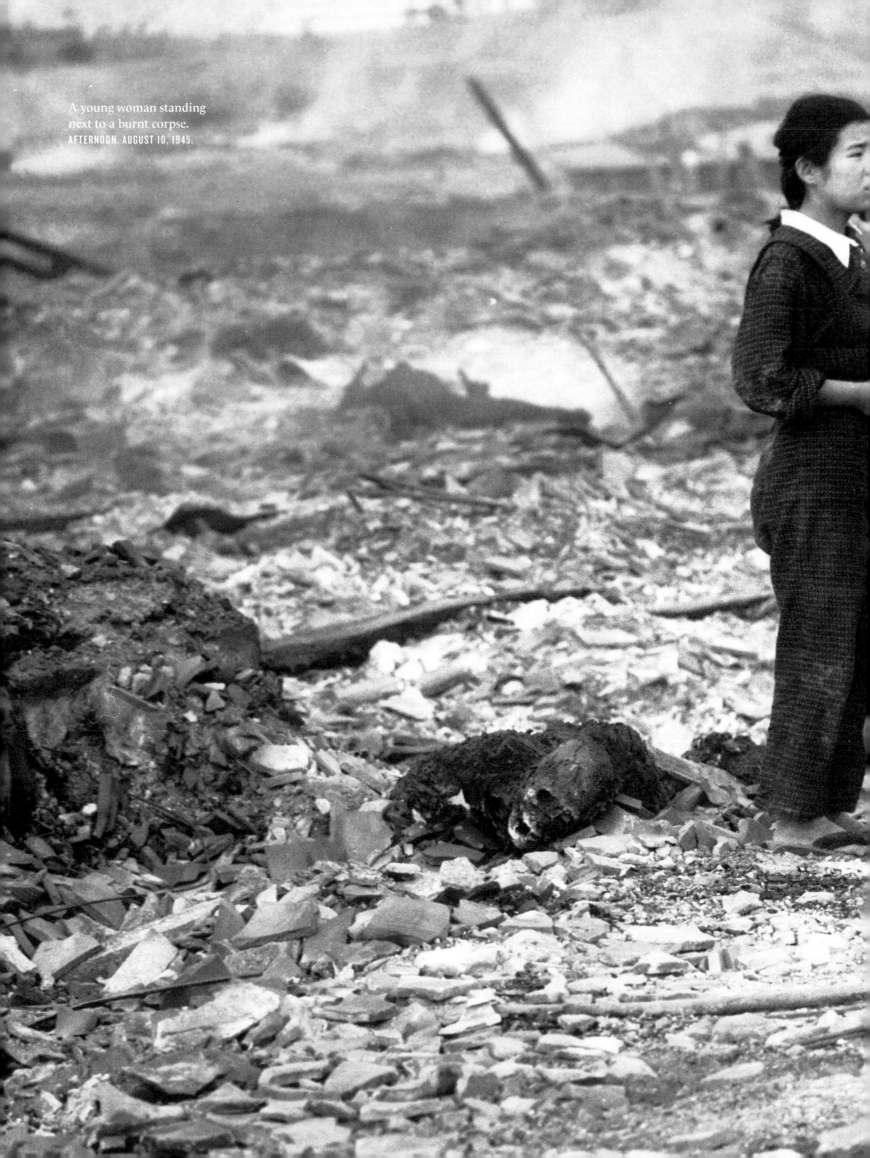

A young woman standing
next to a burnt corpse.
AFTERNOON, AUGUST 10, 1945.

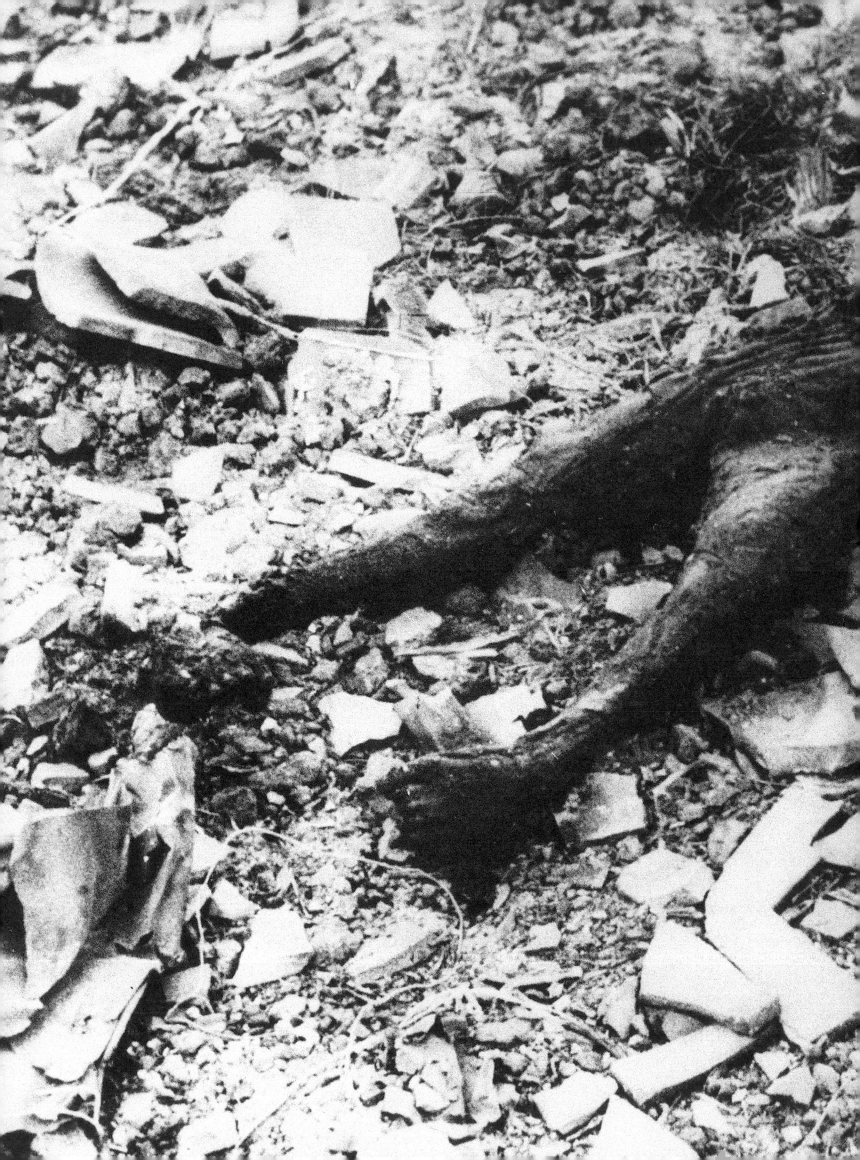

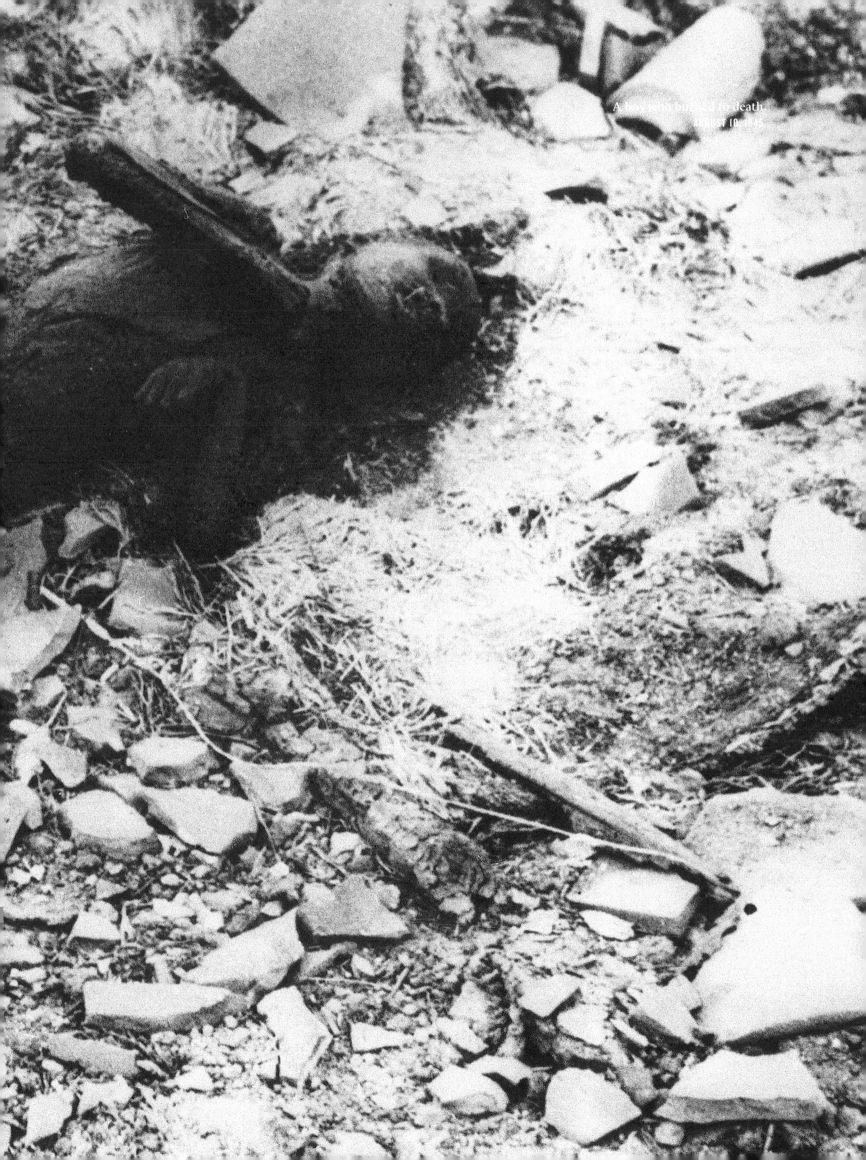

A boy who burned to death.
AUGUST 10, 1945

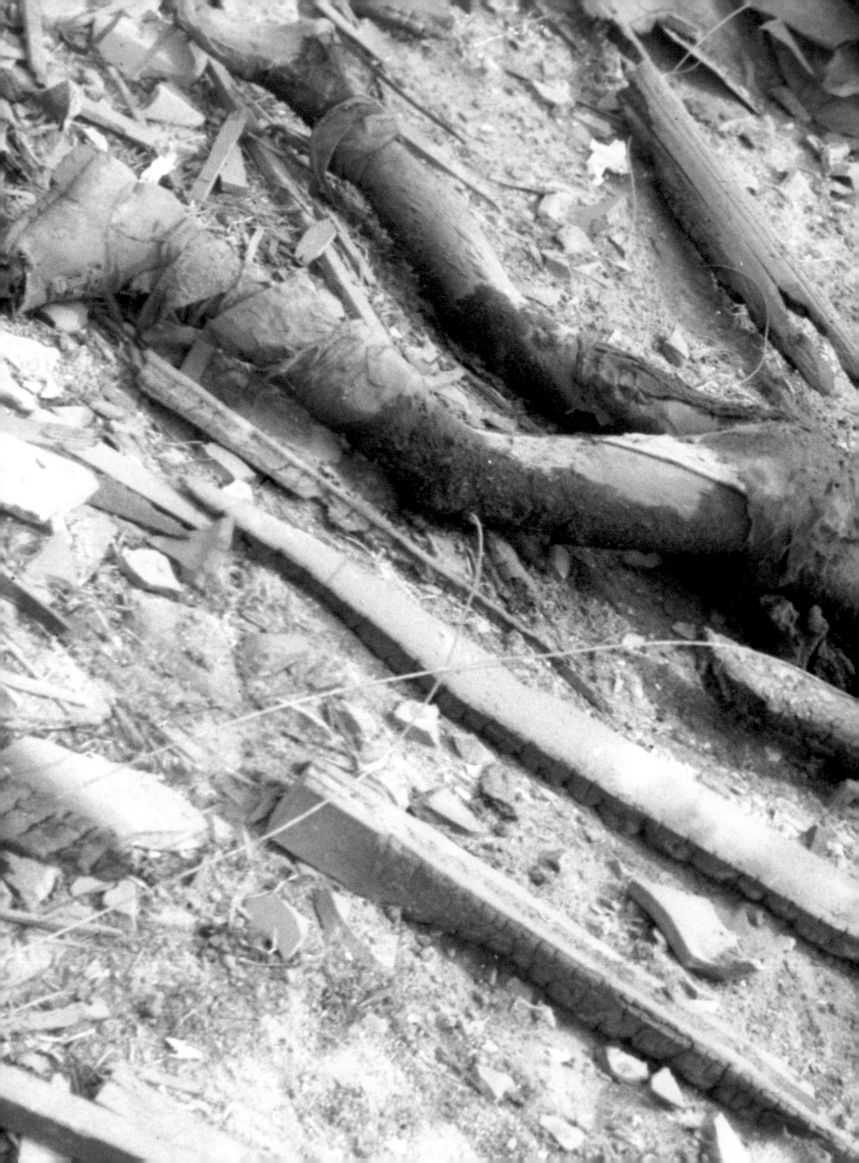

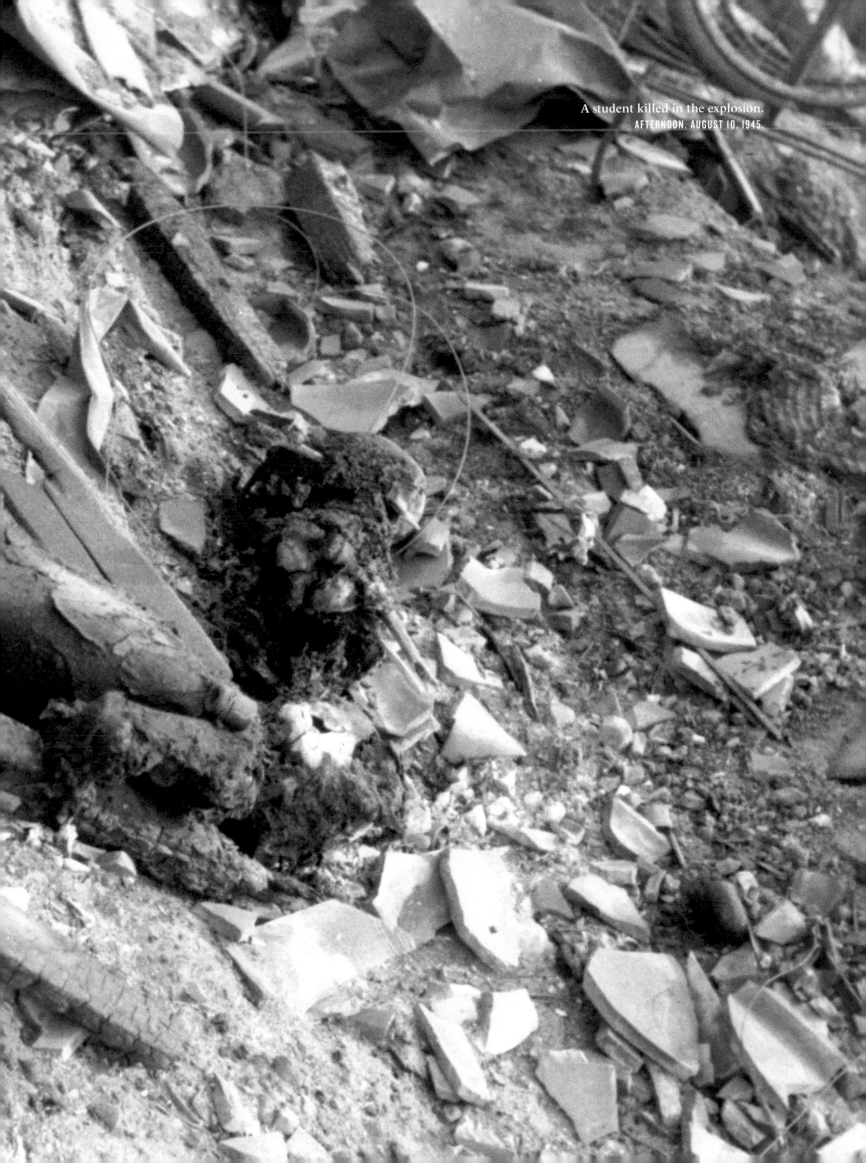

A student killed in the explosion.
AFTERNOON, AUGUST 10, 1945.

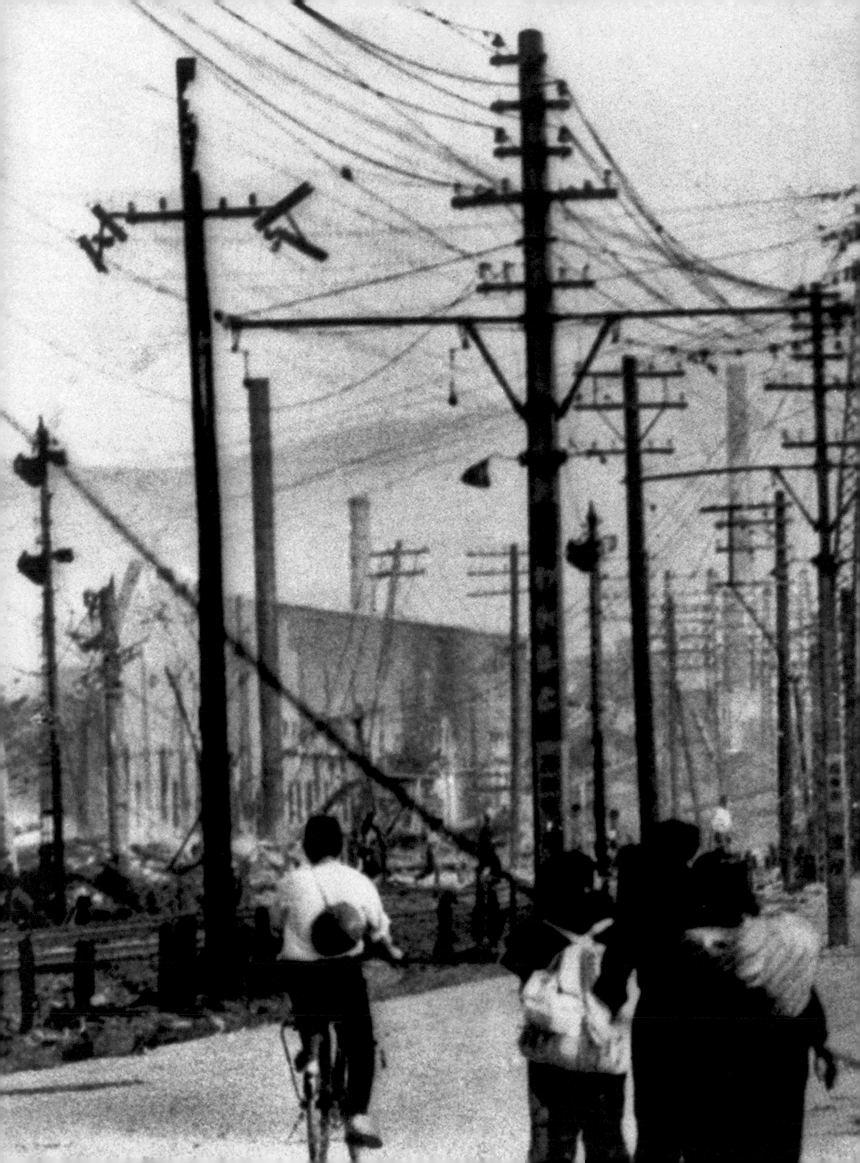

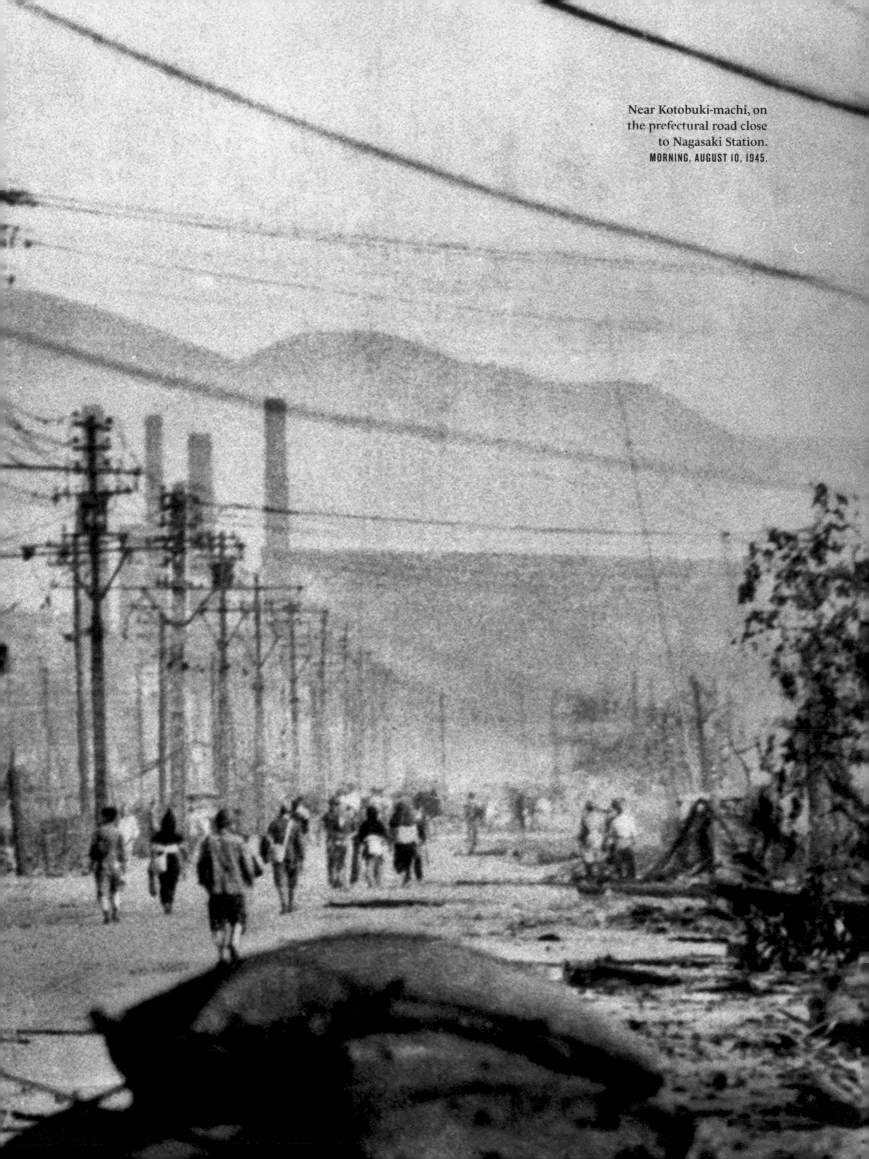

Near Kotobuki-machi, on
the prefectural road close
to Nagasaki Station.
MORNING, AUGUST 10, 1945.

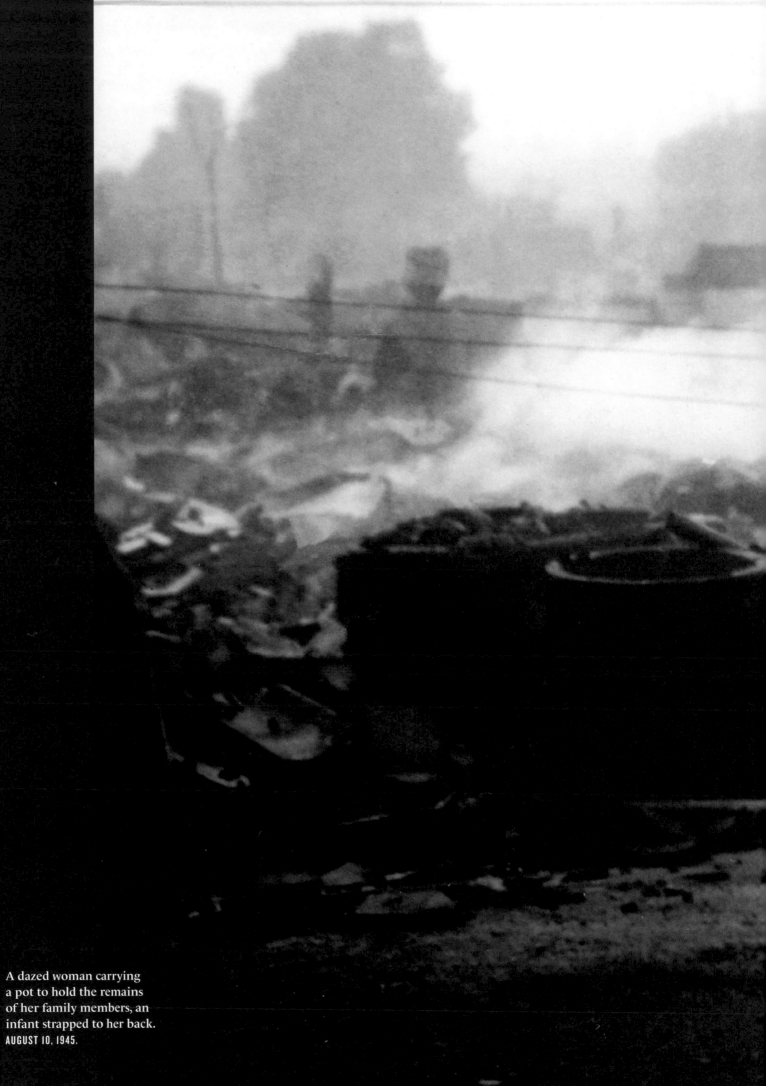

A dazed woman carrying
a pot to hold the remains
of her family members, an
infant strapped to her back.
AUGUST 10, 1945.

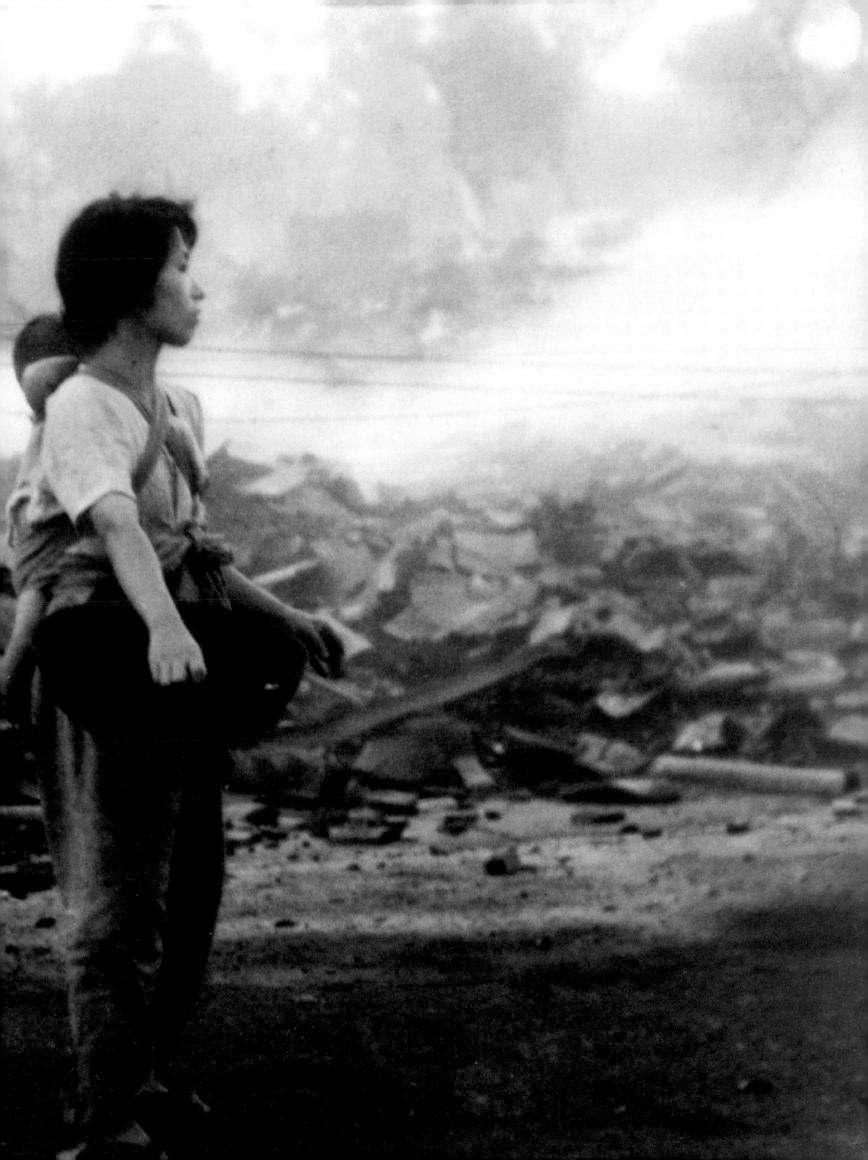

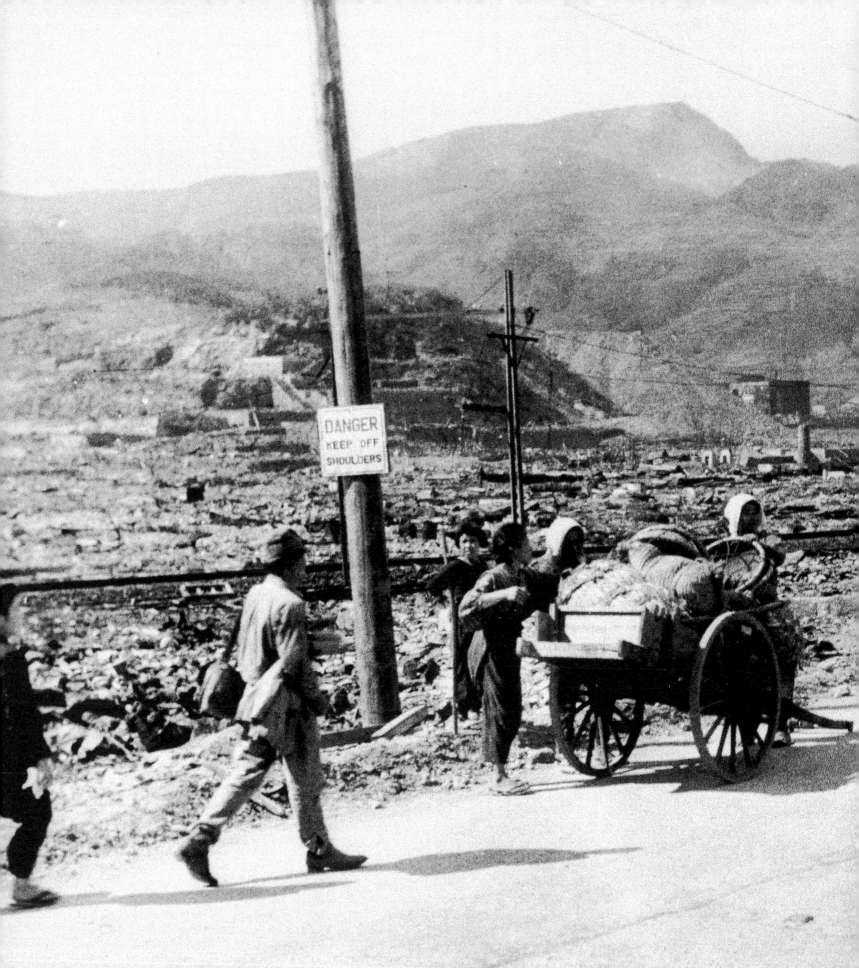

A cart loaded with bags of potatoes on the left, with a US military dump truck on the right.
MID-OCTOBER 1945.

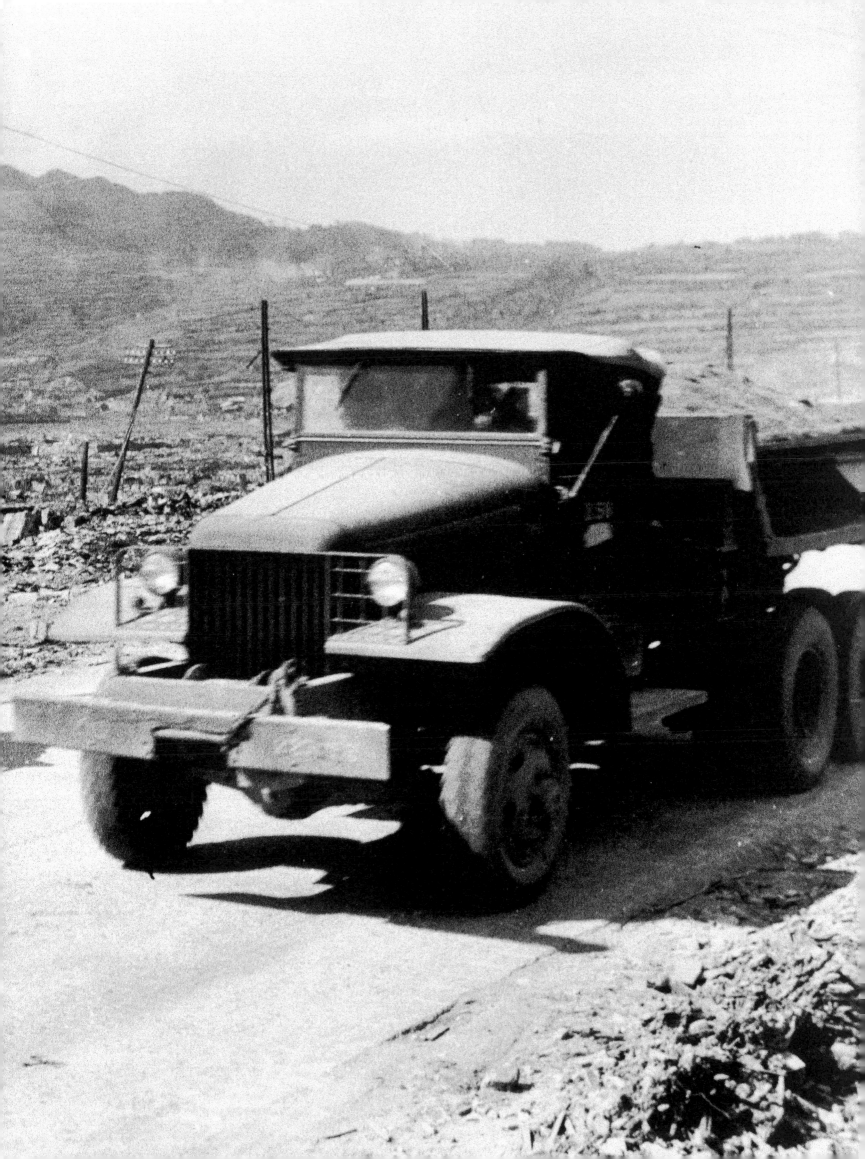

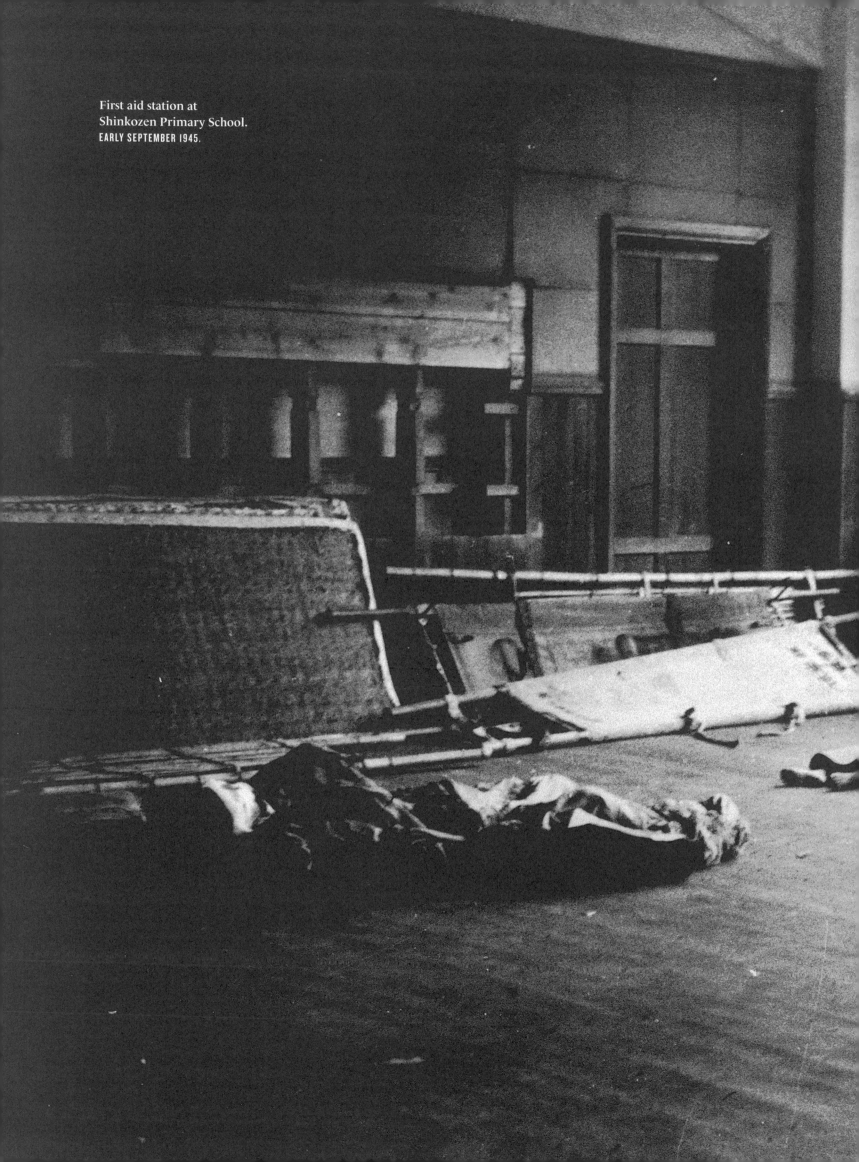

First aid station at
Shinkozen Primary School.
EARLY SEPTEMBER 1945.

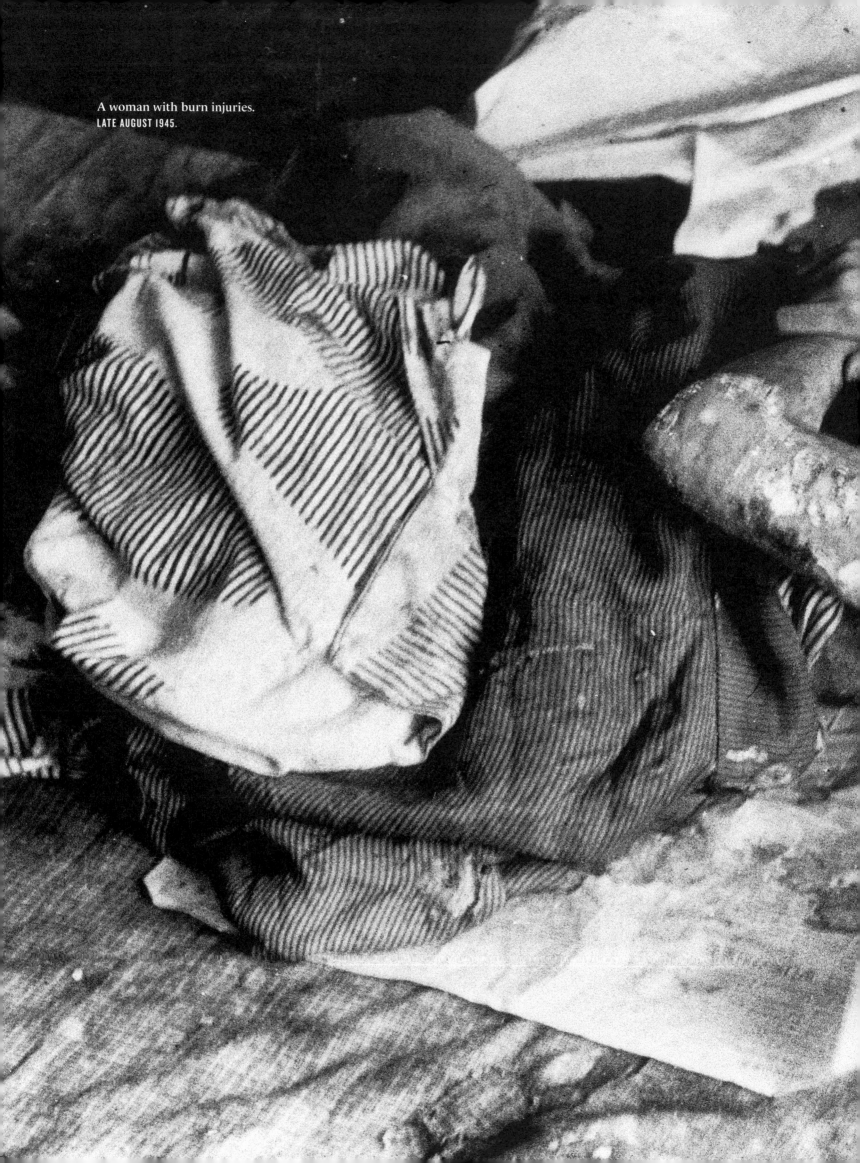

A woman with burn injuries.
LATE AUGUST 1945.

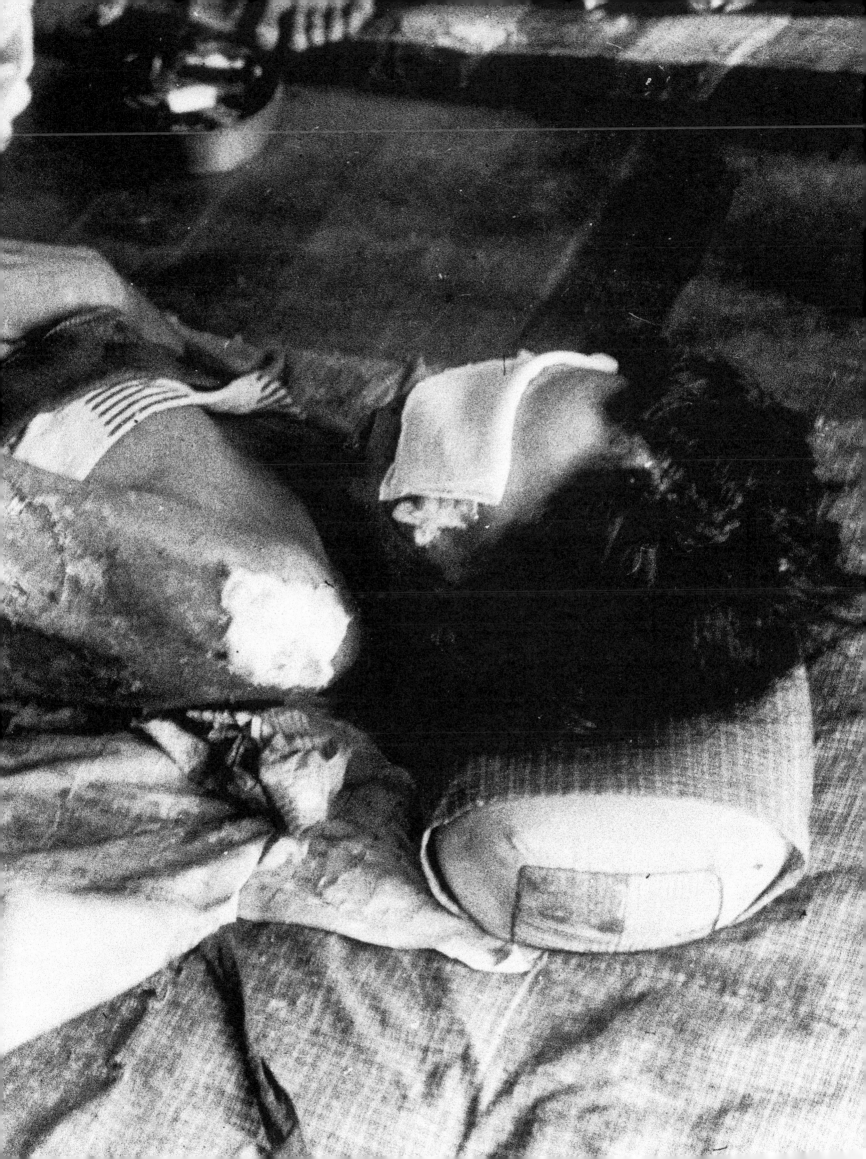

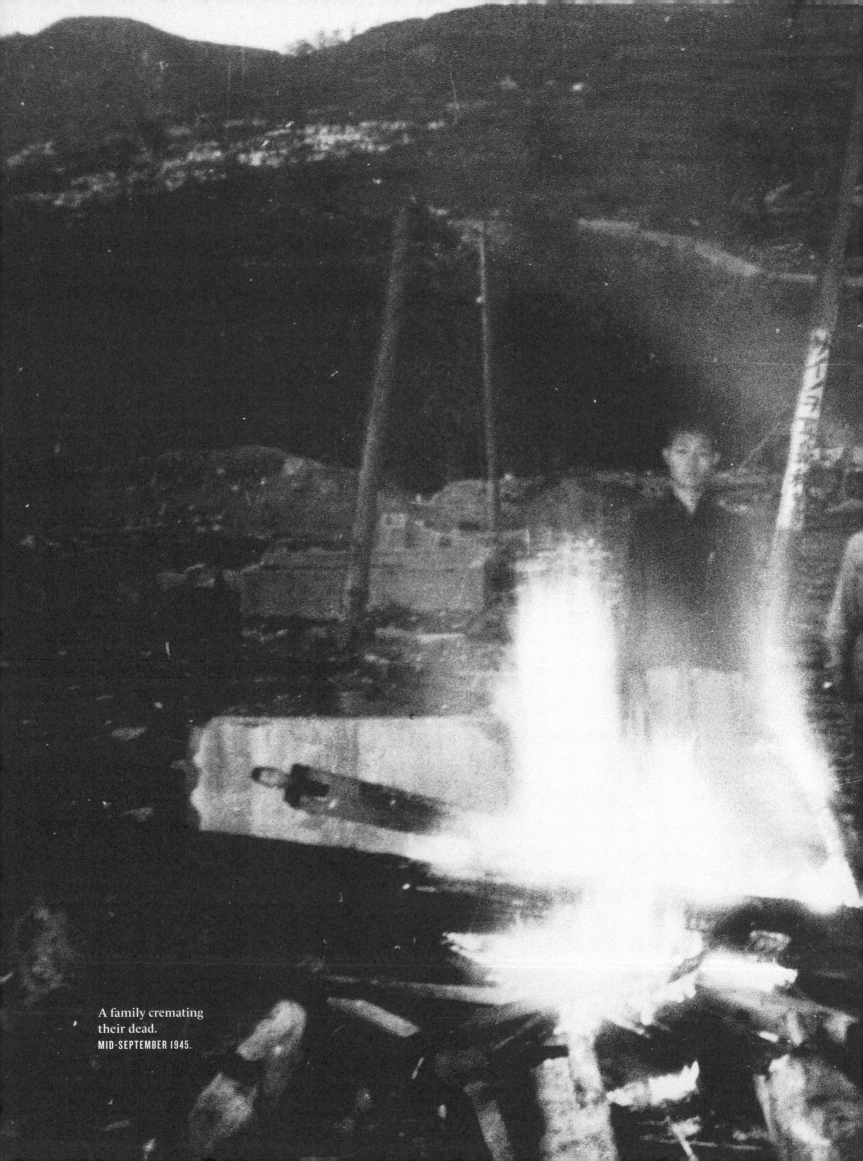

A family cremating
their dead.
MID-SEPTEMBER 1945.

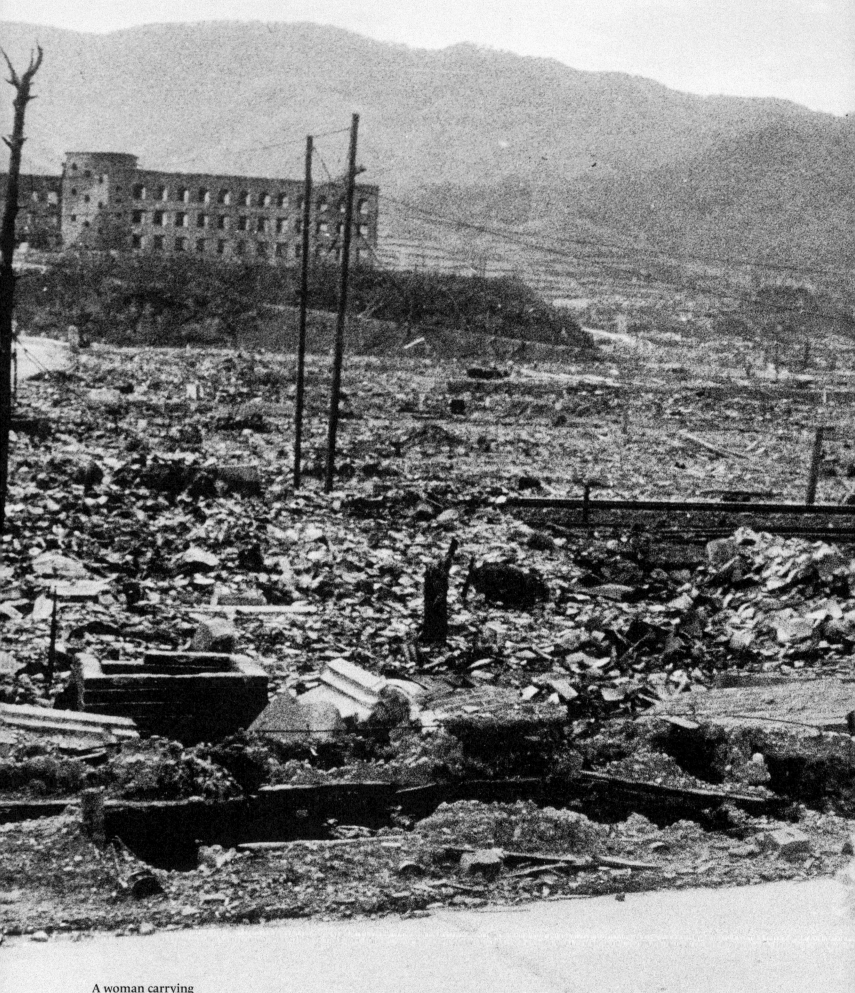

A woman carrying
human remains.
EARLY SEPTEMBER 1945.

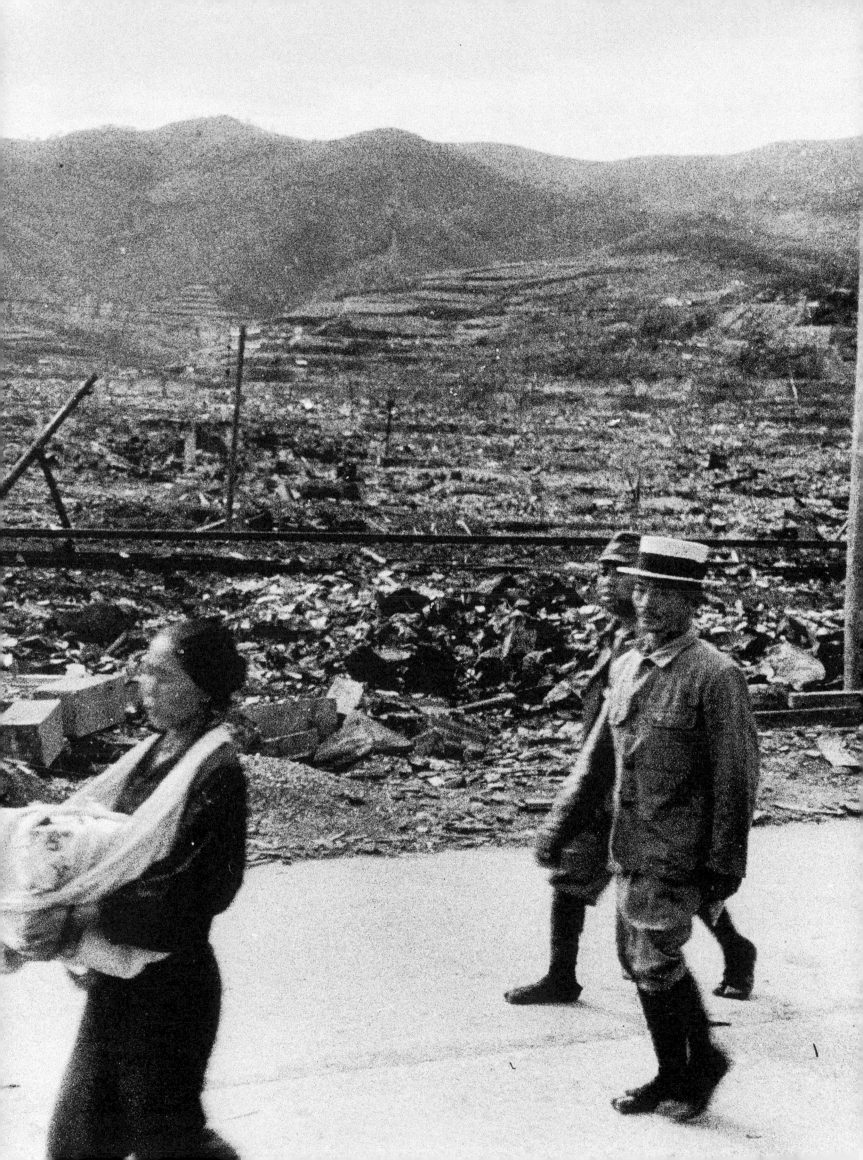

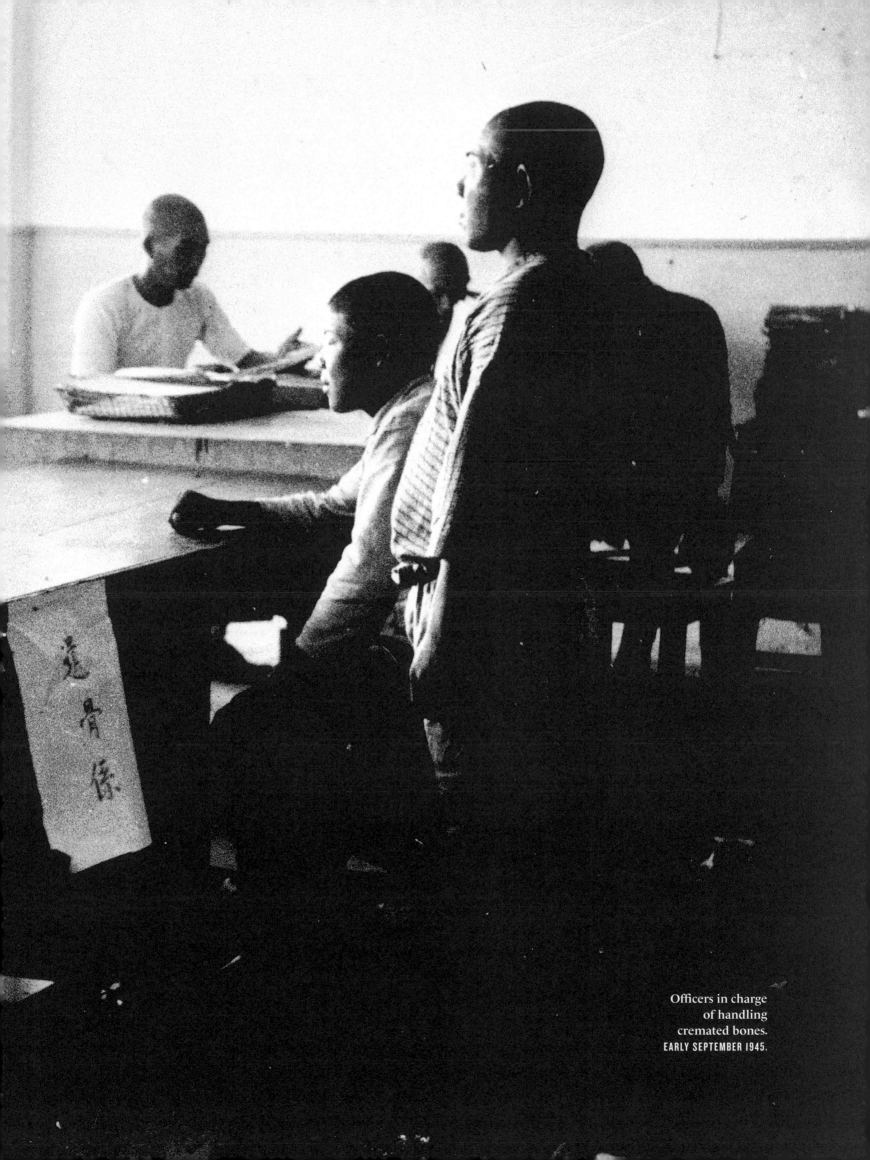

遺骨係

Officers in charge
of handling
cremated bones.
EARLY SEPTEMBER 1945.

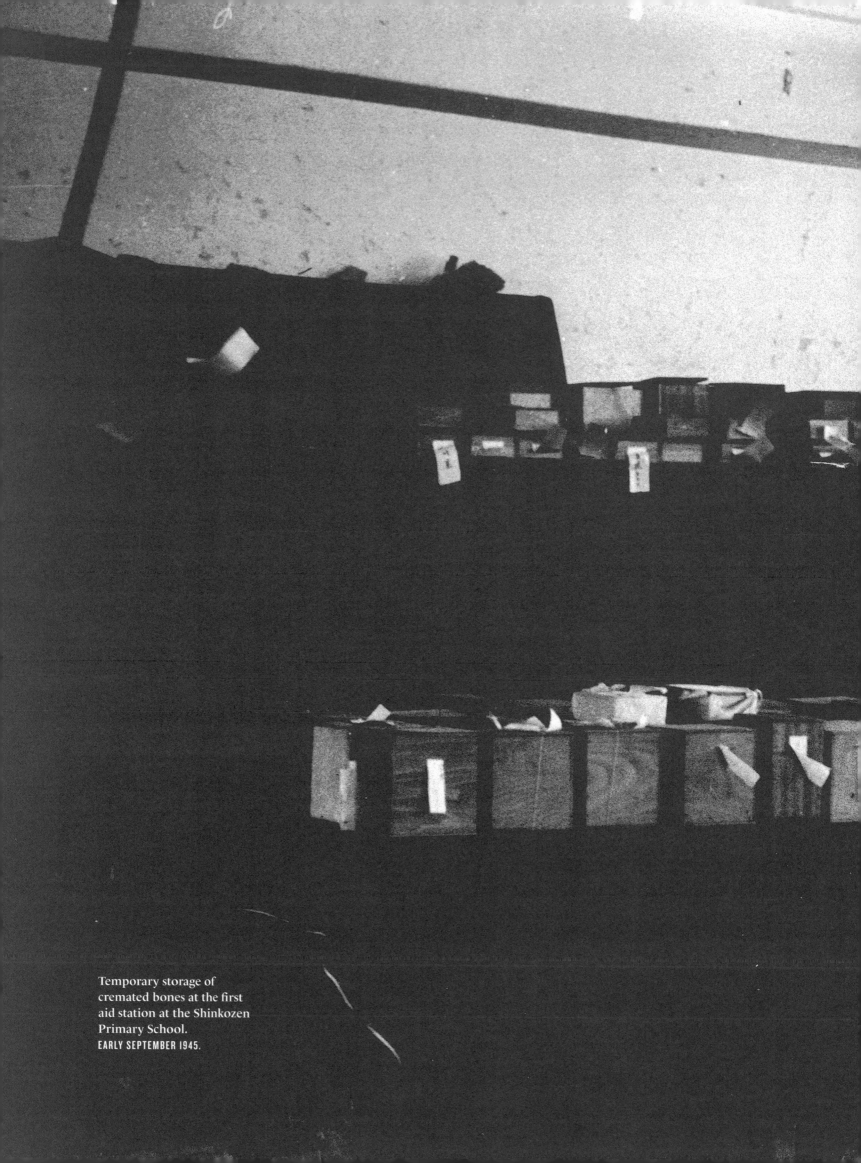

Temporary storage of
cremated bones at the first
aid station at the Shinkozen
Primary School.
EARLY SEPTEMBER 1945.

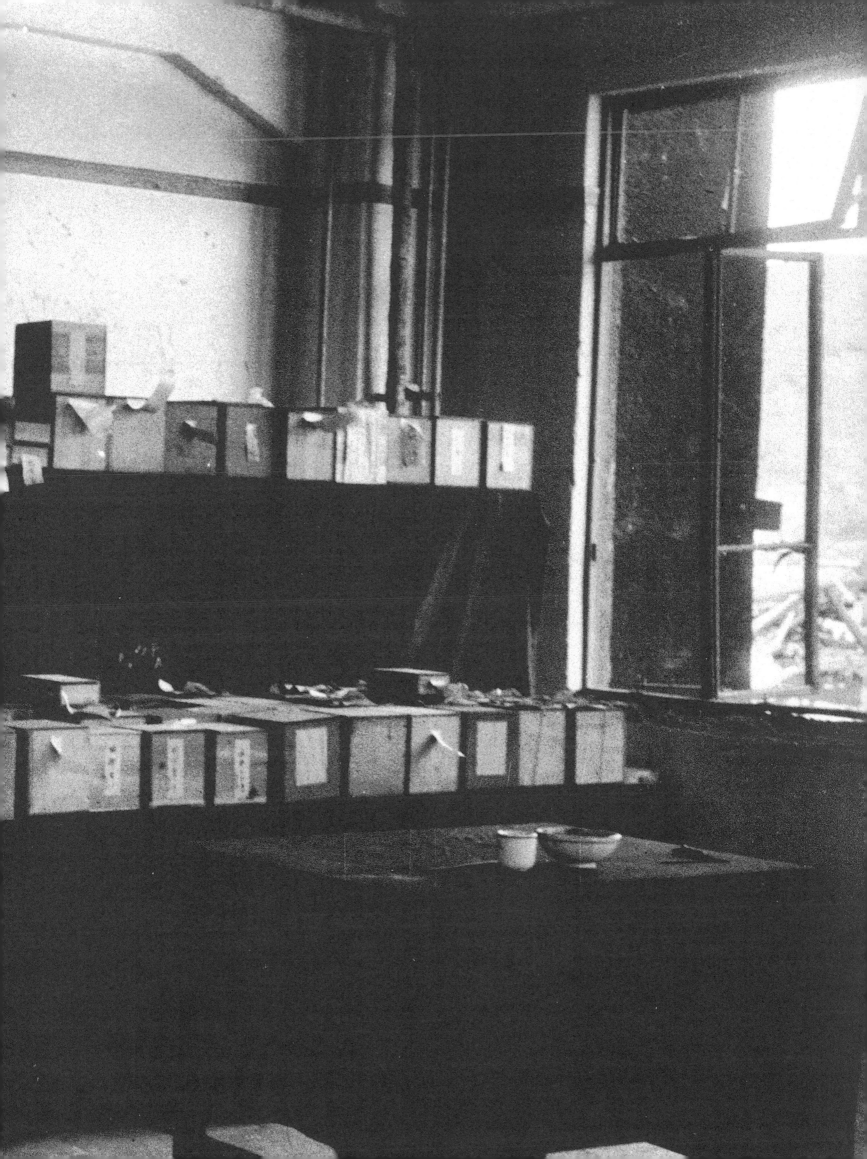

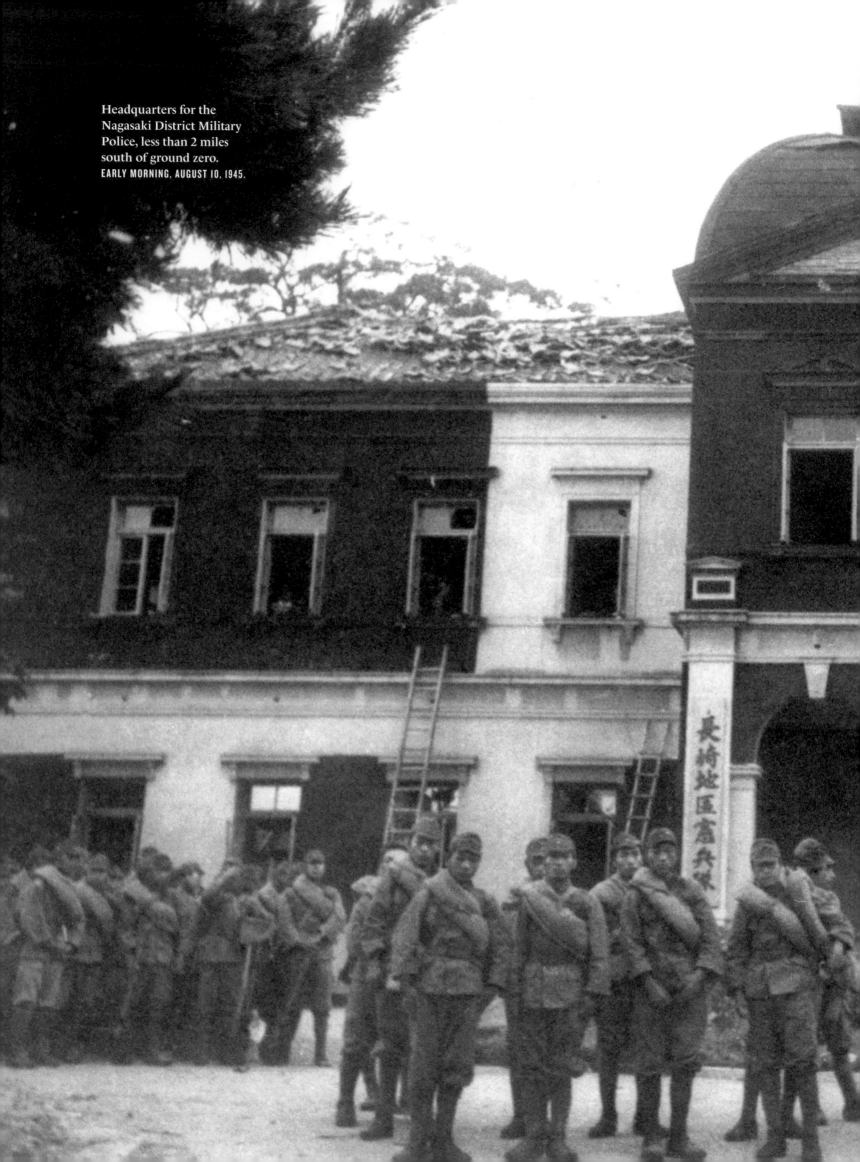

Headquarters for the
Nagasaki District Military
Police, less than 2 miles
south of ground zero.
EARLY MORNING, AUGUST 10, 1945.

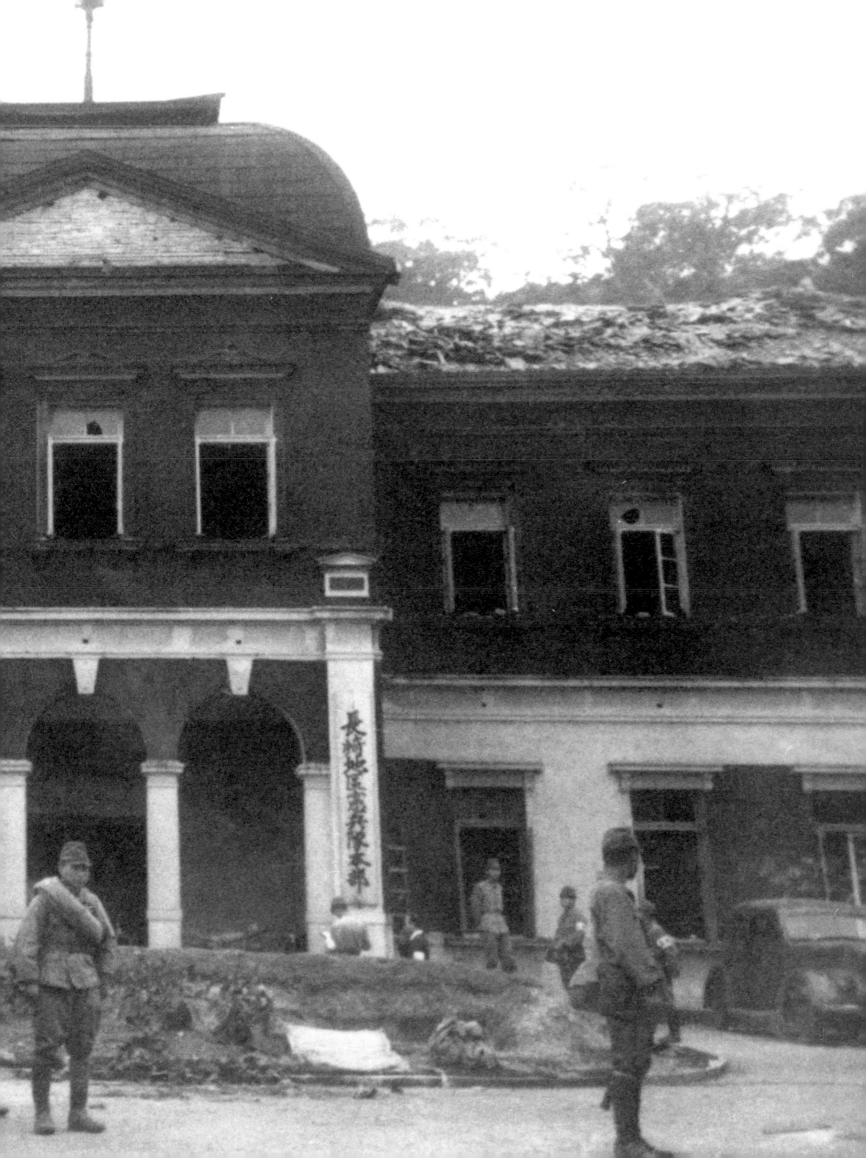

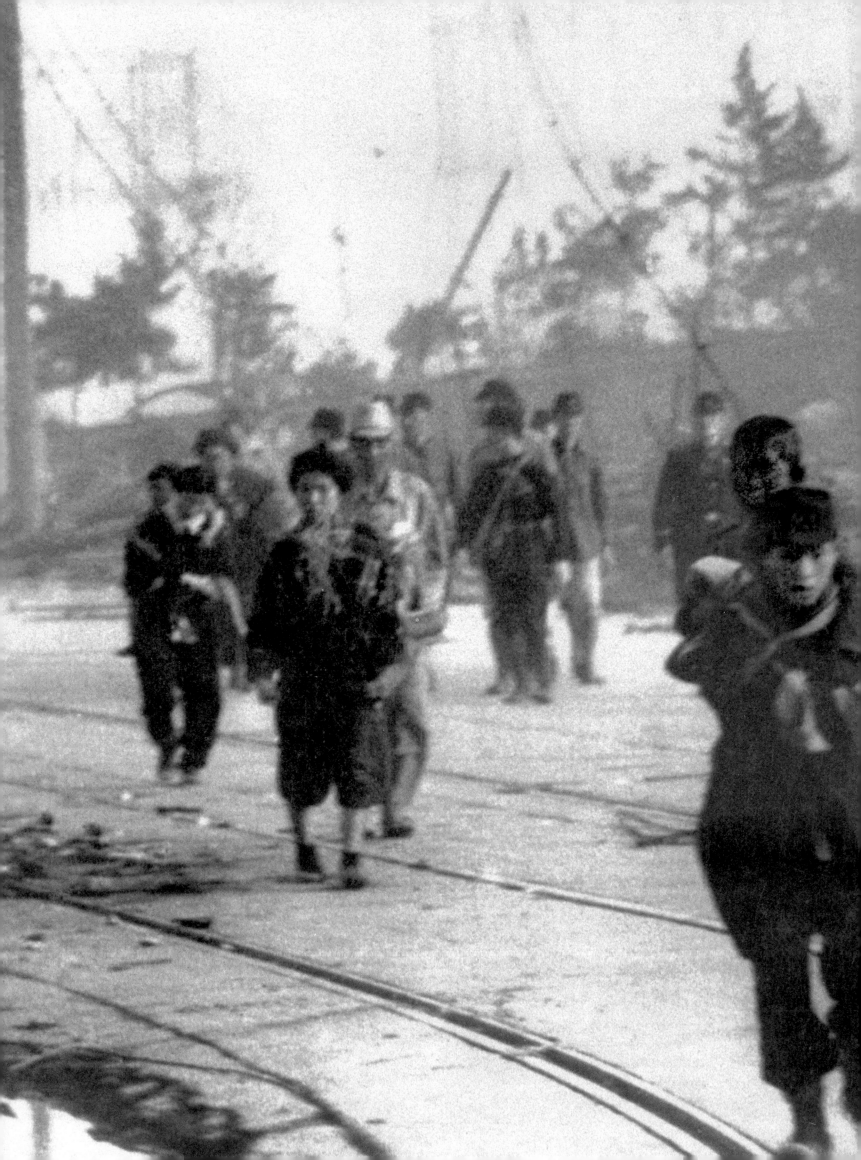

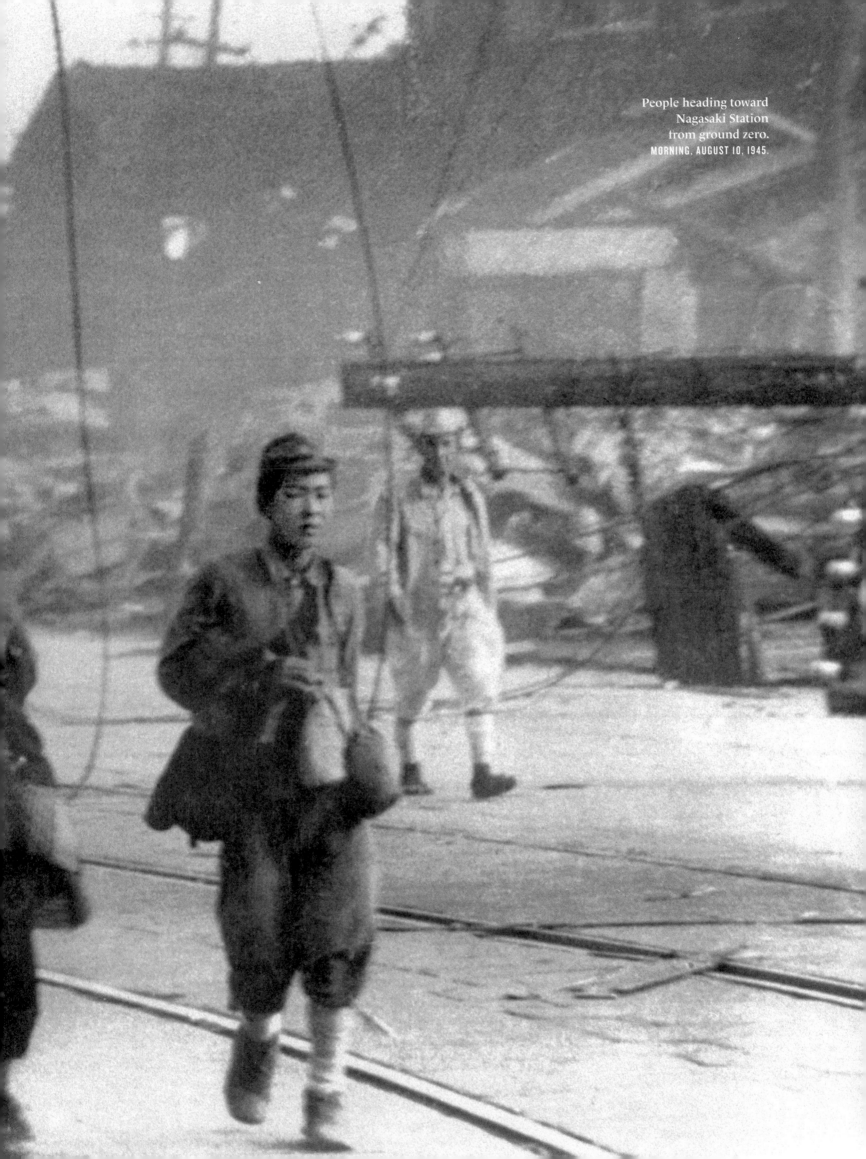

People heading toward
Nagasaki Station
from ground zero.
MORNING, AUGUST 10, 1945.

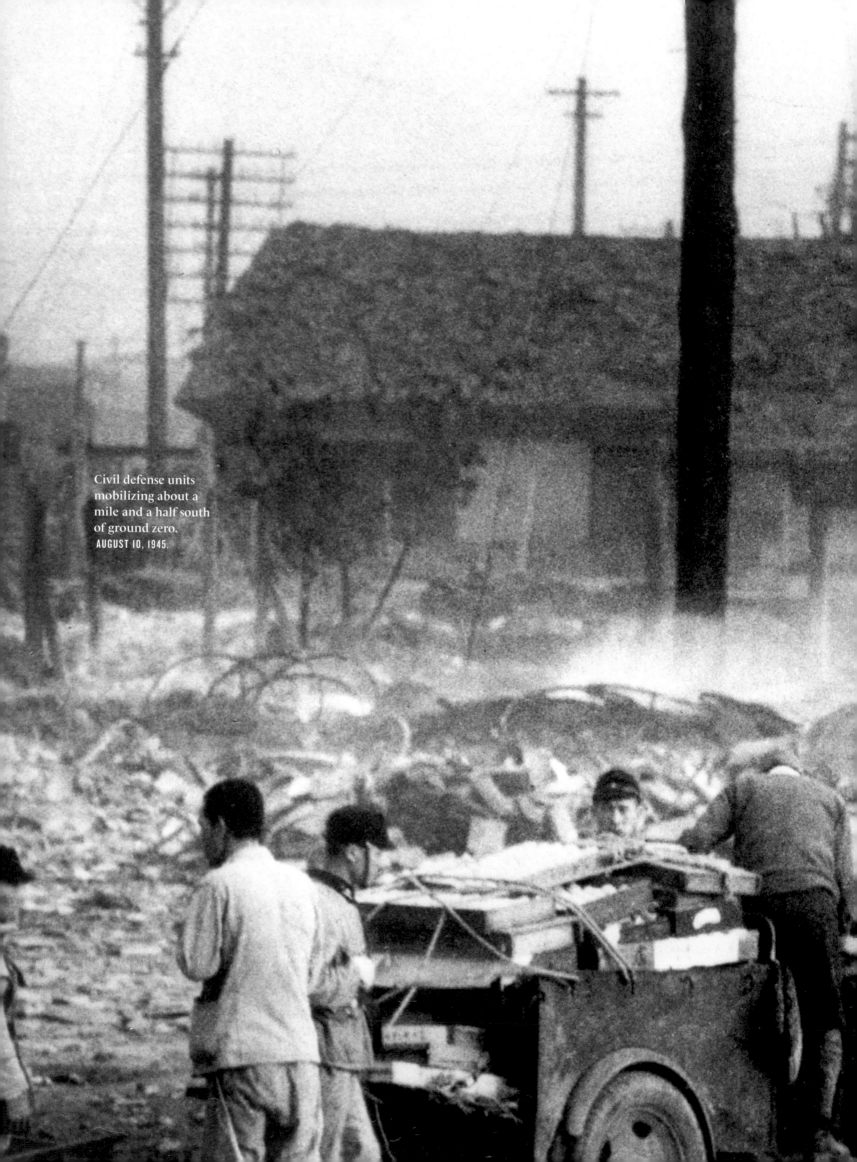

Civil defense units
mobilizing about a
mile and a half south
of ground zero.
AUGUST 10, 1945.

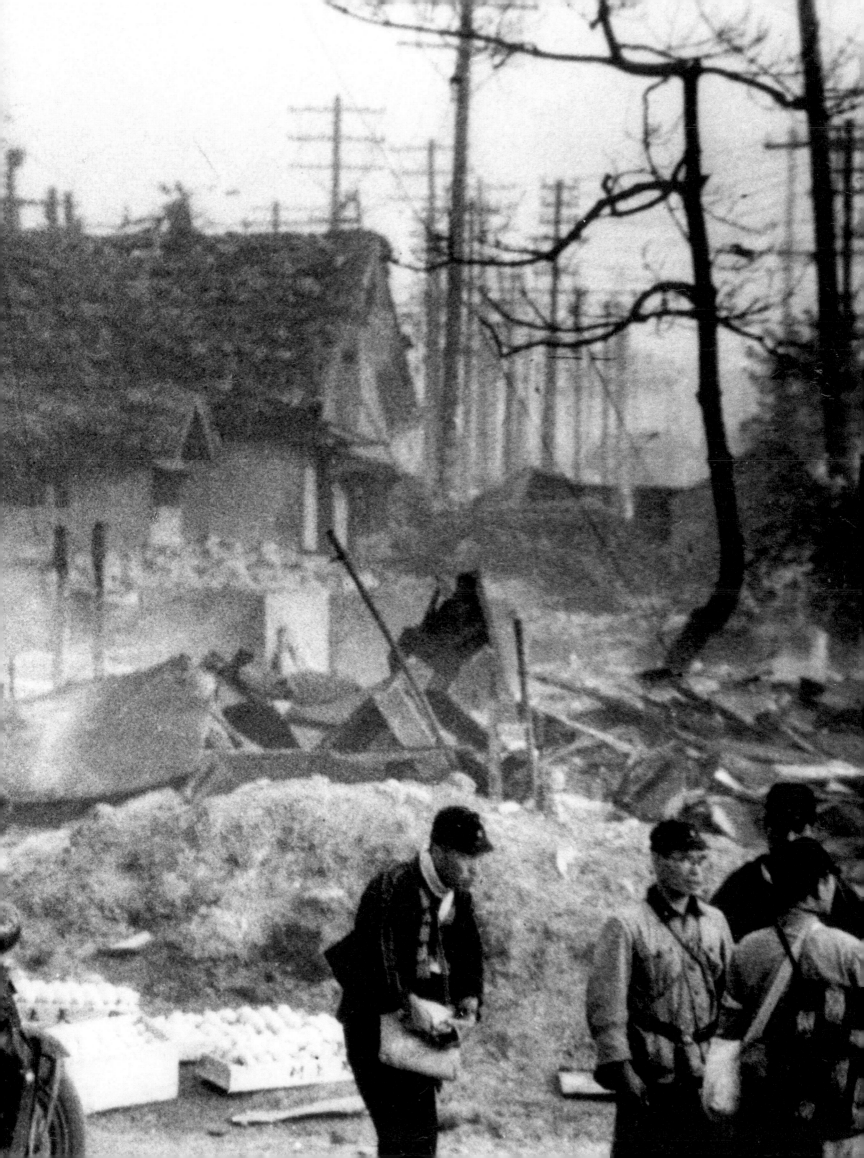

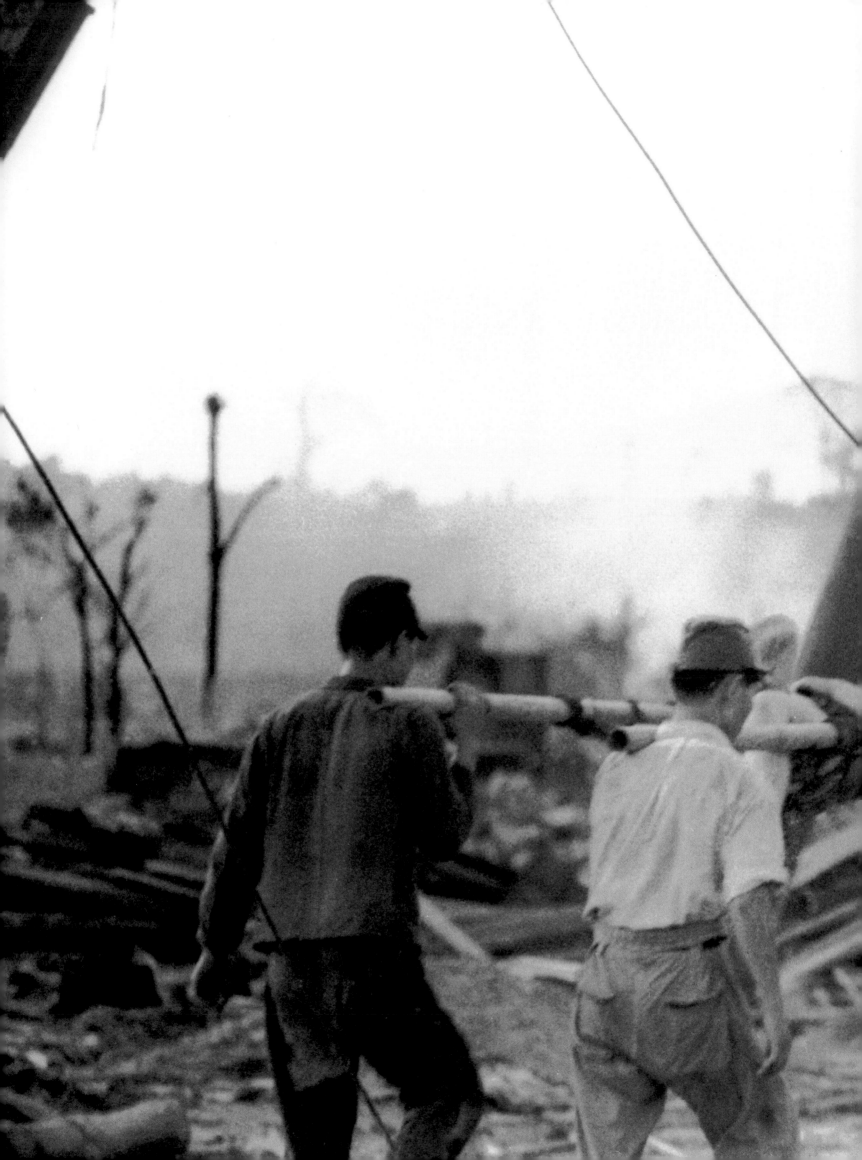

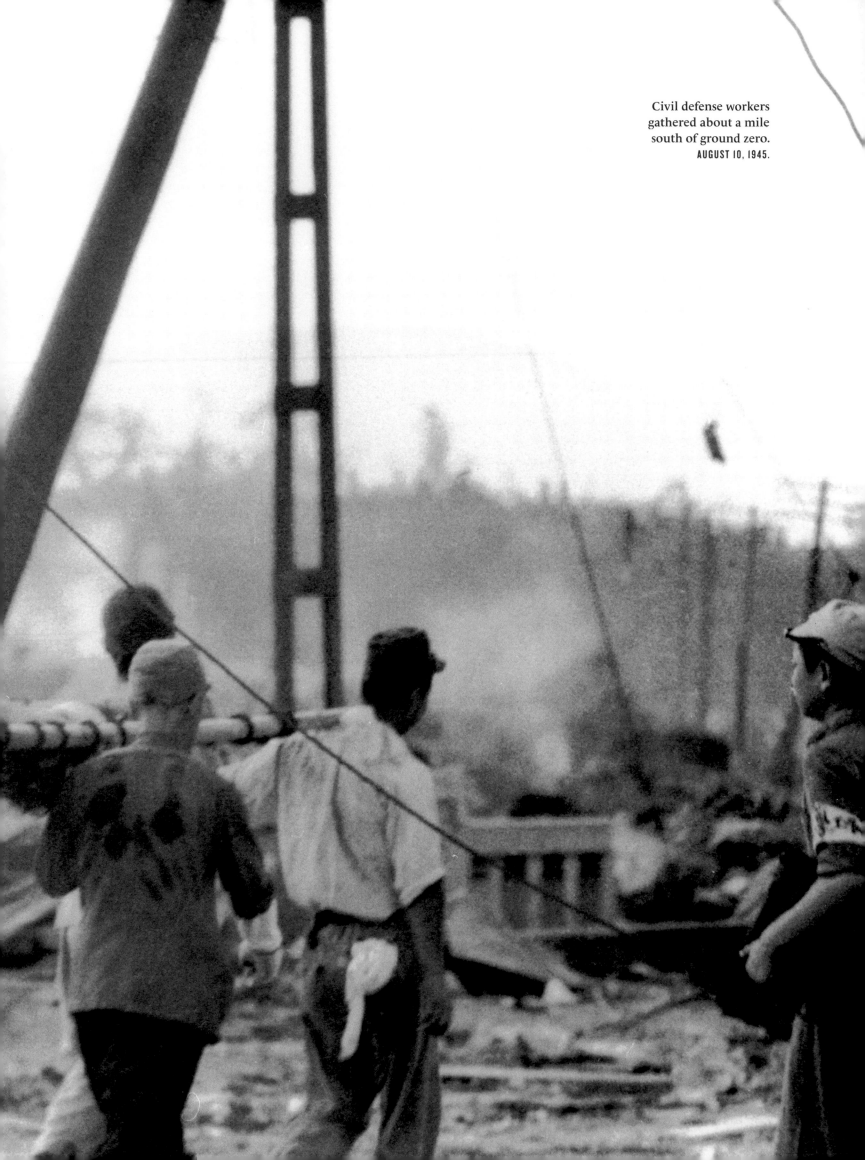

Civil defense workers
gathered about a mile
south of ground zero.
AUGUST 10, 1945.

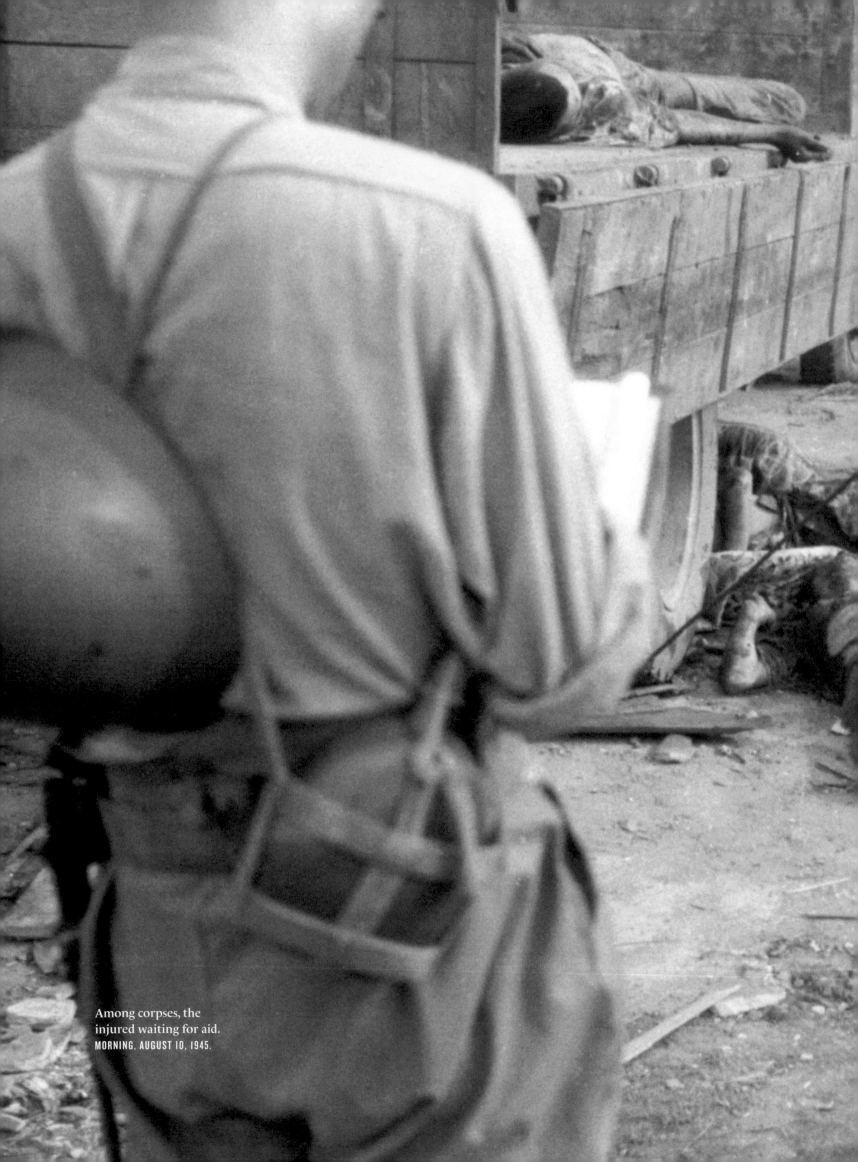

Among corpses, the
injured waiting for aid.
MORNING, AUGUST 10, 1945.

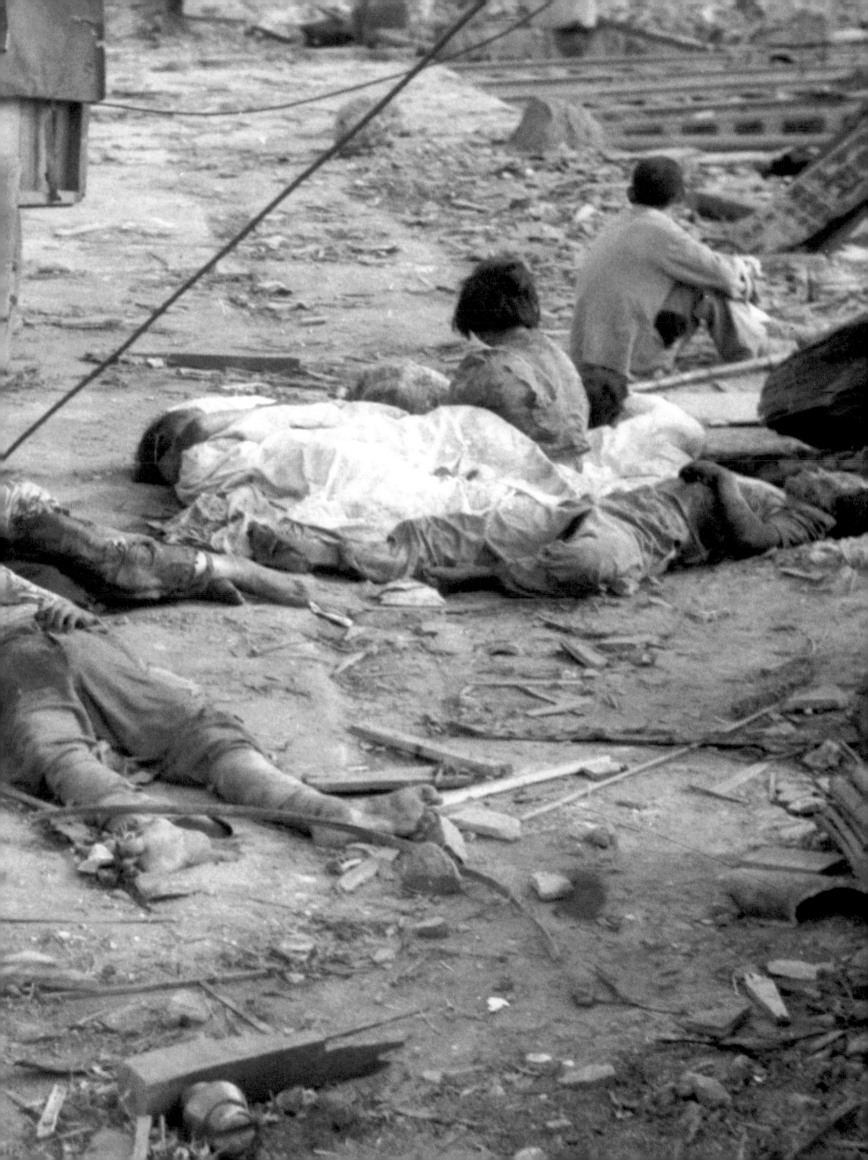

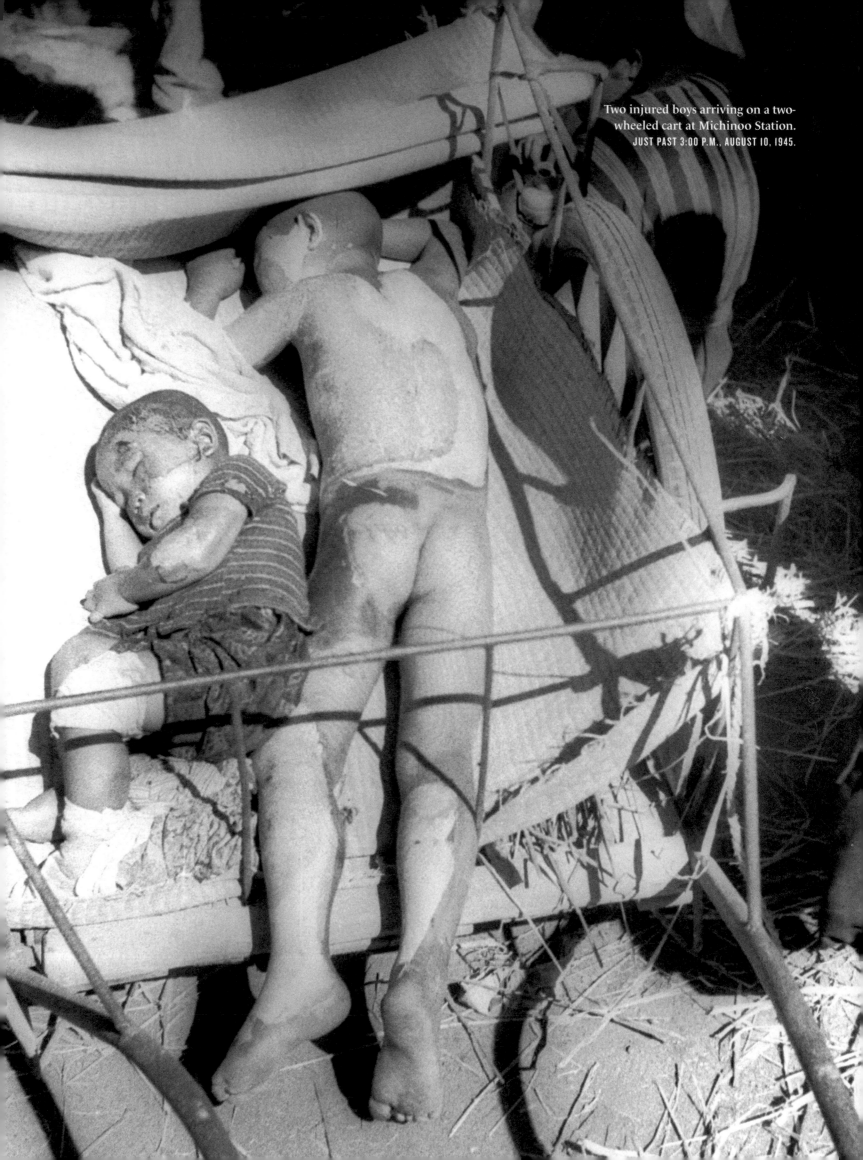

Two injured boys arriving on a two-wheeled cart at Michinoo Station. JUST PAST 3:00 P.M., AUGUST 10, 1945.

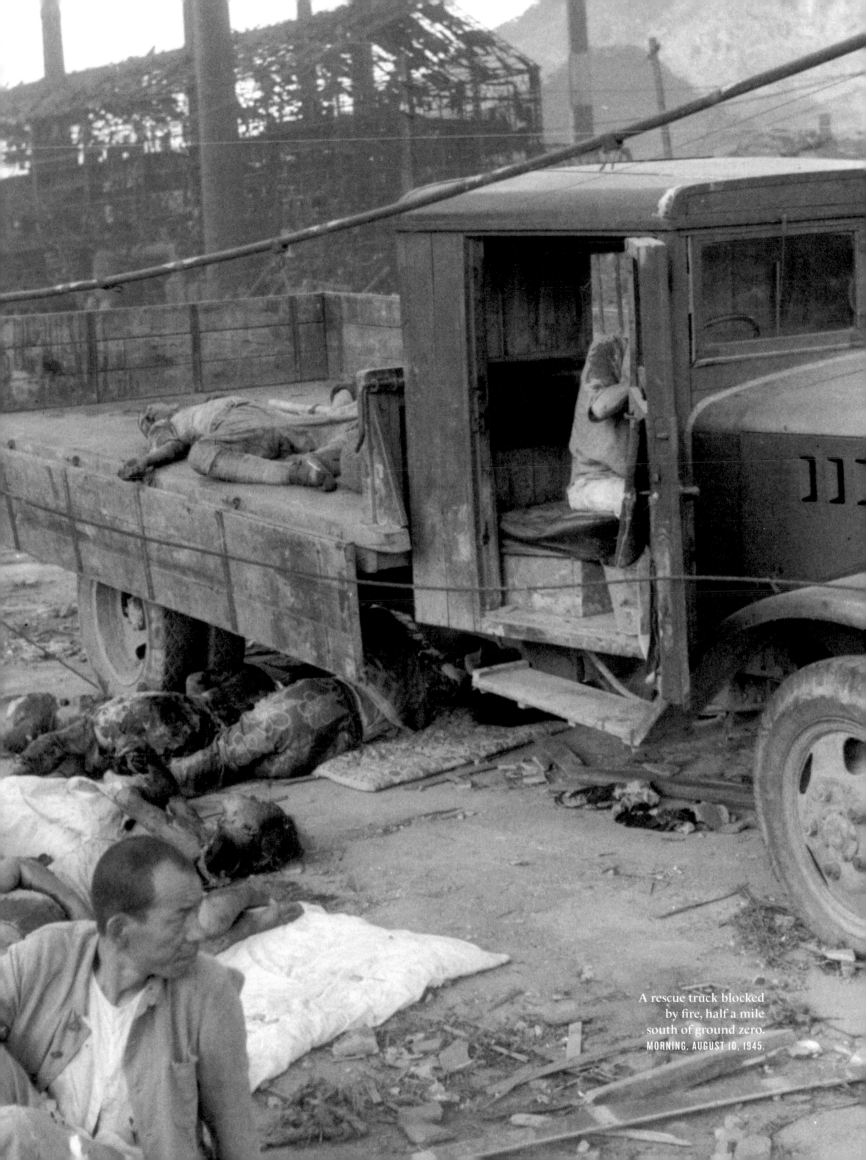

A rescue truck blocked
by fire, half a mile
south of ground zero.
MORNING, AUGUST 10, 1945.

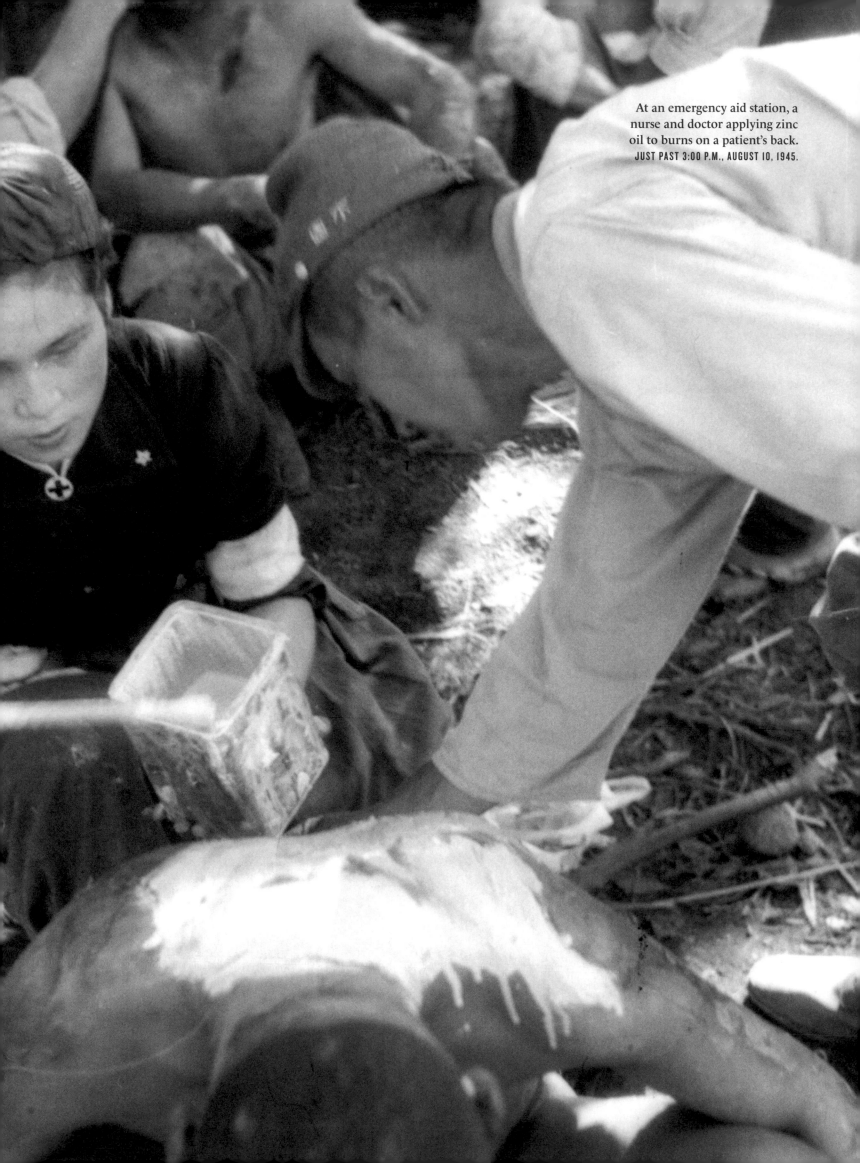

At an emergency aid station, a nurse and doctor applying zinc oil to burns on a patient's back.
JUST PAST 3:00 P.M., AUGUST 10, 1945.

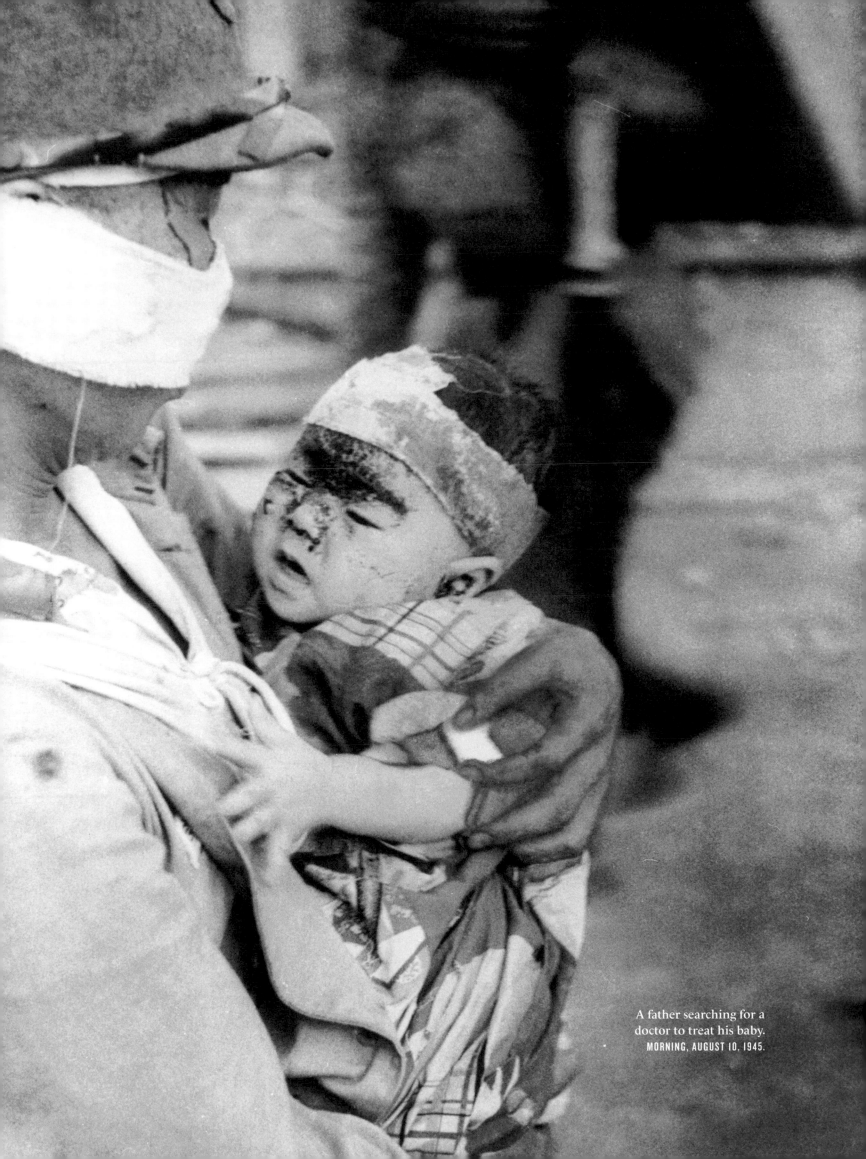

A father searching for a
doctor to treat his baby.
MORNING, AUGUST 10, 1945.

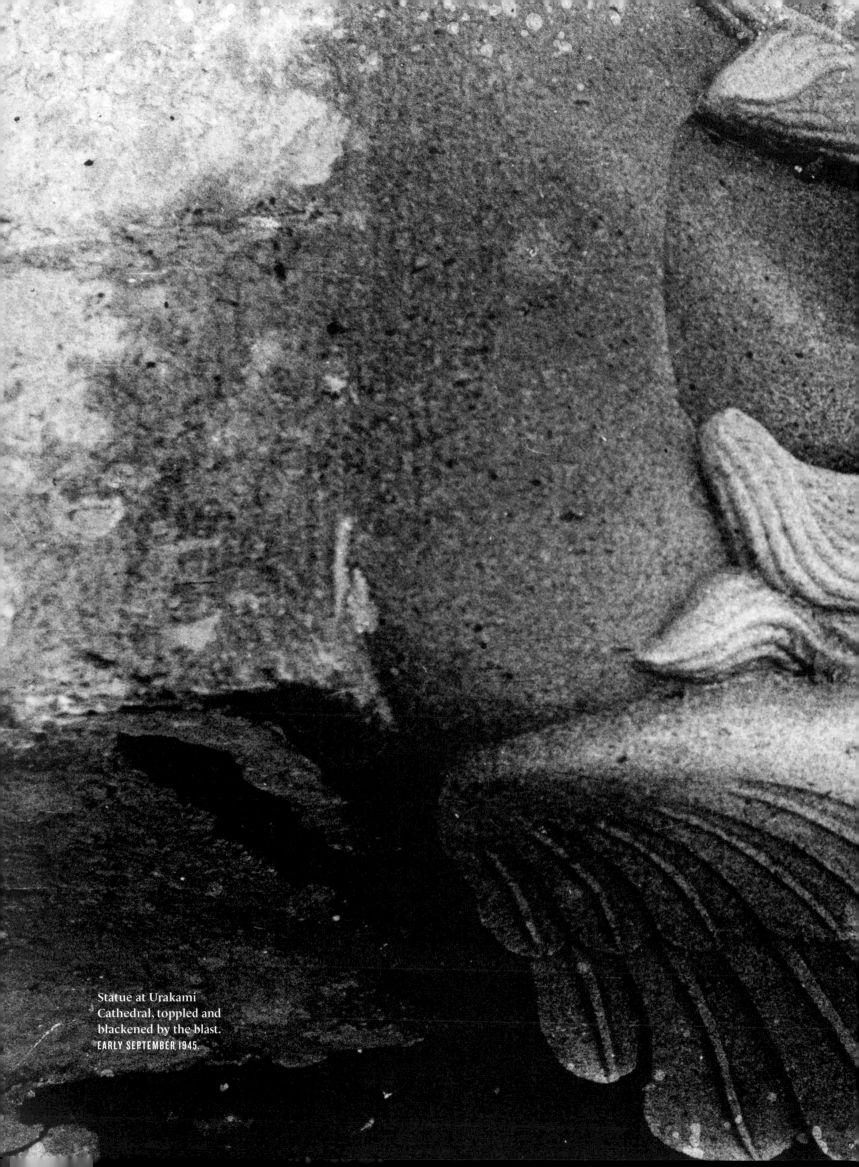

Statue at Urakami
Cathedral, toppled and
blackened by the blast.
EARLY SEPTEMBER 1945.

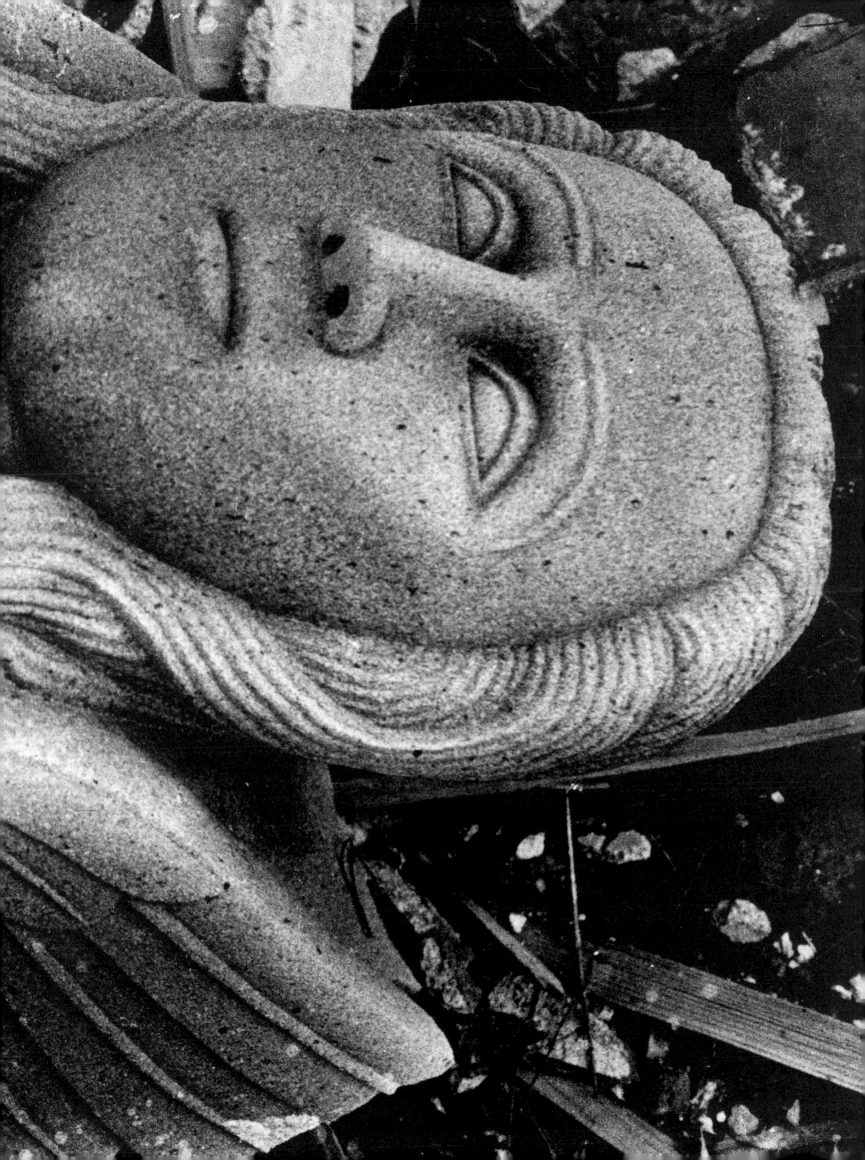

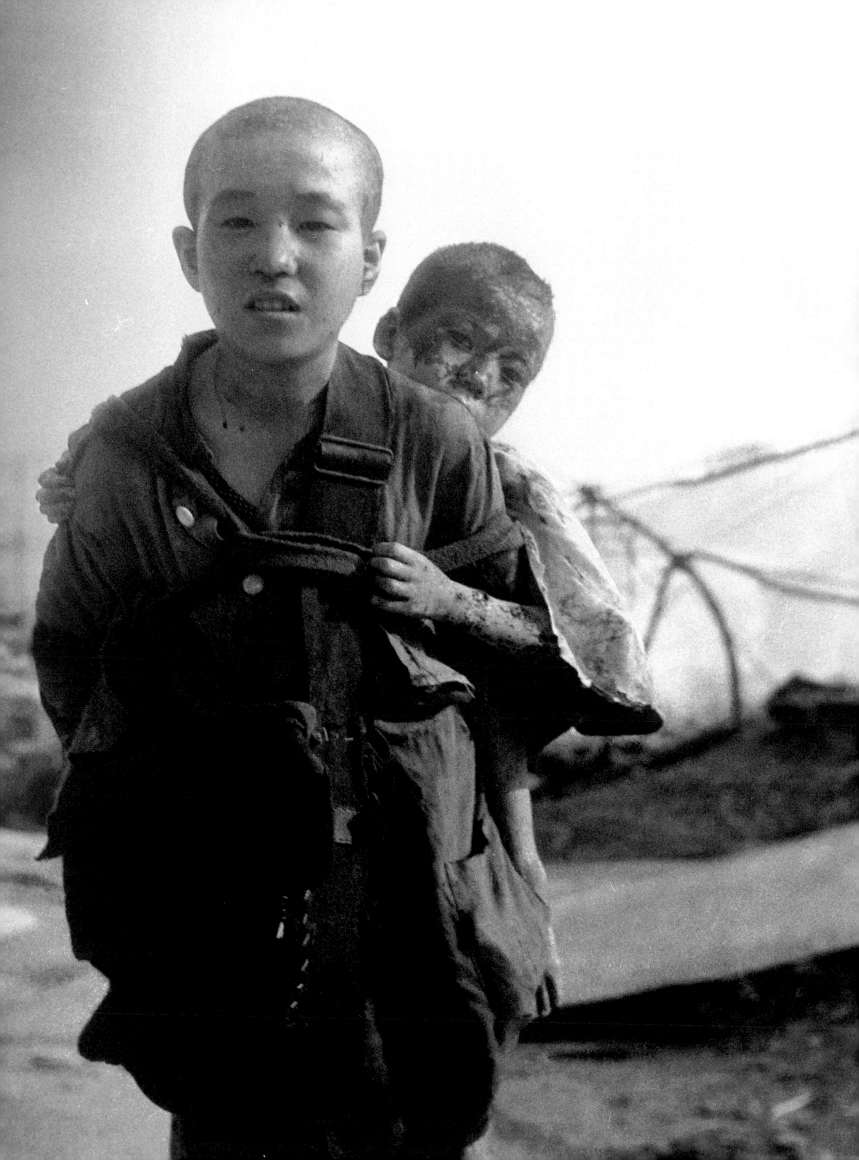

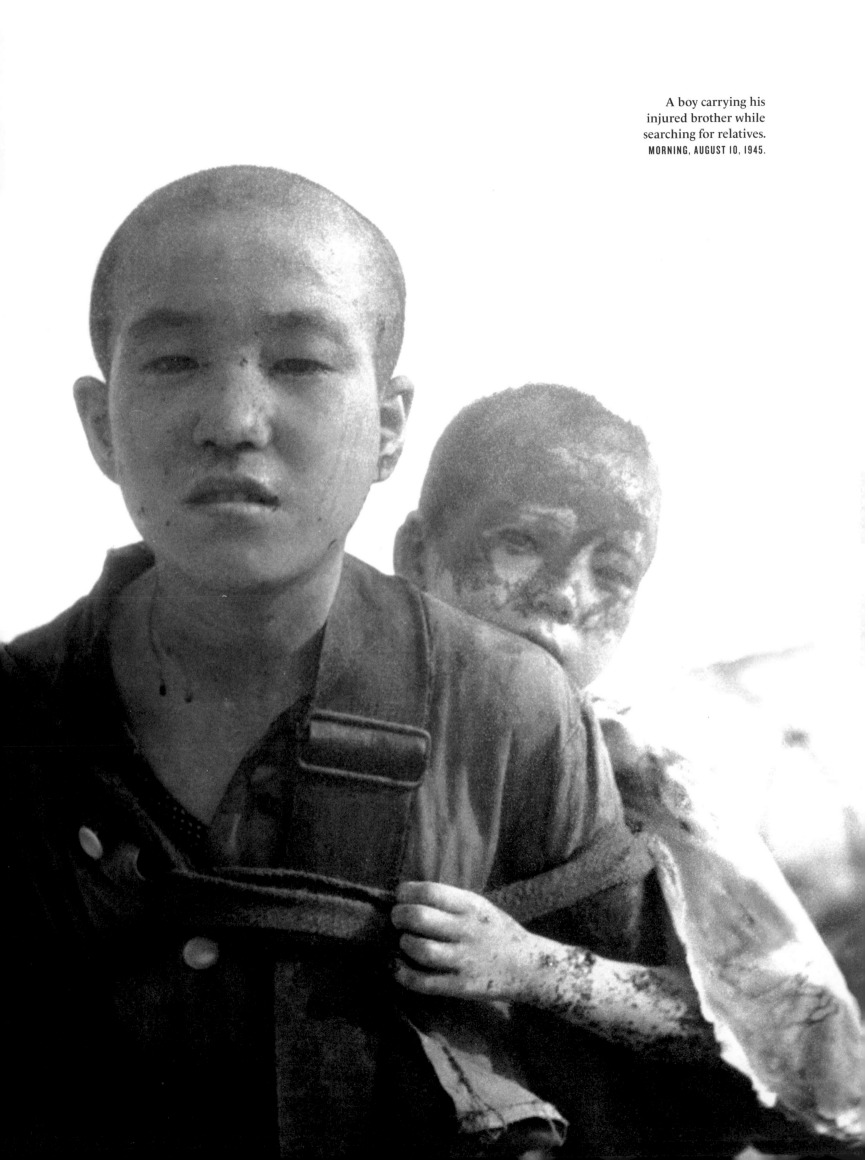

A boy carrying his
injured brother while
searching for relatives.
MORNING, AUGUST 10, 1945.

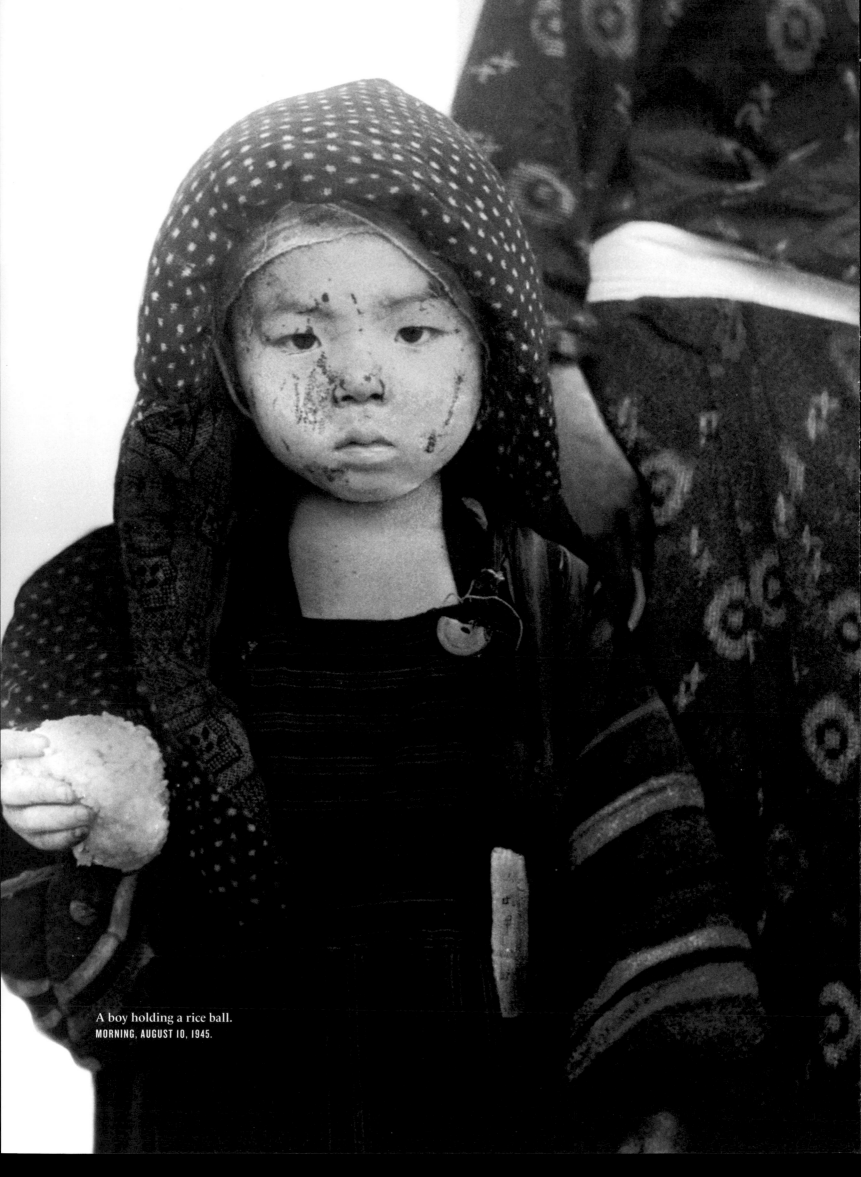

A boy holding a rice ball.
MORNING, AUGUST 10, 1945.

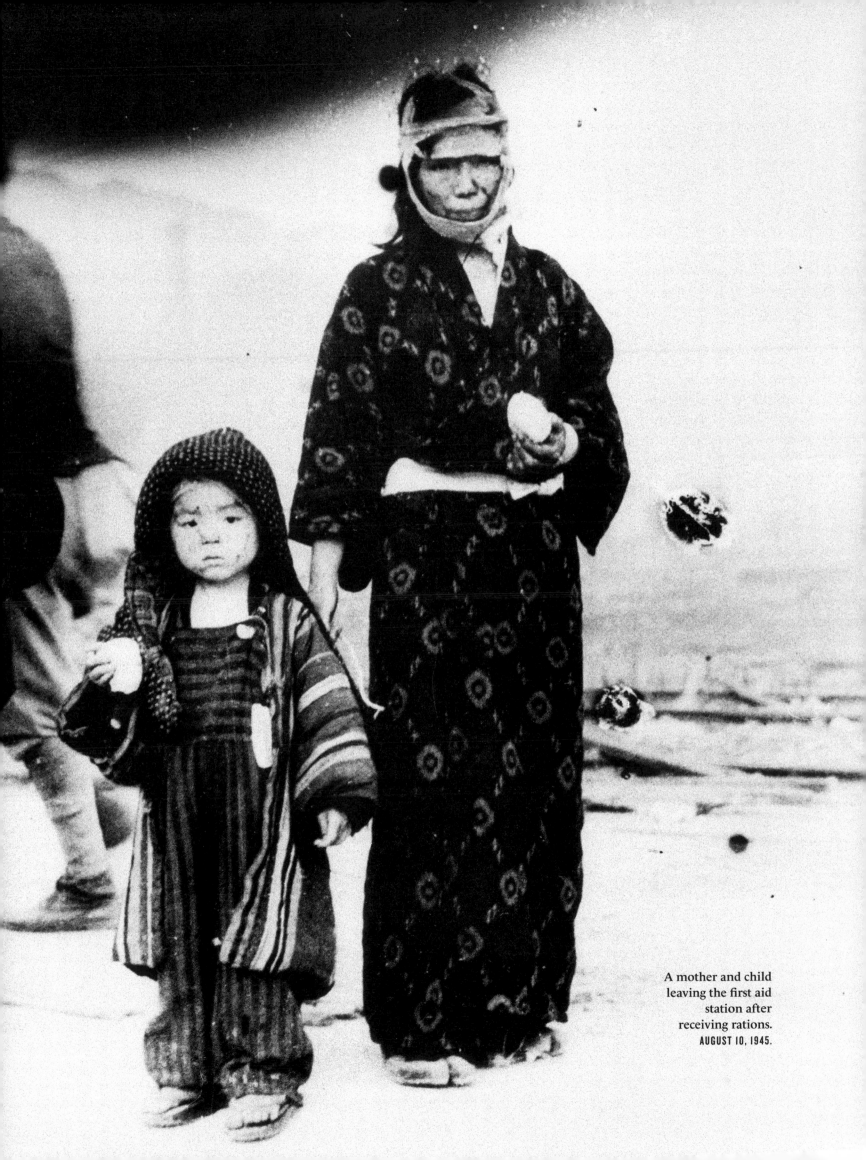

A mother and child
leaving the first aid
station after
receiving rations.
AUGUST 10, 1945.

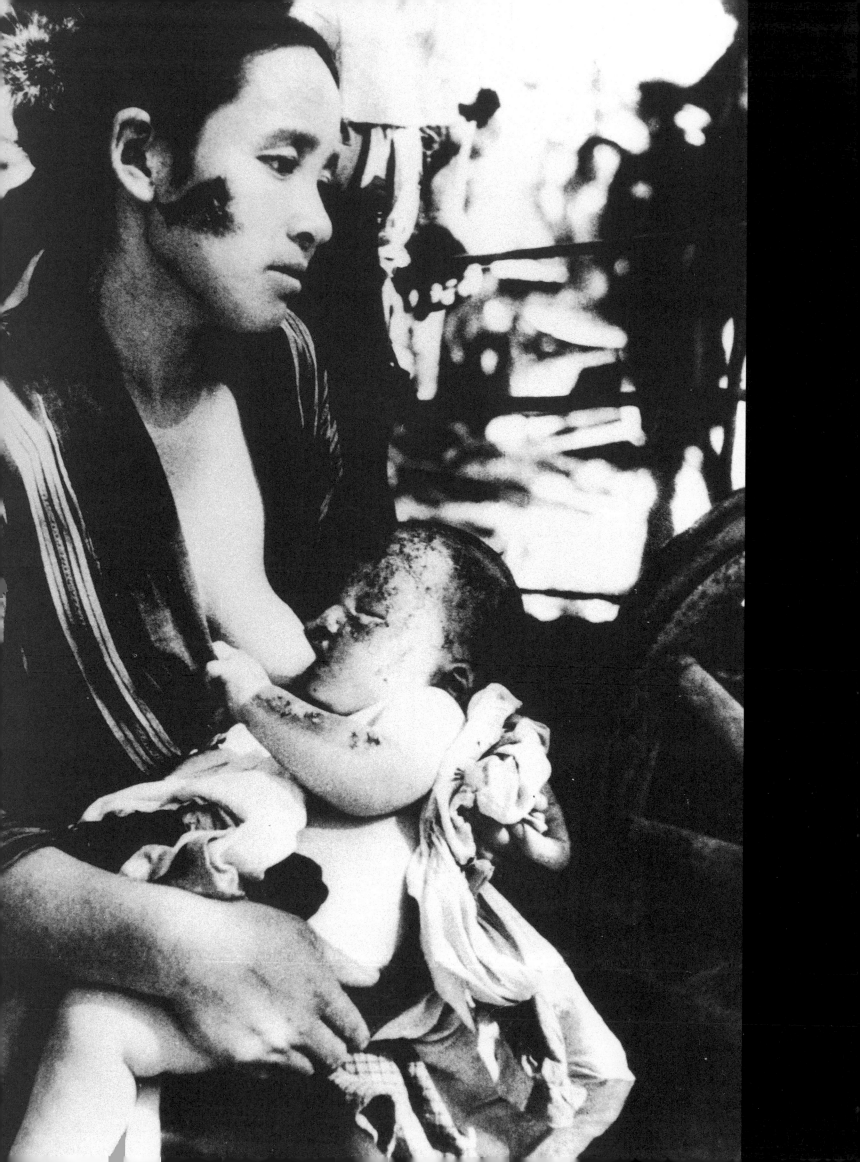

An injured mother
and child waiting
for treatment.
AUGUST 10, 1945.

I like the view from

the window of our head office located in downtown Hiroshima, Japan. The company I work for is a local daily newspaper named the *Chugoku Shimbun*, and it stands just next to the area known as Peace Memorial Park. When you see the tranquil park for the first time, it might be difficult to imagine that the first atomic bomb used against human beings exploded directly over this area on August 6, 1945. The area, which was thriving as a commercial and residential center, turned into a living hell in an instant.

Every year on August 6, the city of Hiroshima holds the Peace Memorial Ceremony in this park. Japanese cabinet members, the prime minister, the representatives of more than one hundred nations, *hibakusha* (survivors of the atomic bombing), and bereaved families are officially invited. At 8:15 a.m., the exact time when the atomic bomb was dropped on the city, all in attendance offer one minute of silent prayer for the victims' souls and for a peaceful future.

I believe many people born or raised in Hiroshima offer a silent prayer at the same time even if they are at home or at work or anywhere else. At least that is what I have been doing every year since I was a child.

I am not originally from Hiroshima. I moved there when I was a young child because of my father's job transfer. In the years that followed, August 6 became a very special date for me because of the peace education I received in school. The month of August is during summer break for kids in Japan, but most of the children who attend public elementary and junior high schools in Hiroshima go to school anyway on August 6 for the purpose of memorializing the tragic event that occurred on that date in 1945. I remember that our whole class watched the Peace Memorial Ceremony on TV and offered a silent prayer. After that, we learned what had happened in Hiroshima in many different ways. Sometimes we watched an animated film, and sometimes we folded paper cranes to honor the children who died in the atomic bombing. Some classes even invited elderly people in the neighborhood to tell us about their war memories.

I would like to share what happened in Hiroshima seventy-five years ago. On August 6, 1945, an atomic bomb dropped by the United States Army Air Forces exploded about 1,968 feet above the ground, and an enormous blast, an enormous heat, and radiation were released. The temperature on the ground near the hypocenter reached 5,432 to 7,232 degrees Fahrenheit. Because of the blast and

heat rays, almost all buildings within 1.3 miles of the hypocenter were destroyed or burned. To make matters worse, the radiation inflicted damage to human bodies. Even those who entered the city soon after the explosion developed radiation disorders. In Hiroshima, the official estimate is that out of approximately 350,000 people, 140,000 had died as a result of the atomic bombing by the end of 1945. On August 9, the United States Army Air Forces dropped another atomic bomb, this time on the city of Nagasaki. The official estimate there is 73,884 people killed by the end of 1945.

Perhaps it is because of the education I received that this overwhelming death toll has stuck in my head. I have always felt that the atomic bomb was something horrible and unforgivable: it killed tens of thousands of innocent people. However, in retrospect, I realize that as a child I did not fully understand the consequences of the atomic bombings, especially in regard to human beings. I may have been too young to reflect on the victims' suffering and to grasp the reality, and as such I took what happened in Hiroshima and Nagasaki as events merely in the past.

By conducting interviews with a number of survivors as a staff writer for a daily newspaper based in Hiroshima, I've gained a deeper understanding of just how inhumane nuclear weapons are. Those survivors helped me realize that the nuclear threat is not just someone else's affair.

Let me share the story of one gentleman who is now ninety years old. In 1945, he was sixteen and lived in downtown Hiroshima with his mother and his younger sister. As a result of the atomic bombing, he lost both of his loved ones and was left alone.

On August 6, he and his mother were at home about three-quarters of a mile from the hypocenter. After the massive blast of the bomb knocked him to the ground in the yard, he looked around and saw his mother pinned under the wreckage of their home only a few feet away. He was unable to save her as fire closed in. She persuaded him to flee, and he cried out to her as he ran, saying, "I am sorry, Mom. I will die soon too."

When I interviewed him, he said to me, "I lied to her. I am nearly ninety. I am such a bad son, don't you think?" He also told me that he found her body in the rubble several days after the bombing. "Her body looked like a burnt mannequin with coal tar. The bomb forced human beings to die without dignity," he said.

As for his twelve-year-old sister, he was unable to find her remains, as she was closer to the hypocenter of the blast. On that day, she was with her classmates

and they were about to help tear down homes to create a fire lane in the event of air raids. Indeed, many students in middle school and up were forced to engage in labor of that type under orders from the Japanese government, as most adult males were serving in the war. It is said that approximately 6,300 mobilized students were killed by the atomic bombing in Hiroshima.

The atomic bomb not only killed innocent people indiscriminately but disrupted and altered the life of survivors. Radiation has affected the health of survivors throughout their lives. It was therefore not only the immediate effects that made the bombs inhumane, but also the long-term effects. I personally know a lot of people who have been struggling with cancers and many other diseases that are likely due to the delayed effects of radiation.

Radiation also left the survivors with endless health fears and deep emotional scars. One woman who barely survived the atomic bombing in Hiroshima told me she had faced discrimination when seeking a marriage partner for fear of unknown effects of the radiation that could potentially be passed down to future generations. In the end, she managed to marry and was blessed with children—but one of her daughters died of cancer a decade ago. This woman still blames herself for her daughter's death, worried that the disease may have been caused by her exposure to the radiation. She said to me, with a sad look, "I cannot escape from the damages caused by the bomb. It has affected my whole life after all."

Obviously, every survivor suffered harsh effects and a tough postwar life. Every time I listen to their testimonies, I sense the sorrow, pain, and anger they still feel. Some of them even say they feel guilty for being alive, because they think they should have died with their families and friends. It is no wonder that many people have been trying to keep their memories of the atomic bombing locked away. Recalling it brings them a great deal of pain.

One may ask why these people let me interview them. When I asked some of them why they decided to share their stories with others, almost all of them said the same thing: "Because I think no one else should ever suffer as we did."

We also can find these convictions in the statement issued by Nihon Hidankyo, a nationwide organization of atomic bombing survivors. In their "Message to the World," the group's first statement, made in 1956, Hidankyo proclaimed their "will to save humanity from its crisis through the lessons learned from our experiences, while at the same time saving ourselves."

Based on this conviction, the members of Hidankyo have repeatedly warned the world about the devastation wrought by these weapons. As they continue to declare, "humanity and nuclear weapons cannot coexist." They share their experiences about the atomic bombings because they believe that the elimination of nuclear weapons is the only way to prevent further tragedies.

One of the members of Hidankyo who has been involved with the antinuclear movement since the late 1950s told me he would never stop trying to achieve their common goal. "If I could realize the world without nuclear weapons," he said, "I could convince myself at last that the deaths of my family and friends were not in vain."

After working for nearly twenty years as a staff writer for a newspaper company that was devastated by the atomic bombing, I have come to believe that I, too, have a moral responsibility to try to bring the true catastrophic consequences of nuclear weapons into the light. I also believe that I have a responsibility to convey the message of the survivors to our readers.

However, I also have come to realize keenly that this mission is getting more and more difficult. With the average age of the A-bomb survivors now over eighty-two, the generational shift is inevitable. The memory of war and the atomic bombing is fading even in the bombed city of Hiroshima. The hours allotted for peace education in the schools have been trimmed compared with my schooldays. Data shows that even in Hiroshima, more and more children are unable to state the correct date and time of the bombings, or even to identify the country that dropped the bombs.

The reality of nuclear weapons is poorly understood even in international politics. While covering international conferences related to nuclear disarmament in Geneva, Vienna, and New York City, I realized that the politicians of nuclear-armed states and their allies, including Japan, always insist on the need for nuclear weapons for the security of their nations. But there is no guarantee that these weapons will never be exploded over our cities. The fact that nuclear weapons actually undermine global, national, and human security tends to be ignored.

In July 2017, the first international treaty completely prohibiting the development, possession, and threat of use of nuclear weapons was passed at the United Nations with the support of 122 member states. Underlying this move was a renewed recognition of the humanitarian consequences of nuclear weapons, which has been drawing greater attention in the international community in recent years. I think we can say that this renewed attention is, in part, the result of efforts made by the survivors. The number of countries and regions to ratify the Treaty on the Prohibition of Nuclear Weapons (TPNW) is increasing. Thirty-four states have ratified it so far (as of November 2019), and it will enter into force ninety days after it has been ratified by fifty countries or regions.

The TPNW was adopted, however, with support only from nonnuclear states. All of the nine nuclear-armed states boycotted the negotiations and remain opposed. Countries relying on the so-called "nuclear umbrella," such as Japan, did not participate in the negotiations, either, and these countries show no sign of joining the treaty. There are still high hurdles facing the treaty if it is ever to go into effect.

Moreover, relations between the United States and Russia are still strained. Negotiations concerning nuclear disarmament between these two nuclear superpowers, which together possess more than 90 percent of the planet's nuclear weapons, are not going well.

Under these difficult circumstances, I learned that Dr. Don Carleton, executive director of the Briscoe Center, was in Japan with his colleagues in the fall of 2018. I also learned they were visiting Japan to prepare for a photo book showing the devastation caused by the atomic bombings. At the time, I was quite surprised, because I knew public opinion in the United States tends to justify the atomic bombings, with the argument that these attacks brought the war to a swifter end than would have otherwise been the case.

I wanted to know more about their project and asked Dr. Carleton for an interview while he was in Tokyo. When I met him, he said to me, "We are not interested in refighting World War II over again. But we really want our students and researchers to have this evidence of what happened in Hiroshima and Nagasaki." After I heard this statement, I became determined to write about the center's project.

Now you have the valuable photographs in front of you. They were taken by people who suffered as a result of the bombing—residents of the bombed cities, Japanese military personnel, Japanese journalists and researchers, and others. They managed to record the devastation of the bombed cities under an unimaginably chaotic situation; some of them even protected the negatives or the prints by themselves, defying a requisition order from the American occupation forces. I really think that these photos are an important contribution to our understanding of the bombings, not only for showing their real consequences, but also for demonstrating what will happen to us if nuclear weapons are ever used again.

This book is also the result of the work of people who were concerned that these valuable records might be lost or scattered as time went by. "Hankaku Shashin Undo," the Anti-Nuclear Photographers' Movement of Japan, provided all the photos presented here to the Briscoe Center. As they understand it, these photos are a heritage that should be shared by the entire human race. This is so true. Memories of the atomic bombings are fading rapidly, and we must sound the alarm bell to the future. These photos can play an important role in sounding that alarm.

Please look at them carefully. This is what really happened in Hiroshima and Nagasaki. Imagine the situation, and try to reflect on the suffering of the victims and their families. They were real people with real lives. Please also be aware that this is not just a problem for other people. This could happen to anybody if a nuclear weapon exploded, whether it was the result of an accident, a terrorist attack, or another war.

On May 27, 2016, US President Barack Obama visited the Peace Memorial Park in Hiroshima and made a speech. As he stood before us, he urged "a moral awakening" for the world. He said we can choose a future in which Hiroshima and Nagasaki are known not as the dawn of atomic warfare, but as the start of our own moral awakening. I sincerely hope these photographs will bring you to a moral awakening.

Michiko Tanaka
The Chugoku Shimbun
HIROSHIMA, JAPAN

HIROSHIMA

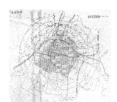

14-15 Map of Hiroshima showing the epicenter of the atomic blast. August 1945. American Occupation of Japan Collection, 1941–1975, Briscoe Center.

16-17 East police station, Shimoyanagi-cho, Hiroshima, three-quarters of a mile from ground zero. The clock stopped at the time of the bomb blast. September 15, 1945. Photo by Eiichi Matsumoto.

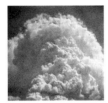

18-19 The mushroom cloud 2.8 miles from ground zero. August 6, 1945. Photo by Gonichi Kimura, courtesy Hiroshima Peace Memorial Museum.

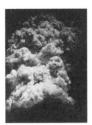

20 "I was one of the students mobilized to work at Hiroshima Army Firearms Supply Depot, about 2,600 meters [8,530 feet] from ground zero. I saw orange smoke above Mount Hiji from the depot, ran up to the second floor, looked out the window toward the northwest and took four photographs in sequence." (Toshio Fukada).
This is the second of those photographs, taken at what was then Building No. 2, Kasumi-cho, Hiroshima City. August 6, 1945. Photo by Toshio Fukada.

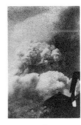

21 Two minutes after the explosion, taken at Kandabashi, Furuichi-cho, Asa-gun, Hiroshima Prefecture, about 4.3 miles from ground zero. August 6, 1945. Photo by Mitsuo Matsushige.

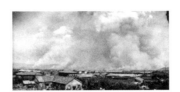

22-23 Most areas of Hiroshima were burned within an hour after the explosion. This view is from the roof of the three-story Marine Training Headquarters in Hiroshima. Almost all the delta areas of the city can be seen to the north. Ground zero is at the center of the photograph. August 6, 1945. Photo by Gonichi Kimura and composed by Ari Beser with two images stitched together, courtesy Hiroshima Peace Memorial Museum.

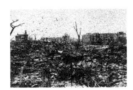

24-25 Among the ruins of their houses, a sign lists the locations of families who lived there. In the lower right is the wreckage of Kagawa bicycle shop in Takajo-machi. At the left is the Hiroshima Chamber of Commerce and Economy. Behind that is the Fukuya department store, Geibi Bank headquarters, and the Hiroshima Branch of Chiyoda Seimei. The Hiroshima Prefectural Industrial Promotion Hall (now known as the Atomic Bomb Dome) is in the center. The building with the broken window on its right side is Honkawa Primary School. August 20, 1945. Photo by Masami Oki.

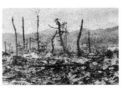

26-27 Looking north from Tokaichi-machi. The remains of a large house are in the foreground. August 20, 1945. Photo by Masami Oki.

Note
All photographs are from the Hiroshima and Nagasaki Atomic Bomb Photographs Archive of the Anti-Nuclear Photographers' Movement of Japan held at the Briscoe Center, except where noted.

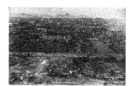

28-29 This photograph was taken at the request of a foreigner, who thought it was strange that cemeteries were located in the middle of the city. It was taken from the third floor of the former headquarters of the *Chugoku Shimbun* newspaper looking toward Ujina. Late 1945 or early 1946. Photo by Yoshito Matsushige/Chugoku Shimbun/Kyodo.

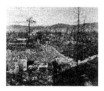

30-31 View from the top of Kyobashi Bridge, looking toward the center of Hiroshima, just under a mile northeast of ground zero. November 1945. Photo by Yoshito Matsushige/Chugoku Shimbun/Kyodo.

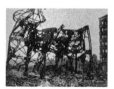

32-33 Used as a shop and warehouse by a kimono wholesaler, this three-story reinforced concrete building was twisted by the blast wave and then collapsed in the high-temperature fires. The steel, valuable at that time as scrap metal, was stolen. The building on the right is the new wing of the *Chugoku Shimbun* newspaper. Its interior was completely burned. Behind the building is the Hiroshima Nagarekawa Church. August 20, 1945. Photo by Masami Oki.

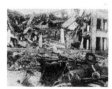

34-35 Looking from the northeast side of Otemachisuji at the remains of Hiroshima Gas Headquarters. The wall and the ceiling facing ground zero collapsed and were burned down by the blast wave. August 20, 1945. Photo by Masami Oki.

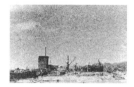

36-37 Near Hacchobori, half a mile from ground zero, a tram car was destroyed by fire. August 10 or 11, 1945. Photo by Satsuo Nakata/Kyodo News.

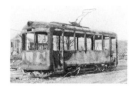

38-39 Nakajima-cho (currently Hiroshima Peace Memorial Park). Early September 1945. Special Committee for the Investigation of A-Bomb Damages (SCIA) photo.

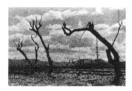

40-41 Remains of the Army Infantry First Supply Convoy building, approximately two-thirds of a mile north-northeast of ground zero. September 30, 1945. Photo by Eiichi Matsumoto.

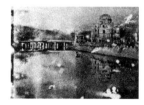

42-43 The Hiroshima Prefectural Industrial Promotion Hall (now known as the Atomic Bomb Dome) after the bomb explosion. Photographed from the downstream side of Motoyasu Bridge. September 1945. Photo by Yoshito Matsushige/Chugoku Shimbun/Kyodo.

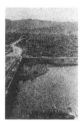

44 View of the west side of Hiroshima from the rooftop of the Chamber of Commerce building. Aioi Bridge is on the left. The pile-up of logs was caused by the Makurazaki typhoon

that hit the region on September 17, 1945. More than 2,000 people died in the storm. Late 1945. SCIA photo.

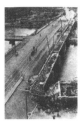

45 Looking across Aioi Bridge from the rooftop of the Hiroshima Chamber of Commerce building. The ruins on the right are the Yagurashita electrical substation. Late 1945. SCIA photo.

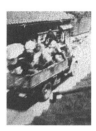

47 Bomb victims were rushed by truck to relief stations in the city's suburbs, which were considered to be safer. Furuichi-cho, Asa-gun, Hiroshima city. August 6, 1945. Photo by Mitsuo Matsushige.

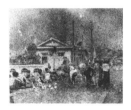

48-49 A temporary aid station was quickly set up outside the Senda-machi police box. Many students from the Hiroshima Girls' Commercial School were treated here by two police officers. Cooking oil from the military supply depot was used for burn injuries. Photographed from the west end of Miyuki Bridge, almost a mile and a half southeast of ground zero. August 6, 1945. Photo by Yoshito Matsushige/Chugoku Shimbun/Kyodo.

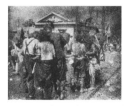

50-51 "I wandered around this place for 30 minutes, hesitating to take the first photograph. I was in a state of shock to face such brutality. By the time I took this second photograph, I had calmed down a little bit. Corpses and injured victims lined both sides of the Miyuki Bridge up to this police box. Rescue relief trucks from Army Shipping Command Headquarters were deployed to Ujina in the afternoon to transport the injured to Ninoshima island toward the evening." (Yoshito Matsushige)
Photographed around 11:00 a.m. at the west end of Miyuki Bridge. August 6, 1945. Photo by Yoshito Matsushige/Chugoku Shimbun/Kyodo.

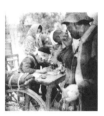

52 Police Officer Tokuo Fujita issues certificates of suffering to bomb victims at a desk in the street on the east end of Miyuki Bridge, about a mile and a half from ground zero, after 4 p.m. on August 6. Fujita had sustained injuries from pieces of glass. Victims were given hardtack, normally reserved for emergency military use. August 6, 1945. Photo by Yoshito Matsushige/Chugoku Shimbun/Kyodo.

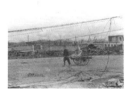

54-55 A young woman, who miraculously survived the bomb explosion at Minami-Ohashi, a mile south of ground zero, is pulled by her aunt on a cart over rubble-covered roads to the Hiroshima Red Cross Hospital. October 4, 1945. Photo by Shunkichi Kikuchi, courtesy Harumi Tago.

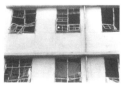

56-57 Hiroshima Red Cross Hospital, less than a mile from ground zero. October 1945. Photo by Shunkichi Kikuchi, courtesy Harumi Tago.

58 Hiroshima Red Cross Hospital, less than a mile from ground zero. September 8, 1945. Photo by Eiichi Matsumoto.

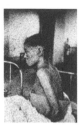

59 Man suffering from radiation sickness being treated at the Hiroshima Red Cross Hospital. September 30, 1945. Photo by Eiichi Matsumoto.

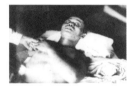

60-61 21-year-old soldier with radiation sickness at Hiroshima First Army Hospital. September 3, 1945. Photo by Gonichi Kimura, courtesy Hiroshima Peace Memorial Museum.

63 Patient at the Hiroshima Red Cross Hospital. October 5 or 6, 1945. Photo by Shunkichi Kikuchi, courtesy Harumi Tago.

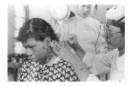

64-65 Bomb victim being treated in the otolaryngology room at the Hiroshima Red Cross Hospital. October 5 or 6, 1945. Photo by Shunkichi Kikuchi, courtesy Harumi Tago.

66 The dark-colored parts of the kimono absorbed more energy from the thermal radiation, causing patterns to be burned on this victim's skin. At the Ujina Branch of the Hiroshima First Army Hospital. August 15, 1945. Photo by Gonichi Kimura, courtesy Hiroshima Peace Memorial Museum.

68-69 Citizens looking for names of patients posted at the entrance to the Hiroshima Branch of Sumitomo Bank in Kamiya-cho, which was used as a temporary relief station. August 12,1945. Photo by Yotsugi Kawahara, courtesy Hiroshima Peace Memorial Museum.

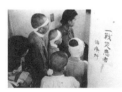

70-71 October 7, 1945. Photo by Shunkichi Kikuchi, courtesy Harumi Tago.

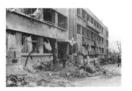

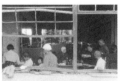

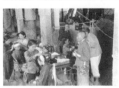

72-77 Temporary first aid station at Fukuromachi Primary School, a third of a mile southeast of ground zero, and patients being treated there. October 7, 1945. Photos by Shunkichi Kikuchi, courtesy Harumi Tago.

78-79 Messages written with chalk on the wall at Fukuromachi Primary School. A message from a father informs students of his child's death. Another relates the death of the school principal. Teachers describe their students' burn injuries. October 6, 1945. Photo by Shunkichi Kikuchi, courtesy Harumi Tago.

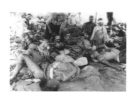

80-81 Patients at the Hiroshima Second Army Hospital first aid tent station located along the Ota River. August 9, 1945. Photo by Yotsugi Kawahara, courtesy Hiroshima Peace Memorial Museum.

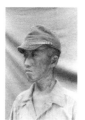
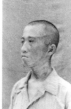

82-85 This soldier was treated at the Ujina Branch of the First Army Hospital. His face was exposed to radiation 1.2 miles from ground zero. The trace was visible when he removed his hat. He suffered inflammation of the cornea in both eyes. October 1945. Photos by Shunkichi Kikuchi, courtesy Harumi Tago.

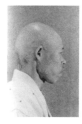
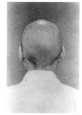

86-87 Patient at the Ujina Branch of the First Army Hospital. October 10, 1945. Photos by Shunkichi Kikuchi, courtesy Harumi Tago.

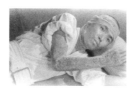

88-89 This man, photographed at the Ujina Branch of the First Army Hospital, was exposed to radiation at Senda-machi, 1.2 miles south of ground zero. Since he was wearing a short-sleeved shirt, he was burned on his right arm. Skin from his buttocks was transplanted to his arm. October 2, 1945. Photo by Shunkichi Kikuchi, courtesy Harumi Tago.

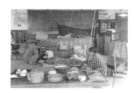

90-91 Temporary first aid station at the Hiroshima Oshiba Primary School. Although the wooden building was heavily damaged, medical treatments were provided in the less damaged areas. The emergency first aid stations were closed throughout Japan after October 1945 when the War Damage Protection Act expired. The Japan Medical Foundation Hospital was used to treat atomic bomb survivors for many years thereafter. October 11, 1945. Photo by Shunkichi Kikuchi, courtesy Harumi Tago.

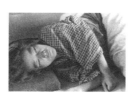

92-93 A thirty-one-year-old woman suffering from the aftermath of being exposed to radiation at the temporary first aid station in the Hiroshima Oshiba Primary School. She and her daughter were exposed to radiation but had no physical injuries. Just after the exposure, she was fine and was able to care for her daughter. A month later, she complained about symptoms and was hospitalized. Her condition worsened in October, with subcutaneous bleeding, shortness of breath, and a bad cough. She died three days after this photo was taken. October 11, 1945. Photo by Shunkichi Kikuchi, courtesy Harumi Tago.

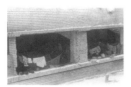

94-95 Hiroshima Teishin Hospital, just under a mile northeast of ground zero. October 8, 1945. Photo by Shunkichi Kikuchi, courtesy Harumi Tago.

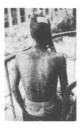

96 A victim with severe burns. Hiroshima Red Cross Hospital. September 1945. Photo by Eiichi Matsumoto.

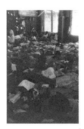

97 Temporary first aid station set up at No. 1 Municipal Primary School in Danbara-Yamazakicho, about 1.6 miles east-southeast of ground zero. A large number of people fleeing the center of the city rushed to the Danbara area, where the impact of the blast was blocked by the Hijiyama hills and there were no fires. Military doctors from the Army Shipping Command Headquarters as well as from the suburbs treated the patients. August 30, 1945. ASHQ photo, courtesy Shogo Nagaoka Collection, Hiroshima Peace Memorial Museum.

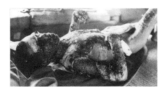

98-99 A burn victim at the first aid relief station on Ninoshima Island, about 6.2 miles from ground zero. Photo taken by order of a military doctor. August 7, 1945. Photo by Masami Onuka, ASHQ photography team, courtesy Hiroshima Peace Memorial Museum.

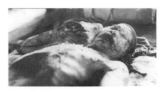

100-101 A bomb victim with burns at Ninoshima Quarantine Office, in Hiroshima city. August 7, 1945. Photo by Masami Onuka, courtesy Hiroshima Peace Memorial Museum.

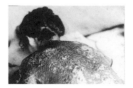

102-103 A woman with burns at Ninoshima Quarantine Office, in Hiroshima city. August 7, 1945. Photo by Masami Onuka, courtesy Hiroshima Peace Memorial Museum.

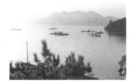

104-105 Japanese Navy submarines abandoned in Hiroshima Bay near Ninoshima Island. October 17, 1945. Photo by Shunkichi Kikuchi, courtesy Harumi Tago.

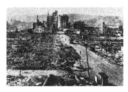

106-107 Looking toward the center of Hiroshima from Hiroshima East Precinct Police Station, .7 miles northeast of ground zero. The *Chugoku Shimbun* newspaper, Fukuya department store, and the Nihon Kangyo bank located here were destroyed. September 1945. Photo by Yoshito Matsushige/ Chugoku Shimbun/Kyodo.

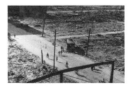

108-109 Photographed from the rooftops of the new annex of the *Chugoku Shimbun* office, facing northwest toward the old building of the Fukuya department store. The Toyo-za Cinema and the burned department store cast shadows on the streetcar path. In the center are the remains of a destroyed tram car. Among

the buildings destroyed in this area were the Kabuki-za Theater and a huge advertising tower for Jintan (oral/health care products). On the road are rescue teams and people searching for their friends and relatives. August 9, 1945. Photo by Yotsugi Kawahara, courtesy Hiroshima Peace Memorial Museum.

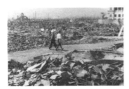

110-111 Ruins of wooden houses and stores photographed westward from Yamaguchi-cho. The people in the middle probably entered the city for rescue relief. On the upper left is Nagarekawa Church and on the upper right the Higashi Police Station. August 9, 1945. Photo by Yotsugi Kawahara, courtesy Hiroshima Peace Memorial Museum.

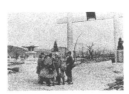

112-113 On their first day in the city after the bomb was dropped, the Hiroshima and Nagasaki Academic Survey Team met at the entrance to Gokoku Shrine. Except for its foundation, the wooden shrine was completely burned down. The team determined the altitude of the explosion and location of ground zero based on lines made by heat waves on fences of Mikage stones around the shrine, stone lanterns, Komainu (stone curved guardian dogs), and Torii (gates). Early October 1945. Photo by Shigeo Hayashi.

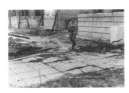

114-115 Survey team member investigating the devastated city. Early September 1945. SCIA photo.

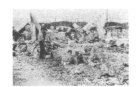

116-117 Looking south from Shima Hospital near ground zero. On the left is the Nippon Eiga-sha film crew (Japan Film Corporation). In the center, Masao Ikeda from the physical scientists' group measures residual radioactivity in the soil with Yukio Miyazaki from Riken (a scientific research institute). Early October 1945. Photo by Shigeo Hayashi.

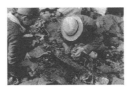

118-119 Biologist Shinryu Obuchi collects earthworms at ground zero. Early October 1945. Photo by Shigeo Hayashi.

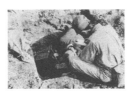

120-121 Masao Ikeda from the physical scientists' group and Yukio Miyazaki from Riken measure residual radioactivity in the soil at the south side of Shima Hospital at ground zero. Early October 1945. Photo by Shigeo Hayashi.

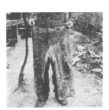

122-123 A member of the science research group holds a pair of trousers contaminated by black rain. Early October 1945. Photo by Shigeo Hayashi.

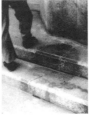

124 The stairs at the entrance to the Hiroshima Branch of Sumitomo Bank. A shadow, resembling that of a person, was burned into the concrete stairs by the blast wave. November 1945. Photo by Yoshito Matsushige/Chugoku Shimbun/Kyodo.

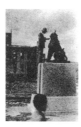

126 Yoshio Suge, a member of the SCIA, studies the Komainu (stone-carved guardian dog) that survived the blast wave at Gokoku Shrine. Mid-September 1945. SCIA photo.

NAGASAKI

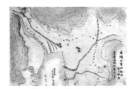

140-141 Map of the damage to Nagasaki. Symbols on the map indicate the locations of Buddhist and Christian religious sites. Early September 1945. Photo by Teiji Nihei.

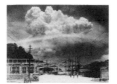

142-143 The first photo of the mushroom cloud taken from the ground, 15 minutes after the explosion, from Kawanami Shipyard on Koyagi Island. August 9, 1945. Photo by Hiromichi Matsuda, courtesy Nagasaki Atomic Bomb Museum.

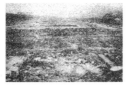

144-145 Remains of the Mitsubishi Heavy Industries Weapon Factory. Yamazato Primary School is in the upper left. August 20, 1945. Photo by Suetaro Mori, courtesy Mitsubishi Heavy Industries, Ltd.

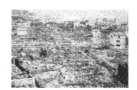

146-147 Nagasaki as seen from the Motoshita-machi Market. August 24, 1945. Photo by Suetaro Mori, courtesy Mitsubishi Heavy Industries, Ltd.

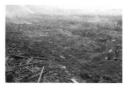

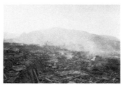

148-151 At Hamaguchi-machi, 273 yards south of ground zero. The man with the field cap on the bottom left of the first photo is a painter, Eiji Yamada, who accompanied the photographer. Nagasaki Medical College Hospital can be seen opposite the hill in the second photo. Around 1:00 p.m., August 10, 1945. Photos by Yōsuke Yamahata, courtesy Shogo Yamahata.

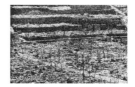

152-153 A completely destroyed area in Nagasaki. Mid-October 1945. Photo by Shigeo Hayashi.

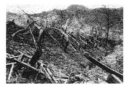

154-155 Tree trunks knocked down by the strong blast wave near the slope on the north side of Prefectural Keiho Middle School. Mid-October 1945. Photo by Shigeo Hayashi.

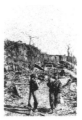

156 Girls walk through charred piles of rubble. Late August 1945. Photo by Eiichi Matsumoto.

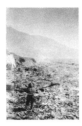

157 From the northern edge of Hamaguchi-machi, 273 yards south of ground zero. Around 1:00 p.m., August 10, 1945. Photo by Yōsuke Yamahata, courtesy Shogo Yamahata.

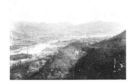

158-159 Urban area of Nagasaki, as seen from Mount Inasa. June 1946. Photo by Torahiko Ogawa, courtesy Nagasaki Atomic Bomb Muscum.

160-161 Almost a mile south of ground zero, water sprays from a ruptured pipe in front of Shotoku Temple, which was destroyed in the blast. August 10, 1945. Photo by Yōsuke Yamahata, courtesy Shogo Yamahata.

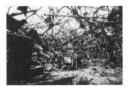

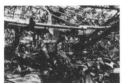

162-165 Damage inside the Mitsubishi Nagasaki Steel Works No. 2 Plant. Mid-October 1945. Photos by Shigeo Hayashi.

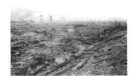

166-167 A quarter of a mile southwest of ground zero. The mound in the bottom right corner is for the tram track. The remaining walls of the Mitsubishi Heavy Industries Weapon Factory Hamaguchi Dormitory can be seen on the left in the distancc. Between 1:00 and 2:00 p.m., August 10, 1945. Photo by Yōsuke Yamahata, courtesy Shogo Yamahata.

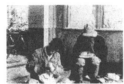

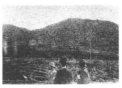

168-171 Members of the Special Committee for Investigation of A-Bomb Damages in the Urakami District. From left to right, first photograph, Teiji Nihei, Masaichi Majima, and Yoshio Suge. Second photograph: Yoshio Suge, left, and Toshimasa Tsutsui. Early September 1945. SCIA photos.

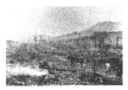

172-173 The atomic bomb exploded about a third of a mile above this location, the Matsuyama-machi intersection. Chinzei Gakuin, a private school, is in the back right. The chimney, center back, was part of the Mitsubishi Nagasaki Steel Works. Around 2:00 p.m., August 10, 1945. Photo by Yōsuke Yamahata, courtesy Shogo Yamahata.

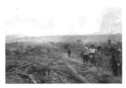

174-175 Looking north from the prefectural road near Iwakawa-machi about half a mile south of ground zero. Afternoon, August 10, 1945. Photo by Yōsuke Yamahata, courtesy Shogo Yamahata.

176–177 The man in the white shirt in the front center might be searching for remains. At Hamaguchi-machi, 660 feet south of ground zero. Around 1:00 p.m., August 10, 1945. Photo by Yōsuke Yamahata, courtesy Shogo Yamahata.

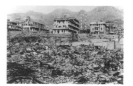

178–179 Nagasaki Medical College Hospital. Late August–late September 1945. Photo by Torahiko Ogawa, courtesy Nagasaki Atomic Bomb Museum.

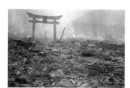

180–181 This Torii (entrance gate) to Sanno Shrine was not destroyed in the blast wave. Near Iwakawa-machi, about half a mile from ground zero. Afternoon, August 10, 1945. Photo by Yōsuke Yamahata, courtesy Shogo Yamahata.

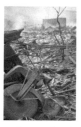

182 A three-wheeled vehicle and its driver hit by the blast's shock wave near Iwakawa-machi, about half a mile south of ground zero. Afternoon, August 10, 1945. Photo by Yōsuke Yamahata, courtesy Shogo Yamahata.

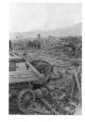

183 A dead horse and wagon near Iwakawa-machi, about half a mile south of ground zero. Around noon, August 10, 1945. Photo by Yōsuke Yamahata, courtesy Shogo Yamahata.

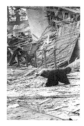

184 An elderly woman crawls on the ground in Mori-machi, about a mile south of ground zero. Around noon, August 10, 1945. Photo by Yōsuke Yamahata, courtesy Shogo Yamahata.

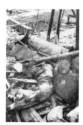

185 Bodies of a soldier and a woman killed when their tram car was destroyed by the blast. Other passengers were thrown from the car. Photo taken from the Shimono-kawa railway bridge about 820 feet south of ground zero. Between 1:00 and 2:00 p.m., August 10, 1945. Photo by Yōsuke Yamahata, courtesy Shogo Yamahata.

186–187 Bones lay scattered on the playground of Shiroyama Primary School, a third of a mile west of ground zero. Early September 1945. Photo by Teiji Nihei.

188 Remains of cremated bodies were everywhere, left on the ground with no one claiming them. Taken at the playground of the Shiroyama Primary School. Mid-September 1945. SCIA photo.

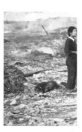

189 A dazed young woman stands next to a burnt corpse near Hamaguchi-machi, less than a quarter mile south of ground zero. Afternoon, August 10, 1945. Photo by Yōsuke Yamahata, courtesy Shogo Yamahata.

190-191 The body of a boy burned to death near Iwakawa-machi, about half a mile south of ground zero. August 10, 1945. Photo by Yōsuke Yamahata, courtesy Shogo Yamahata.

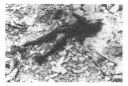

192-193 A student killed in the explosion near Hamaguchi-machi, about half a mile south of ground zero. Afternoon, August 10, 1945. Photo by Yōsuke Yamahata, courtesy Shogo Yamahata.

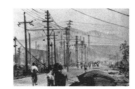

194-195 Near Kotobuki-machi, on the prefectural road close to the Nagasaki Station. The Mitsubishi Heavy Industries Saiwai-machi Plant is on the left. Morning, August 10, 1945. Photo by Yōsuke Yamahata, courtesy Shogo Yamahata.

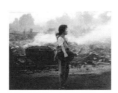

196-197 A dazed woman holds a pot to gather the remains of her family members, an infant strapped to her back. August 10, 1945. Photo by Yōsuke Yamahata, courtesy Shogo Yamahata.

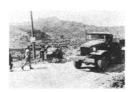

198-199 A two-wheeled cart loaded with potatoes to be rationed is on the left and a US military truck is on the right. Mid-October 1945. Photo by Shigeo Hayashi.

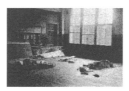

200-201 Temporary first aid station set up at Shinkozen Primary School. Early September 1945. Photo by Eiichi Matsumoto.

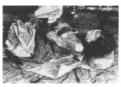

202-203 A woman with severe burns at the first aid station at the Shinkozen Primary School. Late August 1945. Photo by Eiichi Matsumoto.

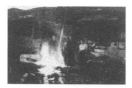

204-205 A family cremates their dead. Mid-September 1945. Photo by Eiichi Matsumoto.

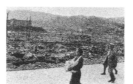

206-207 A woman carries human remains. On the left is the Shiroyama Primary School. Early September 1945. Photo by Eiichi Matsumoto.

208-209 Officers in charge of handling cremated bones at the temporary first aid station in Shinkozen Primary School. Early September 1945. Photo by Eiichi Matsumoto.

210-211 Temporary storage of cremated bones at the first aid station at the Shinkozen Primary School. Early September 1945. Photo by Eiichi Matsumoto.

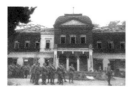

212-213 Headquarters for the Nagasaki District Military Police at Rokasu-machi, less than 2 miles south of ground zero. Early morning, August 10, 1945. Photo by Yōsuke Yamahata, courtesy Shogo Yamahata.

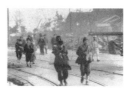

214-215 People heading toward Nagasaki Station from the Urakami District at ground zero. Morning, August 10, 1945. Photo by Yōsuke Yamahata, courtesy Shogo Yamahata.

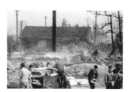

216-217 Civil defense unit at work on the north side of the square in front of Nagasaki Station, about a mile and half south of ground zero. Morning, August 10, 1945. Photo by Yōsuke Yamahata, courtesy Shogo Yamahata.

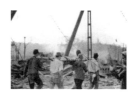

218-219 Civil defense workers gathered near the front of Urakami Station about a mile south of ground zero. Midday, August 10, 1945. Photo by Yōsuke Yamahata, courtesy Shogo Yamahata.

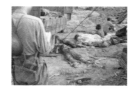

220-221 The injured wait for aid among corpses near Iwakawa-machi, about half a mile south of ground zero. On the left is Eiji Yamada, an artist sketching the devastation. Morning, August 10, 1945. Photo by Yōsuke Yamahata, courtesy Shogo Yamahata.

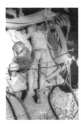

222 Two young boys with burns covering their bodies arrive on a two-wheeled cart at the Michinoo Station, 2.2 miles north of ground zero. Just past 3:00 p.m., August 10, 1945. Photo by Yōsuke Yamahata, courtesy Shogo Yamahata.

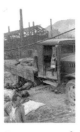

223 A rescue truck is blocked by fire near Iwakawa-machi, half a mile south of ground zero. Behind the truck is the Mitsubishi Steel Works factory. Morning, August 10, 1945. Photo by Yōsuke Yamahata, courtesy Shogo Yamahata.

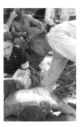

224 At an emergency aid station 2.2 miles north of ground zero, a nurse and doctor apply zinc oil to burns on a patient's back. Just past 3:00 p.m., August 10, 1945. Photo by Yōsuke Yamahata, courtesy Shogo Yamahata.

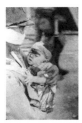

225 Near Ibinokuchi-machi, about a mile south of ground zero, a father searches for a doctor to treat his baby. Morning, August 10, 1945. Photo by Yōsuke Yamahata, courtesy Shogo Yamahata.

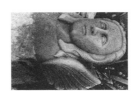

226-227 Statue at Urakami Cathedral, toppled and blackened by the blast. Early September 1945. SCIA photo.

228-229 A boy carrying his injured younger brother on his back searches for relatives near Nagasaki Station. Morning, August 10, 1945. Photo by Yōsuke Yamahata, courtesy Shogo Yamahata.

230 A boy holds a rice ball near Ibinokuchi-machi. Morning, August 10, 1945. Photo by Yōsuke Yamahata, courtesy Shogo Yamahata.

231 After receiving rations, a mother and child leave the first aid station near Ibinokuchi-machi. August 10, 1945. Photo by Yōsuke Yamahata, courtesy Shogo Yamahata.

232 An injured mother and child waiting for treatment near Michinoo Station. August 10, 1945. Photo by Yōsuke Yamahata, courtesy Shogo Yamahata.

ASHQ (1904–1945)

(Army Shipping Command Headquarters under the Japanese Army Department of Transportation)
The Shipping Command of the Imperial Japanese Army commanded and transported ships and was responsible for logistical control of weapons, military equipment, and goods. The government mobilized the army's First Shipping Command, with its headquarters in Ujina, in August 1937 following the breakout of the Sino-Japanese War. It is now part of Minami Ward in Hiroshima. Masami Onuka and Yotsugi Kawahara belonged to the photography team attached to the command.

SCIA (Report published 1951–1953)

(Special Committee for the Investigation of A-Bomb Damages by the National Research Council under the Ministry of Education, Science, and Culture)
The SCIA team, comprising a number of special committees, was charged with, among other things, conducting research and investigations on "nuclear radiation temperature and blast air pressure." Shunkichi Kikuchi, Shigeo Hayashi, and Teiji Nihei were among those who took photographs for the team. Some of the SCIA archives were confiscated by American occupation forces and not returned until 1973.

Toshio Fukada (1928–2009)

Enrolled as a student at Sotoku Junior High School, Fukada was at the Army Firearms Supply Depot in Hiroshima, where he was mobilized for military labor duties, on August 6, 1945. He captured four sequential images of the mushroom cloud five to ten minutes after the explosion with a "Baby Pearl" semi-size film camera that he secretly carried with him from Kasumi-cho, where the depot was located.

Shigeo Hayashi (1918–2002)

Born in Kami-Osaki, Tokyo, Hayashi graduated from Tokyo Photography Academy (predecessor of Tokyo Polytechnic University) and joined Toho-sha, a Tokyo-based publishing company, in 1943 as a staff photographer. He was assigned to the still imaging team of the physics group for a documentary film production project by the SCIA. He covered events in Hiroshima from September 30 through October 11, 1945, and in Nagasaki from October 12 to 22, 1945. He hid his negatives in a locker for years after the war.

Yotsugi Kawahara (1923–1972)

Kawahara worked for the ASHQ photo team. He started capturing scenes of Hiroshima and the temporary emergency care stations on August 8, two days after the attack. He kept shooting the aftermath of the bombing until the end of the war (August 15), taking several hundred images. He was forced to incinerate most of the film on military orders before the American occupation began but secretly saved twenty-five of the shots.

Shunkichi Kikuchi (1916–1990)

Kikuchi worked for Toho-sha as a staff photographer, having joined the company in 1941. Commissioned as a still picture photographer for a medical affairs team for documentary film production under SCIA, he captured 787 images in Hiroshima between September 30 and October 22, 1945, more than any other photographer.

Gonichi Kimura (1904–1973)

Having worked for the photo department at the *Chugoku Shimbun* newspaper, Kimura was assigned to the "Special Discipline Squad" (secretly formed in 1943 to train the suicide attack force) of the Army Ship Transport Headquarters in 1945. He captured images of the mushroom cloud fifteen minutes after the explosion from Ujina in Minami-ku as well as a peripheral view of Hiroshima in flames.

Hiromichi Matsuda (1900–1969)

Matsuda worked as a photography technician at Kawanami Shipyard in Koyagi Island (currently Koyagimachi, where the repair dock of Mitsubishi Heavy Industries is located). He took the very first image of the mushroom cloud on the ground in Nagasaki, approximately fifteen minutes after the atomic bomb explosion.

Eiichi Matsumoto (1915–2004)

Matsumoto worked for the *Asahi Shimbun* newspaper in the publishing / photo images department. He was dispatched to Nagasaki (August 25–September 15, 1945) and Hiroshima (September 18–25, 1945) while on assignment for a feature article on the aftermath of the atomic bomb attack. Having found out that film negatives would be subject to incineration, he concealed them in a locker for protection.

Mitsuo Matsushige (1911–1989)

Matsushige worked for the Hiroshima prefectural government and as an X-ray camera operator. He was at home in Yasufuruichi-cho under medical treatment on August 6, 1945. From the second floor of his house he captured the mushroom cloud two minutes after the explosion and again thirty to forty minutes later. He also took snapshots of trucks loaded with injured victims.

Yoshito Matsushige (1913–2005)

Matsushige worked for the photo department at *Chugoku Shimbun* newspaper and engaged in press corps duties at the command unit of the Army Chōgoku District Headquarters. He was at home in Midori-machi, approximately 1.6 miles from ground zero, on August 6, 1945. That day, he captured five photographs, including now iconic images of citizens near Miyuki Bridge, starting from around 11:00 a.m. They are possibly the only surviving pictures taken that day in Hiroshima that were not of the mushroom cloud.

Suetaro Mori

Mori worked for Mitsubishi Heavy Industries Nagasaki Shipyard as a photo processing technician documenting images of ships, machinery, and plant facilities. In 1945 he was assigned to a team leader at the experimental site of the shipyard. Between August 7 and 27 he was charged with documenting the extent of the damage and destruction at the company's various facilities and affiliates.

Satsuo Nakata (1920–1994)

Nakata worked for the photo department at the Osaka Bureau of the Domei News Agency (predecessor of today's *Kyodo News*). He accompanied the Osaka Unit of the Navy Atomic Bomb Investigation team and photographed Hiroshima on August 10, 1945, four days after the explosion.

Teiji Nihei

A SCIA team member, Nihei photographed Hiroshima and Nagasaki from early to mid-September 1945. His team's primary assignment was to investigate radiant heat temperature and blast wind pressure.

Torahiko Ogawa (1891–1960)

Born in Tsukiji, Tokyo, Ogawa graduated from Tokyo Photography Academy (predecessor of Tokyo Polytechnic University) and was running a photo studio in Sakuramachi, Nagasaki. At the request of the Nagasaki prefectural government, he took 222 photographs between August 20 and the end of September, which were to be submitted to the Ministry of Home Affairs. He went on to take another round of pictures of the devastated city in June 1946.

Masami Oki (1914–2007)

Oki, who was working for the firearms and projectiles department at Kure Navy Arsenal Plant in Hiroshima, captured the mushroom cloud approximately forty minutes after the explosion from his workplace in Yoshiura-cho. Afterward, he photographed ten images showing scenes of the devastated city.

Masami Onuka (1921–2011)

Working for the photo team of ASHQ, Onuka was near the shoreline in Ujina, Minami-ku, Hiroshima, where the army headquarters was located, on August 6, 1945. He started photographing victims on August 7, mostly the critically injured, who had been transferred to the quarantine station in Ninoshima. He then continued shooting the devastating injuries of victims at other emergency care stations.

Yōsuke Yamahata (1917–1966)

Assigned to the press corps at Western Regional Command Headquarters at the Ministry of the Army located in Hakata, Yamahata arrived in Nagasaki around 3:00 a.m. on August 10, right after the A-bomb attack. He started shooting scenes of the devastated city at dawn and took 121 pictures before nightfall. Upon returning to Hakata, he decided to hide his photographs from the military so they could not be used for propaganda purposes. He subsequently hid them from the American occupation forces. In 1952 he published a book of these photographs titled *Atomized Nagasaki: The Bombing of Nagasaki—A Photographic Record*.

ACKNOWLEDGMENTS

I acknowledge with

deep gratitude the many individuals who have made this publication possible. As I discussed in the preface, the idea for *Flash of Light, Wall of Fire* was inspired by the two books by Bensei Publishing Co., *The Collection of Hiroshima Atomic Bomb Photographs* and *The Collection of Nagasaki Atomic Bomb Photographs* edited by Kenichi Komatsu and Kenichi Shindo with the English captions translated by Tsukasa Yokoyama.

Hank Nagashima, who served as a liaison between the Anti-Nuclear Photographers' Movement of Japan and the Briscoe Center, deserves separate and special recognition for his dedication and hard work from the beginning of this project. He worked closely with the Briscoe Center staff, serving as the deeply informed and good humored tour guide and translator for the learning expedition that I made to Japan in November 2018, with my colleagues Ben Wright, associate director for communications, and Alison Beck, director of special projects. Hank has been essential to this project (without him, it would not have happened), and working with Hank has been a true pleasure. I also thank Tsukasa Yokoyama, who shared the additional translation workload with Hank, and Alyssa Adams, director of the Eddie Adams Workshop for photojournalism students, for directing Hank to the Briscoe Center.

While our team was in Japan, we met with Masao Tomonaga, MD, PhD, professor emeritus, Nagasaki University and director emeritus, Japanese Red Cross Nagasaki Atomic Bomb Hospital; and Terumi Tanaka, senior representative of the steering committee for Japan's Confederation of A- and H-Bomb Sufferers Organizations. Those meetings were not only highly informative but also deeply affecting.

The staffs at the museums in Hiroshima and Nagasaki have been especially helpful. At the Hiroshima Peace Memorial Museum, I want to thank Kenji Shiga, former director; Takuo Takigawa, director; Shuichi Katoh, deputy director; Rie Nakanishi, curator; Hironobu Ochiba, curator;

Tomonori Nitta, deputy manager of the outreach division; and Kahori Wada, section chief of the outreach division. At the Nagasaki Atomic Bomb Museum, our thanks go to Akitoshi Nakamura, former director; Kazuya Okubo, director; and Minako Tsurumoto, curator.

During our visit to Japan, our team spent time with students at Fukuyama Technical High School, who gave us a vivid demonstration of their work on a virtual reality version of the atomic bombing of Hiroshima. I want to thank Koutaro Kosaka, principal; Shinji Takata, vice principal; and Katsushi Hasegawa, lead teacher for the school's VR production project, for making that visit possible.

Our team also had valuable discussions with Masami Nishimoto, editor/senior staff writer who continuously provided well-grounded feedback and suggestions to our team based on years of research about the activities of the photographers who captured the crude reality of the atomic bombings, and Michiko Tanaka, staff writer, at Hiroshima's *Chugoku Shimbun* newspaper. Tanaka has also contributed a thoughtful essay to this book. In Nagasaki, we had an informative discussion with Kyosuke Yamaguchi, deputy manager, editorial board, life and culture, *Nagasaki Shimbun*. Toshiyuki Fukumoro and Dr. Toshiaki Mitsudome of Kyodo News Images also provided valuable assistance. I gratefully acknowledge the support of these journalists, as well as Shogo Yamahata, son of Yōsuke Yamahata, and Harumi Tago, daughter of Shunkichi Kikuchi.

An essential component of this publication is the thoughtful and perceptive text contributed by Dr. Michael Stoff, my colleague in the University of Texas at Austin Department of History. He also served as an invaluable advisor to our project. Michael's involvement in *Flash of Light, Wall of Fire* took time away from his own research and writing on the topic of the aftermath of the bombing of Nagasaki. Thank you, Michael.

I have the great good fortune to work with a group of hard-working, dedicated, versatile, and highly skilled professionals at the Briscoe Center who made significant contributions to the project. They include Amy Bowman, photo archivist; Hal Richardson, digital project coordinator; Dr. Sarah Sonner, associate director for curation; Echo Uribe, associate director for administration; and Dr. Holly Taylor, editor and head of publications. Among other contributions, Dr. Taylor served as the center's liaison with the University of Texas Press. Three Briscoe Center administrators served with me as members of the lead team for the book project and for the exhibition that opened in conjunction with its publication: Dr. Sarah Sonner, Alison Beck, and Ben Wright. Alison and Ben made multiple contributions that carried the project from beginning to end, while Sarah applied her magical skills to the accompanying exhibit at the Briscoe Center. Their work, which was conducted with great sensitivity toward the tragic subject matter, has been outstanding in every way. It has been a privilege and an honor to work with them all.

Finally, my praise goes out to our talented partners at the University of Texas Press, including Robert Devens, editor-in-chief and assistant director, Robert Kimzey, managing editor, and freelance designer Erin Mayes, creative director and partner at EmDash. I want to give special recognition to the extraordinary contributions made by David Hamrick, who retired as director of the University of Texas Press a few months prior to publication. In his tenure as director, Dave succeeded in making the press one of the most outstanding scholarly publishers in the United States. Dave was not only an enthusiastic supporter of this book but he was also directly involved, including serving as the photo editor. My debts to Dave go well beyond this book and are too numerous to list here. I wish him a satisfying retirement.

The publication of *Flash of Light, Wall of Fire* has been made possible by funding from the Dolph Briscoe Endowment.

Don Carleton

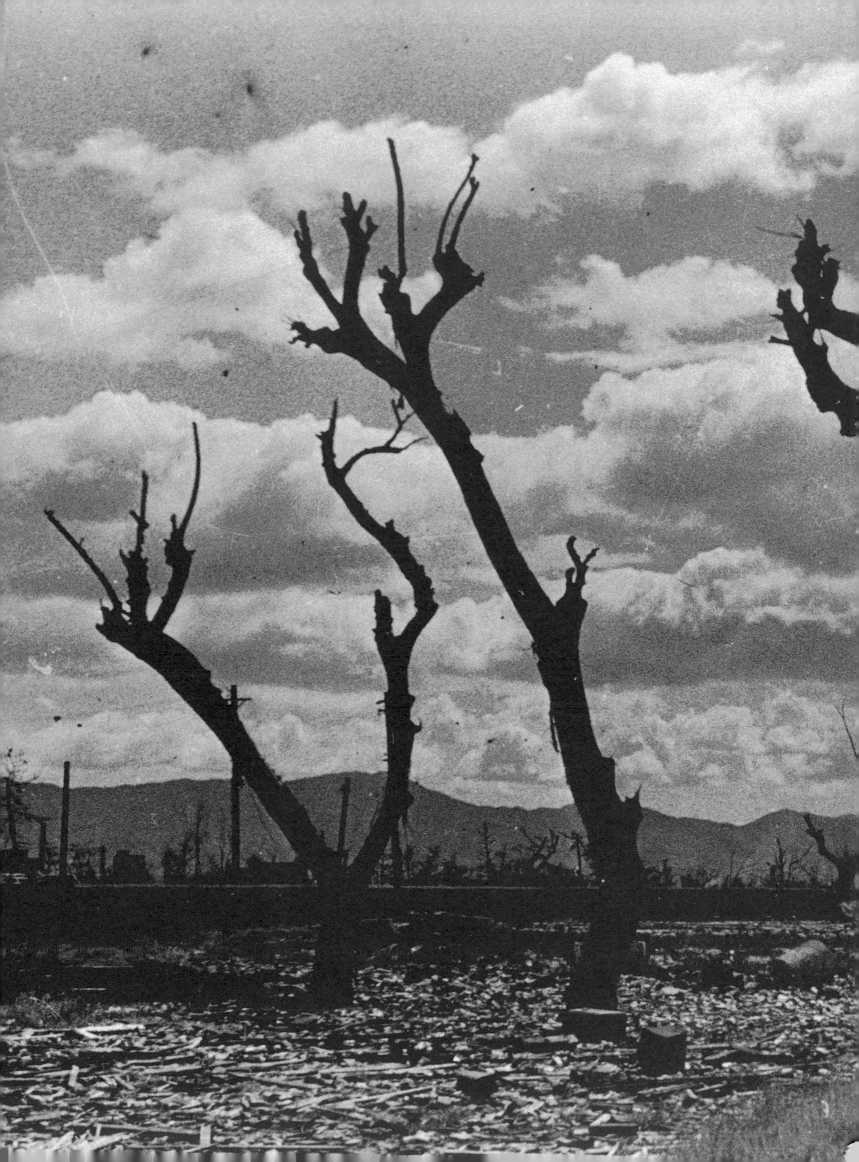